LIGHT *for a* COLD LAND

Lawren Harris's Work and Life – An Interpretation

PETER LARISEY, S.J.

DUNDURN PRESS
Toronto & Oxford

Editing: Avivah Wargon
Film work: Goody Color Separation (Canada) Ltd.
Printing: Midas Printing Limited

Printed and bound in Hong Kong

The writing of this manuscript and the publication of this book were made possible by support from several sources. The publisher wishes to acknowledge the generous assistance and ongoing support of **The Canada Council**, **The Book Publishing Industry Development Program** of the **Department of Communications, The Ontario Arts Council,** and **The Ontario Publishing Centre** of the **Ministry of Culture, Tourism and Recreation**.
 Care has been taken to trace the ownership of copyright material used in the text (including the illustrations). The author and publisher welcome any information enabling them to rectify any reference or credit in subsequent editions.
 Works illustrated are oil on canvas unless the caption states otherwise.

J. Kirk Howard, Publisher

Canadian Cataloguing in Publication Data

Larisey, Peter 1929–
 Light for a Cold Land : Lawren Harris's work and life – an interpretation

Includes bibliographical references and index.

ISBN 1-55002-188-5

1. Harris, Lawren, 1885–1970. I. Title.

ND249.H3L3 1993 759.113 C93-094436-4

Dundurn Press Limited	**Dundurn Distribution**	**Dundurn Press Limited**
2181 Queen Street East	73 Lime Walk	1823 Maryland Avenue
Suite 301	Headington, Oxford	P.O. Box 1000
Toronto, Canada	England	Niagara Falls, N.Y.
M4E 1E5	OX3 7AD	U.S.A., 14302-1000

CONTENTS

FOREWORD

Lawren Harris was a Canadian Titan. Now that he has gained world recognition, it is hard to realize that at one time he was misunderstood, envied and often belittled except by those who came under his spell. Peter Larisey's book is most timely as a scholarly and insightful examination of Harris's entire artistic output, his thought, his writing and his extensive influence. Through this survey of his work and thought, a more profound picture of the man emerges than any purely biographical account could reveal, no matter how intriguing it might have been. The number of paintings and sketches illustrated are in themselves an absorbing document of Lawren's pioneering search against all concurrent trends in Canadian art. Each period of his work clearly surpasses the last in his drive to extract in paint from out of physical reality his daemon – the life force that animated the forests of Northern Ontario, that rumbled behind the impassive face of mountains, that formed icebergs in sun-splashed seas, that was manifest in cryptic geometry and was ultimately the light that shone in everything and every one of us – the sole subject of his final work.

Against the present turpitude of this country it is exhilarating to read of the ardent idealism of Harris and his Group of Seven – the love of "the North," the landscape that to him would give birth to a unique and unprecedented northern culture. In contrast to the unbridled mercantilism of today his belief in the primary role of art in defining a culture returns us refreshingly to a more innocent time when we had statesmen, not politicians, to lead us, leaders who believed that, above all, the arts defined a people.

I was sixteen when I met Lawren and Bess and they were to change my life. A close family friend, Nan Cheney, the artist and intimate of Emily Carr, brought the Harrises to see my art work. I anticipated the visit with great excitement and remember vividly when they walked up the path to my parents' house how imposing he was – erect, trim, vital, with that corona of white hair framing soft but lively brown eyes and the beautiful Bess at his side. Her beauty emanated not only from startling sky blue eyes but from the grace that pervaded her manner, her gestures, her voice and what it said. Devoted, radiant, each shone in the other's presence. Though I was not to know of its celibate nature until I read this book, I realize why the "marriage" appeared to be a blessed relationship of two superior beings who emanated a serenity few could attain – or so it seemed to me at sixteen.

Having looked at everything very carefully, Bess and Lawren said very little. Lawren's only comment was "Swell … just swell."

I loved the mountain experiences as he did, and later did a number of compositions of the Black Tusk in Garibaldi Park. Lawren asked me if he could borrow one for an exhibition of "non-objective" art that he was arranging from his American collection at the Vancouver Art Gallery. It was an approbation far beyond any expectations for a seventeen-year-old would-be artist. I learned that words were never wasted in small talk or flattery by either of them. When something was said it was well worth listening to. Even "swell."

The "at home" Saturday evenings were an astonishing exposure to the purveyors of ideas of his city. Intellectuals not only from Vancouver but also from Europe frequented those evenings, for many composers and conductors, dancers and writers had come to Canada from the conflagration in Europe. Barbirolli, Britten, Arthur Benjamin and Sir Ernest MacMillan were a few I remember. Locally the Adaskins, Ira Dillworth, the Binnings, Birneys, Bells, Smiths, Andrews and MacKenzies were frequent attendants. The ritual was set. After arriving at 8:00 sharp you were seated in the living room, Lawren selected the first recording of his huge collection, spoke about it, clipped the bamboo needle, turned out the lights and left you in the dark to concentrate only on your aural senses.

At 10:00 the lights went on and coffee was served. Suddenly from the night of aural enchantment we entered the day of visible light – the silvery light of Lawren's mountain experiences. The clear blues, muted purples, whites, chrome yellows and silver greys of his non-objective compositions on the walls extended into the serene surroundings of the house. A grey-purple carpet ran throughout on which white or silvery rugs were set with cabinets of beaten tin from Mexico and low white sofas. Lawren's and a few of Bess's paintings glowed with the suffused illumination of the Arctic ice, the mountain summits, the floating icons in an unlimited sky. In this exalted ambience the conversation often turned to Madame Blavatsky, W. Q. Judge, Annie Besant, Buddhism and theosophy. At that young and searching age I was entranced by the lofty concepts for they counterbalanced the awful concurrent violence in Europe that I would have to face in another year. The discussions put the tyrannical tendencies of mankind into a more benign cast of human fate, making them less ominous and disillusioning for one beginning a life's adventure.

Lawren and Bess spoke often of New Mexico where they had exiled themselves from Toronto and where they wished to eventually settle. Vancouver was only intended as a temporary refuge for them, close to Lawren's mother, hospitalized in Victoria. But Vancouver harnessed his unquenchable energy as perhaps no other place in North America could.

Vancouver at that time had a population of 200,000, and its cultural life was tenuously centred on the university, symphony, Player's Club and a small art gallery showing only local works. Lawren changed all that. He awakened the city to its own creative forces in art and music, encouraging the many extraordinary artists, intellects and patrons of that golden age of Vancouver's youth. The Binnings, Smiths, Shadbolts, Koerners, MacKenzies, Grauers, Andrews, and Dillworth, Somerset, Coulthard and so on, galvanized by his enthusiasm, drove this modest sleepy city to become a mecca for new art in every field on the West Coast of Canada. Under him the gallery was extended and opened to international shows. By collecting the unknown Emily Carr's work he gave the gallery its only important collection other than his own works. Ibi Koerner's courageous Vancouver Festival and Dillworth's pioneeering CBC were engendered by the status he had given the arts. You felt you were at the hub of the western creative vortex – leaving Toronto and Montreal far behind. It was one of those rare exhilarating moments in the life of a city in which anything seemed possible.

This was the decade following the war. In 1946, coming back from service overseas – I was at sea about my course in life. Was it to be painting or the diplomatic corps? I went to Lawren who gave me the best advice I had ever received when he said, "Arthur, it would be a mistake to advise about your life. It has to be entirely up to you." I chose architecture.

It was sad to see that era fade in the early sixties. To see the CBC bureaucratized, and, centralizing, drag all the artists back to Toronto, leaving Vancouver a cultural wasteland for ten years; to see the energies that had galvanized the city dis-

perse or silently retire; to see Lawren, always so vigorous, begin to fail and to enter his own silence. One night when I found Bess alone at a local restaurant I was to hear her despair about a world she could no longer understand that was impassive to the promise for humanity and for Canada that she and Lawren had so fervently envisioned.

Before entering hospital herself she gave my mother an Eskimo whalebone head, to keep for her. My mother knew then that Bess would never come out. Peg moved into the serene mansion to take care of Lawren and when we visited him he seemed lost except when he suddenly talked of his painting. Then he would be his old self and would speak of Bess as if she were still there. Peg whispered to me that Lawren didn't fully realize that Bess had gone; I knew that Lawren was well aware that Bess was still there, but on a plane that only he could reach.

Arthur Erickson

PREFACE

This book is an art-historical effort to bring Lawren S. Harris and his work out from behind the fences imposed mainly by the nationalist myth in Canada, but also by this country's continuing hesitations about modernism, mysticism and interpreting its art.

Part of the challenge, of course, is Harris himself. One of the main builders of the nationalist myth, he was, in the early decades of this century, the chief organizer and most articulate spokesperson for the Group of Seven. For example, in 1924 during their heyday he bragged that the art of the Group "had no known art ancestry," that it was a way of painting that was not derived from Europe or anywhere else. Perhaps Harris believed it himself. It was certainly what he wanted Canadians to believe.

However, as the reader will see, the truth is that just about all Harris's paintings, even those of his landscape period (1908–30) were heavily dependent – for their various compositions, pictorial points of view, iconography, use of brushstroke and landscape philosophy – on his experience as a student in Germany (1904–1907). Even Harris's combative style of artistic politics, at times very effective, echoed in some detail strategies he had first experienced in Berlin.

But why did Canadians believe Harris and his colleagues when they made this and similar assertions? With their perennial wish for a sense of identity, Canadians found Harris's rhetoric about the Canadian "people and race" attractive. And if they were "consumingly commercial" but insecure in their ethics, or still utilitarian and pioneer in their sentiments, they could feel an easing breeze of justification in Harris's mystical vocabulary about their country.

A more important circumstance was the widespread ignorance of the German art of the modern period. Until the 1960s, almost all studies of modern art concentrated on French art. They paid little or no attention to the quite different styles and emotional attitudes toward landscape current in Germany, and the quite different struggle of its painting to become modern. For more than three years Harris – young, enthusiastic and receptive – had been surrounded by, caught up in and deeply impressed by this art.

Confronted on his return from Germany with a country cold to the arts and ignorant of modernism, Harris gradually understood his task. He set out to enlighten and educate everyone, and to recruit colleagues. Nationalism seemed to be the necessary starting point, and the Group of Seven's combined energies produced, especially in the 1920s, a major body of regionalist landscape painting. This having been achieved, Harris sought further horizons.

1934 was a momentous year for Harris. After more than a decade leading the nationalist movement in painting, he broke with Canada. Leaving his wife, family and friends and his upper-class life in Toronto, he moved to the United States (first to Hanover, Hew Hampshire and then to Santa Fe, New Mexico) where he fully expected to stay. Almost immediately he began to paint abstractions. Thus he left behind both nationalism as an ideology and representational art as a means of expression.

Canada's entry into World War II in 1939 cut off Harris's funds, and forced him to return to Canada. Still affluent, he moved to Vancouver in 1940 and began a new life as an artist-celebrity. He quickly got involved in artistic

politics at the local and national levels. Soon he was president of the Federation of Canadian Artists, a platform that gave him the best possible opportunity to propagate his mystical philosophy of modern art and his refound Canadian nationalism, now refurbished with a new theoretical basis. Over the next twenty years in Vancouver, Harris's art moved away from the rigid clarities of his early geometric abstractions toward a new though limited appreciation of subjectivity. Out of this and his continuing interaction with the art of the New York avant-garde he developed his own Abstract Expressionism and later, in his luminous last works, paintings with a sense of mystery.

The intensifications of the traditions he painted in, his commitment to a heroic understanding of modernism and his tireless pursuit of continual development well beyond the Canadian nationalist's horizon enabled Harris to produce a body of work unique in his generation.

The strengths of Harris's art have often not been appreciated. An opportunity came in 1984. In the Art Gallery of Ontario's exhibition "The Mystic North: Symbolist Landscape Painting in Northern Europe and North America 1890–1940," Harris's landscape painting stood out well in the European and North American contexts. Appreciation of his abstract painting beyond a small inner circle of admirers began only recently when the Art Gallery of Ontario surveyed it in their 1985 exhibition, "Atma Buddhi Manas." Abstractions from Harris's American years (1934–40) are now popular with some American collectors. Canadians are still circumspect about all his abstractions.

Much that has been written about Lawren Harris has been within the framework of the nationalist myth. Facts about him, his works and ideas have been reverently assembled. I think that we now need studies that also interpret his art, his life and his writing in the wider contexts in which Harris lived, thought and worked. I hope that this book will help in this task.

In preparing *Light for a Cold Land* for publication, economies had to be observed if the book was to be affordable. Regrettably, there are fewer and smaller black and white figures than we had hoped for. The colour plates, though numerous, were at times made from my own slides. This keeps the book close to my research, which is good; at times it produces less good colour plates, which is unfortunate. Economies have also prevented us from including a bibliography. The notes, however, do provide all the bibliographical data used in *Light for a Cold Land*. The reader can find more complete bibliographical information on Harris's landscape period in my thesis, "The Landscape Painting of Lawren Stewart Harris" (1982), available on microfilm in many libraries.

ACKNOWLEDGMENTS

I'd like to begin by thanking the personnel at Dundurn Press, whose ambition and energy moved these words and images from their manuscript stage to a book. I especially thank Avivah Wargon, the watchful coordinating editor, Nadine Stoikoff, who searched copyright permissions and transparencies, Shawn Syms, for editorial assistance, and Kirk Howard, Publisher, for thinking it was all a good idea.

I wish to thank especially Harris's son, the painter Lawren Phillips Harris. In many interviews since the first in 1971, he has been generous with information and insights, yet has never tried to control points of view or shape the results of my research. His wife Anne has also been very informative, and generous with her hospitality. From their daughter, Susan Ritchie, I appreciated hearing a granddaughter's perceptions of Harris as an old man.

I first met Harris's daughter, Mrs. Margaret Harris Knox, in 1973, and since then have found her a mine of information about her father's personal life. She will find many traces of interviews with her in *Light for a Cold Land,* as well as responses to corrections she made to an earlier draft of the text.

There are two art historians I wish to thank. Dennis Reid generously shares his painstaking research in Canadian art and so has made work easier for the rest of us. I also thank the late Dr. Robert Hubbard, former Chief Curator at the National Gallery of Canada, for helpful suggestions as I began research and for his encouragement in Canadian art history of the internationalist point of view I have adopted.

I am thankful to editor Freya Godard who did the difficult work of shortening the text. I am also grateful to my friends Robert Czerny, who helped with early stages of the writing, and Eva Gillies, for the assistance she gave in solving problems of German translation. I owe a special debt of thanks to Bruce Henry, whose observations on the manuscript were both critical and encouraging, and who, as I write this, is preparing the index.

The libraries and staffs at the National Gallery of Canada, the Art Gallery of Ontario and the Vancouver Art Gallery have been very helpful. I also wish to thank the Social Sciences and Humanities Research Council of Canada and the Ontario Arts Council for their generous support.

Finally, I thank my colleagues in the Upper Canada Province of the Society of Jesus who have supported me for years in this and other aspects of my art-historical research. Without their support, *Light for a Cold Land* would not have happened.

PART I

THE EARLY YEARS, 1885–1918

COLOUR PLATES IN PART I*

*The works illustrated are oil on canvas unless the caption states otherwise.

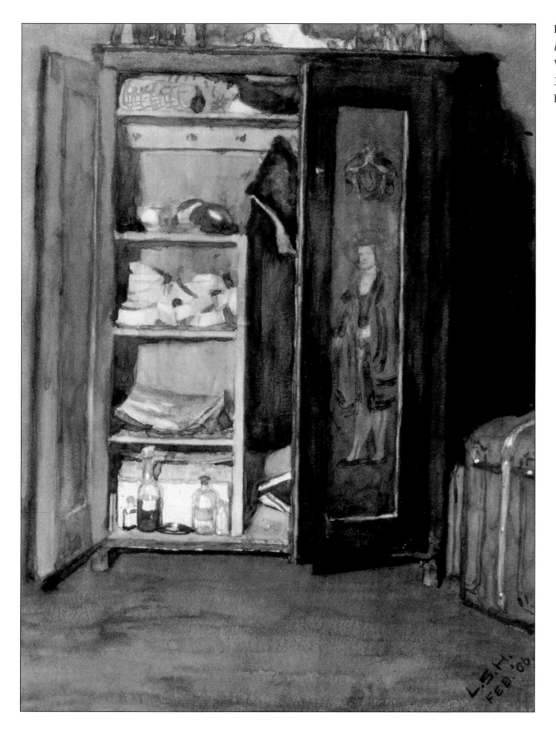

Plate 1
Interior with a Clothes Closet, 1906
Watercolour
31 x 24.8 cm
Private collection

Plate 2
Buildings on the River Spree, Berlin, 1907
Watercolour
59.7 x 45.6 cm
Art Gallery of Windsor

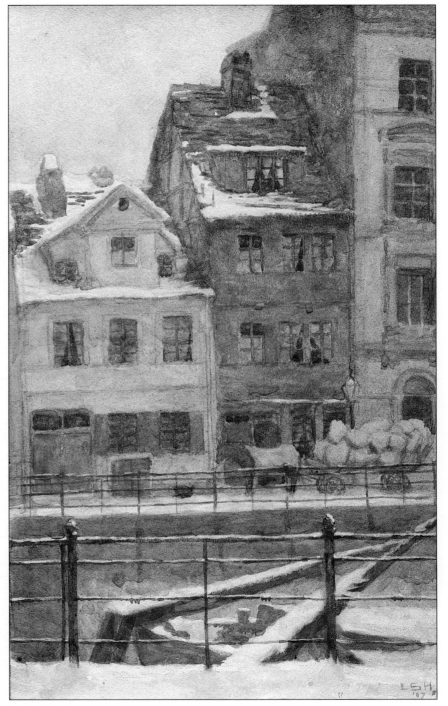

Plate 3
Hills, c. 1907
Oil on board
20.3 x 25.4 cm
Private collection

Plate 4
Over the Old Route into Egypt, 1909
Original oil on canvas,
43.2 x 66 cm
Courtesy of K. R. Thomson
Reproduced here from Norman Duncan,
Going Down from Jerusalem (New York: Harper Brothers, 1909)

Plate 5
Houses, Wellington Street, 1910
63.5 x 76.2 cm
Courtesy of K. R. Thomson

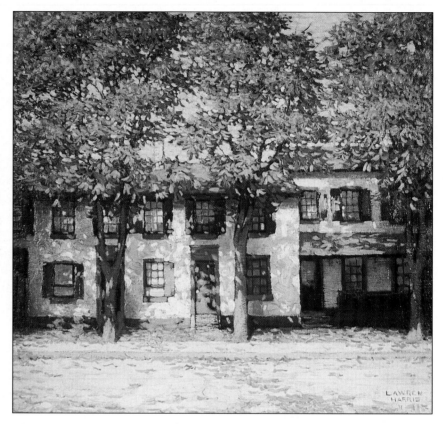

Plate 6
Houses, Richmond Street, 1911
76.2 x 81.3 cm
Courtesy of K. R. Thomson

Plate 8
In the Ward, 1913
Oil on board
26.7 x 34.9 cm
Private collection

Plate 7
The Corner Store, 1912
88.5 x 66.2 cm
Art Gallery of Ontario, Toronto
Gift from the estate of Mary G. Nesbitt, Toronto, 1992

Plate 9
Laurentian Landscape,
1913–14
76.2 x 88.3 cm
Private collection

Plate 10
Winter in the Northern Woods, 1917–18
139.7 x 182.9 cm
Imperial Oil Limited Collection, Toronto

Plate 11
Algonquin Park, 1916
Oil on board
35.4 x 27 cm
McMichael Canadian Art Collection, Kleinburg, Ont.
Gift of Mr. R. A. Laidlaw

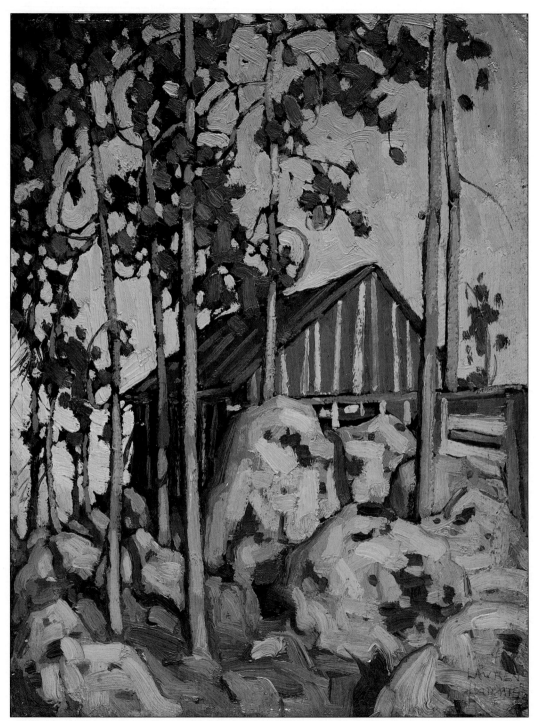

Silver Spoon in Southern Ontario

The Canadian ancestors and family of Lawren S. Harris were inventive and practical, idealistic and, by the time Lawren was born in 1885, rich. All four of these qualities were to merge in various ways as important aspects of his life and career. The first Harris ancestor to come to what would eventually be known as Ontario was a clergyman, the Reverend John Harris, a circuit-rider preacher nicknamed "Elder John." With his wife, Catherine Duggart Harris, who came from the Mohawk Valley of New York State, Elder John migrated shortly after the war of 1812 to what was then known as Upper Canada. Their eldest son, Alanson (1816–94), was born at Ingersoll, Upper Canada.

Alanson Harris married Mary Morgan in 1839. Among their children was Thomas Morgan Harris,[1] who married Anna Kilborne Stewart. They had two sons. The first, Lawren Stewart Harris, was born at Brantford, Ontario, on 23 October 1885, and died at Vancouver in 1970 as one of the best-known painters in Canada's history. His brother, Howard Kilborne Harris, born on 14 January 1887, was killed as a captain in the Imperial army in February 1918 while inspecting a German trench.

The inventive and resourceful streak in the family soon made itself felt. Elder John had "a splendid gift of exhortation" but had difficulty supporting his large family because he disliked farming. To relieve its tedium he invented machines – for example, a revolving hay rake. To augment the family income, Alanson was apprenticed at the age of thirteen to a sawmill operator.[2]

Later, John and Alanson went into a business partnership operating a small sawmill at Whiteman's Creek, Upper Canada. Alanson sold this in 1856 and bought a small foundry at Greensville, Canada West (as Ontario was called between 1841 and 1867), where he started manufacturing farm implements. Eventually Alanson took his eldest son, also called John, into partnership and moved to Brantford. It was this business that invented the "Brantford Light Binder," a harvesting machine that cuts grain and binds it into bundles, which became the basis of the Harris fortune. This binder was in competition with the "Toronto Light Binder" manufactured by Hart A. Massey in Toronto. The two companies merged in 1891, forming the Massey-Harris Company with a capitalization of five million dollars.[3] Lawren Stewart Harris's share of that fortune was to enable him to paint and travel, free of the financial concerns that often restricted his colleagues in the nationalist movement and most other painters in Canada. It also enabled him to subsidize artistic projects he thought valuable, such as the Studio Building he opened in Toronto in 1914.

The economically expanding culture of southern

Ontario was the perfect setting for the Harris family's enterprising, hard-working farmers and inventors. But being religious in Protestant modes was as much part of the culture of Ontario as working hard and exploiting one's talents and energies in competing for financial success. It was a society that placed a high value on visible material progress but also on religious involvements and duties. These were most often accomplished in one of the larger Nonconformist Protestant churches (Baptist, Presbyterian and Methodist). These three, along with the smaller Anglican church, formed an "omnibus denomination" which, by 1881, had a combined membership of more than 77 percent of the total population. Generosity to and through these churches was an important balancing factor to the materialism involved in the emphasis on economic growth. Many Victorian Canadians were looking forward to a kind of millenium where the competitiveness and alienations of their materialistic economic prosperity would be transformed into a rich, enlightened culture.[4]

By these norms of economic success and religiousness, the Harris family were highly successful Ontario Victorians. Lawren's grandfather Alanson Harris, president of A. Harris, Son and Co., was profiled in the *Canadian Album, Men of Canada: or Success by Example* of about 1892. He was praised for his "great inventive ability and [the] wonderful energy which has since characterized him, and laid the foundation for one of the largest agricultural manufacturing establishments on the continent." But Alanson Harris's religious qualities are just as important to the *Album*. We are told that he "was converted at a revival service held in Boston, Ont., when eighteen years of age, and at once joined the Baptist Church, of which he has ever since been an honored member." Like his son Thomas after him, Alanson Harris held almost all the positions in his church open to laymen. And his generosity to the church is stressed. "There are few men in the land who have given more money to the cause of Christ than Mr. Harris." Particular mention is made of his gift of the church lot "costing $8,000, to the Walmer Road Baptist congregation, Toronto, of which the Rev.

Elmore Harris, his son, is pastor."[5]

Dr. Elmore Harris (1854–1911), Lawren's uncle, was the best known of several clergymen in the Harris connection with whom Lawren had direct contact. Bess Harris, Lawren's wife from 1934 until her death in 1969, felt that these men exemplified the idealistic qualities of the family. In 1889, Elmore was the founding pastor of the Walmer Road Baptist Church, in the Toronto neighbourhood where Harris lived as a boy. In addition, Dr. Harris founded the Toronto Bible College in 1894. Also important to Harris's development was his mother's father, the Scottish-born Reverend William Boyd Stewart (c. 1836–1912). He was an important influence on Harris, both through Harris's mother and more directly. While Harris was still a boy – probably after his father's death when he was only nine – Stewart took Lawren, his brother Howard and their mother on a trip to Europe. He was an intellectual and a liberal as well as a working clergyman in the Baptist church; and he had been president of Berea College in Kentucky, the only college south of the Mason-Dixon line to admit blacks as well as whites. He was still expanding his intellectual horizons when he was over seventy by studying Nietzsche's writings in the original German.[6]

Besides influencing Lawren Harris, William Boyd Stewart had an important intellectual and liberalizing influence on his own son, William Kilborne Stewart (1875–1944). Lawren became a close friend of the younger Stewart, stayed in the same pension with him and his wife during his first year in Berlin (1904–1905) and lived near him during his four years as "unofficial artist-in-residence" at Dartmouth College, Hanover, New Hampshire (1934–38).[7]

Lawren's father, Thomas Morgan Harris, was himself an unusually interesting man. He died in 1894 of Bright's (kidney) disease. He knew for some time he was going to die, and the story is that he carefully prepared his young wife to look after their sons without him. He was concerned that she train them to think for themselves as soon as possible,[8]

a stance not common at that time. Thus Harris's liberal heritage came from both sides of his family.

But there was almost certainly another important influence from his father that I believe emerged in Lawren's mature life. Thomas Morgan Harris was to an unusual degree the paradigm of a man who took religion seriously and allowed it to saturate his life. He was as thoroughly committed to his Baptist beliefs and their practical consequences as his son would later be committed to living out his own mystical and theosophical vision. Thomas Harris's piety and work for the Baptist church during his short life was conspicuous and impressive enough to merit a book published by the church press at the time of his death, and several clergymen besides those who were his relatives attended his crowded funeral. His pastor remembered him as a "working Christian" and "a praying Christian" who filled many positions of trust in the congregation: teacher of the Bible class, superintendent of the Sunday school, deacon, the leader of the Young People's Society, vice-president of the Baptist Young People's Union in Ontario, an active worker in the YMCA, and so on.[9]

Stories about the lifestyle that expressed this religious vision in the Harris home come from Lawren's daughter, who learned many of them from her grandmother. There were prayers at home twice every day. Sundays were particularly arduous: no work was done but play was not allowed either; church had to be attended three times and the only reading permitted was the Bible.[10]

The stories about Lawren's and his brother's boyhood remembered in the family tradition frequently describe their high spirits. Lawren was not strong physically and was often kept in bed, but he had "an ardent spirit." Drawing and painting, first used for entertainment, became "an occupation," although he ate his first set of watercolours as though they were candies. Lawren and his friend Billy Davidson, who lived on the same street in Brantford (and who died when he was only twelve), used to paint pictures of all the houses in the area.[11] Thus even in his childhood Harris had

an interest in drawing and painting houses, one of the most important motifs of his landscape period.

Lawren's mother, Anna Stewart Harris, is remembered in the family tradition as "buoyant, outgoing and generous." After her husband died in 1894, Anna Harris moved to Toronto with her two sons, whom she enrolled in Huron Street Public School in the fall of that year. The good relationship the still-young Mrs. Harris had with these two high-spirited boys is a popular part of the family tradition. She herself often told people about how "naughty" she had been not to tell the headmaster of St. Andrew's College (where the boys went in 1899) just what kind of mischief-makers she was enrolling in his private school. Another story about these early years concerns the family car. Anna Harris was one of the first people in Toronto to own a car and recounted having to wait on the front steps of the house while her two sons wrestled on the lawn over who would be the first to drive it.[12] Anna Harris's strong personality would continue, throughout her life, to interact in various ways with that of her son. During the later crisis of Harris's divorce, second marriage and consequent need to leave the country in 1934, he took his mother's advice on important issues seriously. For a while during those years she lived near him in Hanover, New Hampshire, and when Harris moved to Vancouver in 1940, she also moved to the West Coast. Importantly, she came to share her son's interest in mysticism.

Harris was educated for seven years at public schools in Brantford and Toronto, then at a Toronto private school, St. Andrew's College in Rosedale (then, as now, an upper-class section of the city). St. Andrew's opened in 1899 as a school of Presbyterian orientation; Lawren and Howard entered that September, and so became charter-students of the College. Harris entered Second Form, the equivalent of grade eight, more than one full year after leaving grade seven at Huron Street Public School. Thus he lost a year (i.e., 1898–99) in this phase of his education, probably through illness (the College's records indicate that he had a tutor before coming

to St. Andrew's). The records also show that Harris spent two years in Third Form (i.e., grade nine), and graduated from Fourth Form (grade ten) in the spring of 1903, when he left the school.

Bess Harris emphasized the liveliness of the two boys: "both were imps – they were not scholars. They had more ideas per minute and more exuberant vitality to get rid of than most." She also wrote that, while at St. Andrew's, Harris played hockey and cricket and did high diving (though his name does not appear in the school's athletic records). She pointed out that these sports and those he practised later in life – tennis, badminton and squash – call for coordination, speed and a quick mind. Harris is said to have made Christmas cards as a child for the whole family, to have illustrated his school notebooks and to have drawn for "the school paper" at St. Andrew's.[13] However, none of these watercolours or drawings have turned up so far.

The one surviving work of art from this period is a short story, "Jack Brown," published in the *St. Andrew's College Review* late in 1902,[14] when Harris was seventeen. This story is interesting because it reveals some of Lawren's attitudes at that time, and some of the content of his imagination. The story describes the inventions, mainly farm machinery, often ingenious and fantastic, of the hero, Jack Brown, a farmer's son. It climaxes with a description of a flight in the most ambitious of these inventions, a battery-powered flying machine. The prototype of the hero is the Harris ancestor who invented the Brantford Light Binder. The story reflects the family idealism too: "Jack Brown continued his inventions, not to better his father's farm, but to better the world." In the short story, Harris's affection for the family history and for his ancestors' inventiveness and idealism is caught up in a relentless swirl of slapstick comedy that is far removed from the serious tone of all his painting and his later writing.

Among Harris's contemporaries at St. Andrew's College was Frederick Broughton Housser (1899–1936), who was to become a close friend and ally of Harris in the nationalist movement in Canadian painting, and a fellow-member of the Theosophical Society. In 1926, he published his influential history and interpretation of the Group of Seven. Writing about Harris's boyhood, Housser concealed his knowledge that Harris had gone to a private school. He was interested in stressing the populist and democratic aspects of public school, where Harris would have been "rubbing against types of all grades of society." This was important to Housser because he was a leading Canadian Whitman enthusiast and felt that Whitman would have approved of the institution of Canadian public schools "for 'its levelling to divine averages.'" Housser went to the University of Toronto after matriculating from St. Andrew's College in 1908, and later worked for the Massey-Harris Company. In 1914, he married Bess Larkin, whose portrait Harris would paint in 1920, and who would become Harris's second wife in 1934. Nevertheless, Harris and Housser remained friends until the latter's death in 1936 while Harris was in Hanover, New Hampshire.[15]

Another contemporary of Harris at St. Andrew's was Vincent Massey (1867–1967), of the very wealthy family that made up the other half of Massey-Harris. He was to have an exceptionally distinguished career in the Canadian diplomatic service, and would eventually become the first Canadian-born Governor General. Throughout his life, he was to be an important patron of the arts and of higher education in Canada. He became chairman of the Royal Commission on the Arts, Letters and Sciences, whose report (the Massey Report, 1951) made recommendations intended to strengthen Canadian culture and led directly to the founding of the Canada Council.

Harris's career at the University of Toronto was very short. He was registered at University College for the academic year 1903–1904, but was a student there probably no longer than half a year. I have not found out how Harris was able to get into university in 1903, having graduated from St. Andrew's with only grade ten in June of that year. Where his university application form (the only item on file in the

university archives) asks for the date of matriculation, that line has simply been crossed out. Another question poses itself: did Harris get instruction in art in Canada during the half-year before he left for Berlin, i.e., the second half of the 1903–1904 academic year? If he didn't, what did he do during that time?

Housser's account of Harris's university experience is the most interesting:

> In the course of a conventional education we find Harris at Toronto University filling his note-book with pencil sketches of his fellow freshmen and various members of the faculty instead of listening to professional lectures. One of these illustrated note-books was left by accident in the classroom where it was picked up by a professor intelligent enough to see that this student was wasting his time at college. He called at the family residence and stated his opinion, and the incident ended by Harris being sent to study painting in Germany.[16]

Bess Harris, in her briefer account, quoted the professor's words to Harris's mother as though they had been remembered verbatim in the family: "You should send this boy to Europe. He should study art." Anna Harris agreed. Her only stipulation was that Harris should go to Berlin where her young brother, William Kilborne Stewart, who was a professor of German at Dartmouth College, was to be a postgraduate student for the 1904–1905 academic year.[17] Both Harris and Stewart accepted this condition, and in the fall of 1904 Harris sailed for Berlin.

Modernist Berlin and the Middle East, 1904–1908

Figure 2.1
Fritz von Wille
Departing Winter in the Eifel, c. 1904
Unlocated

HARRIS'S LIFE IN BERLIN

Other than his student works, there are no contemporary documents from Harris's years in Berlin. There is a relative consistency in the accounts, however, and the picture that emerges of Harris as intelligent, enthusiastic and energetic fits well with what we know of his personality as a younger student in Canada.[1] To the small-town and provincial experience of his childhood and youth, Harris had to assimilate living in Berlin, a large, cosmopolitan centre fast becoming, under the Prussian leadership of Kaiser Wilhelm II, the cultural and commercial capital of Germany. If Berlin at this time was less renowned than Paris as an art centre, it was not much less exciting.

By the time Harris arrived, there was an organized and articulate avant-garde – by then called the Berlin Secession[2] – whose artists regularly exhibited their own realist and regionalist works, many of which were influenced by French Impressionism and Post-Impressionism and by the earlier Barbizon painters. The Secession also exhibited works of modern artists from other centres, especially from Munich and Paris. The Norwegian Edvard Munch lived in Germany at this time, and his work had been, since 1892, a conspicuous part of the avant-garde program. One aspect of Berlin as

an exciting cultural milieu was the struggle between this avant-garde and the cultural establishment led by Kaiser Wilhelm himself; his conservative outbursts in Reichstag debates on art helped to keep the conflict before the public eye. Berlin was Harris's first experience of the politics of an avant-garde struggling against a conservative cultural establishment. He experienced this struggle within himself as a tension between what he called the "academic conditioning" he was receiving in Germany, and modern art. The experience was to have long-lasting effects on his life as an artist.

Describing her husband during his student days in Berlin, Bess Harris wrote that "his imagination was swarming with impressions gathered by an exploring and active mind," and she added that he had "the ardent spirit, the outgoing nature which was unforced and came quite naturally – a quick and opening mind that was intuitive and perceptive, but was not in the least scholarly – and an active body that was charged with terrific nervous vitality rather than physical strength or robustness." We know, too, that it was not only painting that occupied Harris. His deep, lifelong interest in music was already in evidence. As Bess put it: "Music, great music was for Harris a moving and emotional experience. He went to all the great operas and concerts that it was possible for him to go to."[3] Harris played the violin, and his daughter Margaret told me that he went to Berlin to study

both painting and violin.[4] This theory is supported by his choice of friends while in Berlin: they were mainly music students from North America.

Harris shared this interest in music with his young uncle, William Kilborne Stewart. Stewart had graduated from the University of Toronto in 1897 and was studying German literature (which he had been teaching at Dartmouth College, New Hampshire) the year he and Harris were in Berlin. (He had also been in Leipzig in 1901.) Harris and Stewart had been friends before their trip to Berlin; they used to play chess and had gone on canoe trips together. Stewart's wife had also been a student of modern languages and was a graduate of the University of Toronto. The young couple and Harris lived in the same pension during Harris's first year in Berlin. As Bess Harris commented, echoing her husband's memories of the year, "they enjoyed one another and had fun."[5]

Harris's reading during the Berlin years is also significant. When asked if he had read Hegel, Bess took pains to make it clear that he had not. This is understandable in the context of the nationalist ideology her husband promoted throughout his artistic career. She and Harris did not wish anyone to think that his painting or his thinking was in any way dependent on a European prototype or theorist. She was anxious that her husband's consistent orientation to Canada and the continent of North America as his spiritual and cultural home not be brought into question. According to Bess, during his Berlin years Harris was an avid reader of the Americans Ralph Waldo Emerson and William James.

Harris was to develop into the most theoretically inclined artist of his generation in Canada. While he was a young student in Berlin, this theoretical bent would have shown itself as a curiosity about life, nature and art. It is likely that his uncle, William Stewart, was the mentor who suggested that Harris read Emerson and James. Stewart would himself have been aware of these writers and their debts to German transcendentalism, and would also have taught students of Harris's age at Harvard (1897–99) and then at Dartmouth College. It would have been natural for him to continue in this mode with Harris. Thus while Harris was learning to draw and to paint in watercolours and oils, and experiencing the great variety of German and other European painting, his intellect would have been occupied with Emerson's questions and answers about the meaning of nature and art.

These readings introduced Harris to transcendental patterns of thought that were very close to the religious-philosophical position he later fashioned for himself. A transcendentalist interpretation of nature is not obvious in the regionalist and realist paintings and drawings of Harris's early career; however, such a vision does emerge emphatically during his major landscape period, 1918–30. Harris remained familiar with Emerson's writing late in his life and quoted him on occasion.[6] But for Harris there was another aspect of Emerson's writing that was important: Emerson's openness to Eastern thought and his attempt to harmonize certain parts of its religious concepts with his philosophy.

The importance of this reading during his student years should not be underestimated. It proved a helpful introduction to the studies of Plato and the Upanishads that, shortly after his return to Canada, Harris undertook with the guidance of the dramatist Roy Mitchell, at that time an officer in the Toronto Theosophical Society and a friend of Harris. These interests evolved into Harris's important and lasting involvement in the Theosophical Society. Harris wanted to be considered a philosopher as well as a painter: his ideas on religion and art were deeply interwoven with his landscape, and, later, his abstract painting.

We also know that Harris travelled widely during the four years he was in Europe. Only one of these trips – during the summer of 1905 – brought him back to Canada. The other summers were spent on walking trips in southern Germany and the Austrian Tyrol. He also visited Italy, France and England.[7]

Figure 2.2
Franz Skarbina
*Stralauer Street at the Corner of
Waisen Street*, 1900
Watercolour
44.3 x 27.5 cm
Georg Schäfer Collection, Euerbach

Figure 2.3
Paul Thiem
Fantasy (Wedding Procession), c. 1908
Unlocated

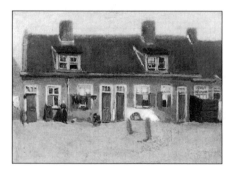

Figure 2.4
Max Liebermann
Houses in Scheveningen, 1872
Oil on board
34 x 47.9 cm
Georg Schäfer Collection, Euerbach

ACADEMIC TRAINING AND HARRIS'S ATTRACTION TO MODERNISM

Writing in 1948 to Sydney Key at the Art Gallery of Toronto, Harris stated that he "went the rounds of the public and dealers' galleries" while he was in Berlin. He insisted that it was the modern painters who interested him most. He mentions that he was "strongly attracted" to Gauguin, van Gogh and Cézanne. In singling out these artists, Harris is reflecting the "mythic status"[8] they had achieved in Berlin before and during the years Harris was there. In fact, Harris's artistic development during his landscape period was profoundly affected by these artists and by the particular blend of naturalism and idealism that marked the Post-Impressionist period in Berlin. In spite of the strong attraction, however, Harris remarked that at the time he did not understand these artists, since his "whole conditioning was academic." In the same letter, he described a typical day: "The classes were the usual academic kind, drawing in charcoal and painting from the model, mornings and evenings. Afternoons, I went to the older parts of the city, along the river Spree and painted houses, buildings, etc. – small watercolors."[9]

When he added that his "whole conditioning was academic" Harris was also referring to the program of discipline imposed by his teachers, and which he accepted as an eager student. This structuring included not only the way his days were programmed by his teachers' studio classes, but also the way the more than three years themselves were structured: in the first two years he drew with pencil and charcoal, and painted only in watercolour. During the last year and a half (1906 and the fall term of 1907), he worked in oils.[10]

In reply to the question, "Studied with whom?" Harris answered, in 1948, "With three different artists." Thanks to Bess Harris, we know the names of these teachers.[11]

The painter Fritz von Wille (1860–1941) is the most likely candidate for the person Bess Harris identified only as "Herr Wille."[12] Von Wille had very little training that could be called academic. Although he had studied drawing at the Düsseldorf Academy from 1877 to 1882, and his landscape paintings could well be labelled conservative (even in the context of Harris's Berlin years), they do not reveal strong academic inclinations, and he considered himself self-taught. Von Wille was the archetypal *Heimatkünstler,* the regionalist painter. This aspect of late nineteenth- and early twentieth-century German painting consisted of works in which artists chose the landscape of a particular, often quite limited, region for their subject matter. The best known of these painters formed groups at Worpswede and Dachau.

Von Wille had initially chosen his landscape subjects from Italy and other parts of Germany, but from 1890 onward, he dedicated himself exclusively to painting scenes from the Eifel region of Germany. Moreover, he selected only certain aspects of this area. These were described by W. Vogel in his review of von Wille's contribution to a 1903 exhibition: "It is not houses, not haystacks, not manure piles or similar things, nor little genre episodes that von Wille gives us in his paintings, but Nature with her vastness and grandeur."[13]

Von Wille's *Departing Winter in the Eifel* (Fig. 2.1) exemplifies the kind of landscape treatment that Harris was to admire when, around 1910, he discovered the work of his compatriot and future colleague in the nationalist movement, A. Y. Jackson. In *The Edge of the Maple Wood* (Fig. 3.16) we see the same time of year – late winter, early spring; the same type of subject matter – a muddy barnyard; the same treatment in rough brushwork; and a composition with a high horizon line. In both works, there is a nonidealizing effort to capture the harsh landscape of a rough region. The roughness of terrain and the high horizon line also appear in many other works by von Wille.

Adolf Schlabitz (1854–1943) certainly qualified for the Harris adjective "academic." He was a portraitist and genre painter who had been trained at the Berlin Academy

(1875–82) and became a teacher at the Akademische Hochschule für die Bildende Kunst (University of Fine Art) in Berlin the year after Harris left, remaining so until 1917. Unlike the self-taught von Wille, Schlabitz studied and travelled extensively and so was in more direct contact with a wider range of artistic traditions. He studied at Paris's Académie Julien from 1883 to 1884 and would have had personal experience of the French Impressionists. Schlabitz's interest in Impressionism was visible in his work in 1904, the year Harris arrived in Berlin. In that year, Schlabitz exhibited three works in the Grosse Berliner Kunst-Ausstellung (Great Berlin Art Exhibition), the most important regular exhibition of the conservative artistic establishment. One of these, *Between Blossoms,* shows a strong Impressionist influence both in the broken brushwork and in the presentation of strong sunlight on bright objects.

Schlabitz was the only one of his three teachers about whose personality Harris remarked: he remembered him as an "interesting character" and spoke, not of Schlabitz's teaching, but of the two summer trips they took together.[14] In the summer of 1906, they went on a walking and sketching tour of the Austrian Tyrol. Schlabitz played the flute while they walked. That summer Harris had his first experience of mountain climbing (near Brixlegg), an activity that later in his life became important in itself. Mountains became the subject of some of his most impressive Canadian landscapes and of several later abstract works.

Schlabitz had a house near the medieval town of Dinkelsbühl in southern Germany, and Harris spent the summer of 1907 with him there. This summer was also important because, as Harris remembered, it was then that Schlabitz introduced him to the poet, painter and philosopher Paul Thiem, whose ideas impressed Harris strongly at the time.

Franz Skarbina (1849–1910), one of the most popular and fashionable painters in Berlin, would have been responsible for a large part of the academic "conditioning" Harris wrote about. In 1904 (the year Harris arrived in Berlin), Skarbina was appointed to the Senate of the Akademie der

Künste, where he had been a professor of anatomical drawing since 1888. The following year he was to receive the crowning glory in a long list of academic honours: the Grosse Goldene Medaille für Kunst of the Grosse Berliner Kunst-Ausstellung.

Academic interests are evident in many of Skarbina's figure studies, where the emphasis is often on line and contour as opposed to the divided brushstroke and dissolving contours of the Impressionists. There is also a stiff academic quality to figures that are supposedly people from the streets of Berlin, for example, his well-known *Youth from the Berlin Christmas Market.*

Figure 2.5
Max Liebermann
House in Noordwyk, 1906
54.6 x 69.9 cm
Unlocated

Figure 2.6
Walter Leistikow
Waldinneres, before 1908
Engraving
Unlocated

Paradoxically though, Skarbina, the most academic of Harris's teachers, was also the most modern. As early as 1888, an article about him was titled "Ein Berliner Realist," and in 1892, he was credited (along with Max Liebermann) with having "broken through the Chinese Wall which had cut off our [German] art from the international stream – that modern stream which is called Pleinairism, Realism, and Impressionism."[15] Within a year, Skarbina had resigned his teaching position at the Berliner Hochschule in protest because its director, Anton von Werner, had closed an exhibition of work by Edvard Munch. The crisis provoked in the art world of Berlin by the "Affäre Munch," as it came to be called, produced the first avant-garde group in the city's history. Skarbina, Max Liebermann and Walter Leistikow, among others, were the founding members of this group, named "Vereinigung der XI," (Union of XI) or "Gruppe der XI." Skarbina also became a founding member of the Berlin Secession, as the group was renamed in 1898.

Franz Skarbina's complexity as an artist was remarked by his contemporaries. He was seen to occupy the middle ground between the moderns, such as Liebermann and the Secession, and the conservative and academic painters, such as Anton von Werner and Ludwig Knaus, and was "similarly valued in both camps, having equal connections with Leibermann and with Knaus, with old Berlin and modern Paris."[16]

During the 1880s and especially during the 1890s, when he was most closely associated with the Berlin avant-garde, Skarbina painted many realist works that dealt not only with urban subjects but specifically with the poor or working-class people in contemporary situations, for example, in *Stralauer Street at the Corner of Waisen Street* of 1900 (Fig. 2.2) and *The Brown Coal Works (Clettwitz)* of 1899.

OTHER INFLUENCES: PAUL THIEM, MAX LIEBERMANN AND WALTER LEISTIKOW

When he was over seventy, Harris still remembered Paul Thiem (1858–1922) and the "shocking and stirring" effect of meeting this poet-painter-philosopher in 1907. It was Thiem whom Harris credited with introducing him to "unorthodoxy." Thus Thiem marked a step in Harris's intellectual journey through Emerson, Plato, the Upanishads and other writers towards the theosophy that gradually came to dominate his thinking.

Like von Wille, Thiem was a regionalist artist, recognized as a painter of "quiet German *'heimatgefühl,'* homeland feeling."[17] Many of his landscapes were of Dinkelsbühl, the still picturesque medieval town on the Wörnitz River, and of nearby Starnberg and its lake. But Thiem also painted portraits, grotesque stories and satires and fanciful fairy tales and legends; in *Fantasy (Wedding Procession)* (Fig. 2.3), for example, there is a screen of naturalistic tree forms beyond and through which we see into the deeper space of the picture, here an imaginary wedding procession into a Gothic church.

Harris told Sydney Key that the modern artists had interested him most. Modern art in Berlin in those years meant the Berlin Secession and its regular series of exhibitions. The best-known artist of this avant-garde group, its principal organizer and its president from the founding of the Secession in 1898 until 1911, was Max Liebermann (1847–1935). Harris would have seen his realist urban landscapes on many occasions. This proved to be an important experience: Harris was influenced not only by the realist subject matter of Liebermann's art, but also by the patterns of composition Liebermann used in these paintings, which were peculiar to him.

In these urban landscapes, Liebermann often presented the façade of a building, a house or a storefront as the most important aspect of a painting, and the figures who happened to be in front of them as quite secondary. These composi-

tions were often from a low, near-frontal point of view, or from a clearly frontal point of view, as in the early *Houses in Scheveningen* (Fig. 2.4) of 1872, and *House in Noordwyk* (Fig. 2.5) of 1906. Even in works such as *Jewish Lane in Amsterdam* of 1884 and *Jewish Lane in Amsterdam (Vegetable Market)* of 1905, where a spatial penetration is developed, the partial façade of the building on the left in each painting is viewed frontally and is an important concern of the painter. Sometimes the façade is seen across an unbroken space, as in *Houses in Scheveningen,* but usually it is screened by one or more trees; such a screen, especially when parallel to the picture plane, stresses the frontality of the point of view, as in *House in Noordwyk.* More consistently than Skarbina, Liebermann chose his subjects from the ordinary and poor sections of cities, often the Jewish quarter. Occasionally, he painted comfortable country homes, such as *Country House at Hilversum* of 1901.

Harris would also have seen the regionalist landscapes of Walter Leistikow (1865–1908) every time he went to an exhibition of the Berlin Secession. Leistikow is now less well known than some of his colleagues in the Berlin Secession, such as Liebermann, Max Slevogt and Lovis Corinth (who published a biography and study of Leistikow's work in 1910). He was, nevertheless, very important to the Berlin avant-garde. In fact, the rejection of his work *Grünewaldsee* by the Grosse Berliner Kunst-Ausstellung in 1898 furnished the occasion for the avant-garde to declare the Secession.[18]

Grünewaldsee is typical of many of Leistikow's works in that it presents a view of the wilderness without figures or buildings; these were termed "pure landscapes" by a contemporary English critic.[19] Several of Leistikow's works are titled simply *Waldinneres* (Wilderness – Figs. 2.6, 2.7). In these the wilderness is presented in shallow space as a wall that completely covers the surface of the canvas, is parallel to the picture plane and is seen from a low point of view. Some of Leistikow's works, such as *At Meran* (Fig. 2.8), resemble von Wille's regionalist depictions of rough, hilly

terrain from a low point of view with a horizon line – the contour of the hills – high in the picture. *House in a Park,* which Harris would have seen in 1906 in the eleventh exhibition of the Berlin Secession, was an interesting variation for Leistikow in that it includes the view of a façade beyond a screen of trees and is very close to the Liebermann compositions that Harris later adopted.

Leistikow was a Berlin representative of a movement in German landscape painting that was very popular throughout Germany, especially during the 1890s and the first decade of this century. Embodying an attitude toward nature that Haftmann called "Naturlyrismus," the movement included among others, Ludwig Dill, Adolf Hoelzel, Otto Modersohn and Fritz Mackensen, all of whom were regular members of the Berlin Secession. One characteristic Leistikow shared with these painters (and with von Wille) was their regionalism. They all belonged to either the Worpswede or the Dachau *Heimatkunst* groups whose painters had left the large cities for quieter regions in the country where they could paint "unspoilt nature."[20] A second characteristic these artists shared was the practice of silhouetting the contrived curvilinear contours of trunks of trees against deeper spaces. In Leistikow, this can be seen in the engraving *Waldinneres* (Fig. 2.6), and in *House in a Park*; it also appears in Otto Modersohn's *Autumn on the Moor* (Fig. 2.9).

A major characteristic of Leistikow and the painters of *Naturlyrismus* was the importance they placed on emotions. Landscape views and their details were not for them objects for analysis, but communicated feelings and moods. Landscape elements became symbols of powerful feelings; there were landscape equivalents for the whole range of their emotions. Haftmann regards these painters as the "legitimate offspring of the German romantics," and their feeling for nature as typically German.[21] It seems to me, however, that the cosmic dimensions of Friedrich's pantheistic contemplation of nature, as found for example in *Monk by the Sea* (Fig. 2.13), have been domesticated in the *Naturlyrismus* painters to the deep feeling of the regionalist artist for a local

Figure 2.7
Walter Leistikow
Waldinneres, before 1908
Unlocated

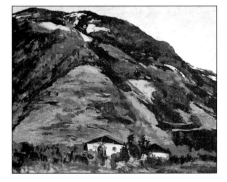

Figure 2.8
Walter Leistikow
At Meran, before 1908
Gouache
Unlocated

Heimat or homeland. These emotions still had mystical dimensions, however. The painters of the Worpswede group, like Thiem and other German landscapists of the 1890s and the early years of this century, were admirers of the fashionable mystical attitudes toward the German land and toward landscape painting that were promulgated by, among others, Julius Langbehn.

MUNCH, HODLER, KANDINSKY, JAWLENSKY AND NOLDE

Writing four decades later of his interest in modern painters while in Berlin, Harris singled out as especially important Gauguin, van Gogh and Cézanne. But the Berlin Secession regularly included works by other well-known modern artists in its twice-yearly exhibitions, and the number of works by these non-Berlin moderns that Harris would have seen was impressive. Furthermore, some of these artists lived for varying periods in Berlin at the same time as Harris and he may even have met them. These included Wassily Kandinsky, Gabriele Münter, August Macke, Emile Nolde, Max Beckmann and Edvard Munch.

Edvard Munch (1863–1944) had been a significant presence in Berlin. The premature closing of an 1892 exhibition of his work by the director of the Berliner Hochschule had precipitated the crisis that saw Skarbina quit his teaching position at the Hochschule and join Liebermann, Leistikow and others in forming the Vereinigung der XI. Munch continued to be valued by the Berlin avant-garde: between 1902 and 1908, he lived most of the time in Germany, and was frequently exhibited by the Berlin Secession. During Harris's years in Berlin, Munch exhibited five times with the Secession and had six exhibitions at private Berlin galleries. He also painted a third version of his *Frieze of Life* in 1906 for the foyer of the Kammerspiele Theatre.[22]

What Harris would have gained from Munch was a reinforcement of the main influences he was already receiving from his German experience. For Munch in his landscapes

frequently chose a low and frontal point of view, and he used a tree or trees (and at times figures too) as a screen beyond which the viewer perceived deeper space, as in *Winter Moonlit Night with Stars* and *Coast at Aasgaard* (Fig. 2.10). The latter work, with its single tree silhouetted against the shore and the expanse of water, anticipates some of Harris's later compositions. It was also the central panel of Munch's *Frieze of Life,* which Harris would have seen each time he went to the Kammerspiele Theatre after the end of 1906.

Also appreciated in Berlin during the early years of this century was the Swiss painter Ferdinand Hodler (1853–1918). By 1904, he was already well known in the German-speaking art world. Harris would have seen a large selection of his works when, in 1905, Hodler was given his own gallery at the combined Tenth Exhibition of the Berlin Secession and the Second Exhibition of the Deutscher Künstlerbund (Federation of German Artists). Harris probably also saw the exhibition of Hodler's work held at Paul Cassirer's gallery in 1907. He may have seen some of Hodler's naturalistic landscapes such as *The Beechwood* (Fig. 2.11) of 1885, which is similar to works of Leistikow and others in its use of the low point of view of a wall of wilderness seen parallel to the picture plane. The naturalism of *The Beechwood* was later left behind as Hodler developed his notions of parallelism and his canons of simplification, which remind the reader of Harris's later paintings and writing.[23]

The works Harris would have seen in the 1905 exhibition included such well-known symbolic and mystical works of figures in landscapes as *Evening Walk* of about 1905 in which the single monumental figure is balanced by a strongly simplified landscape. Hodler's mystical attitudes toward nature and landscape (attitudes which later appeared in Harris's work) are expressed in *Looking into the Infinite* of about 1905. In its subject – a single figure in a vast spatial composition – this painting recalls Friedrich's *Monk by the Sea.* Thus Hodler's work was both Romantic and modern, a synthesis Harris later created in his own major landscape period.

In the works of painters like Alexei Jawlensky and Wassily Kandinsky from Munich and Emil Nolde from Dresden, all of whom exhibited in Berlin while Harris was there, Harris would have seen experiments with expressive uses of brushstroke which were an interesting development in contemporary Berlin. Probably all reflect the contemporary enthusiasm for the art of van Gogh, and would have supplied Harris with the starting point for some of his own experiments.

VAN GOGH, GAUGUIN, CÉZANNE AND MANET

Harris's stay in Berlin coincided with a period of intense interest in Vincent van Gogh on the part of the Berlin avant-garde. Between the fall of 1904 and November 1907, the Berlin Secession and the Paul Cassirer Gallery exhibited at least seventy-two of van Gogh's works. It was thanks to one of these exhibitions at the Paul Cassirer Gallery in the fall of 1904 that Harris had his very first experience of a sharp confrontation between an establishment and the avant-garde. The exhibition stimulated a conservative writer in the art journal *Kunsthalle* to burst out that, far from deserving to be honoured by an exhibition, what van Gogh and his works – with their "excessive brushwork" – most urgently needed was "psychiatric help." A year later, in the same publication, the artist was referred to as "that idiot van Gogh."[24]

In the spring of 1905, Paul Cassirer's seventh exhibition presented at least twenty-three works by van Gogh, more than by any other painter in the exhibition. These included the oil paintings *View from Montmartre* and *The Road Menders at St. Rémy* (Fig. 2.12) of 1889. One can see in this work aspects of van Gogh's art that are in harmony with the urban landscapes of Liebermann: working-class people at their ordinary tasks; an importance given to trees, especially to their trunks; and the importance of the walls of the buildings (here presented obliquely, rather than frontally).

Paul Gauguin (1848–1903) and Paul Cézanne (1839–1906) were two of the artists Harris termed "modern" and to whom he said he was attracted. If Harris saw much of the works of either of these artists at this time, however, it was not in Berlin, but during his travels, especially to France, since only two works of Gauguin were exhibited by the Berlin Secession during Harris's years in Berlin. These were *The Birth of Christ*, a work from his Polynesian period, and a landscape, *Martinique*. Two aspects of these works are worth noting. First, Gaugin's practice of juxtaposing areas of strong or bright colours in the Post-Impressionist manner was quite at variance with that of Harris's teachers and other painters in the Berlin milieu. Second, the paintings reflect Gauguin's ideal of an "escape from urban civilization."[25]

Although the Berlin Secession was interested in Cézanne, it did not exhibit any of his works during Harris's years in Berlin. Paul Cassirer, however, exhibited a Cézanne still life in his spring group exhibition in 1905, and a landscape, *Village at the Coast,* in 1906. Harris would also have encountered works by both Gauguin and Cézanne on his trips to Paris.

During the early years of this century the leaders of the Berlin avant-garde were influenced by the work of Edouard Manet (1832–83). As early as 1886, Jules Laforgue, the French Symbolist poet, had described a work of Skarbina's in the Paris Salon as within Manet's tradition of "peinture claire."[26] From the point of view of the student of Harris's work, the most important work of Manet's in the Berlin milieu was his painting of 1882, *Country House at Rueil*. Acquired by the National Gallery in Berlin in 1906, it had already been exhibited in Berlin by the Secession in 1903. Harris's and Liebermann's preference for this type of frontal composition of a house screened by trees would have been strengthened by finding this example of it among the works of Manet, one of the acknowledged masters of the modern period.

Figure 2.11
Ferdinand Hodler
The Beechwood, 1885
101 x 131.1 cm
Kunstmuseum der Stadt Solothurn
Gift of Mrs. Erika Pitirs, 1971

Figure 2.12
Vincent van Gogh
The Road Menders at St. Rémy, 1889
74.9 x 92.7 cm
The Phillips Collection, Washington

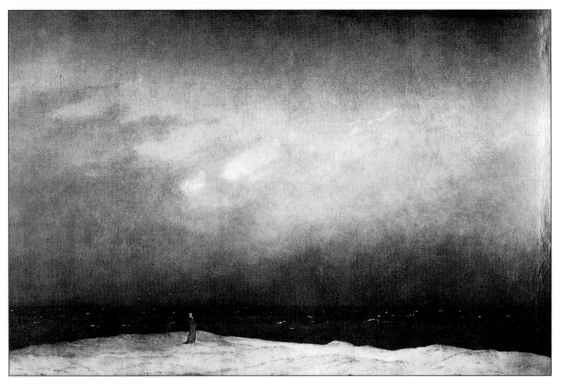

THE REVIVAL OF CASPAR DAVID FRIEDRICH AND THE AUSSTELLUNG DEUTSCHER KUNST AUS DER ZEIT VON 1775–1885

Harris had the best possible exposure to the Romantic landscape tradition of Germany through his experience of the works of its greatest exponent, Caspar David Friedrich (1774–1840). The year Harris arrived in Berlin, Andreas Aubert described Friedrich as "the most German of Germany's painters who had been forgotten by Germany itself."[27] In 1906, the major exhibition *Ausstellung Deutscher Kunst aus der Zeit von 1775–1875* (Exhibition of German Art, 1775–1875) constituted what has been called the first revival[28] of Friedrich's painting. A large number of works from different periods in his career were exhibited,

among them *Cross in the Mountains (Altarbild)* and *Monk by the Sea* (Fig. 2.13), both of which combine explicitly religious motifs with dramatic presentations of deep spaces in nature, and *The Solitary Tree* (Fig. 2.14), which employs the motif of the twisted tree silhouetted against a presentation of deep space. The exhibition also included a stunning composition of near and distant forms in an arctic image, *The Sea of Ice* (Fig. 2.15). In *Landscape in the Riesengebirge* and *Seacoast in Moonlight*, Friedrich reduced landscape painting to minimal but evocative natural forms that frequently remind a Canadian viewer of Harris's Lake Superior works. There were also examples of works in which Friedrich silhouetted a screen of dead or dying trees through which the viewer perceived a more distant view, but Harris was probably more familiar with the well-known *Abbey in the Oakwood* (Fig. 2.16), which was in the collection of the Schloss Charlottenburg in Berlin.

The *Austellung Deutscher Kunst aus der Zeit von 1775–1875* was perhaps the most important exhibition in Berlin while Harris was there. Mounted in 1906, the exhibition had the deliberately nationalist intention of finding out what the art of the German peoples had been during the nineteenth century. The two large volumes of the catalogue of this exhibition contain about 1,600 illustrations chosen from the more than 2,000 works that formed the exhibition at the Königliche Nationalgalerie. In addition to art up to 1875, the exhibition had a section called "The Recent Masters," which included Skarbina (one work) and Liebermann (twenty-one works), as well as several other painters who were still alive while Harris was in Berlin. Thus the exhibition was an encyclopedic collection of German painting from about 1775 to the early years of this century; that is, from the classicism of painters like Joseph Anton Koch (1768–1839) to just before the Expressionist period.

The effect on Harris of many works in this exhibition would have been to consolidate, enhance and expand the main orientations that he was then receiving from his regionalist and realist teachers and their colleagues, and from the

romanticism of Caspar David Friedrich. Thus Harris would have experienced the peasant-oriented realism of Wilhelm Leibl, whose *Three Women in Church* was exhibited, and the urban realism of Adolf von Menzel, who had influenced Harris's teacher, Skarbina.

Johann Christian Clausen Dahl (1788–1857), a Norwegian painter who spent much time in Germany, was a close friend of Friedrich's and was influenced by his art. Harris would have seen twenty-two of Dahl's works in the 1906 exhibition, including *Winter Landscape on the Elbe* of 1853 and *Birch Tree in a Storm*, both of which silhouetted single trees against deeper spaces within centralized compositions. In the same exhibition, Dahl also exhibited *Tree Study,* in which, like Friedrich's *Forest in Late Autumn*, the wilderness is presented in relatively shallow space, and fills the picture surface. In this type of composition, both Friedrich and Dahl look forward to compositions by Thoma and Wilhelm Trubner, and to similar works by Leistikow and eventually by Harris. An earlier painter, Christian Morgenstern (1805–1867), who has been described as an important representative of realist landscape painting,[29] was represented by two quite similar paintings of small waterfalls. In *Waterfall in Upper Bavaria* and *Forest Brook in Harz*, the close view of the wilderness subject occupies the whole picture plane. Their similarity to later paintings of waterfalls by Harris is striking.

Compared to the art being done elsewhere in Europe in the early part of this century, the painting of Leistikow, Liebermann, Skarbina and others seems unfamiliar to us. One of the effects of viewing the 1906 exhibition – even through reproductions – is to see that their art belongs within the traditions of nineteenth-century German painting. Since these traditions were, until recently, relatively unknown to non-German art historians, Harris's painting was not properly related to them. Taken as a whole, these ways of painting embrace a continuum of attitudes toward landscape painting that spans the naturalism of Leistikow and Thiem and the mysticism of Friedrich and Hodler. Sometimes the adjectives "naturalist" and "mystical" are appropriate for the same artist, even for the same work.

It is in this milieu that Harris began his artistic career.

HARRIS'S FIRST PAINTINGS: STUDENT WORKS AND THE ILLUSTRATIONS FROM THE MIDDLE EASTERN TOUR

Very few works survive from Harris's years as a student in Berlin.[30] The drawings and watercolours that survive are all urban in subject, and realist in treatment, and clearly within the realist aesthetic of Skarbina and Liebermann. The oil paintings are of wilderness or agricultural landscapes.

The earliest of Harris's student works is the watercolour *Interior with a Clothes Closet* (Plate 1), which is signed and dated "Feb. '06." The signature, "L. S. H." in block letters, was the earliest form of Harris's signature, which he used for his student works, for most of his illustrations for *Harper's Monthly Magazine* of 1908 or 1909, and in his earliest Canadian works. This work is the only one known for which Harris gave not only the year but also the month in which it was painted.

This very dark painting is within the realist aesthetic of painting ordinary objects without idealizing them, and it demonstrates some of the skill Harris had already acquired in presenting different materials and textures. It was probably painted in Harris's own studio or his corner of the larger studio of one of his teachers. There is a trunk on the right on the floor that, besides guiding the viewer's eye into the picture, demonstrates Harris's ability to paint leather and shiny metal. The closet is black on the outside, while the wood on the inside is natural. The panel on the unopened door shows a painting in dull tones of a man in Renaissance period clothing underneath what might be a coat of arms. Parts of the closet painted black are shiny, for example the lintel over the door: thus Harris demonstrated the ability to distinguish textures within the same colour. The interior contains a pair of pants, what look like several stiffly starched collars, and

Figure 2.14
Caspar David Friedrich
The Solitary Tree, 1822
54.9 x 71.1 cm
Nationalgalerie, Berlin

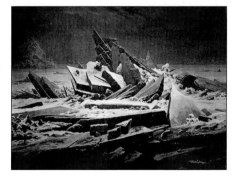

Figure 2.15
Caspar David Friedrich
The Sea of Ice, c. 1823–24
96.8 x 127 cm
Hamburger Kunsthalle, Hamburg

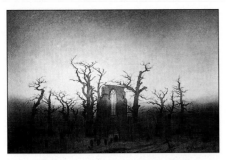

Figure 2.16
Caspar David Friedrich
Abbey in the Oakwood, 1809–10
110.5 x 170.8 cm
Schloss Charlottenburg, Berlin

Figure 2.18
Head of an Old Lady, 1906
Charcoal on paper,
mounted on cardboard
34 x 27 cm
Private collection

some finished watercolours casually lying on the floor on the right and on the middle shelf on the left. The low, frontal point of view and the shallow space of this composition look back to Skarbina and especially to Liebermann, and forward to most of Harris's urban landscapes. The work is probably unique in Harris's oeuvre because it is his only interior view, except for the incidental interiors in the very few portraits he painted.

The two student works dated 1907 are both street scenes done in Berlin in the winter. In the very dark pencil drawing on cardboard, *Street in Berlin* (Fig. 2.17), one looks down a dark alley from a point of view at or near ground level, past the overhanging upper stories of the building on the right, to the wall of the taller building at the rear of the composition. There is snow on the roofs, the eaves, the wagons and the ground. Because Harris spent the winters of his student years in Berlin, it is not surprising that *Street in Berlin* is a winter scene. Harris's realist intentions can be seen in the decision to paint ordinary commercial wagons and what must be a rear view of the buildings involved, and not their presumably more impressive street façades. There are prototypes for the deep spatial composition in both Skarbina's and Liebermann's work.

The watercolour *Buildings on the River Spree, Berlin* (Plate 2) is a more interesting painting for the student of Harris's work. It is the earliest example of the carefully worked out, layered compositions that were to become his main stylistic feature throughout his career as an urban and a wilderness landscapist. It also shows that even as a student Harris was influenced by the way Liebermann composed his urban landscapes at least as much as he was influenced by Skarbina.

The frontality of Harris's composition is stressed in this work by the iron railings on both near and far banks of the river. They establish planes parallel to the picture plane and to the façades of the buildings, and become screens through which one perceives further depths of space in the painting. The railings also help to stress the low point of view. The

horse and wagon, a frequent element in his Canadian urban landscapes, appear here in Harris's work for the first time. In his later works they almost always function as an item of realist iconography, suggesting working-class involvement and milieus. But beyond this iconographic function, they articulate another plane in space, not just by being there, but by the direction of their movement along the street: they too establish a plane parallel to the façades and to the picture plane.

The colours in *Buildings on the River Spree, Berlin* range from the bright white of the snow through the pale yellow of the building on the left to the browns of the other buildings, and to the dark browns of the boats, parts of which are visible on the river. The sky is a neutral grey. It does not contrast or conflict with the range of brown tones of the colour scheme. The windows of the pale yellow building on the left have curtains coloured a contrasting blue-green which gives a slight liveliness to the otherwise low-keyed tonal painting. The watercolour is applied with care, yet without perfect smoothness. One can see, if not the brush-strokes, at least an unevenness in the colour itself, suggesting the medium but also the light-absorbing surface being represented, probably stucco. Some of the liveliest painting in this work is the snow across the lower part of the painting. Here Harris achieves sparkling effects of light by using gouache. This interest in the painting of snow became a major aspect of many of Harris's later urban landscapes, and also of many of his wilderness landscapes.

The portrayal by Harris of an elderly, plump and quite ordinary lady in the charcoal drawing *Head of an Old Lady* (Fig. 2.18), was in the realist tradition of Skarbina and Adolph von Menzel (1815–1905), both of whom had drawn similar subjects. The naturalism and spontaneity Harris strove for in presenting this smiling face did not become characteristic of his work. Neither did studies of the human figure, although Harris did a few portraits between 1919 and 1932.[31]

There are several early small oils by Harris; some were

probably done in Germany. It is impossible to tell with certainty the German paintings from works done shortly after his return to Canada, such as *Near St-Jovite* (Fig. 2.20) of 1908. In their constant use of the high horizon line and the generally low and frontal point of view of hills, all these early works reveal the influence of Harris's teacher von Wille, as well as that of some of the works of Walter Leistikow. A small white house provides an accent in the foreground of two of the works of Leistikow, including *At Meran*, and in Harris's *Sketch (Houses and Hills)* (Fig. 2.19). In *Hills* (Plate 3) and especially in *Sketch (Houses and Hills)*, the transition between the layers of hills is made less abrupt by the gradual lightening values of the purple, although the contours remain clear. These two are probably student works because the mountains are too high to be in the Laurentians, the only mountains Harris visited during his early years in Canada. The use of purple also suggests that these are student works. Friedrich used purple extensively, and Harris was probably influenced by him in this regard. Harris's earliest certain Canadian works did not make use of purple, but it becomes a frequent colour in his work around 1912.

In these two works, the area of the board has been divided into nearly horizontal bands of colour pretty much as he did in the unfinished painting (Fig. 2.21) on the back of *Autumn Trees*, which shows how Harris began his works at this time. The picture would have been completed by developing each of the colour areas, a practice that helps explain some of the difficulties that Harris experienced in some of his early Canadian oil paintings.

Before Harris settled down in Toronto in 1908, he spent more than two months travelling in the Middle East with the writer Norman Duncan (1871–1916). Duncan was preparing a series of eight travel articles for *Harper's Monthly Magazine*, for which Harris did fifty-nine illustrations. The following year, the articles were published in book form, with a selection of the illustrations.[32]

From evidence in the articles, the trip probably lasted from November 1907 to February 1908.[33] There is no suggestion in the articles of heroism or risk: for Duncan, the trip was made "in expectation of mild adventure."[34] At times, he described the desert scenery, but more frequently he wrote about their twenty or so retainers, their occasional guests, and the travellers they met. Evenings were passed in playing games or telling stories. They must have come from Damascus to Jerusalem by train, boat or a combination of these; the caravan part of their journey began at Jerusalem. We know that they did take a train for the very last part of the trip, from Kantara, on the Suez Canal, to Cairo.

This trip to the Middle East to write and illustrate a story was a late manifestation of the nineteenth-century cultural phenomenon known as orientalism. This British and European interest in the Middle and Far East during the nineteenth century had extended to many artists, and thus, though Harris's trip to the Middle East represented a departure from the patterns of his realist and regionalist teachers and their associates, it was part of a long tradition.

Harris himself thought in 1948 that in his work for *Harper's Monthly Magazine* he had produced "the world's worst illustrations."[35] This might explain why only one of the paintings or drawings for them has survived. If they were returned to Harris from the magazine, he may have destroyed them along with all but the few student works we have, since he is known to have destroyed work he considered inferior. Most of the originals of the illustrations were in oils or possibly gouache, which one can see from some of the textural effects Harris created. The only mention of Harris's medium in the articles refers merely to "canvas and colors."[36] The others were pencil drawings.

The low point of view and frontal, shallow composition that we noted in Harris's urban landscapes recurs in the two most interesting illustrations, both careful portrayals of old men. In *Musa Hamid, the Blind Musician* (Fig. 2.22), reproduced in colour in the magazine but in black and white in the book, Harris creates a flat shallow space by means of a richly coloured carpet that covers the floor and is suspended

Figure 2.17
Street in Berlin, 1907
Pencil on cardboard
33 x 15.6 cm
Private collection

Figure 2.19
Sketch (Houses and Hills), c. 1907
Oil on board
20.3 x 25.4 cm
Private collection

Figure 2.20
Near St-Jovite, 1908
Oil on board
14 x 21 cm
The Ottawa Art Gallery,
The Firestone Art Collection

from the wall behind the seated old man. The circular opening of the oud the old man is playing is on the central vertical axis of the painting and its flat surface is parallel to the picture plane and to the backdrop. This enables Harris to articulate the shape of the cream-coloured instrument by silhouetting it against the musician's dark clothes and the richly coloured backdrop. The work thus achieves an icon-like stillness and gravity.

In a Slow Aged Muse under the Shadow of the Lemon Tree (Fig. 2.23), originally a pencil drawing, presents another old man in shallow pictorial space. This work also has meditative weight, partly because of the person portrayed, a local poet-philosopher, Ahmed Ased-Ullah of Damascus. The fifth article in Duncan's series concentrated on his and Harris's meeting with this man and Ahmed's philosophy of beauty. This must have inspired Harris to create a better-than-average illustration. Ahmed Ased-Ullah claimed that "in all beauty, whether come by the intention of the gods or men, God resides,"[37] and so related religion, nature, art and beauty in a synthesis – like the one Harris eventually articulated for himself, using a vocabulary drawn from theosophy and other mystical sources.

All but three of the illustrations were reproduced in black and white in both magazine and book. One of the exceptions was *Over the Old Route into Egypt* (Plate 4), which became the frontispiece of the book. This full-page illustration is divided into two main contrasting colour areas: the mauve sky and the orange-yellow sand. The colour contrasts are repeated with deeper purple for the shadows of the camels and their footprints in the sand. The use of purple, here contrasting with gold-yellow, is quite different from the use of purple in Harris's landscapes in oils. There, the purple in varying intensities is added to the browns and greens of the painting. In this illustration, large areas of light values of the contrasting colours are juxtaposed, creating a bright effect. These show the influence of the Post-Impressionists – possibly of Gauguin and especially of van Gogh – an influence that would occur again in Harris's painting, interestingly enough, in a work of

1913, *Laurentian Landscape*, which would be for him an isolated but important colour experiment.

The energetic and enthusiastic personality that emerges from these articles by Duncan is the only contemporary description we have of the youthful Harris. Duncan always refers to him in the language of their retainers, as the "younger *Khawaja*" (the younger Master). Duncan seems to have had the attitude of an indulgent uncle toward an impetuous nephew whom he observes closely and criticizes with affection. Rarely does he represent the artist doing anything quiet: the most exciting passages in his texts are descriptions of Harris's escapades. One of his first references to Harris has him "bobbing on a tall *thelul*" (a species of camel) while tossing a ball with Taufik, one of their retainers. At one of the regular evening entertainments, Harris began a game of tag:

"Catch me!" shouted the younger *Khawaja*. Here was a familiar game; the challenge, though spoken in English, needed no interpretation. They reached to seize him; but the younger *Khawaja* leaped from the quick hands of the muleteer, dodged the catspring of the Sudanese, buffeted Aboosh, overturned the Bedouin, and darted off into the moonlight with a whoop like a shriek of a disappearing locomotive. They were after him in a flash.[38]

Duncan describes Harris's excitement on another occasion, when he had returned to their quarters in a *khan*, or inn, after being out in the city of Damascus: "The younger *Khawaja* burst in, as though escaping pursuit, his eyes at the widest, his cap askew on the back of his head, his cane waving in a frenzy of emotion; and I knew, knowing him, that some encounter of the queer streets we [*sic*] traversed had mightily stirred him. 'Awful!' he ejaculated, in his extravagant way. 'I tell you it was fearful – terrible – horrible!'" Harris told of having encountered a man who had tended a furnace of the city baths for years and had been blinded by

dust from the fire, but who was nonetheless grateful for the opportunity to work and enjoy the "favour of the bathkeeper." This is what had so upset Harris, who had given a gold piece to the man.[39]

Duncan's use of "extravagant" is almost as close as he gets to criticizing Harris. There was another occasion, however, where he points to an attitude he evidently did not like in his companion. Two of the retainers in the caravan had given in to Harris's "whim" to linger on the road. The three had dropped far behind the caravan and were making Aboosh, the dragoman or caravan leader, and Duncan anxious. Finally Harris and the others arrived, leading a prisoner. A band of Bedouin who passed them had denounced Harris as a "Christian lout," and his two companions had defended him (Harris was unable to dismount from his camel in time), taking the prisoner, whom Harris insisted be turned over to the authorities. When Duncan protested, Harris reacted vehemently: " 'What!' cried the younger *Khawaja*, 'would you have this fellow go free? Why,' he exclaimed, outraged, adopting the English attitude, 'he attacked – *us!*'" Reluctantly Duncan agreed, but added that it was "for the unpardonable offense of lifting a hand against the Anglo-Saxon, or the servant of the Anglo-Saxon, in an eastern land occupied by the English."[40] In contrast to his behaviour in this incident, Harris would later reject colonialism and what he called "the English attitude in Canada."

Early in 1908 Harris returned to Canada. He did not arrive in Toronto empty-handed. He was bringing a solid training in the traditional crafts of painting and something else unusual for a North American: an extensive knowledge of recent German art and its philosophies. But, paradoxically, Harris had also acquired a deep attraction to the international heroes of modern art, their understanding of creativity, their avant-garde strategies and politics. All of these qualities would affect Harris's Canadian career.

Figure 2.22
Musa Hamid, the Blind Musician, 1907–08
Oil or gouache
Illustration for *Harper's Monthly Magazine,*
December 1908, facing 140

Figure 2.23
In a Slow Aged Muse under the
Shadow of the Lemon Tree, 1908
Pencil
Illustration for *Harper's Monthly Magazine,*
January 1909, 207

Figure 2.21
Verso of *Autumn Trees,* c. 1908
Oil on board
14.1 x 21.9 cm
Private collection

The First Canadian Decade
of a Would-Be Modernist, 1908–18
Nationalist Rhetoric, Decorative Painting and a Nervous Breakdown

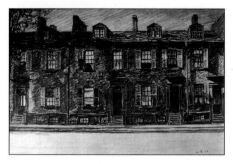

Figure 3.1
Adelaide near Simcoe, 1908–12
Pencil on paper
18.1 x 27 cm
Private collection

FAMILIAR HOME GROUND

Harris returned as a young man to the same circles he had left as a student, and continued to do what was normally expected in society. Less than two years after his return, on 20 January 1910, he married into a prominent family. Although the Harrises were of Presbyterian and Baptist background, Harris's bride, Beatrice (Trixie) Phillips, was Anglican, and the marriage took place in the Anglican Church of the Redeemer in downtown Toronto. After their honeymoon, the couple returned to a house on Clarendon Avenue in a comfortable Toronto residential area.[1]

On the morning of his own wedding day, Harris had given his mother in marriage to Edward V. Raynolds. However, Anna Raynolds' second marriage was tragically short: her husband died on their honeymoon. While recovering from her second widowhood Anna joined the Church of Christ, Scientist and remained a member for the rest of her life, becoming a lay preacher. She also found ways of using her wealth for charitable purposes. During World War I, Anna was in England, where she helped run the Massey-Harris Convalescent Hospital.

Lawren and Trixie had three children, Lawren Phillips, Margaret Anne (Peggie) and Howard Kilbourn, all born during the first decade of their marriage. While Mrs. Raynolds was in England, Lawren and his family lived in her house at 123 St. George Street. In 1919 they moved to Queen's Park, an address of great prestige, where they stayed until 1926. The family moved three more times, each time to a house specially designed for them – a testimony to both Harris's restlessness and the resilience of the family fortune.

Thus, Harris's environment was elegant and easy, in sharp contrast to the slum houses and stores that were the main subjects of his urban landscapes. His affluence was also very unlike the penury of many of his colleagues, who had to struggle to be artists while holding down regular jobs as commercial artists or teachers. For in "consumingly commercial" Toronto, little art was bought – and until the success of the nationalist movement Harris championed, almost no Canadian art.

TORONTO AS HARRIS'S ARTISTIC MILIEU

Harris's artistic milieu in Toronto was very different from the international art scene, where the first ten years of this century were exciting ones for the development of modern art. In Berlin, Harris had experienced an evolved artistic environment in which an avant-garde had been

organized in the early 1890s, and was flourishing while he was there, attracting from other cities the artists who in 1910 would be called the German Expressionists. Paris was unchallenged as the major European art centre. The importance of the great Post-Impressionists – Harris's heroes Gauguin, van Gogh and Cézanne – was being recognized. In the first decade of the century Matisse led the Fauves into new realms of colour expression. Picasso painted *Les Demoiselles d'Avignon* and soon afterwards, with Georges Braque, produced the first Cubist works. Alfred Stieglitz and the Photo-Secession Gallery that he founded in 1905 gave New York a consciousness of the dialectic between conservative and avant-garde art during the same decade.

In Toronto, however, the commercial entrepreneurs who dominated the city created an atmosphere that people interested in either modern or conservative art found stifling. The Arts and Letters Club of Toronto was founded in 1908 by eight men seeking "an absolute escape from all that otherwise made Toronto," a city they found – with Kipling – to be "consumingly commercial."[2] These eight included the artist Charles W. Jefferys and the critic Augustus Bridle. Bridle and Jefferys drew up a list of professionals in various arts, writers, academics, and collectors, who were invited to become members – among them Harris. Their regular lunches were gatherings of kindred spirits seeking a haven of mutual support, intellectual conversation and cultural activities. The club became very important to the development of culture in Toronto, fostering the Toronto Symphony Orchestra, the Mendelssohn Choir, Hart House Theatre and the Group of Seven, among others.

In the club, Harris's enthusiasm and energy acquired a new name: his nouveau-riche accoutrements (a car and a sonora phonograph) were tolerated because he was such an "exuberantly democratic radical."[3] The club had its conservatives as well, one of whom, Hector Charlesworth, would become a severe critic of the Group of Seven's art.

Harris entered fully into the life of the Arts and Letters Club. He was active on their magazine, *The Lamps,* and

wrote one of the longer review articles in a more ambitious club project, *The Year Book of Canadian Art 1913.* He also designed sets for their theatre productions and played the violin in the club orchestra. In 1948, Harris wrote that the club "offered the members a stimulus of workers in all the arts – this was most marked in the early days … Its members met those who both encouraged the group as a new creative venture in art in Canada and those who violently opposed and denounced it … both were helpful."[4]

The major annual art exhibitions in Toronto were held by the Ontario Society of Artists, which had been founded in 1872 to foster original art in the province. Harris was elected a member in 1911. His participation in the OSA exhibition of that year was the first public showing of his work other than the *Harper's Monthly Magazine* illustrations published in 1908–1909. Augustus Bridle, in his capacity as critic for the *Canadian Courier*, praised Harris as one of the youngest but one of the best artists in the exhibition.[5]

One of the two other regular opportunities for exhibiting in Toronto was with the Royal Canadian Academy. Though Harris was never elected to this national organization, he exhibited with it twelve times between 1912 and 1928. He also took advantage of the remaining exhibition opportunity, at the annual Canadian National Exhibition.

THE FIRST URBAN LANDSCAPES AND THE REALIST TRADITION, 1908–13

On returning to Canada from Germany, Harris continued to work without interruption within the realist tradition of presenting urban landscapes that he had learned in Berlin. This style is illustrated by a group of drawings he did between 1908 and 1912. Practically all his drawings were done in preparation for subsequent painting, but these were meant as finished works. They are all views of slum or poor areas in Toronto (Figs. 3.1–3.4), and in several ways, they resemble Harris's student drawing, *Street in Berlin* (Fig. 2.17). The sky and other large areas are often organized with

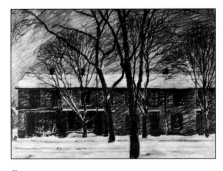

Figure 3.2
Col's Grocery (Spadina Ave. South of Queen),
1908–12
Pencil on paper
17.1 x 21.6 cm
Private collection

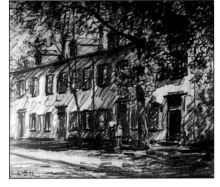

Figure 3.3
Peter Street below King, 1908–12
Pencil on paper
14 x 16.5 cm
Private collection

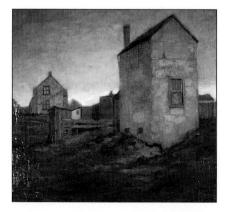

diagonal pencil strokes; two of them also show the backs of buildings, and in one of them Harris pictures parked wagons or carts. Like the Berlin drawing, three of them show the buildings in such a way that depth in space is stressed; the other three adopt the low frontal point of view Harris had used in *Buildings on the River Spree, Berlin* (Plate 2) and which he had experienced in the work of Liebermann (Fig. 2.5).

With *Peter Street below King* (Fig. 3.3), Harris advances on his known student drawings, thanks to a variety of pencil strokes to show a façade spattered with sun and shade. Overall, however, he did not develop in these drawings the realist assumptions he had inherited from Skarbina and Liebermann. His first oil paintings show the beginings of Harris's earliest transformations of the realist tradition.

Harris's earliest known Canadian urban landscape in oil is *Top o' the Hill, Spadina* (Fig. 3.5). Just as for some of his student works in Berlin, he chose a slum site. His colours reinforce the mood of poverty and near-squalor: the work is a brown tonal painting with a neutral grey sky. *Top o' the Hill, Spadina* illustrates how firm a grip the realist aesthetic had on Harris at this time. However, this painting shows the first signs of another impulse at work, one which would gradually express itself in Harris's urban landscapes. Here the paint is applied thickly on the two sides of the house. Wide brushstrokes are laid on top of underpainting in such a way that one can see the individual strokes. Almost all of them are horizontal, as though Harris were building up the surface with bricklike strokes. The horizontal movement of the strokes is punctuated by verticals that are really the thickened ends of the brushstrokes. These brushstrokes are not representational in intent; rather they are used to enliven the wall area, to make the painting more visually stimulating. Thus a sense of decoration emerges in Harris's first realist Canadian painting, but it is still subordinate to the overall seriousness of realist attention to social content.

There are prototypes for such brushstrokes in Harris's student experience, though not in the paintings of Harris's teachers or their friends. The main source would probably be the painting of van Gogh, whom Harris admired as a modern artist and whose works were exhibited frequently by the Berlin avant-garde while Harris was there. Younger artists from Munich who exhibited with the Berlin Secession were following van Gogh's lead in the use of expressive brushstroke. Both Jawlensky and Kandinsky used brushstrokes on top of an underpainting in a way that resembles the later Harris experiments. In another painting of Harris's, *Little House* of about 1909 (Fig. 3.6), the brushstrokes are similar: they are mainly horizontal, with some few thickened edges, but without the clear vertical accents of *Top o' the Hill, Spadina*. Again, they enliven the perception of the flat wall of the house. *Little House* is a transitional work in which Harris chose the frontal compositional mode of Liebermann and, in presenting a red house in a winter setting with snow, moved away from the tonal painting of *Top o' the Hill, Spadina*.

The colour scheme of *Little House* and its peculiar spotlight effect look forward to Harris's first major success as a painter, *Houses, Wellington Street* of 1910 (Plate 5). In this work, Harris established the compositional format that he followed for most of his career as an urban landscapist. The relatively flat façades of the buildings are seen through a screen of trees parallel to the picture plane, past a horse-drawn sleigh. The sleigh, like the wagon in *Buildings on the River Spree, Berlin* (Plate 2), establishes another plane parallel to the picture plane, and thus contributes to the sense of layers through which one perceives the façades. This element recurs occasionally in Harris's work; the screen of trees became a familiar device in his urban landscapes.

In *Houses, Wellington Street* Harris has handled light in a peculiar way, concentrating it in one area, almost like a spotlight. The painting is dark to the left and right, and the brightest parts of the building are in the centre. Harris used this effect again in a wilderness landscape, *The Drive* (Fig. 3.11). A strong unifying effect in the painting is the dominant grid of verticals – trees, windows, walls, chimneys and drainpipes – and horizontals – the street, the basement lines of the houses, the rows of windows and the lower and

upper roof lines. All the verticals are crossed by horizontals. This play of verticals and horizontals is carried even into the brushstrokes: the paint has been laid on in verticals and horizontals, especially in the brightly lit area of the red façades of the buildings. In *Houses (Group No. 19)* (Fig. 3.7) the painting of the white façade of the house with its green shutters makes an even more deliberate use of vertical and horizontal brushstrokes. They produce a rich, decorative texture with an almost cerebral feeling of control.

Houses, Wellington Street was first shown in the Ontario Society of Artists Exhibition of 1911. Harris himself valued it in later life: it was the earliest work he allowed to be exhibited in the two retrospective exhibitions held during his lifetime. Augustus Bridle wrote in the *Canadian Courier,* "L. S. Harris has the only convincing street scene in the show, and it is masterpiece enough to make up for the hugely interesting defects in his two backwoods things, both of which betray a strong potentiality in one of the youngest painters."[6] Bridle's sensibility and taste in painting were very close to Harris's own, and he was an important Canadian supporter of Harris's emerging career as a realist and national painter.

Although Skarbina and Liebermann had helped Harris adopt the poor areas of Toronto as a suitable subject for painting, he was probably also inspired by Bridle's article "The Homes of Working Men," published in the *Canadian Magazine* in 1903.[7] In this article, illustrated with photographs such as "The Rough-cast, Two-Story House, Emblematic of the Second Lowest Grade" (Fig. 3.8), Bridle categorized the various types of row housing then in use in Toronto. Almost all Harris's urban landscapes are of similiar row houses.

In *Houses, Wellington Street* Harris obviously had difficulty with the finer branches of the leafless trees silhouetted against the sky, which is painted with thick strokes of blue. The branches are painted thinly, like shadows on the undulating sky, and in some spots their forms all but disappear. In an attempt to deal with this, Harris has smeared brown paint

through most of the area of the tops of the trees, but he has just obscured the problem. The difficulty is due, I believe, to Harris's manner of blocking out his paintings, as can be seen from the incomplete painting (Fig. 2.21) on the back of an early work. In *Houses, Wellington Street* he had probably done the roughly painted blue sky before he realized that the tree tops would pose this problem. Later, as in *The Pine Tree* (Fig. 3.21) of 1917–18, he conceived his paintings in an integrated fashion from the outset, so that the brushwork and the subject matter were treated compatibly.

In *Houses, Richmond Street* of 1911 (Plate 6) this problem does not recur because there are leaves on the trees. In this painting, Harris has juxtaposed areas of complementary colours. The blue sky, painted in a fashion similar to that of *Houses, Wellington Street,* is next to the area of yellow leaves. So too, the reds of the door frames and window sills contrast with the green of the shutters and of the door itself. Harris has also used divided brushstrokes to separate such complimentary colours, as demonstrated by his treatment of leaves on the ground. Each leaf is depicted by a separate brushstroke of yellow, but blue brushstrokes are scattered among the yellow leaves. Harris subordinates this Impressionist technique to his own decorative purposes, to enliven the row of leaves extending across the street.

The spattering of sunlight in *Houses, Richmond Street* recalls a painting of 1904, *Karlsbader Promenade,* by Harris's teacher, Skarbina. For the compositional format, however, Harris has returned to the Liebermann type he preferred, and as exemplified in Liebermann's *House in Noordwyk* (Fig. 2.5) of 1906.

In November 1911, Harris was much impressed with an exhibition of small oil paintings by J. E. H. MacDonald (1873–1932), and later he wrote, "I was more affected by these sketches than by any paintings I had seen in Europe."[8] That winter, Harris and MacDonald began sketching together. One of the sites they both painted was the gas works in Toronto (Fig. 3.9); it was one of the few times when Harris painted an industrial subject. Despite the overall effect of

Figure 3.6
Little House, c. 1909
Oil on board
19.9 x 14.2 cm
McMichael Canadian Art Collection, Kleinburg, Ont.
Gift of Mr. R. A. Laidlaw

Figure 3.7
Houses (Group No. 19), c. 1910
Oil on board
26.7 x 34.9 cm
Courtesy of K. R. Thomson

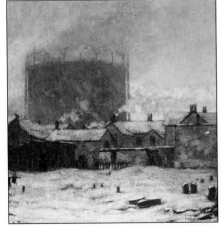

grimness and desolation, Harris has used his decorative brushwork on the wall of the building on the right and on the low building in the centre.

Another work, *Building the Ice House, Hamilton*, is a more interesting example of Harris's painting at this time, because of his dramatic use of brushstrokes. The horizontals and then the verticals are painted so as to appear as if done with one brushstroke. Even for the sky and the very distant mauve horizon, the brushstrokes are thickly painted verticals. Being very familiar with J. E. H. MacDonald's painting at this time, Harris probably would have known a small painting by MacDonald dated 1911 that shows lumberjacks on logs in a river. There are other paint strokes on the logs, but each log is made to look as though it were painted by one stroke. Since Harris would have been aware of this type of brushstroke in MacDonald's painting, I support the 1912 date for *Building the Ice House, Hamilton* even though the bold confidence of the brushstrokes in this painting has given rise to speculation that it should be dated later.[9]

THE FIRST WILDERNESS LANDSCAPES AND THE REGIONALIST TRADITION, 1908–12

In 1908, Harris began his long series of sketching trips into Canada's North; he has left us a list of the first five of these trips.[10] The first, in the fall of 1908, was to the Laurentians, with Fergus Kyle, a fellow member of the Arts and Letters Club. The second and third trips were with another Arts and Letters Club member, J. W. Beatty. In the spring of 1909 they went to Haliburton, north of Toronto and near Algonquin Park; and in the fall of that year they went to Memphrémagog, Quebec. The fourth and fifth trips were with J. E. H. MacDonald. In the early spring of 1912, they went to Mattawa and Temiscaming, on the northern reaches of the Ottawa River. In the fall of 1912 they went to the Laurentians.

There were two trips that Harris did not include on his list. In early winter 1909, he went on a second assignment for *Harper's Monthly Magazine*. Again he worked with Norman Duncan, this time to prepare illustrations for Duncan's article on a preacher in the lumber camps of Minnesota.[11] The second trip that Harris does not mention was to Go-Home Bay on Georgian Bay, Lake Huron, where he rented a cottage for the summer of 1911.

Harris probably discarded many of these early sketches and perhaps some of the paintings, so it is impossible to gain a complete picture of his artistic production. Nevertheless, the works that survive indicate to us what he considered important. The series of these early wilderness landscapes culminates in *The Drive* of 1912. The earliest is *Near St-Jovite* (Fig. 2.20), a small work signed in the lower right corner with the early form of Harris's signature, "L. S. H." done in block letters. *Near St-Jovite* best shows us the skill and the type of landscape composition that Harris brought back from Germany. From a colouristic point of view it is very far removed from his later landscape work. This painting is locked into a brown tonal colour system. The sky is a deliberately neutral grey; there is no colour contrast in the painting at all. The view is of a very rough foreground terrain with boulders, beyond which one sees a swamp or lake, and beyond that the largest hill in the painting, which also has boulders coloured in the same way as the ones up close. The brushwork is as rough in most of the painting as the terrain it depicts. The manner of painting the trees silhouetted against the sky is noteworthy: Harris drew his brush filled with dark brown paint over the roughly painted sky, so that the silhouetted trees, rather than being independent forms, are part of the varying density of brushwork of the sky. The basic composition of this work is very much like his teacher von Wille's or like Leistikow's, as is his choice of rough terrain and the roughly brushed-on paint.

A quite similar painting of 1908, *Laurentians near St-Jovite* (Fig. 3.10), is different in its use of colour. Here the sky is not a neutral combination of greys but is blue with a white cloud. The hill in the background, which forms the main element in Harris's usual landscape composition of this

period, is painted with strokes that do not attempt to present it in as naturalistic and detailed a fashion as in *Near St-Jovite. Laurentians near St-Jovite* is not a tonal painting. The shift is towards a brighter combination of different colours. There is some complexity in the composition in that a yellow path in the foreground goes into the middle ground. The nearby trees are silhouetted against the hill and the sky. Harris's technique at this time is still one in which he paints the dark colour of the tree (apparently black) over the already painted sky. The consequent problem, that the roughness of the sky menaces the overlying tree form, was soon overcome, but it is in evidence in this wilderness landscape as it is in his urban landscapes of the same period.

Harris's stay at Go-Home Bay on Georgian Bay in 1911 produced yet another type of colour experiment, this one prompted by the colours of the water, sand and sky. In *Georgian Bay* (Fig. 3.14), a typical low coastline or island is silhouetted across an expanse of water and against a sunny sky in which white clouds are suspended. Harris uses a thick brushstroke again, expressing the shapes in sculptural relief. The sunny, summer feeling of this work is not typical of Harris's development, although later he did paint other summer scenes. The silhouetted trees against the horizon are a familiar theme in the Group of Seven's paintings; this is an early example from Harris.

The Drive of 1912 (Fig. 3.11) is probably from Harris's trip to Temiscaming and Mattawa. The painting was exhibited at the OSA Exhibition in March of 1912 and was purchased by the National Gallery of Canada, making it an important landmark in Harris's career.

While quite large, this landscape is in the tradition not only of his own earlier small wilderness landscapes, but also of his teacher von Wille and of Walter Leistikow (Fig. 2.8). In *The Drive,* one looks from a fairly low point of view across a valley and up a hillside to the high horizon formed by the contours of the hills. The snow across the bottom of the painting is treated with interesting broad rhythmic strokes. The painting shows lumberjacks working on logs;

across the river, the white river-bank up to the tree line, the trees up to the horizon of the hill and finally the clouded sky form three more horizontal bands across the painting. One senses little divergence from the regionalist tradition that Harris inherited from his teachers, except perhaps in the broad and lengthy brushstrokes at the bottom and in the patch of sunlight in the middle. This chance patch of light might occur in nature, but it has a sense of convenience about it that approaches artificiality. It certainly helps Harris focus his composition.

In these early landscapes, one can see the influence of Harris's *Heimatkünstler* teachers and their friends in the low, frontal view of hills, the choice of rough and wild terrain as a subject and the roughness of the brushstroke. But there is another link with von Wille, Leistikow and the painters of *Naturlyrismus.* Like them, Harris was attempting to express not just objective views, but feelings. For instance, commenting in 1911 on *A Load of Fence Posts* (Fig. 3.12), one of the four works he exhibited in the 1911 OSA Exhibition, Harris wrote, "'A Load of Fence Posts' is an endeavour to suggest the dreary, empty, lonely feeling of a Northern twilight." Even the idea of northern loneliness might have had its prototype in the title of a von Wille painting.[12]

In two comments on his own works at this time, Harris introduces an explicit moralizing note. Of *The Return from Town* (Fig. 3.13), Harris wrote, "In this picture I have sought to contrast a party of tipsy lumbermen returning, intoxicated and hilarious, to their lumber camp, as against the still dignity, the high solemnity of the forest through which they are passing. I have attempted to bring out the dignity of nature as against the – less worthy qualities in human nature."[13] Throughout all the changes in his life and art, Harris always conceived of art as having a serious moral role in society. Of *Along Melinda Street,* he wrote: "The aim was to suggest the movement of a snow storm – the way in which it swirls around things and gets into every nook and opening as if nature were endeavouring to clean the works of man of their grime and dirt." There are echoes of his strict Protestant

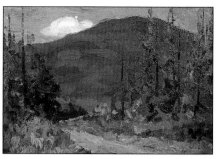

Figure 3.10
Laurentians near St-Jovite, 1908
Oil on board
15.2 x 21.6 cm
Private collection

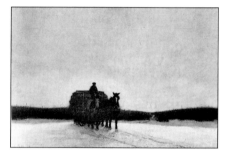

Figure 3.12
A Load of Fence Posts, 1911
80 x 121 cm
McMichael Canadian Art Collection, Kleinburg, Ont.
Purchased in honour of Michael Bell, Director of the McMichael Canadian Art Collection, 1981–86

A most pleasing thing about these pictures … is that the subjects which inspired them are truly of this country, and the knowledge upon which they are based must have required not alone a keen observation but a number of years of study in the North. The incident of the northland, the cold crispness of its snows, the suggestion of mystery and bigness … is done in a perfectly simple and masterly way.[14]

Harris's review of the Royal Canadian Academy exhibition of 1911 is critical and provocative. Many of the pictures he sees as praiseworthy in certain aspects, "but as a whole as a unit, they are at fault. They do not attract the eye to one particular spot, obscuring more or less the rest of the picture. One believes a masterpiece must be a unit, a little world, and that this is one of the great secrets of art of all time."[15] Harris then criticizes the work of several artists, including G. A. Reid (1860–1947), then one of the best-known artists in Canada, for failing in this basic requirement. Reid was principal at the Ontario College of Art and a recent president of the Royal Canadian Academy. This attack on one of the most eminent among the academicians was an attention-getting expression of Harris's developing avant-garde stance, the young artist against the established. This stance is illustrated by the Lismer cartoon that accompanies Harris's review (Fig. 3.15). It shows Field Marshall HRH The Duke of Connaught, KG, the Governor-General of Canada, paying an official visit to the exhibition. The Governor-General and his entourage are shown arriving on the right; in the centre are some of the paintings and four bulky, aging academicians bowing low before the vice-regal party. Behind these and on the extreme left stands the boyish figure of Harris.

In his review of the exhibition of the Canadian Art Club in the *Year Book of Canadian Art 1913*, Harris also makes clear his preference for a nationalist art. His only general criticism of the exhibition was that there were not more "Canadian subjects." The Canadian Art Club, which

upbringing here. These statements also show that Harris was already reaching beyond the realist aesthetic of painting realities that one can observe for oneself. The other levels of meaning would ultimately interest Harris more. In the meantime, he was on the threshold of decorative developments in his art.

THE ACTIVIST, 1911–14

Harris's fascination with the North is evident in his first published article, which appeared in the initial number of *The Lamps*. In his short review of an exhibition of the work of Arthur Hemming in October 1911, Harris praised the works for their Canadian subject matter and for showing a knowledge and love of the North. The imagery Harris used to describe the North is very similar to the mystical language of his later articles:

held annual exhibitions between 1908 and 1915, was a closed, carefully chosen group of painters who had broken away from the OSA, claiming that the OSA exhibitions had been bad and that the Society was neither effective nor respected. The club persuaded Canadian artists such as James Wilson Morrice and John Hammond, who had left Canada to further their careers, to exhibit their work in Canada. Harris was never invited to exhibit with the Canadian Art Club, but he considered that their series of separate exhibitions had been of "undoubted benefit" to Canadian art. He praised the work of J. W. Morrice and of Ernest Lawson, as well as paintings by Marc-Aurèle de Foy Suzor-Coté (1869–1937) and Maurice Cullen. Cullen's painting of snow he found "a very good treatment of a very difficult subject."[16] Archibald Browne was not among the more modernist of the painters in the exhibition, yet Harris applauded his work, which echoed his own attitudes about feelings in landscapes.

The Future Group of Seven

The most important new contact for Harris during these years was J. E. H. MacDonald, through whom he met A. Y. Jackson (1882–1974) of Montreal and the group of artists working as illustrators for the commercial art firm of Grip Ltd., where MacDonald was the chief designer. These included all the other artists who eventually formed the Group of Seven – Arthur Lismer, Frank Carmichael, Frank Johnston and Fred Varley – as well as Tom Thomson (1877–1917).

MacDonald was born at Durham, England, and came to Canada at fourteen.[17] He studied art at the Hamilton Art School and in Toronto at the Central Ontario School of Art, became a graphic designer at Grip Ltd. in Toronto, and then returned to England to work as a commercial artist. On his return to Toronto, he was rehired by Grip Ltd., where he met Tom Thomson. Born at Claremont, Ontario in 1877, Thomson was brought up at Leith, Ontario, where his family had a farm. After attending business colleges in preparation for a business career, Thomson worked for several photo-

engraving firms before joining Grip Ltd. in 1907. He had some training in art in Toronto in 1905–1906, possibly under William Cruikshank.[18]

Arthur Lismer (1885–1969) was born in Sheffield, England. He studied at the Sheffield School of Art and at the Académie Royale des Beaux-Arts in Antwerp. In 1911 he emigrated to Canada, where he was hired by Grip Ltd.[19] Not long after, Frank Carmichael (1890–1945) was taken on as an apprentice. While at Grip he studied part time with William Cruikshank and George Reid, and also at the Toronto Technical School under Gustav Hahn.

Frank Johnston (1888–1949), another member of the Grip firm at this time, was trained as an artist under Cruikshank, Reid and Hahn, and also studied at the Pennsylvania Academy.[20] Fred Varley, a native of Sheffield, England, came to Toronto in 1912, and was hired by Grip Ltd. Like Lismer, he had been educated at the Sheffield School of Art and the Académie Royale des Beaux-Arts in Antwerp. Five of the members of the nationalist movement working at Grip were also members of the Arts and Letters Club: MacDonald, Lismer, Carmichael, Johnston and Varley. With Jackson and Harris, the number was complete.

Harris's main contact with this group of men, all of whom wanted to be painters, and particularly to use Canada as their subject matter, was MacDonald, who was also instrumental in putting Harris in touch with A. Y. Jackson. In 1913, Jackson received a letter from MacDonald. He later described the event:

Macdonald's letter was about *Edge of the Maple Wood* [Fig. 3.16], the canvas I had painted in 1910. If I still possessed it, he wrote, a young Toronto artist, Lawren Harris wanted to buy it … The immediate result of MacDonald's letter was that Harris bought my canvas … A second result was that I began my association with the artists responsible for changing the course of Canadian art for many years to come.[21]

Figure 3.13
The Return from Town, 1911
Unlocated

Figure 3.14
Georgian Bay, 1911
Oil on pressed wood board
13.9 x 21.8 cm
McMichael Canadian Art Collection,
Kleinburg, Ont.
Gift of the Founders,
Robert and Signe McMichael

In 1948, Harris recalled his earlier reaction to the painting:

In 1910 at an exhibition of the Ontario Society of Artists we saw a painting entitled *The Edge of the Maple Wood.* It stood out from all the other paintings as an authentic, new expression. It was clear, fresh, and full of light, luminous with the sunlight of early Canadian spring … that painting is significant because it marked the first time that any Canadian painting had contained such startling variety.[22]

The painting is, in fact, very similar in subject, time of year, composition and mood to works of von Wille, like *Departing Winter in the Eifel* (Fig. 2.1). *The Edge of the Maple Wood* was in Harris's collection until it was purchased by the National Gallery of Canada in 1937.

In May 1913 Jackson met MacDonald, who introduced him to Lismer, Varley and other artists at the Arts and Letters Club. Of his meeting with Harris, Jackson wrote:

He [Lawren Harris] was, I found, a young man, well educated, widely travelled, and well to do … To

Lawren Harris art was almost a mission. He believed that a country that ignored the arts left no record of itself worth preserving. He deplored our neglect of the artist in Canada and believed that we, a young and vigorous people, who had pioneered in so many ways, should put the same spirit of adventure into our cultivation of the arts … He believed that art in Canada should assume a more aggressive role, and he had exalted ideas about the place of the artist in the community.[23]

However, Jackson was not at that moment persuaded to join the group in Toronto. After spending the summer and fall painting on Georgian Bay, he planned to go to the States to work as a commercial artist. Through Harris's intervention, Harris's friend Dr. James MacCallum offered Jackson first the use of his cottage, and then a room in the Studio Building he and Harris were putting up in Toronto. He also guaranteed Jackson's expenses for a year. Jackson decided to stay in Toronto.

Jackson brought into the group one of its best art educations, as well as a wide experience of Impressionism and other modern movements. He had begun his career in commercial art in Montreal when he was twelve, and studied art part time with Edmond Dyonnet and William Brymner. In Montreal, Jackson worked in the lithography business with occasional sketching trips into the nearby countryside. In 1906 he went to Chicago, where he worked for a firm of commercial designers and studied at the Art Institute of Chicago in the evenings. In 1907, Jackson enrolled at the Académie Julian in Paris. After doing a lot of travelling and sketching in Europe, he returned to Montreal in 1909.

The group at Grip Ltd. had been sketching on weekends, and encouraging each other in the hopes of becoming artists who would paint nature as they found it around them. Harris's introduction to them through MacDonald brought together all the initial members of the future Group of Seven. The results were exciting. Harris, who shared in and

Figure 3.15
Arthur Lismer
Academicians Are Sometimes Actors when Pictures Become a Play, 1911
Ink on paper
4.8 x 13.3 cm
Illustration for *The Lamps,*
December 1911, 9
Courtesy of
Mrs. Marjorie Lismer Bridges

ACADEMICIANS ARE SOMETIMES ACTORS WHEN PICTURES BECOME A PLAY
Cartoon by A. Lismer

fostered this enthusiasm, persuaded A. Y. Jackson to join the group and provided the very important practical help of the Studio Building.

Although Harris and Dr. MacCallum jointly sponsored the Studio Building, Harris was the sole purchaser and the mortgagor. At some later date, Harris and MacCallum agreed to the terms of their joint ownership: three-thirteenths were MacCallum's and ten-thirteenths were Harris's. The building was highly serviceable and is still being used for artists' studios. Originally, besides studio space, there was to be a gallery and a theatre. In other words, it was planned to function as a cultural centre: one of Harris's best practical ideas, and a quite original one for Canada at that time. Artists in the building got large studios at low cost. Jackson considered the Studio Building "a lively centre for new ideas, experiments, discussions, plans for the future and visions of an art inspired by the Canadian countryside. It was, of course, to be a northern movement."[24]

The first occupants of the building when it opened in 1914 were A. Y. Jackson, Harris, Arthur Hemming, J. W. Beatty, Curtis Williamson and J. E. H. MacDonald. Thoreau MacDonald mentions that Thomson used the basement and then the shack at the rear.[25] Hemming, Beatty and Williamson were being promoted by Harris because in their different ways they too were interested in a Canadian art. Harris's ability as an organizer was obviously important to the development of the movement. A. Y. Jackson acknowledged this: "While we rather prided ourselves that the group had no leader, without Harris there would have been no Group of Seven. He provided the stimulus; it was he who encouraged us always to take the bolder course, to find new trails."[26]

Toward the end of 1913, opposition to the new attitude toward art in Canada found a voice, again from within the Arts and Letters Club, when H. F. Gadsby wrote an article in the *Toronto Star* entitled "The Hot Mush School, or Peter and I." MacDonald quickly replied with a letter to the editor, and the movement had its first public controversy. The stance taken by the emerging group toward criti-

cism was an avant-garde aspect of their program. Gadsby's article was the single negative response they received at this stage: reaction was usually favourable. They attempted to fan any mention of criticism into a public issue, realizing that they could thus get the attention of the Canadian public and awaken them to the possibility of an art that was Canadian. The reaction of the Group to later criticism was identical.[27] As for Harris, this process recalled the avant-garde confrontations of his student days in Berlin. He was deliberately trying to create such confrontations in Toronto.

Harris's best-orchestrated event of this nature was a letter to the *Globe* on 4 June 1914, in reply to an article about the Federal Art Commission and the National Gallery. Harris's letter asserts that "the most vital part" of the question about a National Gallery had not been touched on in the Commission's program:

We have no assurance whatever that the dearly beloved art commission is not going to continue spending fifteen or twenty times as much on foreign art as on Canadian. We are already too well supplied with European pictures … the number of Canadian patriots who won't have anything but foreign work in their collections need no Government to endorse them in their snobbishness. Yet this is what the art commission is doing. Out of touch, with no sympathy or enthusiasm or any belief in the future of Canadian art save that it ape the past and severely copy European standards, it [the art commission], with its stupid policy is merely helping the dealer to blind the people whom the Canadian artist must depend on for a living.[28]

Harris then suggests that the government should grant the money to the art societies in Canada, and let them purchase the paintings. This, he claims, would result in wiser spending than one could hope for from "any commission of laymen."

Figure 3.16
A. Y. Jackson
The Edge of the Maple Wood, 1910
54.6 x 65.4 cm
National Gallery of Canada, Ottawa
Courtesy of Dr. Naomi Jackson Groves, Ottawa

Figure 3.17
Algonquin Park Sunburst, c. 1912
Oil on board
20.3 x 23.5 cm
McMichael Canadian Art Collection, Kleinburg, Ont.
Gift of Mrs. Doris Speirs

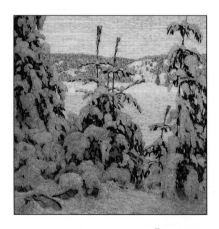

The policy included a grant by the government to foster interest in art in Canada, designed to assist the artists and to educate the public. But Harris argues: "How the artist is assisted or the public educated by a National Gallery at Ottawa full of second-rate foreign pictures is not evident." He then scolds the commission for not bringing to Canada such exhibitions as the Scandinavian exhibition that he had seen in Buffalo, or other exhibitions of modern art that had been shown in American cities. In one of the earliest expressions of his anti-European stance, he asserts that Canadian art is bound for oblivion "unless it cuts itself loose from Barbizon and Holland and the Royal Academy of England and becomes somewhat more than a mere echo of the art of other countries."

Fortunately, Harris had an acquaintance on the commission, Sir Edmund Walker. A millionaire, Walker had been a supporter of Canadian art for years, and of the emerging group at least since 1913.[29] He was Chairman of the Board of Trustees of the National Gallery, as well as the boards of several other major cultural institutions. He was also a fellow member of the Arts and Letters Club, and one can imagine Walker and Harris getting together over lunch to decide how best to stage the event. After the letter appeared, Walker promised official help. And help apparently came, for that year, the National Gallery of Canada bought works by Harris, Jackson, Lismer, MacDonald and Tom Thomson. Walker had already been instrumental in persuading the government of Ontario to buy a Thomson, a Lismer and a MacDonald.

DECORATION AS A VALUE, 1913–18

The strongest element in Harris's development as a painter during these early years of artistic politics is the growing importance of the decorative effects that were just beginning in the earlier landscapes – the use of brushstrokes and impasto to enliven the flat surfaces.

Urban Landscapes, 1912–1917

Harris exhibited a diminishing number of urban landscapes during 1912–17. In 1912, he exhibited six; in 1913 only one, *The Corner Store* (Plate 8), painted in 1912. In 1914 only one of the four paintings Harris exhibited was an urban landscape, *Houses, Centre Ave.* From 1915 to 1917 he exhibited only wilderness landscapes, these too in diminishing numbers. *The Corner Store* is similar to Harris's *Houses, Wellington Street* and *Houses, Richmond Street.* Like the former, it has a low point of view, the façade of a building screened by leafless trees. The horses pulling what is probably a sleigh have a compositional function similar to that of the horse in the earlier picture. There is a similar concentration of light, almost a spotlight effect, created by the strongly lit façade, which is the light colour of roughcast, the stucco popular for working-class houses in Toronto. The spotlight effect is strengthened by the unnaturally dark blue of the sky, the dark branches of the screen of trees and the dark trees seen down the street on the left.

The painting is similar to *Houses, Richmond Street* in that it depicts a roughcast building, and uses a similar combination of red and green for the shutters and window elements, recalling the Post-Impressionist technique of juxtaposing areas of contrasting colours. One can see that Harris has had difficulties similar to those he had in *Houses, Wellington Street* with painting the small leafless tree-branches against the sky. Again, he has dealt with it by similarly spreading brown paint around these branches, obscuring rather than solving the problem. An important difference from both the previous works, however, is that Harris has developed a spatial penetration on the left, articulated by the trees and the cleared sidewalk, diminishing in size. The composition is probably indebted to Liebermann for this development as well as for the frontal point of view (Fig. 2.5). The realist aesthetic is still very much alive at this point in Harris's career, as is his dependence on Liebermann for his compositional models. Fergus Kyle praised Harris's contri-

bution to the 1913 OSA exhibition as showing "the beauty of the commonplace."[30] In *Houses* of 1913 the row of houses ending on a corner shows a spatial development on the right similar to that on the left in *The Corner Store*. There is, however, an important difference. In the sky the paint is applied in horizontally worked brushstrokes, using two colours of blue. Between the two trees on the left, some of the brushstrokes could best be described as bricklike. This is the first appearance of such strokes in a sky area by Harris, or any Toronto painter. The roughcast façades are painted in some areas with almost-white paint stroked over the slightly darker underpainting, with frequent horizontal working. The pale yellow-white of the façade contrasts comfortably with the sky and its two blues. The dull red and green of the shutters and the roof and window elements similarly contrast. The meeting of the wide brushstrokes of the sky with the top branches of the trees in the foreground is still uncertain, but one sees that Harris has become aware of the problem. The smaller trees to the left and right are treated very similarly to those in *Houses, Wellington Street*. The softness of the colours and the presence of the wide brushstrokes in the sky area mark this as one of the clearest early expressions of the decorative impulse that was to confront the realist aesthetic still present in the urban landscapes.

Several of Harris's urban landscapes dating from 1912 refer to the Jewish district of Toronto known as "the Ward." The choice of subjects in the Ward is another link with Liebermann, many of whose subjects were Jewish streets or sections of town, like *Jewish Lane in Amsterdam*. Housser felt the subject matter illustrated Harris's open mind: "He welcomes in his heart both Jew and gentile and accepts them as they are with a friendly gesture which speaks the essence of a democratic faith." In fact, Housser attributed the bright colours in these Ward pictures to Harris's attempt to interpret the gaiety of the Jewish temperament.[31] In his painting *In the Ward* (Plate 7), the decorative thrusts in Harris's urban landscapes reach their maximum intensity. One recognizes Harris's usual approach to composition. The screen,

here formed by one tree and its heavily painted autumn foliage, may well be indebted to Paul Thiem's *Fantasy (Wedding Procession)* (Fig. 2.3). The brightness of the painting is due, not to the spotlight effect we have seen in many of the urban landscapes, but to a traditional device of landscape composition also found in the Thiem work: the viewer and the artist are in the dark shade under the tree in the foreground. The brightness is achieved to some extent by contrast with this very dark area.

The decorative quality is best seen in the choice of colour for the row of houses from the centre to the left – bright tomato-red – and the hatchinglike way the brushstrokes have been worked in nearly vertical and horizontal strokes. On the façade of the three-storey house on the right, the white, cream and tan paint is of thicker texture than the red. The brushstrokes are sweeping, seemingly erratic, very different from the systematic brushstrokes in the red building. In contrast, the partial façade of the building on the extreme right is painted thinly, although one is conscious of the brushstrokes carefully laid on in horizontal and vertical axes.

Another painting helpful to an understanding of Harris's development during this period is *House in the Ward*, which was painted while Harris was on leave from the army in 1917.[32] Harris has presented the façades of a pair of roughcast buildings from an almost frontal point of view, and without his customary screen of trees. The roughcast is damaged on the building on the left, and Harris has painted the damaged areas a soft gold. The colours used in this painting are interesting. The roughcast is rendered naturalistically, and the colours in the thickly brushed sky are also true to nature. The dirty snow in the foreground is a gentle mixture of tans, yellows and white. The other colours stand out as accents in this pastel field. Most noteworthy are the salmon-pink fence and the rich blue-green on the door- and window-frames, and on the shutters and door on the house on the right. *House in the Ward,* with its realist subject matter and its gentle, decorative colour harmonies, was probably Harris's last urban landscape before his personal crisis of early 1918.

Wilderness Landscapes
and the "Tomato Soup" Experiment

Toward the end of 1913, the excitement of the painters committed to finding a Canadian art was growing. Considerable optimism was in the air, thanks to a number of events, including the review that had labelled them "The Hot Mush School." In the fall of 1913, Harris and MacDonald went on a sketching trip to the Laurentians. Jackson had joined the Torontonians and had moved into Harris's studio, waiting for the Studio Building to open, and was busy painting his *Terre Sauvage*. Tom Thomson, who had been brought by Dr. MacCallum to meet Jackson, was fascinated by *Terre Sauvage* and came back again and again to follow its progress. This exciting atmosphere, with all the companions now together, included "lively exchanges of opinion." There was the "stimulus of comparison and frank discussion on aims and ideals and technical problems." It was in this intense studio environment that Harris painted *Laurentian Landscape* (Plate 9). Jackson tells us: "One of Harris's efforts to get vibrant colour was to drag his brush quickly through three or four colours and slap it on the canvas. Among ourselves it was known as Tomato Soup."[33] As a starting point for this experiment, Harris took one of his early Laurentian paintings, done on his first sketching trip in Canada in 1908, *Near St-Jovite* (Fig. 2.20). He made it larger (76.2 cm high) and changed its proportions: the earlier painting is a horizontal rectangle, the later painting almost a square. All the forms in the earlier painting are repeated, but their proportions are changed to accommodate this new format. The colours and their application have also changed. The painting is very bright, rivalling *In the Ward* in intensity. The large hill area is the only one that seems to have been painted with a brush loaded with more than one colour, in this case yellow and red. Seen together from a distance, the two colours appear to be orange. The very bright blue sky overhead is punctuated with white clouds. The foreground is painted with broken brushwork, using different yellows, relieved by the grey boulders.

The painting was an expression of the excitement, optimism and experimental frame of mind that united the painters as they moved into the Studio Building. In Harris's work, *Laurentian Landscape* constitutes a promise that was not fulfilled, for he moved away from such vigorous colour experiments into the gently decorative snow paintings that became his main interest until his breakdown in early 1918.

The Scandinavian Exhibition in Buffalo in 1913 and Harris's Snow Paintings

During the previous winter, in January 1913, Harris and MacDonald had gone to Buffalo to see the Exhibition of Contemporary Scandinavian Art. The experience was an important one for the emerging group of nationalist painters, because they discovered the similarity of landscape in the Scandinavian countries to what they were trying to paint in Canada. As MacDonald put it: "Except in minor points, the pictures might all have been Canadian, and we felt 'this is what we want to do with Canada.' "[34] In 1948, Harris wrote:

> Here was a large number of paintings which corroborated our ideas. Here were paintings of northern lands created in the spirit of those lands and through the hearts and minds of those who knew and loved them. Here was an art bold, vigorous and uncompromising, embodying direct, first-hand experience of the great North. As a result of that experience our enthusiasms increased and our conviction was reinforced.[35]

Although all the artists found the Scandinavian example encouraging, it was of particular importance to Harris, for it started him on the series of snow landscapes that dominate his work from 1914 until 1918.

These snow landscapes show a development away from the near naturalism of *Algonquin Park Sunburst* (Fig. 3.17) of about 1912 and *The Drive* of 1912. In the latter Harris has

treated the snow within the framework of a tonal organization of colours, toward the large, highly decorative *Winter in the Northern Woods* (Plate 10) of 1917–18. The intervening works include *Morning Sun, Winter*. This 1914 work is similar to contemporary canvasses by MacDonald and Thomson. As in MacDonald's *Edge of Town: Winter Sunset No. 2*, long, slanting shadows of unseen trees extend from the lower edge into the middle of the painting. For the sky Harris uses two blues, with light blue brushstrokes laid horizontally on the darker blue underpainting; the sky contrasts with the more natural presentation of the trees. Another new element in this painting is a deciduous tree, painted in pink, to the left of centre. The distant hill marking the horizon is mauve. These and similar colours become progressively more important in the snow paintings.

What must be called Harris's first success among his snow paintings is *Winter Morning* (Fig. 3.18), also of 1914, in which leafless trees form a screen through which one sees the row of purple trees that mark the horizon line, and beyond that the richly developed sky area. *Winter Morning* is derived from the *Waldinneres* types of composition so familiar to Harris in his Berlin days, but with its unusual combinations of pastel colours, this snow painting does not evoke the sense of confrontation with the wilderness of the prototypes. In *Winter Woods* Harris explores a new possibility for which he is probably indebted to Scandinavian prototypes: the textured, tapestrylike surface achieved by painting the elements of the evergreens individually. Another example of this technique is *Winter Woodland* (c. 1915), in which the well-separated, bricklike strokes of thick pale green are carefully laid on a pale pink underpainting. This type of brushstroke and the decorative, unnaturalistic colouring continue to the end of the snow paintings; in *Snow II* (Fig. 3.19), they are adapted somewhat to naturalistic cloud forms.

Winter in the Northern Woods has the unusual feature of pink tree trunks. The emphatic bricklike strokes in the sky are light blue on a darker blue. The parts of the trees silhouetted against this sky are a pale olive green. This is the last in the snow series, which shows Harris having moved from a naturalistic presentation of regionalist landscapes into highly decorative transformations of this tradition. They do not challenge the setting and society around them but complement them.

With Tom Thomson in Algonquin Park

Tom Thomson, the least educated of all the artists of the group, became the archetype for the other members. They agreed that they would take turns helping him move into new treatments of line, colour, and so on.[36] To their credit, they recognized his talents, which, in the years immediately preceding his death in 1917, reached heights of colouristic excitement not attained by any of the others. They promoted an image of Tom Thomson as a natural man of the North, a canoeist and trapper who was born in, continued to be related to and lived in the North. Indeed, for city-bred Englishmen like Varley and Lismer, and even for MacDonald, he must have seemed a phenomenon, able to live in the wilderness to which they were only being introduced. Harris, participating in the wilderness myth that attracted well-to-do Torontonians to the Muskoka cottage area, had spent summers in the North with his mother. Harris, Dr. MacCallum and Thomson went to Algonquin Park together in the spring of 1916.

The colouristic excitement of *Laurentian Landscape* is not a starting point for the sketches done in Algonquin Park; the highly decorative pastel snow scenes intervened. In Algonquin Park that spring of 1916, Harris regained some of his enthusiasm for experimenting with bright colours, although in comparison to his *Laurentian Landscape* the results are tame. They are also unexciting when compared to contemporary works by Tom Thomson.

Harris's oil sketches from this trip stand midway between the naturalism of some of his earlier work and the decorative snow scenes. There is an obvious effort to create hot, vibrant colours in *Laurie Lake, Algonquin Park*. The

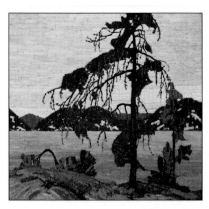

Figure 3.20
Tom Thomson
The Jack Pine, 1916–17
127.9 x 139.8 cm
National Gallery of Canada, Ottawa

decorative element is dominant in *Algonquin Park* of 1916. The trunks of the slender trees, interspersed among the boulders, are a bright, cherry red, similar to the vertical lines in the gable of the shack, and some of the tree-branches are worked into slender, curving, Art Nouveau–derived lines.

The Lake Simcoe Paintings

The series of paintings, mainly oil sketches, done near Lake Simcoe, about sixty miles north of Toronto, brings us into the period of Harris's personal crisis in the late spring and summer of 1918. In comparison to his other paintings, especially his snow scenes, they are surprising for their conservatism. This is particularly true of his choice of natural, summer colours, the greens and browns of fields and trees, and the blues of sky and water. Interesting too are the settings, not wilderness but agricultural. Even when, as in *Kempenfeldt Bay, Lake Simcoe*, bright colours are used for the sky, they are colours that belong in nature.

Another feature of these works is the verisimilitude with which they depict the flat topography of the region. All of them silhouette trees against the wide expanse of sky above a low horizon line. *The Pine Tree* (Fig. 3.21) is an example. Unlike the same elements in *Houses, Wellington Street* of 1910, here the roughly brushed sky and the equally rough brushwork depicting the tree balance each other. This painting shows a convincing integration of composition and brushwork, used to depict both near and distant objects in a coherent and lively pictorial space.

These Lake Simcoe works are sketches, that is, oil on board, but *Kempenfeldt Bay,* c. 1917, is a large Lake Simcoe canvas that echoes the decorative snow paintings in its brushwork in the sky, and echoes as well the Algonquin Park paintings in its preference for slender tree-trunks. This work, however, is a wilderness rather than agricultural landscape. Nevertheless, the large painting is definitely gentle and decorative, and not at all like the rugged northland the nationalist painters had chosen for their region.

Harris seems not to have been proud of these paintings, for he exhibited none of them at this time, nor did he choose any of them for his retrospective exhibitions. He refers to them in a letter to J. E. H. MacDonald as "sky studies." Responding to MacDonald's encouragement he claims that although they are "not very good," there were a few that he considers "worthy."[37] He complains of what he calls the "meagreness of [landscape] material at hand" at Lake Simcoe. These sketches mark a return to a colouristic naturalism, to a more simple, almost timid understanding of regionalism. For his models, Harris seems to have returned to the gentler *Heimatkunst* painters, as embodied, for instance, in the silhouetted tree trunks in Walter Leistikow's *House in a Park* and Adolf Holzel's *Evening Landscape.*

HARRIS'S NERVOUS BREAKDOWN, 1918

Early in 1918, Harris had a nervous breakdown. He moved out of Toronto to his summer home on Lake Simcoe and allowed his studio to be used by someone else during this time. In a letter to MacDonald written over a year after the crisis began, Harris described some of his symptoms: "troubleous" sleep, "terrified tossings" and "apprehensive opening of eyes." In an earlier letter, he described himself as "the victim of moods." He felt confused and disoriented: "curiously shifty as if in an element that was making great sport of me. I can't or don't rather, keep on one track." He fears that all he has done has been futile: "At times I impress myself as having built everything … on sand."[38]

It is natural to wonder about the state of Harris's marriage at this crucial time. What was going on? The marriage ended in divorce in 1934; what might it have been contributing to the accumulating tensions leading to Harris's breakdown? Very little information about either the marriage or Trixie herself seems to have survived in the Harris family. Trixie has been described as never having developed beyond the conventional level of culture and interests that she brought into the marriage in 1910. In that hypothesis, she

would have represented for Lawren the socially acceptable, the decorative, the ordinary. But Lawren was hungering for deeper and so unorthodox meanings, and for an as yet unnamed authenticity in both life and art.

Although it is impossible to be sure what caused the breakdown, three other probable causes suggest themselves.

Military Service

Harris joined the army in the spring of 1916, about a year after his brother Howard. He began as a private in the Canadian Officers Training Corps. By 5 May he had received his "Infantry Certificate" and was recommended for appointment as a Lieutenant in the Tenth Royal Grenadiers Regiment, with headquarters in Toronto. Harris was taken on as a "supernumerary" officer (meaning that he would not be sent overseas) and was assigned to the Musketry Staff, Military District No. 2, where he worked as a gunnery instructor. One of his assignments was to design targets resembling the topography and buildings at which the soldiers would be shooting.

Harris resigned his appointment effective 1 May 1918. Although none of the several letters between the military authorities state the reason, Harris later referred to the event as a medical discharge. Housser believes that Harris's military experience was the major cause of his breakdown. Throughout the war there was great pressure for men to enlist and for all other groups in Canada to support the war effort. Harris may well have been susceptible to this pressure. According to Housser, Harris attempted to fit into the war effort but was unable to: "In him [Harris] the National spirit of the day provoked a desire to express what he felt about the country in a more creative and magnificent communion than a communion of war. It must be on a grander scale than anything hitherto attempted, heroic enough to stir the nationalist pulse when the stimulus of struggle had been withdrawn." Harris "became nervous and unstrung under the discipline of the war machine. His health gave out. In 1917 [sic] he received his discharge from the army."[39] Housser is

attributing to Harris a clarity of ideas that he did not possess at the time he was in the army, and is probably judging from Harris's development throughout the following decade. Nevertheless the vision of this "more ... magnificent communion" had already germinated in Harris's imagination, and was about to mature.

Two Deaths

On 8 July 1917, Tom Thomson was killed while paddling a canoe on one of the lakes in Algonquin Park that he knew so well. The cause of his death remains a mystery, but Harris, with many others, believed he was murdered.[40]

Thomson's death shocked the group of nationalist painters in Toronto, for whom he was more than an ordinary colleague. A. Y. Jackson wrote from England, where he was on military service:

> Without Tom the north country seems a desolation of bush and rock. He was the guide, the interpreter, and we the guests partaking of his hospitality so generously given ... my debt to him is almost that of a new world, the north country, and a truer artist's vision because as an artist he was rarely gifted."

On another occasion, Jackson asserts that it was because of Thomson's death that the group "had not heart to go back to Algonquin Park, so they moved to Algoma and Lake Superior ... and other parts of the country."[41] Harris would have been troubled by similar feelings of loss, having been with Thomson during the winters in Toronto during the war, and on a sketching trip with him only a year earlier.

A second death occurred on 22 February 1918, when Howard, Lawren's only brother, was killed in action while inspecting a German trench. Harris's breakdown followed soon after, and in two months he had resigned his military appointment. Lawren and his brother seem to have been very different as adults – Howard studied law at Osgoode Hall

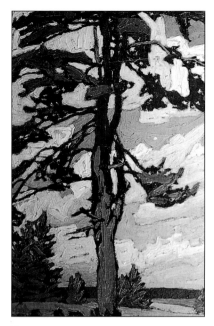

Figure 3.21
The Pine Tree, 1917–18
Oil on board
35.3 x 27 cm
Private collection

and joined a Toronto brokerage firm after graduation – but, according to the family tradition, they had been close friends.

Dissatisfaction with His Own Art: A Speculation

Another factor in Harris's breakdown may have been that he was dissatisfied with his own art at this time, for there were inconsistencies between Harris's own painting and his at times strident rhetoric about what Canadian art should be. He had written about the mystery of the Northland as early as 1911. The challenge of the North was in part its ruggedness and the kind of difficulties that ruggedness created. Yet, when Harris painted his snow scenes, they were not done in the North but in Toronto's High Park and the city's ravines.[42] And the snow paintings themselves, far from being strong depictions of the Northland, were gentle, decorative works in soft, pastel colours. Other works he exhibited during this period were also decorative. We know from his later assertions about his development that Harris saw this decorative phase, in retropect, as only a preliminary one. It is likely that Harris compared his own work with the work of others in the group, in particular that of Thomson, who made spectacular advances in his painting during his last year and a half. Thomson's output in a great variety of sketches and paintings was colouristically bright and aggressive; his painting convincingly embodied the nationalists' ideal that the rugged and difficult "North" was the suitable locus of Canada's homeland art.

Whatever the causes of Harris's illness, one thing is sure: he ended his first decade as an artist in Canada in pain, bewilderment and desolation.

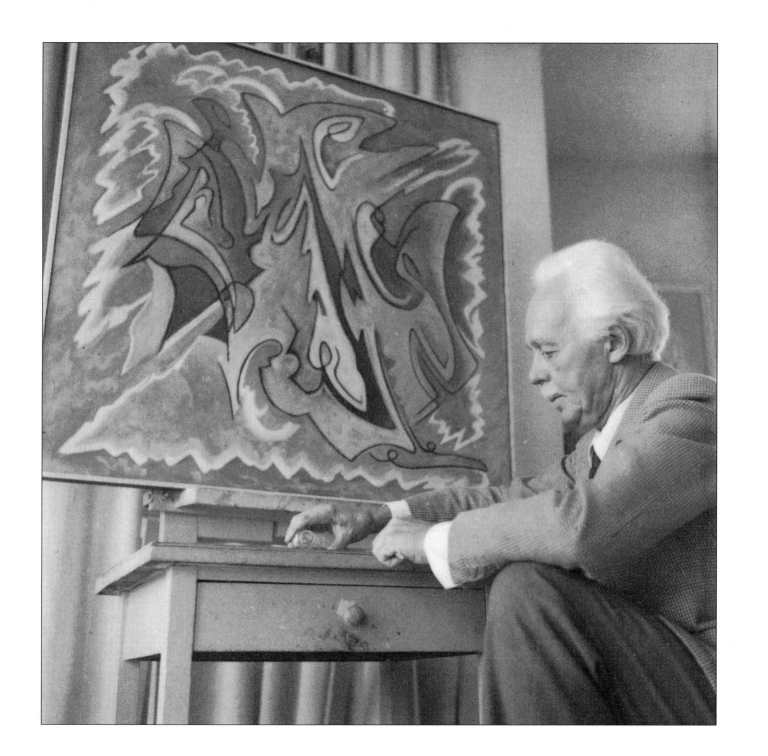

PART II

HARRIS'S MAJOR LANDSCAPE PERIOD, 1918–30

COLOUR PLATES IN PART II

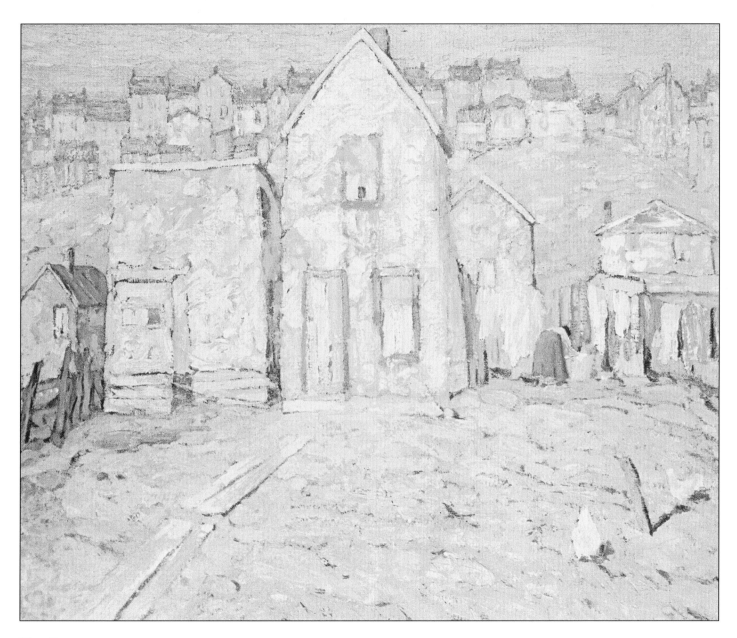

Plate 12
Outskirts of Toronto, 1918
81.3 x 94 cm
Private collection

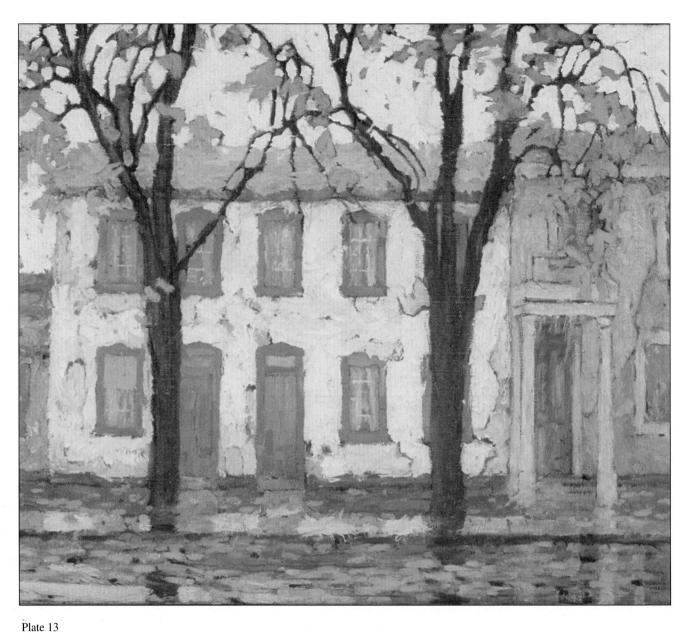

Plate 13
Houses, Chestnut Street, 1919
81.3 x 96.5 cm
The Robert McLaughlin Gallery, Oshawa, Ont.
Gift of Joan F. Pelly, Edward D. Fraser, John C. Fraser and Charles L. Fraser

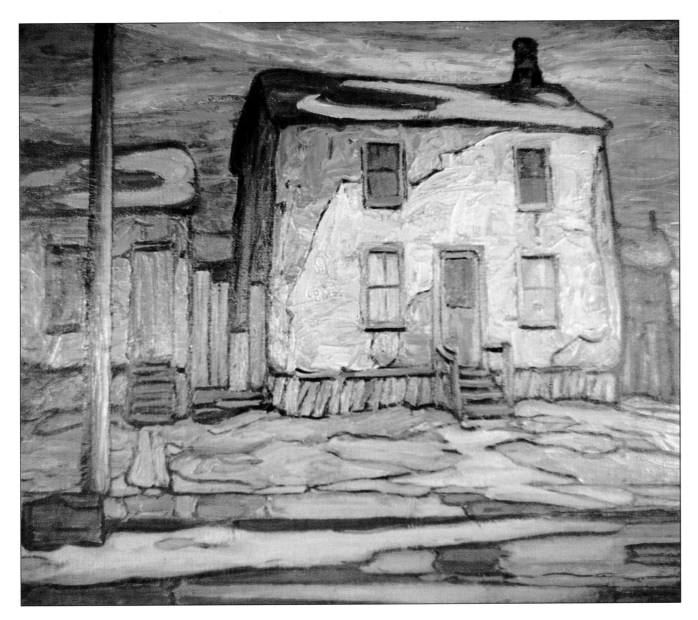

Plate 14
A House in the Slums, 1920
81.3 x 96.5 cm
Private collection

Plate 15
Elevator Court, Halifax, 1921
96.5 x 112.1 cm
Art Gallery of Ontario, Toronto
Gift from the Albert H. Robson
Memorial Subscription Fund, 1941

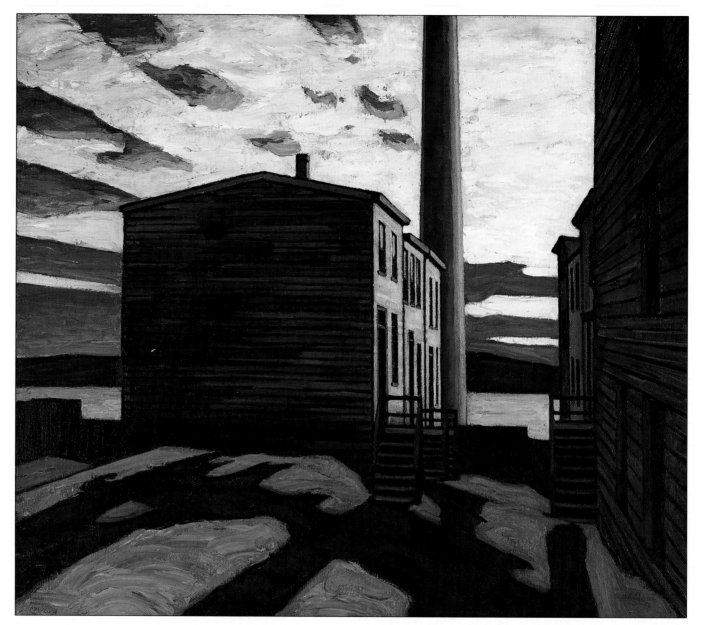

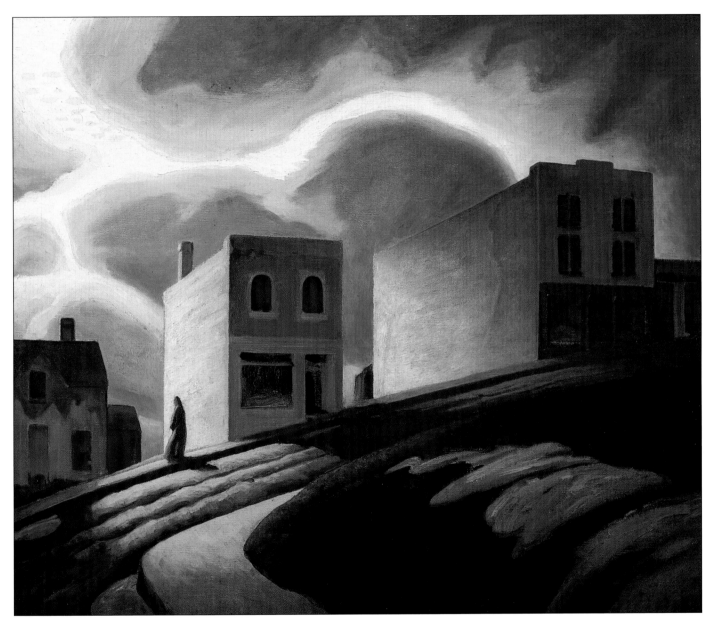

Plate 16
Ontario Hill Town, 1926
85.1 x 100.6 cm
University College Collection,
University of Toronto

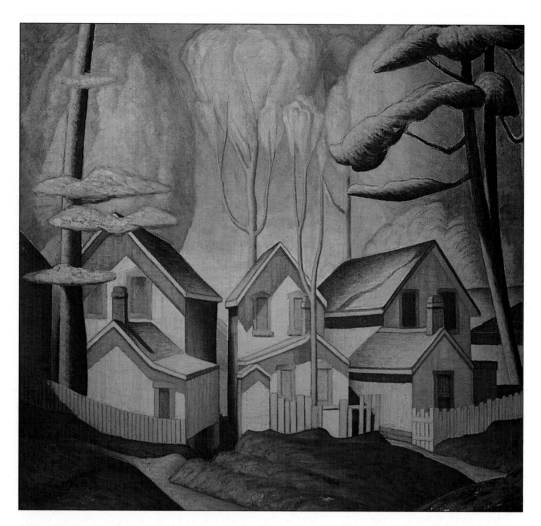

Plate 17
Summer Houses, Grimsby Park, Ontario, c. 1929
91.4 x 101.6 cm
Private collection

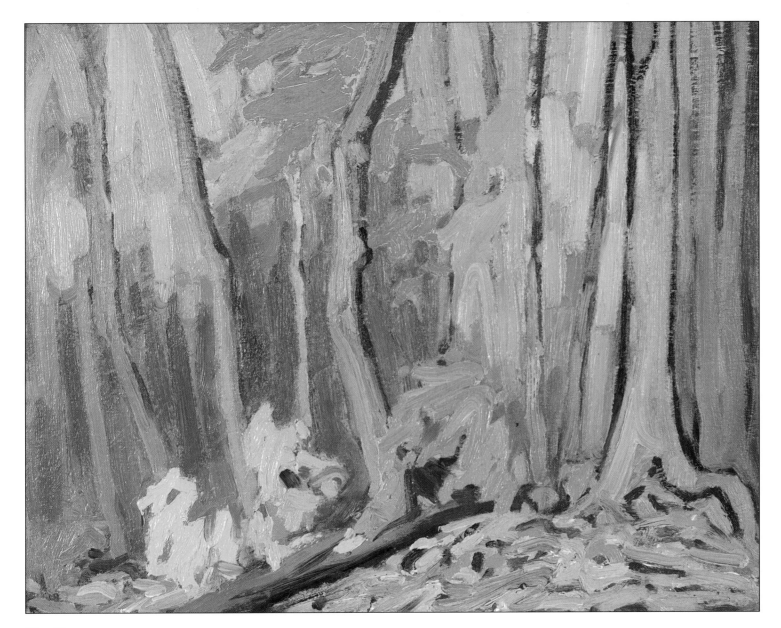

Plate 18
Wood Interior, Algoma, No. 1, 1918
Oil on board
26.7 x 34.9 cm
Collection of Mr. and Mrs. Ken Soon

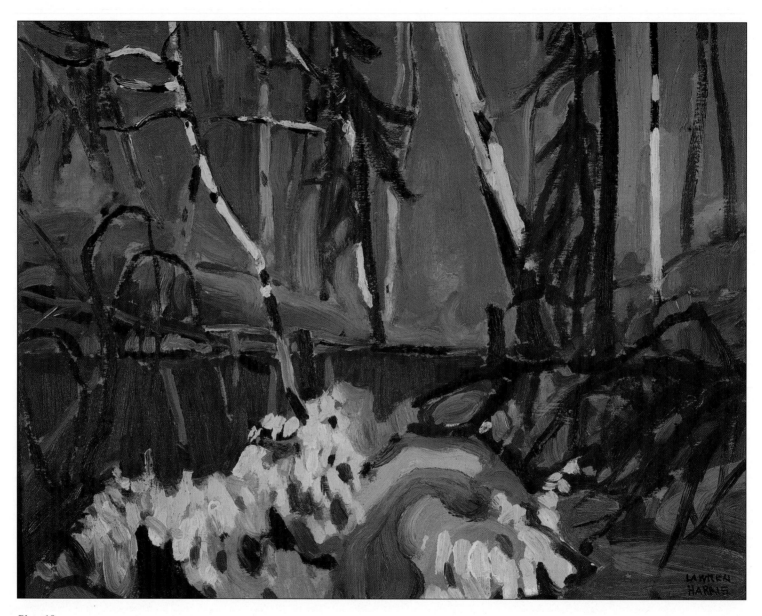

Plate 19
Above a Beaver Dam, Algoma, 1919
Oil on board
26.7 x 34.9 cm
Private collection

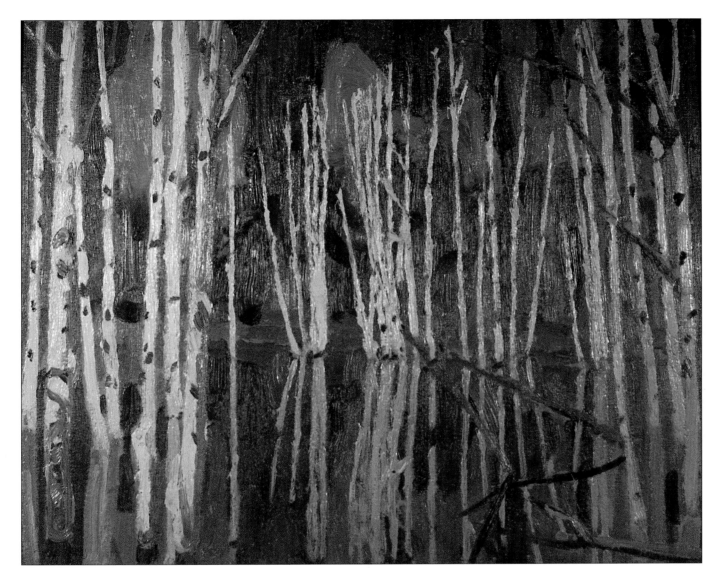

Plate 20
Algoma Sketch, 1918
Oil on board
26.7 x 34.6 cm
Private collection

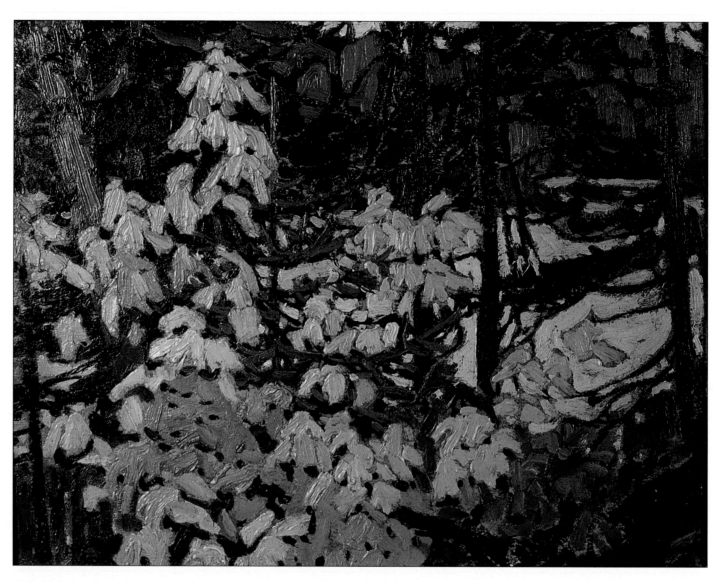

Plate 21
Algoma Sketch CXIX, 1919
Oil on board
26.4 x 34.9 cm
Courtesy of K. R. Thomson

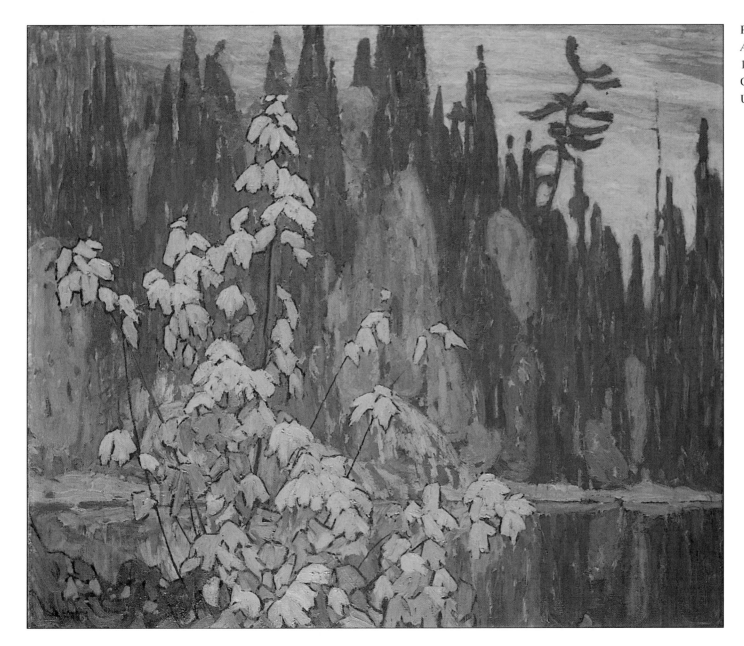

Plate 22
Autumn, Algoma, 1920
101.6 x 127 cm
Collection of Victoria
University, Toronto

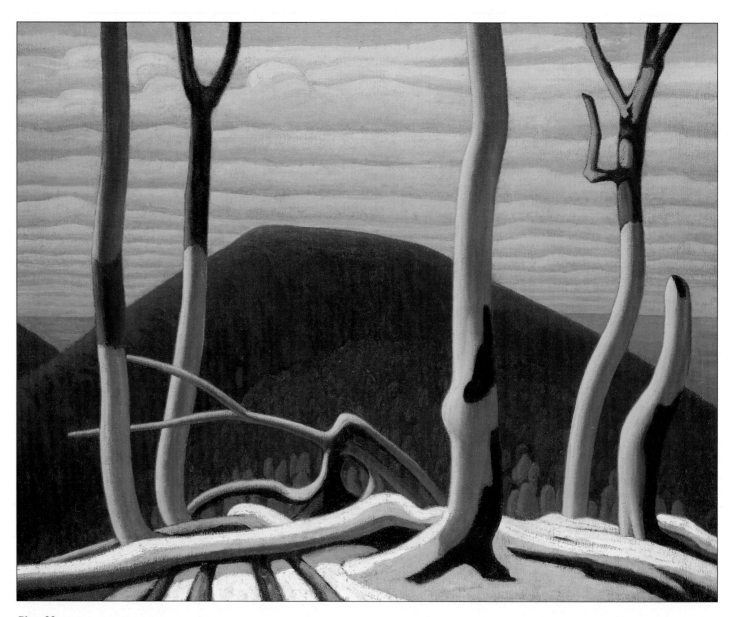

Plate 23

Above Lake Superior, c. 1922

121.9 x 152.4 cm

Art Gallery of Ontario, Toronto

Gift from the Reuben and Kate Leonard Canadian Fund, 1929

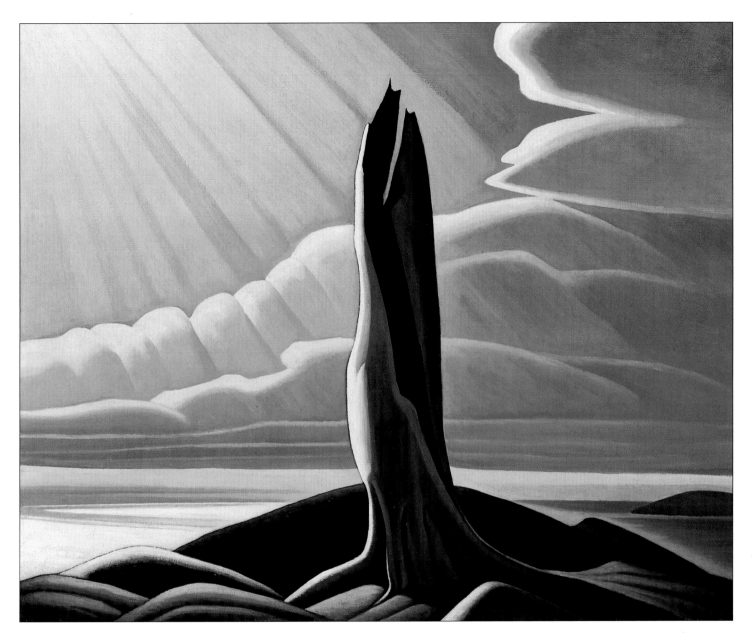

Plate 24
North Shore, Lake Superior, 1926
102.2 x 128.3 cm
National Gallery of Canada, Ottawa

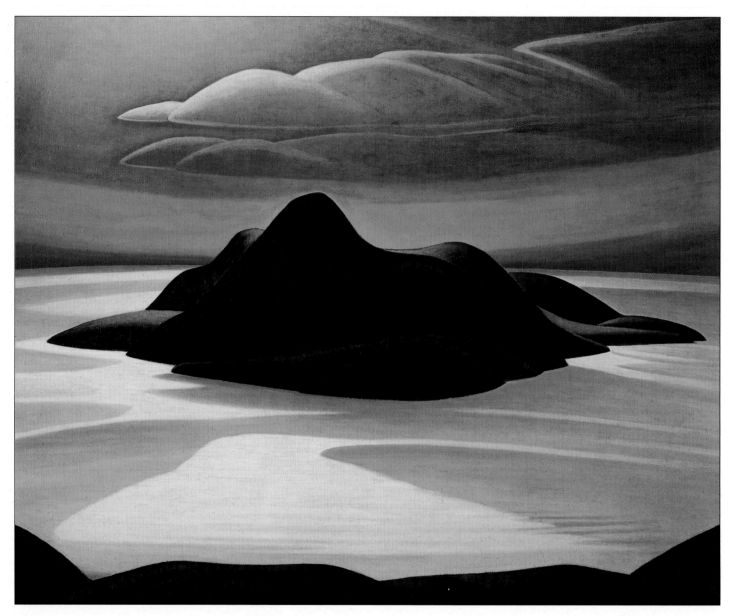

Plate 25
Pic Island, 1924
121.9 x 151.8 cm
McMichael Canadian Art Collection, Kleinburg, Ont.
Gift of Col. R. S. McLaughlin

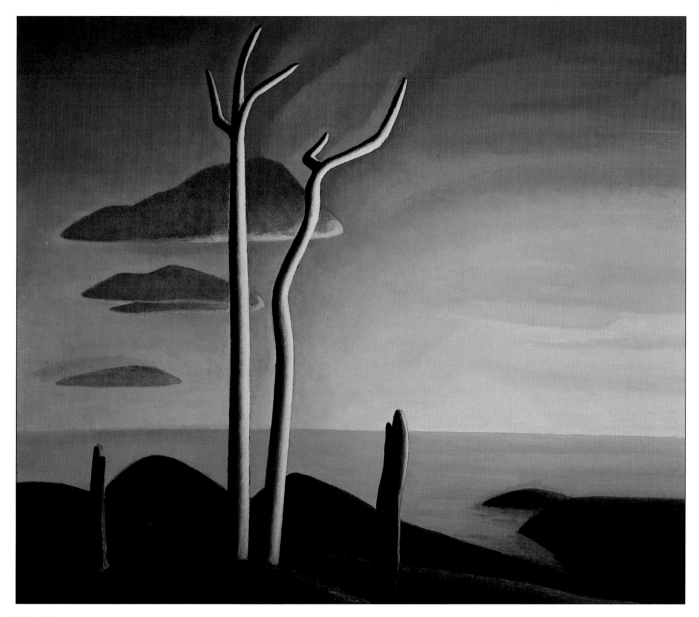

Plate 26
Lake Superior III, c. 1928
86.1 x 102.2 cm
National Gallery of Canada, Ottawa
Vincent Massey Bequest, 1968

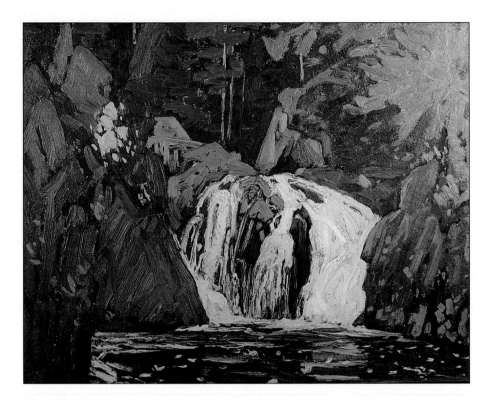

Plate 27
Agawa Waterfall, 1919
Oil on board
26.7 x 34.3 cm
Courtesy of K. R. Thomson

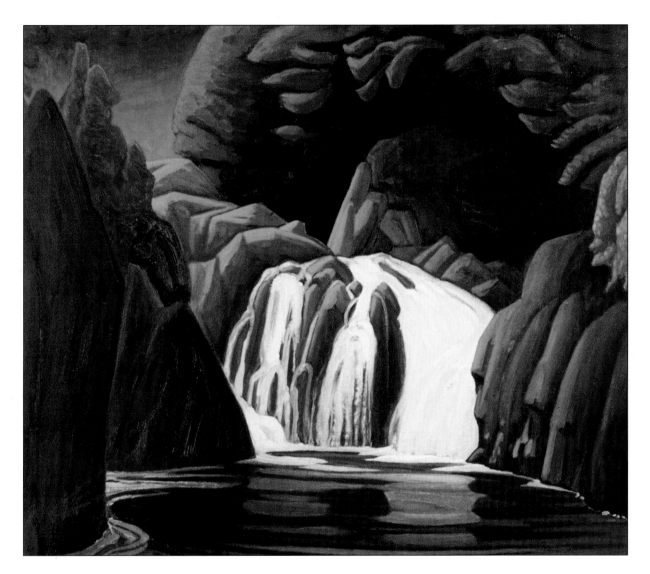

Plate 28
Algoma Waterfall, c. 1926
87.6 x 102.9 cm
Imperial Oil Limited Collection, Toronto

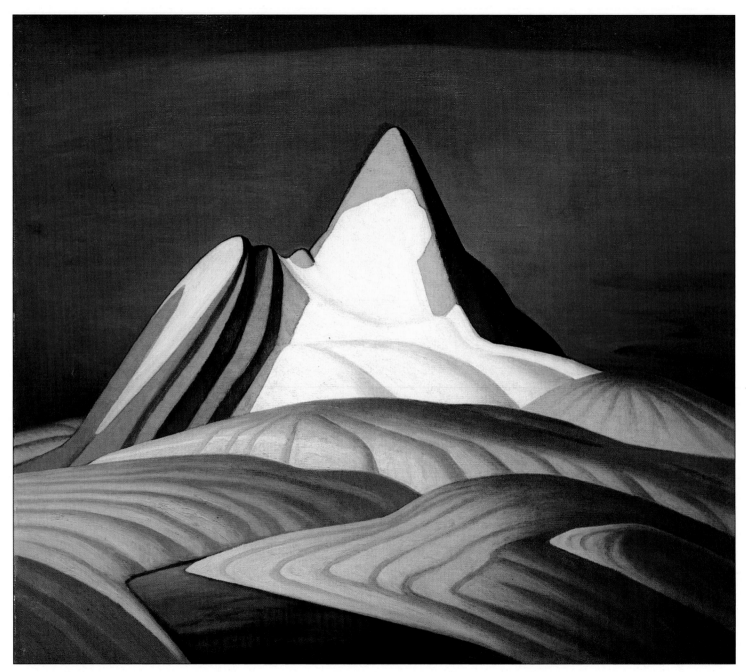

Plate 29
Isolation Peak, c. 1930
81.3 x 127 cm
Hart House
Permanent Collection,
University of Toronto

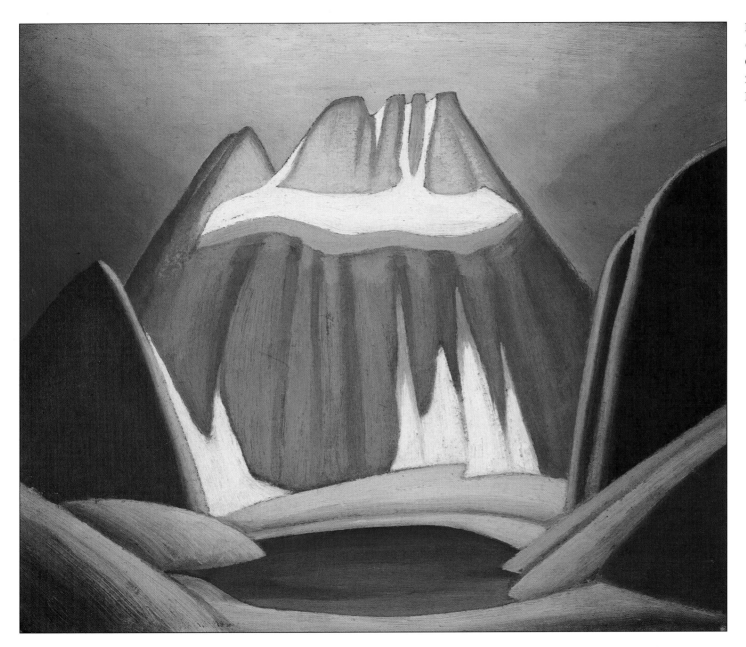

Plate 30
Consolation Lake, c. 1927
Oil on board
29.8 x 37.5 cm
Private collection

Plate 31
Lighthouse, Father Point, 1930
107.9 x 128.1 cm
National Gallery of Canada, Ottawa
Gift of the artist, Vancouver, 1960

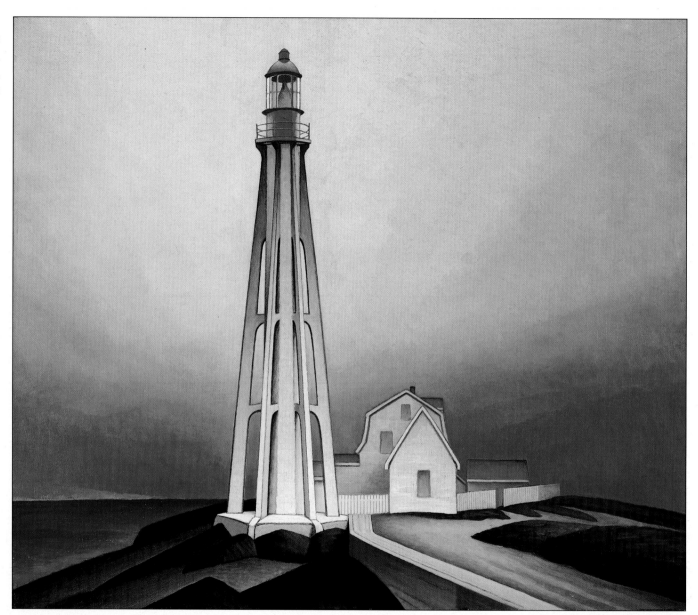

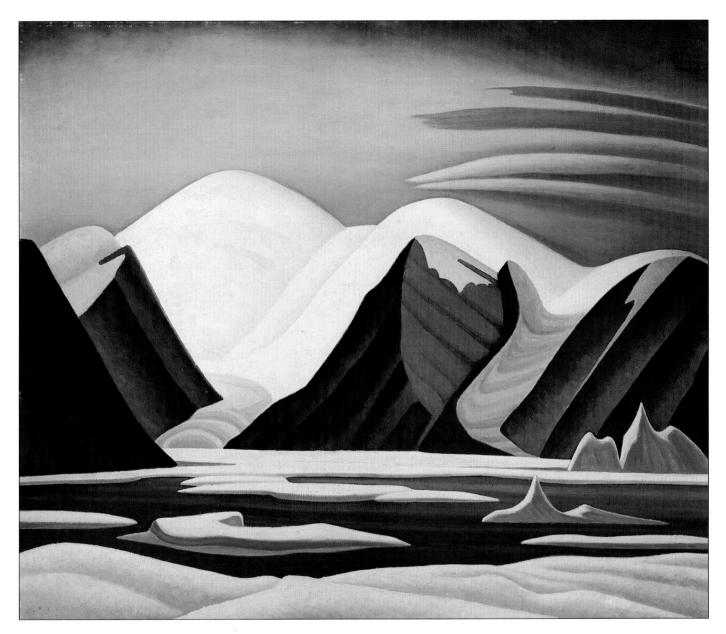

Plate 32
Bylot Island, c. 1930
107.4 x 128.4 cm
National Gallery of Canada, Ottawa

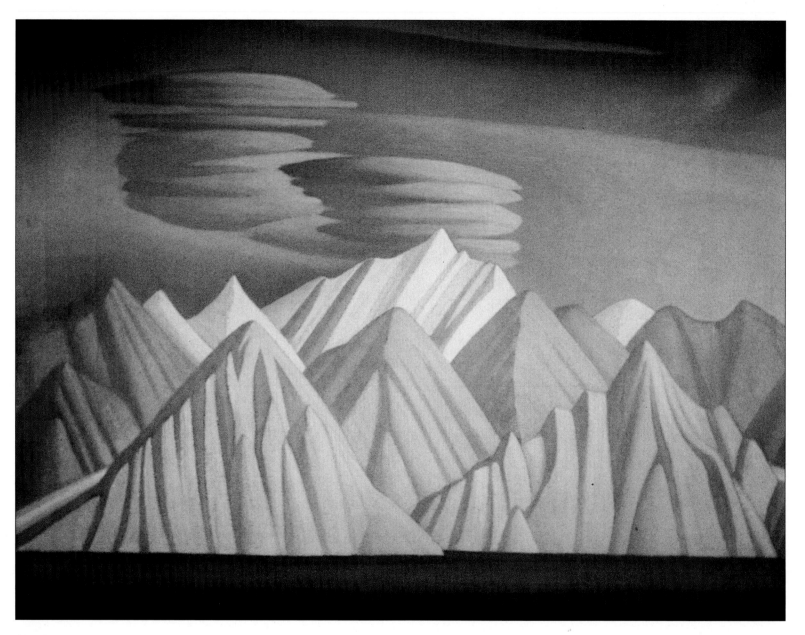

Plate 33
Bylot Island I, c. 1930
81.3 x 114.3 cm
Unlocated

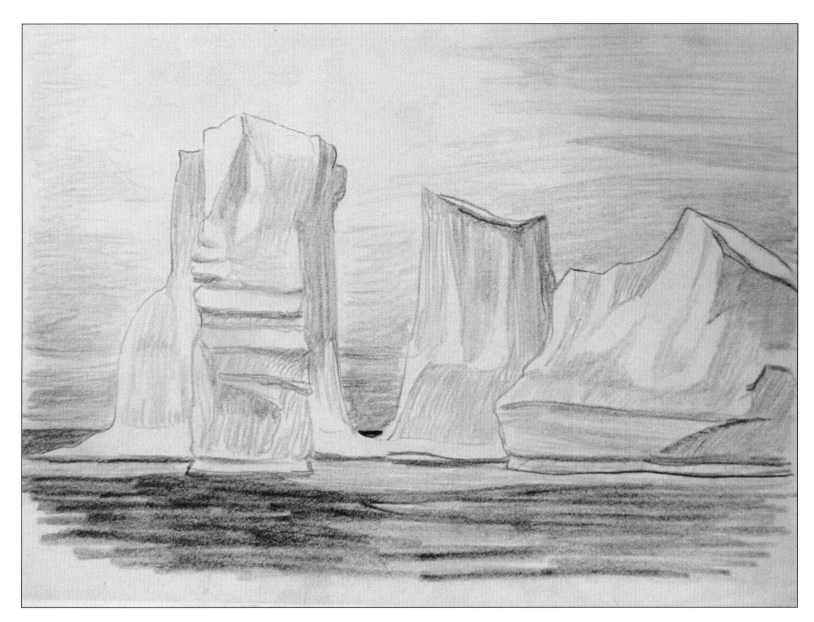

Plate 34
Icebergs, Smith Sound, 1930
18.4 x 25.4 cm
Pencil on paper
Private collection

Plate 35
Arthur Lismer, *In Excelsis* and *Hope,* c. 1924
Charcoal on paper
Private collection
Courtesy of Mrs. Marjorie Lismer Bridges

Breakdown Cured
Mysticism, Theosophy and Canadian Nationalism

THE CONVALESCENT TRIP INTO THE ALGOMA REGION

In May of 1918, less than a month after his discharge from the army, Harris travelled to the Algoma region, a part of Northern Ontario he had not visited before. Accompanying him was his friend Dr. James MacCallum, the Toronto oculist who had shared with Harris the costs of the Studio Building. The purpose of the trip was twofold – sketching and convalescence. The only way to reach the northern Algoma region was to travel to Sault Ste. Marie (708 km north of Toronto) and then take the Algoma Central Railway, which runs due north for about 274 km before turning westward toward Lake Superior and Thunder Bay. Harris later described the region as "a rugged, wild land packed with an amazing variety of subjects. It was a veritable paradise for the creative adventurer in paint in the Canadian North."[1]

In 1926 Housser called the scenery "the grandest ... east of the Canadian Rockies." He continued:

The Algoma country is charted on a grand scale, slashed by ravines and canyons through which run rivers, streams, and springs, broadening into lakes, churning lightly over shoaly places or dropping with roll and mist for hundreds of feet. Granite rocks rise to noble heights – their sides and tops solidly covered with hardwood, spruce and pine, a perfect glory to the autumn.[2]

Housser added: "No wonder Harris was delighted." Delighted and excited Harris certainly was. In the fall of 1918 he returned to Algoma and began his major landscape period. The works based on Harris's trips to Algoma are discussed in chapter 7.

The Importance of Mysticism in Harris's Recovery

MacCallum was not the only friend who rallied to Harris at this time. MacDonald became a confidant and mentor, as shown by Harris's letters from Lake Simcoe to MacDonald in Toronto. These letters also reveal the importance of mysticism in Harris's recovery. The contradictions in Harris's life were gradually integrated into his mystical vision, so that he was eventually able not only to work again, but also to contribute new vigour and enthusiasm to fostering the nationalist movement.

Harris had been reading philosophers and mystics for some time, and during his student days in Berlin Paul Thiem had introduced him to "unorthodoxy." In a 1918 letter to

MacDonald, whom he considered superior to himself in spiritual development, Harris briefly described the wide mystical framework that was to free him for new creative activity and become his spiritual home for the rest of his life:

> Therefore, it may be of advantage to refrain from cajoling oneself or tying one's sense of what is permanent into knots and rather let it be driven home … that one is plumb at the bottom of the ladder that leads to all infinity and blessedness and be grateful that even if one cannot see at all distinctly, at least one can look up and anticipate the time when one is ready to start climbing.[3]

Thus the twelve years of Harris's major landscape period began with a combination of a sketching trip into the North and his discovery of a mystical interpretation of life. In fact, from 1918 to 1930, Harris's energies were divided between sketching in the North and painting in Toronto, and his writings about his mystical views of life, art and nationalism. It is noteworthy that during his illness Harris was still active as organizer and persuader. During the next twelve years, he gave ample evidence of his refound health and enthusiasm.

From Breakdown to "the leading modernist among Canadian painters," 1918–30

Between 1918 and 1924, Harris was the main organizer of eight sketching trips to the Algoma region. Four of the trips, including the last, took place in spring; the rest were made during the vividly coloured fall season. In the fall of 1921, Harris and Jackson pushed farther north and west to the North Shore of Lake Superior. Harris and some of his colleagues visited there each fall between 1921 and 1928. Beginning in 1924 and continuing until 1928, Harris painted during the summers in the Canadian Rocky Mountains. In

1929 he accompanied Jackson to Quebec for a sketching trip along the south shore of the St. Lawrence River. Near Rimouski he did the sketches and studies that culminated in the large painting *Lighthouse, Father Point* (Plate 31). The following year, again with Jackson, Harris went on the government supply ship, the *Beothic,* into the far reaches of the Arctic. Although the wilderness landscapes resulting from these sketching trips were Harris's main line of development, until about 1929 he also continued to paint urban landscapes in the realist tradition.

During the same period Harris committed a considerable part of his energies to working out his mystical ideas about life and art. His first published work based on these ideas was *Contrasts: A Book of Verse* of 1922,[4] a collection of transcendentalist reflections on life, which he illustrated himself. He also wrote an important, though unpublished, paper on his mystical view of the nature of art, "Art Is the Distillate of Life," which he finished by about 1925, though he had probably begun it around 1922. From 1923 until the early 1930s, Harris published articles and reviews of books and exhibitions, mainly in the *Canadian Bookman,* the *Canadian Forum* and the *Canadian Theosophist.* The most important of these writings were two articles in which he expounded his mystical view of Canadian nationalism: "Revelation of Art in Canada" of 1926 and "Creative Art and Canada" of 1928.

Harris also won prizes at two international exhibitions, as well as joining an international organization of avant-garde artists, the Société Anonyme, and arranging for an exhibition of their art in Toronto in 1927.[5]

In 1929 Harris's article in "Creative Art and Canada" was republished in *Yearbook of the Arts in Canada, 1928–1929,* edited by his friend Bertram Brooker, the first painter of abstractions in Canada. Brooker claimed that Harris "is regarded as the leading modernist among Canadian painters, a verdict confirmed when he was invited a year or two ago to exhibit with the Société Anonyme."[6]

HARRIS AND THE GROUP OF SEVEN

By the summer of 1918, the only painters in the nationalist movement still in or near Toronto were Harris, MacDonald, Carmichael and Johnston. Jackson and Varley were overseas as war artists, and Lismer was in Halifax, Nova Scotia, where he had gone in 1916 to be principal of the Victoria College of Art. During the war years the emerging group had managed to keep some attention focused on their artistic aims through exhibitions and some controversy.[7] The tragedy of Thomson's death in 1917 was turned into a martyrdom, and memorial exhibitions were held. Thomson was written about, and a wider public was made aware of the aims of the group. Late in 1917, the artists began to publish articles about the new Canadian art in *The Rebel,* a magazine which had been started that year at the University of Toronto.

After Harris's first visit to Algoma in May 1918, he and Dr. MacCallum, this time with MacDonald and Johnston, went back in the autumn on the first "boxcar" trip. (These trips were so-called because the painters lived in a boxcar which the Algoma Central Railway moved for them from place to place.) The results of this sketching trip were presented in a three-man show, "Algoma Sketches and Pictures," at the Art Museum of Toronto in the spring of 1919. This first independent public showing of the group reaffirmed that their art was to be oriented to the North, and to "the discovery of their own country."[8]

Fall sketching trips to Algoma including various members of the group continued until 1921. In addition there were springtime trips in 1920, 1921 and 1924 (the last trip to Algoma). In the fall of 1919, Jackson joined MacDonald, Johnston and Harris for the second boxcar trip, and in December of that year, Hector Charlesworth criticized their contributions to the Royal Canadian Academy exhibition particularly because they "profess[ed] to have originated a 'school.'"[9]

By May 1920 the "school" had its name, and its members – Carmichael, Harris, Jackson, Johnston, Lismer, MacDonald and Varley – presented their first exhibition. They called themselves "the Group of Seven." They seem to have adopted the name in February or March of that year. The name echoes that of the first avant-garde Berlin group, the Vereinigung, or Gruppe, der XI, and that of Les XX, founded in 1883, the Belgian artists who were the first moderns to name themselves with a number. The Group of Seven's first exhibition opened on 7 May 1920 at the Art Museum of Toronto, with a catalogue for which William Colgate believes Harris wrote the forward.[10]

The Group of Seven held eight exhibitions in all, the last in 1931. Meanwhile, however, Harris and others in the Group continued to exhibit at the exhibitions of the Royal Canadian Academy, the Ontario Society of Artists and the Canadian National Exhibition. Beginning in 1926, the Group invited other artists to participate in their own exhibitions. Frank Johnston exhibited only once with the Group, and in 1926 he was replaced as a member by A. J. Casson (1898–1992).

Harris's Contribution as Organizer in the Group

The Group of Seven prided itself on having no officers and no formal structure; no minutes were taken at its rare meetings. Most of the conversations among members of the Group would have been at the Arts and Letters Club or at the Studio Building. Consequently, Harris's organizational contributions were often unseen beyond the Group. In 1918, however, while living at Lake Simcoe, he had to do much of his organizing work by mail, so we have a written record of his activity. Harris not only had to organize the fall 1918 trip, he also had to persuade J. E. H. MacDonald to join it. His letter to MacDonald, already quoted in chapter 3, shows Harris's enthusiasm at work even while he was ill:

> I am very delighted that you feel as you do about
> getting into the rugged North in September, and I
> am confident that it will benefit you considerably.
> You will in no sense be a hindrance or could be

even though you were to blow up and scatter your-self all over the scenery, spoiling it for our transcrib-ing. You won't get upset and if you should, it won't last and if it does it won't be any great shakes because we will be quite cosy and not subjected to even the exceedingly mild hardships of Minden. So all contingencies having been met more than half way and thrust behind our respective backs along with Satan, we will have a profitable and joyous time.

Having reassured MacDonald, Harris goes on to describe the trip. His rhythm conveys his enthusiasm, and his command of the many details testifies to his skill as an organizer:

The trip – overnight on C. P. R. to the Soo [Sault Ste. Marie]. Next day at the Soo we enter a caboose which will be our home while in the North. Said caboose is hitched on to some train or other, hauled to a siding in the Agawa Canyon 120 miles north of the Soo and left there for two or three days while we proceed to get a strangle hold on the surroundings. From mile 120 we are picked up by a down-going train and left on another siding for a few days and again picked up and left on still another siding and so on until we land in the Soo with a mass of sketch-es and C. P. R. ourselves home again … I may be assuming that you are fearfully ignorant regarding railroad rolling stock but just in case you are – a caboose is a most comfortable box. Pleasant bunks, stove, tables, chairs and all the solid, essential com-forts of a home save that all out doors acts as the plumbing. We will have a cook to prepare our fod-der and do the odd scrubbing.[11]

Harris ends this part of the letter with the buoyant optimism that, except on very rare occasions, was his hallmark: "As yet I have had no reply from the manager of the railroad about the caboose and arrangements but I feel certain that there will be no hitch." As it turned out, it was a boxcar, and not a caboose, that they used in the fall of 1918 and again in the fall of 1919, when Harris organized a similar trip.

There are other indications of Harris's organizational activity. The meeting at which the decision was made to form the Group of Seven was at Harris's home on Queen's Park Crescent. Again, according to his letter to the director of the National Gallery, Eric Brown, Harris arranged for the *Canadian Bookman* to commit half a page monthly to Canadian art, and for Bess Housser to collect and edit the material. He then attempted to persuade Brown to be the Ottawa correspondent. In the same letter, Harris told Brown of the Group's decision to have an exhibition in London, England, and asked Brown to arrange for the exhibition space.[12] Harris may well have been bringing pressure to bear on Brown with this request, since Brown was at that time arranging for the selection of Canadian works for the British Empire Exhibition.

Harris's organizational abilities were not devoted to the cause of Canadian art alone. In 1927 he arranged to have the exhibition of the Société Anonyme brought to the Art Gallery of Toronto.[13] It was Toronto's first exhibition of the abstract art of Kandinsky, Mondrian and others. Harris's per-sistence as an arranger, persuader and organizer suggests that he had inherited some of the organizational ability that had helped build the Harris family business. Thanks to his share of that wealth, Harris did not have to earn a living, and so was able to spend time on such tasks. He also sometimes subsidized the sketching-trip expenses of other members of the Group.

The Group's Main Supporters and Critics

The decade following 1920 saw the Group of Seven move from a barely known Toronto modernist group to being widely promoted as the creators of a distinctive Canadian school of art. After the opening of the eighth, and last, Group

of Seven exhibition in December 1931, there was a reception at Harris's home. A. Y. Jackson read a statement in which he spoke of the Group's intention to expand into a larger, national body. Called "the Canadian Group of Painters," the new group had its first exhibition in 1933. The Group of Seven's struggles with the conservative artistic establishment had been won, and they were now effectively an establishment themselves.[14]

The Group's success was due in large part to the support that they received from the National Gallery of Canada. Besides continuing to purchase from the Group's exhibitions, the gallery, under the leadership of Eric Brown, arranged that it would choose the Canadian paintings when exhibitions were sent abroad. This ensured the presence of all the members of the Group in these exhibitions. Brown's manipulation stepped firmly on the toes of the Royal Canadian Academy which, according to its constitution, was responsible for the supervision of exhibitions sent abroad. The enmity between the academy and the National Gallery reached a peak late in 1926 when the academy led a public attack on Brown, the "art dictator of Canada." The academicians followed this up in 1927 with a petition to the prime minister for an academy-appointed board to replace the National Gallery's trustees. The academy failed, partly because of Brown's astute politics and partly because the exhibitions the National Gallery sent overseas were so successful: British writers and critics were enthusiastic about the Group's paintings in both the 1924 and the 1925 Empire exhibitions. An important benefit of this controversy was that the daily press became interested and the Group and its aims became known even to ordinary newspaper readers.

Although Harris wrote later about the severe criticism the Group was subjected to after their first exhibition, the truth is that there was no such criticism. The show was ignored by Hector Charlesworth (editor of *Saturday Night* and soon to be the Group's severest critic), and other commentators were encouraging. The second exhibition – held in 1921 – drew no comments at all. The third, in 1922, was again reviewed favourably, and again Charlesworth was silent. However, after a trip to Ottawa in the fall of 1922, Charlesworth became irate that many artists whom he considered fine painters were not represented in the National Gallery, while there were "over thirty pictures by the 'Group of Seven.'" He then wrote the article "The National Gallery a National Reproach."[15]

Charlesworth also attacked the gallery's control over the selection of the jury for the British Empire exhibitions. He feared that this jury would support an effort "to make the younger and more freakish schools of landscape predominant," at the expense of "the elder and more accomplished craftsmen whose works interpret Canadian life and scenery with a more suave and poetic inspiration." Later, Charlesworth complained that the reviews by British critics favorable to the Group were the result of a "lobby." His next article on the topic bore the headline "Freak Pictures at Wembley." (The exhibitions were held there, and are frequently referred to as "the Wembley Exhibitions.") When London's Tate Gallery bought a Jackson from the exhibition Charlesworth wrote again, in "Canada and Her Paint Slingers," that the Group and their allies "seem to be succeeding to some extent in spreading the belief that Canada is a land of ugliness; and its art a reflection of a crude and tasteless native intelligence."[16]

The fourth Group of Seven exhibition opened on 9 January 1925. It occasioned the first review of a Group show by Charlesworth, in which he attacked what he called "the group system in art."[17] However, the following year Harris's old friend, journalist Fred Housser, published his influential book *A Canadian Art Movement: The Story of the Group of Seven*. This enthusiastic appraisal established the Group firmly in Canadian history. From 1924, Housser's wife Bess was in charge of the art section of the *Canadian Bookman*. She too promoted the Group's vision of Canadian art and published articles by Harris and other Group members.

In 1928, in a review of the Royal Canadian Academy exhibition, Merrill Denison, a fellow member of the Arts and

Letters Club, pointed out that the Group of Seven had won a long battle:

> The fifteen-year feud between the Group of Seven and the Academy is ended with victory for the *enfants terribles* of Canadian art. No longer can the Group enjoy the vilification that is the reward of the precocious few, because the many have now joined them and the calliope has become merely an overcrowded bandwagon. If there is any surprise about the show it is in the completeness with which the point of view of the Group of Seven has triumphed.[18]

HARRIS'S MYSTICAL INTERESTS AND THEOSOPHY

On 19 March 1924, Harris, who had been in contact with theosophy from at least 1909, was "affiliated to" the Toronto Theosophical Society; he had been for some time a "member at large" of the International Theosophical Society.[19] Even before 1924, Harris had been involved with the Toronto society. In February 1922 and again in January 1923, its records mention Harris as part of the decorating committee, a position he held again in 1925. From 1926 to 1930 Harris gave an annual series of lectures on theosophy and art. He also gave "Young People's Classes" on theosophy in 1933, and he and others spoke on a radio series he helped organize, which continued into 1934. The subject of the radio talks was "The One Immutable Law: Reincarnation and Karma." Harris had been introduced to Eastern religions by reading the American philosopher Ralph Waldo Emerson while a student in Germany. According to Bess Harris (who checked her statements with him), Harris considered Madame Blavatsky and W. Q. Judge to have "introduced the eastern way of thinking to the western world" and he felt that their influence through the Theosophical Society was "a beneficial one to the citizens of Toronto."[20]

Many of Harris's friends also belonged to the Theosophical Society in Toronto during the 1920s. These included Fred Housser and his wife Bess (who became Harris's second wife), and Roy Mitchell and his wife, the painter Jocelyn Taylor Mitchell. These friends provided Harris with a close-knit circle of admirers of his painting and his ideas. Roy Mitchell, who had been a member of the society since 1909, had introduced Harris, during the years just after his return from Germany, to Plato and Eastern texts. Mitchell promoted experimental ideas in drama, and was the founder of Hart House Theatre in Toronto and a professor of drama at New York University. His ideas on the theatre were part of a general theory of art that corresponded closely to Harris's own.

Housser's book about the Group of Seven was published in 1926, the same year that one of Harris's two major articles on his mystical views of Canadian nationalism was published in the *Canadian Theosophist*. Within the community of the Theosophical Society in Toronto, Harris was accepted both as an artist and as a person with serious mystical interests. Harris benefited enormously from this support for the main enterprises of his life. Nor did theosophists value him only as an artist. They obviously took him seriously as a writing and teaching member of the theosophical community for, on at least two occasions, the *Canadian Theosophist* published Harris's homiletic reflections on religious topics. These were "Strength," published in 1927, and "Science and the Soul," published in 1931. In 1933 Harris addressed an international theosophical meeting on the subject of "Theosophy and Art." His lecture dealt, from theosophical points of view, not just with art but with aesthetics, ethics and the irrelevance of moral codes for advanced individuals.[21]

Harris was greatly influenced by the Irish-American theosophist and lawyer William Quan Judge (1851–96). In 1894, Judge was accused by the influential theosophist Annie Besant of forging letters from Tibetan mahatmas, or adepts of the highest order, and as a result became well

known internationally. There is evidence that he believed that he himself was the mahatma "K. H." From perhaps as early as 1918, Harris read daily from Judge's translation of the *Bhagavad Gita.* During the last fifteen years of his life he believed himself to be the reincarnation of Judge, a belief that illustrates the depth of emotion tying Harris to the Theosophical Society and through it to Eastern religious beliefs.[22]

It is not surprising then that the vision of humanity that Harris expressed in his article of 1931, "Science and the Soul," was thoroughly theosophical. He scorned the "props of ecclesiastical authority" and the "quibblings of theology." He believed that the human being was composed of layers of reality – physical, astral, mental and Buddhic – much as they are depicted in theosophical charts and tables such as Leadbeater's "Involution and Evolution" (Fig. 9.5). The layer of least value was the physical. A human's "real being," Harris believed, existed in the realm of the spirit in a "universe of soul or consciousness" which the "awakened soul" or "proficient" could perceive. On this, he claimed, was based one of the main beliefs of theosophists, "the universal and ever-persisting law of brotherhood or the unity of consciousness." Harris held that this "enduring and inexhaustible meaning" would survive "throughout the incarnations and beyond them."[23]

The world view that Harris expounded in 1931 was theosophical in vocabulary but in structure was not unlike Ralph Waldo Emerson's. Like that of the theosophists, Emerson's transcendentalist vision divided the world into layers, that is, into the realm of physical illusion and the realm of spiritual realities. And, like the theosophists, Emerson was deeply interested in Eastern religions. His ideas probably served as a bridge between Harris's Protestant background, within which Emerson would have been a welcome guest, and the more elaborate mystical concepts and structures of theosophy.

Why did Harris the artist become a theosophist? What was theosophy; and why did it attract other artists of the modern period? Part of the answer lies in the history of theosophy and the nineteenth-century cultural conditions that helped shape it. Part lies in the similarity of the reactions of many late nineteenth-century artists – Symbolists and Post-Impressionists – to those same cultural conditions.

Theosophy

The importance of theosophy for our period began with the three books of the Anglo-Russian Helena Petrovna Blavatsky (1831–91): *Isis Unveiled: A Master-Key to the Mysteries of Ancient and Modern Science and Theology; The Secret Doctrine: The Synthesis of Science, Religion and Philosophy;* and *The Key to Theosophy.* She claimed to have received important parts of her revelation from long-dead Tibetan mahatmas. She insisted that theosophy was the primordial wisdom-religion, the secret doctrine that underlies all existing religious creeds and scriptures; to the Western reader, however, her books appear almost completely Eastern in terminology and imagery: reincarnation and karma, the mahatmas, the levels or planes of being, nirvana, the view that human beings participate in an ego-dissolving return to the "Universal Divine Principle."[24] The texts of Hinduism are frequently referred to, and the Theosophical Society published its own editions of them, at times with commentaries. Like Hinduism, theosophy is syncretic and tolerant, and considers itself able to assimilate many elements of other religions. Blavatsky was well aware of European theosophical traditions as well. She held that the Neoplatonist Plotinus (ca. 205–270) was a true theosophist because he wished to found a religion based on a system of intellectual abstraction.

In 1875 Blavatsky founded the Theosophical Society in New York, later establishing its world headquarters at Adyar, Madras, India. The aims of the society were:

1) to form the Nucleus of a Universal Brotherhood of Humanity without distinction of race, colour or

credo; 2) to promote the study of Aryan and other scriptures, of the world's religion and sciences, and to vindicate the importance of old Asiatic literature, namely the Brahmanical, Buddhist, and Zoroastrian philosophies; 3) to investigate the hidden mysteries of Nature under every aspect possible, and the psychic and spiritual powers latent in man especially.[25]

According to Annie Besant, the primary meaning of theosophy was the direct knowledge of God. The search for this direct knowledge of God was called mysticism or esotericism. This search she considered common to all religions, although theosophists held that their task was to cast this search in a scientific form. The secondary meaning of theosophy was what one arrived at after separating the beliefs common to all religions from those peculiar to each religion. Theosophy would thus present the truth in all religions, and so could become a consensus of world beliefs. This consensus would be the universal religion, the wisdom-religion, the esoteric tradition, the secret doctrine, or theosophy, "from which all separate religions spring, the trunk of the tree of life from which they all branch forth."[26]

The theosophists' program included opposition to what they called "comparative mythology," an omnibus phrase covering scepticism, scientific method and any application of criticism to mythology. Theosophists taught that such activity reduced religion to human dimensions, and psychology to physiological and materialistic terms. Against the materialism of "comparative mythology," the theosophists asserted "comparative religion"; against what they saw as the pervasive nineteenth-century scepticism they asserted modern gnosticism, insisting that intuitive religious knowledge was not only possible but necessary and available to all. Generally hostile to modern science with its insistence on empirical observation, controlled methodology and verification, theosophists believed that the knowledge gained through "spiritual consciousness" was just as trustworthy as that of the intellectual and sensory consciousness. Although they admitted that facts had a reality, they insisted that scientific explanations were merely hypotheses. Some of the speculations of science they accepted, presenting them as support for their general position that reality lay behind the physical plane composed of matter, which was dissolvable. In support of this concept of matter, implications of modern scientific knowledge – such as the discovery of radium – are discussed in the introduction to Besant and Leadbeater's *Thought Forms:* an example of how in nineteenth- and twentieth-century theosophical tradition mysticism, clairvoyant experiences, esotericism, theology, philosophy and various scientific ideas can be held together.[27]

By 1912 there were thousands of members in the International Theosophical Society, comprising several hundred branches and publishing more than twenty reviews and journals.

Theosophy and Art

The wide inclusiveness of the theosophists' thinking was one aspect of the movement that helped make it attractive to those who felt ill at ease with the domination of science and the fragmentation of traditional – usually Christian – certainties. The movement appealed to those who needed to know that they were operating and living in a world with structure and meaning. Without the categorizing propensities of the Western mind, theosophy was easily able either to assimilate or to reject any new discovery or theory. In an age of many new scientific ideas, these were important and soothing abilities. Kandinsky, for example, saw in theosophy values similar to his own: It not only opposed the belief that positivism and the methods of material science were the only means to knowledge, but also affirmed the validity of an inner, spiritual knowledge, independent of matter and the senses. Kandinsky saw theosophy as "a strong agent in the general atmosphere presaging deliverance to oppressed and gloomy hearts."[28]

The general theosophical position on art is elaborated by the Indian theosophist C. Jinarajadasa (1875–1953), whose

explanations of the theosophical understanding of art are found in his *First Principles of Theosophy* of 1921 and *Art as Will and Idea* of 1927. Jinarajadasa held that the cultural growth of the human race would not be complete until everyone could function on the highest plane, that is, on the plane of nirvana. Up to the present, "the highest achievement of mankind has been to touch, through the efforts of a few geniuses, the Buddhic plane, through art." What Jinarajadasa means by the term Buddhic plane, and its relationship to the astral, nirvanic and physical planes, can be grasped from his diagrams, "The Planes of Reality" and "Function of the Arts" (Figs. 4.1 and 4.2). In Jinarajadasa's view, the function of art is to teach mankind "to attain to THAT which exists out of time and space by using time and space." In so functioning, creative art is "our highest tool of cognition so far."[29] Thus, it seems to me, in the literature of theosophy the artist could find the reassurance of an exalted estimation of his role in human development.

Another important theosophical notion was that of the "adept." This word denoted someone who had been initiated into a higher level of being, who, having been perfected through several reincarnations, was now "something more than a man."[30] In this notion, artists could find a parallel to their own psychological experience of having special knowledge and could find a justification for the antisocial aspects of their avant-garde struggles. Artists could see themselves as part of a progressive movement surrounded, like adepts, by other people in various stages of initiation, more or less able to discover the meaning of the artists' work. Beyond this innner circle lay the vast public who needed the enlightenment the artist could bring, but were not yet developed enough to receive it with understanding.[31]

Harris's main theme in "Science and the Soul," his article of 1931, is the opposition between modern science and theosophy. In very general terms he argues that modern astronomy, physics, archaeology and biology have made significant contributions "to the welfare of the lower nature, the personal-physical man." But, quoting an unidentified "author

of studies in the *Bhagavad Gita,*" Harris maintains that " 'the truths thus discovered are unrelated to man's real self. They are not seen, nor understood in relation to the One Life, but remain disjointed fragments outside the real man.' "[32]

In writing about this opposition, Harris was extending a theosophical tradition into the Toronto milieu of the 1930s: opposition to the modern scientific mentality was at the centre of recent theosophy and was often implicit or explicit in theosophical writings. Through their impressive achievements during the nineteenth century, science and technology had won a dominant place in the minds and hopes of people. The new scientific method and the myth of objectivity seemed to be making discoveries possible in all realms of knowledge. The philosophical expression of the forces of science and progress was positivism.

Like the theosophists, artists and critics in the late nineteenth century reacted against the culture dominated by this scientific rationalism. In his study of the aesthetics of the period, A. G. Lehmann points out that the two functions that art would be allowed to serve in a culture dominated by positivism robbed it of any independent significance.[33] Within positivist thinking, one could imagine an "art for art's sake" aesthetic in which art was seen as play, as irrelevant to life, at best a decoration for the status quo. The other type of art that positivism could tolerate was naturalism, an art that recorded or copied nature. Such art could be considered the handmaid of science, and the artist could sometimes be endowed with a quasi-scientific support for his naturalism. For instance, contemporary scientific theories of the analysis of light partially underlay Impressionist and Neo-Impressionist painting. In such naturalism, the independence of art was threatened, since it could easily be co-opted by the scientific and positivistic currents of the surrounding culture.

The result of the struggle waged against positivism by late nineteenth-century painters was an antinaturalist movement that spread all over Europe. Its heroes were Cézanne, van Gogh and Gauguin, who were much admired by the Berlin avant-garde while Harris was there as a student.

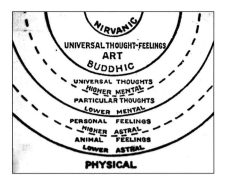

Figure 4.1
C. Jinarajadasa
The Planes of Reality
Fig. 116 from his *First Principles of Theosophy* (1921), 314

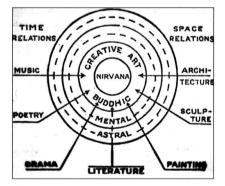

Figure 4.2
C. Jinarajadasa
Function of the Arts
Fig. 117 from his *First Principles of Theosophy* (1921), 319

When, years later, Harris named these three artists as the moderns who interested him most in those years (chapter 2), he was echoing the Berlin version of the Post-Impressionist attitude.

Theosophy and Harris's Rejection of Abstraction

Harris, as he makes plain in his paper "Art Is the Distillate of Life," wanted to express the deepest realities of the spiritual in his painting. Unlike Kandinsky, Casimir Malevich and Piet Mondrian, who with the help of theosophy all turned to abstraction to express their spiritual meanings,[34] Harris still felt in the late 1920s that representational painting was adequate to that spiritual task, especially for Canadian artists and their people.

He did not distill from theosophy formulations and images as rigorously minimal as had Malevich and Mondrian, nor did he work out a theory of artistic creation as precise and detailed as Kandinsky's. In the 1920s, the years of his major landscapes, Harris was attracted to the breadth and sweep of theosophy and its potential for gathering all of reality and experience into a grand pattern of ascent toward ever-wider horizons. This theosophical and religious development was his route out of what he called the "severest orthodoxy" of the Protestant culture of Southern Ontario. Bess Harris, writing in 1968, strove to make it clear that her husband did not paint "the dogmas and doctrines" of the Theosophical Society. What he wanted "was to imbibe the [spirit] of the ancient eastern wisdom, and then to imbue his own work and life as he went along with the feeling and thought which to some extent was the outcome of his endeavour."[35]

In Harris's development, his artistic milieu, Toronto, was a determining factor. He strove to create paintings that combined natural Canadian landscape forms and spiritual ideas drawn from his experience of theosophy. I believe that Harris saw that the landscape-based nationalist movement was necessary in Canada, not just for chauvinistic purposes, but to establish the right of painting and the artistic imagination to exist in the country at all. This was an aspect of Harris's artistic life not paralleled by the experiences of Kandinsky, Malevich and Mondrian. Although each of them was involved in a struggle between the avant-garde and the conservatives, they were painting in countries where there were long-standing artistic traditions. Harris shared their commitment to spiritual meanings, modernity and the avant-garde, but he translated these commitments within the Canadian milieu into the mystical landscape painting tradition.

In commenting on the exhibition of the Société Anonyme in Toronto in 1927, Harris wrote as though he expected abstraction eventually to develop in Canada, although he assured his readers that when it did, it would be a Canadian, not a European, type of abstraction. In a letter to Emily Carr just after he returned from a trip to Europe in 1930, Harris gave a longer explanation of his attitude at that time toward landscape and spirit, abstraction and nature:

I cannot yet feel that abstract painting has greater possibilities of depth and meaning than art based on nature and natural forms. As you say it so frequently becomes arid – but, of course, it need not. I have seen almost no abstract things that have that deep resonance that stirs and answers and satisfies the soul, however. But that does not say that some painter may not produce them tomorrow or the next day.

But I have an idea – confirmed by what I felt in Europe – that we here, in our own place, on new land, where a new race is forming will find for the present and perhaps for some time to come, that the fullest life in art for us comes by way of nature, sharing and imbibing her life; her deep, deep intimations – and establishing ourselves by getting that into our art. Abstract painting is now somewhat natural to Europe – only somewhat – because though they

sever themselves from earth they are not yet, any of them, in heaven. With us, with a new adventure largely before us (not behind us) it doesn't seem natural to me. We have not yet learned nor made use of one one-billionth of what nature has for us as a people – and we need it. Profundity to me is the interplay in unity of the resonance of mother earth and the spirit of eternity. Which, though it sounds incongruous means nature and the abstract qualities fused in one work. To you and me and many others the representational, as representation means nothing – the spirit is everything – but we cannot get the spirit without the use of representation in some degree or altogether (it doesn't matter) so we use the representational because it provides a home for the spirit – and we sensed the spirit first and always through the life and forms of nature.[36]

Harris's involvement in theosophy was related to dynamic elements of the international artistic culture of his time, and was significant for his evolving attitude toward simplification of form in his painting. It was also very important for the writing in which he expressed his ideas on art, life and Canadian nationalism.

Harris's Major Writings on Art, Mysticism and Nationalism, 1918–30

Harris was a theoretical painter, and he wanted his philosophy to be taken seriously by those who were looking at his pictures. His statement about it is unambiguous:

You cannot sever the philosophy of the artist from his work. You belittle the man in his work when you accept his skill, his sensitivity in patterning, in building forms, his finesse in accenting, his suavity in technique, but reject his philosophy, his background. People do this through fear or incapacity to accept life. Without the philosophy, or in other words the man, in the work of any great artist, you have nothing.[1]

During the years 1918 to 1930, Harris worked out a philosophical and mystical aesthetics that gave him the foundation of and the sanction for his attempt to create an art that expressed not only Canadian realities, but also universal, spiritual meanings.

Harris's main writing during the early years of this period consists of *Contrasts: A Book of Verse,* published in 1922; an unpublished paper on the nature of art, "Art Is the Distillate of Life," probably finished by 1925; and two articles that bring together his spiritual ideas on art, his

Canadian nationalism and a mystical racism: "Revelation of Art in Canada," published in 1926, and "Creative Art and Canada," published in 1928. There were also several smaller articles and reviews of exhibitions and books that help reveal the comprehensiveness of Harris's spiritual interpretation of art. Letters in 1918 and 1919 to his colleague MacDonald, and around 1930 to Emily Carr, also help us to understand his ideas and feelings.

THE TRANSCENDENTAL STRUCTURE OF *CONTRASTS*

In his correspondence with J. E. H. MacDonald in 1918 and 1919, Harris had indicated the role mysticism played in his recovery, and sketched in very general terms the framework within which he was to develop. In *Contrasts: A Book of Verse,* written between 1918 and 1922, he presented a more fully articulated expression of his view of life.[2] The book is a carefully orchestrated arrangement of sixty-one poems. Harris wrote them in free verse, probably in emulation of his favourite poet, Walt Whitman. Although the poems are divided into five sections – "Descriptive," "Emotional," "People," "Definitions" and "Spiritual" – the underlying structure of the book is transcendental; that is, it sees reality as divided into two levels. The first of these levels is the

materialistic life of those who live unconscious of, or actively suppressing, the life of the spirit. The second is the spiritual or transcendental level that consoles individuals and encourages spiritual vision and growth. In the second section, "Emotional," Harris describes the lower level of existence with a moralistic rhetoric reminiscent of the preachers in his background:

> This is the age of the soul's degradation,
> Of tossing into the sun's light
> The dross and slime of life,
> And glorying in the miserable glitter.
> Hell's tinsel, and allurements and stupifying glare
> Shot over the soul's great sadness
> With cries and sneers and hard hosannahs.
>
> (36)

He describes the people inhabiting this level as "Gawky, awkward, ugly" (53). If people took time to look carefully at themselves, they would see that they were of little value. He divides people into "Those who lust and those who hate" (62). "Earth Life" from the "People" section of the book views people with a pessimistic moralism:

> People,
> Drugged by lusts
> And plunged into a billion little hells
> By self-isolations
> Scurry around
> Seeking satisfactions –
> With voracious earth gaze
> They dig the gutters for treasures
> Search gaudiness for pleasures
> Pursue forgetfulness through vices …
>
> (64)

Some of the poems show links with Harris's personal life. In "Emotional," Harris frequently treats sadness and personal pain. "After War" probably echoes Harris's own experience:

> Pain dust
> Settling on the earth
> After storm-stirrings –
> Quietly settling
> In slow sorrows.
>
> (33)

However, Harris saw that his own suffering has enabled him "in the great heart of me" (51) to understand and share the sufferings of others, and both to "know the whyfore" [sic] of these sufferings and be able to teach this wisdom. He believes he has "lived them through this many times / So that the way will not be strange nor too hard" (52). Harris later affirms that it is only through someone who has suffered that others can find sight:

> People,
> Blind between birth and death,
> Can alone find sight
> Through those
> Who have been dragged down,
> Bound and crucified,
> Tried out
> And found
> Sound – strong – great.
>
> (63)

This is also one of Harris's earliest expressions of his notion of the artist as seer who must struggle with those who would crucify him.

The second level of the book, the spiritual or transcendental, emerges with the last three poems of the "People" section. In "The Hoax," the most cheerful poem in the book, Harris, in symbolist fashion, suggests a meaning indicated by the presence of laughter – fish, sky, sea and land are all

laughing "at the people" – without saying exactly why. The detailed seaport imagery of "The Hoax," derived probably from Harris's trip in 1921 to Nova Scotia, is placed "on the shores of time" (66). Harris saw the suffering he had been writing about as actually the route to joy. In "Undaunted" he reflects on how people are fascinated with the suffering and deaths of others, because they are

Ever seeking some secret transmutation.
Something within them knows that in utmost
 suffering is born immortal joy.
That martyrs find a great glory.
That heroism is a divine distillation.

(69–70)

The twenty-six poems of the final sections "Definitions" and "Spiritual," together with the last three poems of "People," form the higher or transcendental level of the book. In these poems, Harris refers frequently to joy, to the soul's "All conquering greatness" (81). In "Darkness and light" he clusters light with notions of exaltation, beauty, ecstasy, love, freedom and weightlessness (91). In "Rhythm," Harris describes bodies, nations, races, lands and worlds as passing through stages of development and decay, but affirms that all arrive eventually at "the zenith" (84–85), which he does not describe. The union of the individual soul with the transcendent is affirmed as the "God-like capacity" of the soul (107). In "The World Doubts," Harris describes the activity of the seer-artist as "some lover of light" who pierces through the darkness of doubts:

Loosening,
Letting down
Long shafts of golden ecstasy
On millions of mire-bowed heads –
But few raise their heads.

(117)

There are dark reminders of the lower level in Harris's regrets that people are not listening to those who would bring the light. He associates the "mob" of unbelieving, ordinary people with "The Beast," in the poem of that name. Instead of the usual "coarseness," those who "rise above the mass" will have "A smoothness of soul" (112–13). The last poem in the book is the short but solemn "Great Song," in which Harris affirms the momentous importance of the artist-poet-seer:

Down through the ages
Goes great song
Quickening the dead.

(125)

Contrasts was perceptively reviewed in early 1923 in the *Canadian Forum* by Barker Fairley, who had written admiringly about Harris's painting the year before. Fairley, a scholar and a poet himself, criticized Harris's poetry for lacking, among other things, any "interest in particularized, individualized human life." That says it well. Harris was moving toward a radical idealism in which getting beyond the individual and the "personal" was necessary for spiritual progress. He had never known poverty. To judge from these poems its pain was not an experience that awakened his compassion. Instead, the images of poverty and slums were useful to Harris as a teaching device for his transcendentalism. He was probably well-intentioned, but definitely naive. Late in his life even friends spoke of Harris as being insulated, thanks to his wealth, from ordinary people and their problems.

The main sources for the transcendentalist structure of this book of poems – the division of reality into two realms – were Plato, Emerson and Thoreau. At times Emerson's influence can be perceived in Harris's imagery. The laughter of land, sea and sky in "The Hoax" (66) recalls the similar though more tranquil image of a smile in Emerson's essay, "Spiritual Laws": "For it is only the finite that has wrought

and suffered; the infinite lies stretched in smiling repose."[3]
Harris uses a much more energetic, though still idealistic image in "The Irrepressible":

The irrepressible
In its dip into limitation,
Supremely surges through every confine
.
Through all time it sweeps,
Creating, breaking and discarding,
Through sins and crimes and catastrophies,
Rebellions, wars and massacres
Inexorable,
All powerful –
A Flame that licks along all channels,
Burning everything
Into its own white heat
On its ecstatic return
To freedom.

(103–04)

Harris is also in Emerson's debt for his ideas on the relationship of the artist-poet-seer to the ordinary people around. Harris's notions of the artist, who must struggle to be true to a personal vision, as in "Finding Sight" (63), are similar to those in Emerson's essay "Self Reliance." Emerson wrote: "For non-conformity the world whips you with its displeasure" and "To be great is to be misunderstood."[4] Harris's poem uses the more drastic imagery of the bringer of light being held down, bound and crucified by "People" (63).

Although the main influence on Harris's book of poems was American transcendentalism, it also shows the influence of theosophy, particularly in Harris's highly critical attitude toward skepticism and doubt. In "The World Doubts," he writes

The whole world doubts
And flaunts its doubts –

Millions of men
Are blurred, blotted out,
Lost in the confusion –

(116-17)

It is into this confusion that "some lover of light" (117) attempts to bring vision. Harris was also developing a more negative attitude toward orthodox religions. The aggressiveness of these attitudes cannot be accounted for by Emerson's gentler statements on similar topics.[5] In this Harris echoes the vigorous polemical style of theosophists: "Beliefs are belittlements / … denials / Of the soul's / All-conquering greatness" (81). These sentiments are not surprising, for Harris was reading the literature of theosophy at least from the time he began recuperating from his nervous breakdown.

"ART IS THE DISTILLATE OF LIFE"

Harris probably wrote his unpublished paper on the nature of art between about 1922 and 1925. There are two versions in the Harris Papers: one handwritten by Harris, and the other, which I used, a twenty-six-page typescript with editing and additions in Harris's hand. I have adopted the first sentence of the paper as its title. It is not a nationalist document but, just as Harris put forth his general, transcendentalist ideas on the meaning of life in *Contrasts,* so in "Art Is the Distillate of Life" he deals with art and its meanings, again in general terms.

The well-known English critic Roger Fry, writing a brief two or three years before Harris about the value of artistic experience, asserted, "One can only say that those who experience it feel it to have a peculiar quality of 'reality' which makes it a matter of infinite importance in their lives. Any attempt I might make to explain this would probably land me in the depth of mysticism. On the edge of that gulf I stop." Harris, an enthusiastic reader of Fry, had similar views but no such hesitations. The paper's opening gathers together the main themes:

Art is the distillate of life, the winnowed result of the experience of a people, the record of the joyous adventure of the creative spirit in us toward a higher world; a world in which all ideas, thoughts and forms are pure and beautiful and completely clear, the world Plato held to be perfect and eternal. All works that have in them an element of joy are records of this adventure. For joy is the abiding mood of the creative spirit, is swift, and projects vision through the sluggishness of time's ways to eternal clarity. We approach the world of pure ideas by our imagination guided by our intuition and our great struggle is to keep pure and undefiled the things we have seen and felt and known and to give them form in the outer world, a form whereby our life may be enriched and enlarged. It is this infiltration age after age that constitutes our spiritual evolution, that moves us nearer the all comprehending state of peace.[6]

Among the more significant of the ideas expressed in this passage is the belief that artists somehow express not just their own experience, but that of a people itself. This notion parallels similar attitudes in the *Heimatkunst* tradition to which Harris was exposed in Germany. Those who have penetrated to the "higher world" where forms and ideas are clear and beautiful, have the responsibility to express these forms adequately to the outer world, so that the life of the people can be enriched. Art so produced is an antidote for the suffering of the world, which Harris had described in his poems, since art participates in the "abiding mood" of joy of creative spirit.

Harris, in transcendentalist fashion, saw visible nature as a veil or a garment behind which one could perceive "that which is timeless and entirely beautiful" (14B). With this notion in place, Harris explains that in true art naturalism, or the imitation of nature, has to be transcended. Since nature is a veil, "the imitation of anything in visible nature, which

many suppose to be the function of art, is, in so far as it is merely imitation, nothing less than the prostitution of great powers … Art really begins where imitation ends" (15). This notion is also the basis for Harris's justification of the antinaturalist distortions of his art: "The contemplation of visible nature and the rendering of natural scenes and effects come to demand the use of the high powers of selection and arrangement, and, eventually by way of a simplification of the naturalistic to its fundamental and purest forms we achieve the purity of creative vision" (15).

THE KEY NOTION: ECSTASY

The notion of ecstasy was an important one for Harris. Here it forms part of his description of the function of art: "Always it [art] seeks order, an inevitable structure, a weaving of all parts into a unity beyond questioning. So age after age, art gives us assurance of that which is ageless, forever new, positive and glorious … Art is man's ecstasy" (9). The test of a great work of art is not its brilliance of technique, but whether or not it would "move us toward ecstasy" (10). Such art should "convince us that there is eternal clarity." To accomplish this, "even for a moment," art "must cause the wildly active surface of life to be forgotten and at the same time still the little agitations of the soul for long enough to let us glimpse the simple and noble serenity of all eternal ways" (10). Ecstasy, Harris wrote, brings us the conviction that "we can and must become gods … In us can glow the transmuting flame of eternal life … [and] when we create we are aware of this" (14).

Harris also explores the notion that "all great art is impersonal," an important idea that would recur in his writing in the early 1930s. It represents an ideal for which he strove in his paintings from the mid-1920s to the end of his landscape period around 1930. Each human being is a personality that "is but a reflection of a greater self that abides eternally in a greater world and ever seeks to inform us here of that perfect world in so far as we permit it. By transcending the

personal we attain to this greater self which alone can give us vision into the whole … All great art is impersonal, achieved by a sublimation of the personal in ecstasy" (14B).

Writing in 1933, Harris related the notions of the impersonality and universality of art to beauty, seeing beauty as "the true talisman, whereby we may know that we are participating in a life greater and more enduring than the evanescent, constantly changing lives of our personal selves." He described beauty, in theosophical fashion, as "a pervasive power in art and in life … the very spirit of the plane of being we theosophists call buddhi."[7] This cluster of notions reflects theosophical thinking about art as explained by Jinarajadasa. In this theory, art and "universal thought–feelings" exist on the buddhic plane, just below the plane of nirvana (see Fig. 4.1).

Harris also related the impersonality of art as experienced in ecstasy to the artist's perception. In "Art Is the Distillate of Life" Harris writes that in the state of ecstasy, the artist "sees most clearly, most surely, most convincingly" (20). Writing in 1933 about aesthetics, art and the creative life, Harris went further, asserting that they can only be understood "by awareness at the summit of the soul, at the very forefront of our being. The reason for this is at the summit of the soul, at intensity of awareness, we are every one of us essentially simple; we are pure perception without encumbrances, not a person but a perceiving power."[8] Such a passage recalls the ideas of Emerson, which were probably Harris's main source.

In "Art Is the Distillate of Life" Harris states that only in ecstasy "can he [the artist] love into being appropriate forms for his vision," and thus fulfil his responsibility to all men (20). In 1933, Harris wrote again of ecstasy and impersonality and their relationship to the artist's creativity:

In real creative concentration the artist is over his head, as it were, and if this becomes sufficiently intense he comes upon a unique experience. He moves into a pure creative moment which is above

life as we know it. He then becomes a creative agent, a power and not a person. To the artist, this most desirable moment is not a retreat from reality, but reality itself.[9]

The similarity of this notion of "reality" to Roger Fry's is not surprising, since Harris was very familiar with Fry's book *Vision and Design* and led discussions of it among his friends in the 1920s.

Ecstasy and vision, "transcendental moments of awe" which raise the person "above the narrow life of the body," are also important aspects of the writing of the Irish nationalist and theosophist A. E. (George Russell), whose works Harris was reading at this time. And both Harris and A. E.'s notions of ecstasy fit comfortably with the definition given by Blavatsky: "A psycho-spiritual state; a physical trance which induces clairvoyance, and a beatific state which brings on visions." In ecstasy, "the Divine essence could be communicated to the higher Spiritual Self," an experience available only to "the very, *very* few."[10] Both Harris and Russell believed that ecstasy was also the source of artistic meaning. Harris claimed that the social responsibility of the artist was "to keep pure and undefiled the things we have seen and felt and known" in ecstasy, so that the artist could "give them a form in the outer world, a form whereby our life may be enriched and enlarged" (1).

Another probable influence was Clive Bell, whose book *Art* Harris owned. Bell too had a conception of ecstasy very close to Harris's: "A good work of visual art carries a person who is capable of appreciating it out of life into ecstasy." Bell, like Harris, was interested in the relationship of religion to art: he felt that "all artists are religious." Bell considered that art and religion were different but "twin manifestations of the spirit." Though Harris believed that the creation of art should be subordinate to and express the religious experience of the artist, he would have been able to find support for his position in reading Bell. Elsewhere, Bell referred to Cézanne as the earliest manifestation of

Post-Impressionism, which he equated with the modern movement, the context within which Harris saw himself developing in Canada. In fact, Harris believed his own ideas and attitudes about art constituted the essence of modernism. Commenting, in 1923 or 1924, on T. S. Eliot's *The Waste Land,* he wrote: "Here is the disillusioned, fearless, and penetrating vision of the true modern."[11]

HARRIS'S ARTICLES AND REVIEWS

Harris's articles and book and exhibition reviews from 1923 to 1930 show that he had a continuing interest in mysticism and that he extended his theoretical aesthetic synthesis into discussions of artistic issues that were mainly Canadian in scope.

The Mystical Theme

In early 1924, Harris reviewed two books on mysticism, *Cosmic Consciousness: A Study in the Evolution of the Human Mind* by Richard Maurice Bucke, M.D., and P. D. Ouspensky's *Tertium Organum.* Harris's enthusiasm is conveyed by the review's title: "The Greatest Book by a Canadian and Another." *Cosmic Consciousness* begins with a description of the development of consciousness. What Harris appreciated was the sense of structure that the book gave to this development. Harris describes it as a tracing of "the evolution from the simple consciousness of the animal through self consciousness to cosmic consciousness, showing it to be a natural evolution of the mind through brute to demigod." The transcendental scheme of Harris's world view thus acquired an evolutionary profile. Bucke defines the term "cosmic consciousness" by studying various examples or "cases" of it in history. These include Buddha, Confucius and Christ. Harris praised Bucke for showing "that such individuals are the pioneers of the new race."[12] This is Harris's first use of the term "new race," an expression which was important to him in his later reflections on Canadian nationalism.

The Russian theosophist, mathematician and popular philosopher P. D. Ouspensky quoted several pages from Bucke in his own *Tertium Organum.* Harris felt the books complemented each other, and should be read together. For him, the major contribution of Ouspensky's book was the rational methods it implemented and the conclusions that the author drew for art: "For here at last, we have given us a reasoned, spiritual basis for our conviction that art is the beginning of vision into the realm of eternal life."

Harris's mystical theory of art became a prism through which he analyzed all artistic phenomena. The abstract and representational pen-and-ink drawings of Bertram Brooker exhibited in the Ontario Society of Artists exhibition of 1929 were like "the best of modern art" because they embodied "a reverberation which comes from the spiritual resonance that informs all that is the best in the ages."[13]

The only one of Harris's articles written in the 1920s that does not deal with art is "Strength," published in the *Canadian Theosophist* in 1927. "Strength" is a short, gentle, theosophical homily suggesting that in "lofty souls" and "advanced individuals … consciousness of strength retreats to an inner, impersonal sanctuary … perhaps … it is hidden entirely." Thus, Harris explains, a person who is truly great "may appear as nothing in the eyes of men," in contrast to "Primitive Man" whose idea of strength "is an outward apparent force in the body and its passions."[14] Harris is echoing the theosophical view that classified people into the lower, spiritually undeveloped on the one hand, and adepts and clairvoyants able to perceive finer levels of reality on the other. He is also echoing the transcendentalist, layered view of nature articulated in *Contrasts.* The article is also interesting because it indicates that the editors of the *Canadian Theosophist* were taking Harris seriously as a writing and teaching member of the theosophical community, not just as an artist.

The Nationalist Theme

During 1924 and 1925, the Group of Seven was becoming better known through the press coverage of the Wembley controversies described in chapter 4. Early in 1924, Harris was interviewed by a journalist about the Group. His replies, although less abstract and theoretical than his writings, are in harmony with them: "It [the art of the Group of Seven] had no known art ancestry. It was not derivative. It was not English Landscape. It was not French Impressionism or Post-Impressionism. It was a natural growth in the country … Nature evolves new species by 'spirits,' sudden and inexplicable leaps into altogether novel flowerings."[15] The statement is understandable in the light of Harris's contemporary articles dealing with his mystical view of Canadian nationalism.

Harris's 1923 article, "Winning a Canadian Background," celebrates the publication of a book of four plays by the Canadian author Merrill Denison. Harris is unstinting in his praise, judging the book to be "the first authentic, entirely indigenous literary work done by a Canadian." If such a work of art has been created in Canada, Harris argues, "it means that in our land vision is being found, that conviction is being born. It means that as a people our heart begins to beat." Until such creativity "is at work or commences to work" in a people, "there is no real life in us [Canadians] … we experience to no collective purpose." He insists, in wording that recalls A. E., that Canadians should be seized by the conviction "that we can create as fine or finer things as any people."[16] Moreover, Harris saw art as the link between the world of vision and ecstasy and the development by Canadians of their culture.

Harris expanded on the relationship between the artist and the artist's people in his article "Artist and Audience," published in 1925. For Harris the artist was an avant-garde leader of the people, and he expressed this in the mystical terminology of his growing religious vision. Harris carefully laid the foundation for his notion of the artist's leadership. "No age or nation," he writes, "is capable of giving a complete expression to the possibilities in man." Each nation and period has limitations of experience and seems "destined … to unfold and bring to fruition a certain idea or ideas inherent in it and which alone can evolve in its day and circumstances." Thus, creative activity, which Harris holds is essentially always the same, produces different results in different ages and nations. The artist's freedom is limited by "the limits of the possible vision, first of his people, then of his day." But Harris feels that this restriction has the merit of forcing the artist to concentrate his powers on some particular need of his people, and "enables him to give precision to his work, and if he be great, to give it an eternal meaning."[17] Thus his theory enables Harris to discuss both the regionalist aspects of his experience and the mysticism that was more and more deeply affecting him, to talk about both the particular place and time and the universal.

His theory comes down to this: The artist, at his best, is in touch with the "creative spirit," one of Harris's synonyms for the transcendent. At the same moment, he is in touch with "the eliciting power of his audience … It is these two forces drawn into him and working within him in fusion that is creative." The artist should seek to meet the needs of his audience, which he distinguishes from "what the public wants." "The distinction is one of depth. 'What the public wants' is superficial, external, sensual, the concern of the appetites, the job of the panderer, the shrewd seeker after money or fame, and is sensed by the development of passions, cravings, lust … What an audience needs, exists in the almost unknown slumbering desires in the higher part of its being." The artist "leads his audience … to the extent that he summarizes, clarifies, gives precision to their hidden, highest longings … so that they see made clear what was vague, nebulous, almost half distrusted, and come closer thereby to a recognition of their greater selves and are rewarded by a great sense of the fullness of life, by re-assurance of their nobler intimations."[18]

In an obituary of Sir Edmund Walker, Harris expresses his ideas on Canadian nationalism less abstractly. Clearly Canadians, through their patronage of modern art, could

share in the spiritual responsibilities of creative artists. He praises Walker for having the courage to support the Group of Seven, describing Walker's patronage as "a living interest in the dawn of a spiritual consciousness in his people." The opposition to creative artists and their patrons in Canada comes from "the well-nigh ineradicable notion" of Canadians "that nothing worthwhile" could be created in Canada. The creative artist or patron, on the other hand, believes "that it is spiritual suicide to import designs and works in lieu of creating them ourselves and to import individuals to succeed for us when we should make every effort to succeed for ourselves."[19]

HARRIS'S THEORY OF ART, RACE AND NATIONALISM

The main subject of Harris's writing in the late 1920s was his particular blend of notions of nationalism, race and people and his wilderness landscape painting. His ideas owe much to various sources: Emerson, theosophy, the Canadian fascination with the North and the mystical ideas of the relationship between landscape and its people that he had encountered in Germany. In "Art Is the Distillate of Life," Harris did not write about art in Canada, but about art in general, stating for example that art was the result of the experience of "a people" not of "the Canadian people" (1). In his articles "Revelation of Art in Canada" and "Creative Art and Canada," published in 1926 and 1928 respectively, Harris wrote specifically about the Canadian artist's geographic and human environment, the artist's "people and race," the special difficulties a creative artist experienced in Canada and the artist's avant-garde responsibilities.

Race in the Tradition Harris Knew

The word "race" has, since the Hitler era, all but disappeared from expressions of nationalism and from writing about art and culture. But Harris, writing in the 1920s when the notion

of race was widespread, showed himself a child of his time. This is not at all surprising, since such notions were prevalent in the thinking of the people who influenced him personally. He would also have been familiar with the concept of a Canadian race expressed in the popular traditions of Canadian nationalism dating from the time of Confederation.

Notions of race and geographic determinism were combined with a religious mysticism in the thinking of Paul Thiem, the painter, poet and Schopenhauerean philosopher who fascinated Harris when he met him in Germany in 1907. Thiem's religious beliefs were enmeshed with his ideas about landscape and its effect on a people. He put great emphasis on geography in his landscapes and believed there was a special bond between the people in a given area and their landscape. In fact, Thiem exemplified an attitude toward landscape, mysticism and the occult that flourished in Germany away from Berlin and other major centres.[20] Harris had similar views about Canadians, seeing them as a people set in the North.

This native German mysticism was easily compatible with the antipositivist attitudes prevalent in Europe during this period. Some of the German writers used occult notions of theosophy in support of their own ideas, although theosophists, who believed in the superiority of Eastern religions and cultures, were not racists. One of the important notions Thiem shared with this Germanic tradition of landscape mysticism was that each German should be an artist.[21] The German *Volk* was seen as having "a particularly vital spiritual revelation, a correspondence with the creative demiurge more valid than that of other peoples." Harris also stressed the importance of creativity in a people. Thiem was probably his source and his main link with this tradition.

"Race" was a concept that Harris would have encountered frequently in his reading. Emerson's notion of race was based on pre-Darwinian ideas of ameliorative evolution. He adapted Johann von Herder's notion of the "close correlation between geographical environment and the physique, temperament and the intellectual powers of races." Emerson's

English Traits is an attempt to account for what he regarded as the obvious superior qualities of the English which, up to recent times, had served them so well. One of his central points was that the North, because of its hardships, produced superior races. England, he felt, owed her superiority to the rare coincidence of a good race and a good place. Although different peoples came and conquered the island, only the strong among them could survive the difficult, almost arctic site. However, Emerson thought that the present-day Anglo-Saxon race was deteriorating, and if it was going to regain its superiority it would do so in response to a new geographic challenge. This would be achieved, he felt, in America.[22] It seems clear that Emerson's notion of an English race determined by its contact with the North was one of several sources for Harris's own ideas about the effect that the North could have on Canadians.

The concept of race was also important to the theosophists, who believed that humanity as a whole was evolving toward a higher type of race. One aspect of Blavatsky's doctrine on race is especially interesting because it may well have given Harris an additional sanction for his view that there was a new race forming in America:

> Pure Anglo-Saxons three hundred years ago, the Americans of the United States have already become a nation apart, and, owing to a strong admixture of various nationalities and inter-marriage almost a race *sui generis*, not only mentally but also physically … a primary race *pro tem*, before becoming a race apart … They are … the germs of the *Sixth* sub-race … and will become … the pioneers of that race which must succeed to the present European fifth sub-race.[23]

To my knowledge, Harris wrote only twice about race in such general terms. In his article of 1933, "Theosophy and the Modern World: War and Europe," he related the notion of race to the theosophical doctrine of reincarnation. He states that the "harvest" of the coming war in Europe will not be understood "unless we see and accept that reincarnation for the individual, for the tribe, for the class, for the nation and race, is a fact in nature … It is quite obvious to any occultist that the Masters know this better than other men." Nine years earlier, in his review of Bucke's *Cosmic Consciousness*, Harris had also used the notion of "race" in a general, nonnationalistic sense, referring to the individuals that Bucke described as having experienced cosmic consciousness – including Buddha, Confucius and Christ – as "the pioneers of a new race whose spiritual eyes have been opened."[24]

The theosophist whose ideas most closely resembled Harris's own was A. E., because he was involved in art, mysticism, discussions of race and the organization of nationalist programs in Ireland. Harris believed that A. E. was "a truly sweet and grand man" and that he belonged "to the clan of the christs." He considered A. E. "one of those who shew us where we're headed for, these dear mystics who live in eternity and let time go hang."[25] In the same letter Harris mentioned that A. E., although "a remarkable talent," had stopped painting because he was afraid that it might give him too much pleasure and so "limit his vision"; Harris admired this puritanical aspect of A. E.'s personality. With this much enthusiasm on Harris's part it is not surprising that two quotations from the Irishman were used in the catalogue of the first Group of Seven exhibition in 1920.

Harris's Views of the Canadian Artist's People and Race

Harris first used the notion "race" in "Revelation of Art in Canada," published in the *Canadian Theosophist* in 1926. It was the first of two articles in which he described his mystical view of art and Canadian nationalism; the second and more important article, "Creative Art and Canada," was published in the *McGill News (Supplement)* in 1928. These two articles constitute Harris's main attempt to make a comprehensive

statement about Canadian nationalism. In the writing on Canadian nationalism that he had been doing since 1923, Harris had been using the expression "the Canadian People," by which he meant the inhabitants of Canada. The word "race" referred to the inhabitants of North America, that is, the Canadian and American peoples combined. (Harris's vision was not broad enough to include Mexico or Mexicans.) Harris's references to the Canadian artist's "people and race," express both nationalism and North American continentalism.

He often used expressions such as "the growing race of America"; "a new race which is finding its own character," and regretted that "so many people in North America ... view the strivings and directions of the new, now adolescent race – their race – with disdain or misgivings."[26]

Harris, like Emerson and Paul Thiem before him, saw this people and race as geographically determined. In harmony with the Canadian tradition of writing on race, Harris believed that the main though not the only geographic determinant of the Canadian people and the new race forming in North America was the North. By "the North" Harris and his friends did not mean just the Arctic: the concept – which was widely accepted in Canada – included areas quite close to Toronto and Montreal, as well as the Arctic and everything in between. Thus Harris, in 1954, referred to his earliest sketching trips – to Haliburton, to the upper Ottawa River and Lake Temiskaming and to the Laurentian mountains north of Montreal – as having put him "into working contact with the character of the North for the first time."[27]

The Influence of the North on the Canadian Artist's People and Race

The notion of a Canadian race geographically determined by the North figured prominently in the Canadian tradition of nationalism from around the time of Canadian Confederation in 1867 to at least the 1920s. Harris and his colleagues were by no means the first Canadians to see special artistic significance for Canada in the North. As early as 1908, the art critic H. Mortimer-Lamb had written: "No painter has yet experienced the spirit of the great northland, none perhaps has possessed the power of insight which such a task would demand."[28]

To notions of the physical, medical, moral, intellectual, political and social effects of the North current in the Canadian tradition, Harris added his ideas on the spiritual and mystical influence of the North. In 1926 he explained its effect in "Revelation of Art in Canada":

> Indeed no man can roam or inhabit the Canadian North without it affecting him ... The North will give him [the Canadian artist] a different outlook from men in other lands. It gives him a difference in emphasis from the bodily effect of the very coolness and clarity of its air, the feel of the soil and rocks, the rhythms of its hills and the roll of its valleys, from its clear skies, great waters, endless little lakes, streams and forests, from snows and horizons of swift silver. These move into a man's whole nature and evolve a growing, living response that melts his personal barriers, intensifies his awareness, and projects his vision through appearances to the underlying hidden reality.[29]

In asserting that the ultimate effect of the geography of the North was spiritual, putting the artist in touch with the "underlying hidden reality," Harris was echoing his transcendentalist and theosophical sources. He had written about the North and its "suggestion of mystery and bigness" in his first published article in 1911. By 1926 his language was more mystical and absolute: "True Canadians," he asserted, are "imbued with the North." In 1928, he wrote of their environment "in the fringe of the great North and its living whiteness, its loneliness and replenishment, its resignations and release, its call and answer, its cleansing rhythms."

Harris was emphatically optimistic about the liberating effects the North could have on creativity:

Two months in our North country of direct experience in creative living in art will bring about a very marked change in the attitude of any creative individual.

It will bring him an inner release and freedom to adventure on his own that is well-nigh impossible amid the insistences and superficialities of Europe.[30]

But more than this, Harris thought of the North as the source of Canada's national artistic destiny:

It seems that the top of the continent is a source of spiritual flow that will ever shed clarity into the growing race of America, and we Canadians, being closest to this source seem destined to produce an art somewhat different from our southern fellows, an art more spacious, of a greater living quiet, perhaps of a certain conviction of eternal values. We were not placed between the southern teeming of men and the ample, replenishing North for nothing.

Harris believed that Canadians could play a special role in forming the new race because: "We in Canada are in different circumstances than the people in the United States. Our population is sparse, the psychic atmosphere comparatively clean, whereas the States fill up and the masses crowd a heavy psychic blanket over nearly all the land."[31]

Harris's attitude toward the "new race" forming in North America continued with little change into his late writings. It formed the context within which Harris, although a Canadian nationalist, saw Whitman and Lincoln as examples for Canadians to follow. His attitude should also be taken into account when considering Harris's happy six-year stay in the United States (1934-40), as well as the fact that at

least twice in 1939 he participated in exhibitions as an American. (In both exhibitions he showed other paintings in the Canadian sections as well.)[32]

Canadians, the New Race, Europe and England

The main method Harris used to describe the new race he saw emerging on this continent was to contrast it with European culture. The earliest written expression of this anti-European attitude is a letter he sent to the Toronto *Globe* in 1914. In it, Harris warned that Canadian art was bound for oblivion "unless it cuts itself loose from Barbizon and Holland and the Royal Academy of England and becomes something more than a mere echo of the art of other countries." Time and again in his writings, Harris stressed this contrast with Europe. The new North American race would be "the race of the new dispensation which will develop and embody the new attitude. It grows now largely within the swaddling clothes of European culture and tradition but its ideals are not the same. Its attitude is not the same." Canadian artists had begun with "adventures in imaginative and intuitive living" because "the land is mostly virgin, fresh and full-replenishing." Canada, whose "personality ... commences to form and grow," had to meet "the insistent, distracting, superficial emanations from older growths, from Europe particularly."[33]

Harris believed this struggle with European attitudes to be inevitable. But North Americans in Canada had a particular problem which their counterparts in the United States did not – Canadians who wished to be creative had to contend with the "English attitude in Canada":

It is the belittlement of colonialism still fostered among a people no longer a colony. It is the English attitude in Canada sick with its own superiority seeking health where for it there is none ... Since our beginnings in Canada, it has been opposed to everything that is spontaneous or free or creative,

that is, everything that is in the spirit of the North ... All that made this country Canadian had to fight tooth and nail for its life against English superiority and self-sufficiency.[34]

The Role of Art and the Artist in Canadian Nationalism

In his 1923 article, "Winning a Canadian Background," Harris insisted that it "is surely the function of art to externalize all that within us lies hidden. For art is the living body of life made majestic only by full expression ... a heritage only to be known, understood and possessed by a people when the creative is at work or commences to work in that people." In 1924, he added that Canadians had a "crying necessity to evoke spiritual well-being from within ourselves" and not attempt to draw it from other cultures. This would be accomplished "by the creative spirits among us through the arts." In "Revelation of Art in Canada" in 1926, Harris wrote that although all men would be affected by contact with the Canadian North, the artist's experience was especially significant. Because of the artist's

constant habit of awareness and his discipline in expression, [he] is perhaps more understanding of its moods and spirit than others are. He is thus better equipped to interpret it to others, and then, when he has become one with the spirit, to create living works in their own right, by using forms, colour, rhythms and moods to make a harmonious home for the imaginative and spiritual meanings it has evoked in him ... This in time, in and through many men creates a persisting, cumulating mood that pervades a land, colouring the life of its people ... It is called the spirit of a people.

He reflected on the importance of art for a people, again linking it to the spiritual:

Indeed the occurrence of a living art in every age, with every people ... is a tremendous factor in the evolution of the soul. It is a sign that the human can achieve an attitude of child-like wonder, exuberant devotion, a simplicity and directness that goes straight through all erudite deviousness, all cynicism, all sorting and labelling and telling of heads, all smugness and satisfaction, to the exacting light of spiritual realms.[35]

Harris therefore saw the artist as a leader of the people, with the task of bringing them into spiritual awareness, struggling against conservative attitudes, deviousness, cynicism and smugness:

That the artist leads his audience is true, true to the extent that he summarizes, clarifies, gives precision to their hidden highest longings, however unconsciously. So that they see made clear what was vague, nebulous, almost half distrusted, and come closer thereby to a recognition of their greater selves and are rewarded by a greater sense of the fullness of life, by a reassurance of their nobler intimations.[36]

It was also the artist's responsibility, as he wrote in "Artist and Audience," to discern what the real needs of his audience or people were, and to distinguish them from "what the public wants."

In attempting to explain what he meant by a nationalist art Harris used the notions of the particular and the universal. In this context, however, particular did not mean a particular site or building, as it had in his earlier writing. In "Creative Art in Canada" in 1928, Harris meant a particular country, Canada itself. The universal was the infinite, spiritual reality. Harris wanted both to justify the existence of a nationalist art and to relate it to an art of universal significance:

We can say then that the idiom, the emphasis, the garment of art in each age and in each people is the result of the awakened sense of the relationship of mankind, time and place, and that this is what we call national or immediate. And we may also say that the universal urge toward unity through infinite diversity and toward the consummation of understanding and love through infinite experience is of the spirit and that this is not immediate only, but external. The creative faculty is the means of communion between these two, the immediate and the eternal.

Thus Harris saw creativity playing a crucial mediating role between Canadian nationalism and the ultimately more important universal values. This description helps us understand his impassioned plea for creativity in 1924, in which he urged Canadians to adopt a world view that saw "that life is creative and that a people only live when they create, and that all other activities should be but a means to creation."[37]

Harris's Views on Contemporary European Notions of Race and Nationalism

Harris's mystical racism raises an inevitable question: What did Harris think of the political and social consequences of nationalist and racist ideas as they were emerging in the 1920s and the 1930s, especially in Europe? He was certainly aware of them. In "Creative Art and Canada," he strove to dissociate his notions of race and nationalism from the "combative or competitive implications" he perceived such concepts had acquired. In 1933, he discussed Europe and its problems in "Theosophy and the Modern World: War and Europe," published in the *Canadian Theosophist*. It is a wide-ranging article in which, in traditional theosophical fashion, Harris attacks conventional religion, "priestcraft" and the scientific mentality. Foreseeing the possibility of lethal weapons that could provoke "the end of an age," Harris

placed some of the blame for this threat on "that abstraction the nation or state, under whose strictly inhuman cloak, all manner of treachery and cruelty may be not only committed and condoned but encouraged ... as witness the devilish moral cowardice of Germany today, a people who under the cloak of a fanatical belief in the superiority of the Aryan-Germanic racial strain – a myth if there ever was one – make a scapegoat of another and utterly helpless people, the Jews in their midst, and bully and butcher and crucify them." Harris quoted William Q. Judge: "and the 'intellect alone will send us all to hell sure.' "[38]

HARRIS'S AWARENESS OF EUROPEAN AND AMERICAN ART

Harris's writing and other activities from 1926 to 1930 leave no doubt that he was aware of a wide range of European and American art. Early in 1926 he reviewed the large inaugural exhibition of European, American and Canadian art at the Art Gallery of Toronto. From late in 1926 into the spring of 1927, Harris was deeply involved with the Société Anonyme (of which he was the only Canadian member) and so became more familiar with the art of the European avant-garde, including Kandinsky, Picasso and Marcel Duchamp. During these years, Harris was also putting together a mounted set of 63 photographs of mainly modern art that he probably used for teaching (they are now with the Harris Papers in the National Archives of Canada).

The Art Gallery of Toronto Inaugural Exhibition, 1926

Toward the end of January 1926, the Art Gallery of Toronto celebrated the opening of its new buildings with a large conservative exhibition. Harris's review of this event and the exhibition was enthusiastic. His judgments, not surprisingly, are frequently an expression of his mystical theory of art. He thought the exhibition, which included works "from the

middle ages down to today," was important because it gave "a cursory survey of the spirit in painting for over four hundred years." He particularly admired a Bellini *Madonna and Child, Portrait of a Venetian Procurator* by Tintoretto and a large seascape by Cuyp, *The Maas at Dordrecht*. He felt that the best work in the gallery of modern French painters was Jean-François Millet's sketch for the famous painting *A Man with a Hoe:* it had "depth of feeling and sensibility to the hidden truths and movement of life." In contrast, much of the work by other French artists was "almost foolishly light and superficial." He elaborated: "The importance of the Impressionists fades with the passing of time. One is inclined to forget their contribution of light and colour in searching for more lasting qualities." Harris had praise, though, for Post-Impressionists Cézanne and Gauguin.[39]

Although twenty-three Americans were exhibited, Harris praised only Arthur B. Davies and Rockwell Kent. The rest of the Americans, he claimed, "represented the average of the academies ... No one of these canvasses approaches Thomson's *The West Wind* or *Jack Pine* in devotion and greatness of spirit." When Harris turned his attention to Canadian art, he praised Thomson's painting as "far and away the most stimulating among the Canadian artists." (This claim for Thomson, who had died in 1917, was not surprising: no living Canadian artists were permitted to exhibit.) This was the only way that Harris could write about his own movement. Thomson's *The West Wind* and *The Jack Pine* (Fig. 3.20) "contain the lasting qualities of the best old masters. The devotional mood of *The Jack Pine* is the same as in Bellini's *Madonna and Child ... The West Wind* is perhaps the most forceful picture in the whole exhibition." The paintings of J. W. Morrice (1864–1924) were "the work of a minor poet" compared to Thomson's, which were the work of "a great poet, an artist in the highest sense of the term." Harris found that the works of Cornelius Kreighoff (1812–72) produced "an emotionally informing experience," and thought the coloured drawings of Daniel Fowler (1810–94) "things of real distinction." He dismissed the works of Canadians Paul Peel (1860–92) and Blair Bruce (1859–1906) because they were not obviously Canadian but "might have been done anywhere."[40]

The Société Anonyme's Exhibition at the Art Gallery of Toronto

Harris spent a good deal of effort in late 1926 and early 1927 campaigning – successfully, as it turned out – to have an exhibition of the Société Anonyme's collection of international modern art brought to the Art Gallery of Toronto. The Société Anonyme (which Harris was invited to join in August 1926) had been founded in 1920 by wealthy American Katherine Dreier to foster the development of an acceptance of modern art, particularly by Americans. Its members, who included Kandinsky, Picasso, Man Ray, Fernand Léger, Marcel Duchamp, Franz Marc, El Lissitzky and many others, were drawn from many countries.

Harris described his impressions of the exhibition in his "Modern Art and Aesthetic Reactions: An Appreciation," which reflects his optimistic frame of mind and his spiritual interpretation of the avant-garde role of modern art. He doubted "if any exhibition we have had [in Toronto] ever displayed such a wealth of ideas, or so much real adventuring, or so large a proportion of stimulating and profound works."

He found, however, that "most of the pictures required of the spectator a new way of seeing."[41] With Harris's Toronto readers in mind, one could include in this category works of Synthetic Cubism by Picasso (1881–1973) and Georges Bracque (1882–1963), *Interieur Métaphysique* by Giorgio de Chirico (1888–1978) and the transparent sculptures of Antoine Pevsner (1886–1962).

Harris wrote that most of the works were abstract. When he turned his attention to them he divided them into two groups, "one half of them [coming] from naturalistic sources wherein the more abstract and lasting qualities of design, movement, rhythm, equilibrium, spatial relationship, light,

and order were extricated from the fleeting aspects of a scene or scenes to suggest its informing, persisting life."[42] In this category Harris could have included (among other works by lesser-known artists) the wood relief sculptures of Jean Arp (1887–1966) and *Abstraction 1925* by Fernand Léger (1881–1955), which made use of forms derived from vases, musical instruments and typography.

Harris's description of the second category of abstraction, which he preferred, was as follows:

> The other half, and in the main the most convincing pictures, were directly created from an inner seeing and conveyed a sense of order in a purged, pervading vitality that was positively spiritual. Many of these abstractions appeared flat at the first seeing, but with contemplation or sometimes in an unguarded moment, they unfolded in space and became absolute within their frames … and though the boundary lines of the planes were as sharp and precise as a knife edge the space was soft and palpable.

In this category Harris may have placed Kandinsky's *Gaiety* (illustrated in the catalogue), *Proun 99* by the Russian El Lissitzky (1890–1941) and Mondrian's lozenge-shaped *Clarification I,* which was illustrated in Harris's article. Defending such abstract works against the accusation that they were arrived at by mathematics, Harris insisted that they were

> emotional, living works, and were therefore capable of inspiring lofty experiences; one almost saw spiritual ideas, crystal clear, powerful and poised … Only long time, much brooding and hard work, through almost endless study and penetration into the ephemeralities of nature will lead to classification that has the high resonance of spiritual reality."[43]

These are Harris's first recorded comments on abstract painting.

Harris's Trip to Europe, 1930

Harris's extensive awareness of European art was supplemented by a trip to Europe in 1930. He went to Stuttgart and Munich, but also to Paris, where he met Marcel Duchamp and just missed meeting Katherine Dreier. He made the trip mainly to examine modern houses in Europe (especially in Stuttgart), so he could make a judgment on the design of the "new mansion"[44] he was about to have built in Toronto.

It is not without irony that Harris, who advocated a theory of Canadian nationalism that rejected Europe as a model or source of traditions for Canadian art, should have consciously sought European precedents for the design of his home. What is more, the architect he chose was not a Canadian but a Russian émigré, Alexandra Biriukova. Harris's house, her first Canadian work, is a symmetrical arrangement of smooth-surfaced, almost austere two- and three-storey masses. The main feature of the façade is the three-storey vertical element made up of the entrance door surmounted by a two-storey round-headed window, the whole adorned simply with an Art Deco surround.

The trip also gave Harris a chance to see avant-garde art in Europe. Shortly after his return, he wrote to Emily Carr, repeating the anti-European and continentalist stance he had articulated at length in his major articles on nationalism and art:

> We're glad we went abroad. It defines things. Our way is not any of the European ways – the attitude is different; race, outlook, reaction and everything. Cézanne, Picasso, Matisse, Derain, etc. and etc. How they belong to Europe, fit in – a logical continuation of tradition – but America, Canada, a different thing – another approach – a new dispensation."[45]

His description of these artists as a logical continuation of their European traditions is in harmony with Harris's assertion that art embodies "the experience of a people."[46] This notion is also behind his assertion, in his article on the Société Anonyme's exhibition in Toronto in 1927, that when abstract painting did eventually come to Canada it would be a Canadian type of abstraction. Harris probably saw the advent of abstraction in Canada as inevitable, but at this point in 1930, though his attitudes were definitely changing, he was not ready himself to begin abstractions and he probably believed that the Canadian people were not ready for abstract art either.

Realism and the City without the Spirit

Harris's Urban Landscapes

The most important aspects of Harris's painting during the years 1918 to 1930 – his major landscape period – were his continuing transformation of the two traditions of painting that he had brought back from Germany. These were the Skarbina-Liebermann-inspired urban realism and the *Heimatkunst* regionalism that concentrated on wilderness subjects. Harris transformed the realist tradition, taking it as far as he could go toward idealism, and then abandoned it about 1929 or 1930. He transformed the regionalist tradition, taking it from a commitment to specific wilderness sites and their peculiarities toward paintings in which he strove to create images not of local validity only, but of universal, spiritual meaning.

THE SIGNIFICANCE OF *CONTRASTS*

In Harris's poems, the city is where he has found the examples of suffering on the lower level in his transcendentally structured world. The city is either explicitly present or implied in the images, and is the site he chooses for his descriptions "of the soul's degradation."[1] If we accepted the ideas in *Contrasts* as a framework for interpreting Harris's urban landscapes, then the houses of the poor in these paintings would have been meant to convey the life of the lower level of existence described in the poems, those aspects of the world that are without consciousness of the spirit.

But there is a difference between the poems and the actual urban landscapes he painted: he often identifies the site of the house, for example, *Italian Store in the Ward* and *A House in the Slums* (Plate 14). In *Contrasts*, no place is mentioned, because the poems are an attempt to enunciate general truths about the human condition. On the other hand, his paintings articulate these truths in relation to the particularities of his time and place. In this he is being faithful to his transcendentalist mentors. To Emerson, "the artist must employ the symbols in use in his day and nation to convey his enlarged sense to his fellow-men."[2] Two illustrations from *Contrasts* are relevant. The first, decorating the title page of the section called "Descriptive," is the only urban landscape among the illustrations (Fig. 6.1), and in spatial composition is unlike any other urban landscape by Harris. For the most part the buildings are the houses of the poor, his favorite urban subject. The view, however, is down the middle of the street so that the vanishing point is on the horizon in the centre of the drawing. The orthogonals formed by the sidewalks and the eaves of the buildings draw the eye immediately into an experience of depth in space. Probably executed in 1922, this illustration underlines the importance of deeper space in Harris's thinking at this time.

Figure 6.1
Descriptive
Ink drawing
4.4 x 8.9 cm
Illustration for *Contrasts* (1922), 9

In two respects Harris's drawing suggests that he was recalling the urban landscapes of Edvard Munch, such as *Evening on Karl Johan Street* of 1892.[3] Both works embody a negative view of the city. Munch has presented this in part through the staring intensity of the figures; Harris's negative view of the city appears in the poems themselves. The second similarity is in their compositions. Harris, seeking to convey similar feelings, may have adopted the use of orthogonals from Munch. The Norwegian artist is again brought to mind by Harris's drawing *Glace Bay* (Fig. 6.6) of 1925. Like the faces in Munch's *Evening on Karl Johan Street,* the woman in Harris's drawing, who is also set in receding perspectival space, stares out at the viewer.

Harris equated the image of depth in space with depth in meaning.[4] In the context of his poems, it is an image that presents both levels of reality: the immediate realm of the city and the realm of the spiritual, which Harris presents here as infinite space. As with the structure of the book, the transcendental level is the larger framework into which the lower level fits. In the urban landscapes that Harris began to paint in 1918 he became interested in the deeper space, but this interest was combined with his usual focus on frontal compositions.

The second illustration from *Contrasts* relevant to Harris's urban landscapes is the title page of the "People" section. The nationalities of the people shown are unidentifiable, they are not presented as individuals and the landscape on which they stand could be anywhere. This reflects Harris's purpose in the poems to enunciate general principles about the human condition. The people are like the figures in his urban landscapes, such as *Studies of Women in the Ward,* in that they are anonymous and have no psychological presence.

THE URBAN LANDSCAPES TO c. 1922 AND HARRIS'S SOCIAL CONSCIOUSNESS

In the years preceding his nervous breakdown, Harris had painted fewer and fewer urban landscapes, gradually transforming the urban landscape tradition with its origins in social realism into a decorative, colourful, eye-pleasing style, for example, *House in the Ward*. After his breakdown, the houses of the poor again become numerous in his work, but now the urban landscapes become both the images of Harris's own experience of suffering and pain and the images he uses to embody his view of human life on the lower level of existence. In his poetry he describes the lower level where human beings suffer, in contrast to the transcendental level where they expand "in joy."[5]

Harris's painting displayed the two levels or layers before he is known to have written any of the poems for his book. The deepening space in the paintings became the image of the deeper meanings that were as important to him now as the closer views of the suffering city. The new compositional arrangement begins in what may be the first painting he did after the onset of his breakdown, *Outskirts of Toronto* (Plate 12); it was probably painted before his convalescent trip with Dr. MacCallum in May 1918. The flowering dandelions, the mud, and the bright sun suggest early spring. Some aspects of the work are similar to his earlier urban landscapes. The façades of these houses of the poor are seen from a rather low, frontal point of view. The woman bending over the clothes basket is a staffage figure like those in *Studies of Women in the Ward*, and in this follows Harris's sources in Liebermann's work.

The most significant formal change in this painting is in the definite presentation of deep space. We are looking not at the façades of one row of houses, but beyond to another row on the hill on the horizon, also seen frontally. In the foreground the central area is connected to the lower edge of the picture by a path of planks across the muddy front yard. These planks are on a perspectival orthogonal, as though Harris had the obvious space-creating devices he used in the drawing "Descriptive" in mind and interrupted them with his layered, frontal composition. These two ways of creating an image of space also appear in other works. In *Black Court, Halifax* (Fig. 6.4) the orthogonals formed by the clapboard-

ing of the houses on the left and the gutter extending from the bottom right corner of the painting are interrupted by the forms of the houses in the middle distance which are presented frontally. In *Elevator Court, Halifax* (Plate 15) the orthogonals dominate the sky and the ground area as well as the positioning of the houses. Even the large wall of the building on the left, which we view frontally, seems to be absorbed into the orthogonal system. There are similar combinations of space-creating devices in many of Harris's urban landscapes of this period. *Shacks* of 1919 shares with *Outskirts of Toronto* the frontal point of view combined with the presentation of depth in space. The same is true of Harris's last urban landscapes, *Red House in Winter* (Fig. 6.7), of 1926, and *Summer Houses, Grimsby Park, Ontario* (Plate 17), c. 1929.

Outskirts of Toronto shows three other changes from his earlier urban landscapes. First, the site is not in downtown Toronto but at the edge of the expanding city. The second difference is the violence of the colours. An overall yellow, unusual in Harris's work, is juxtaposed with the reds of the window and door frames, the woman's skirt and some of the clothing on the line. There are also some strokes of strong purple on the left, forming the rail fence. The difference from the naturalistic colours of a nearly contemporary Lake Simcoe landscape like *The Pine Tree* (Fig. 3.21) is remarkable. The third difference is the shape of the two main buildings, which are narrower at the eaves than at the base, as though tilted backwards or deliberately distorted. The distortions and the violent colours seem to express his disturbed emotional state at this time.

Although the main line of development of Harris's urban landscapes after his nervous breakdown was his interest in deeper space, some paintings remain close in composition to his earlier decorative works: but even these embody important differences. One such frontal view of a row of houses of the poor, complete with a screen of trees, is *Houses, Chestnut Street* of 1919 (Plate 13). Instead of the bright sunlight on intense colours of his 1913 *In the Ward*

(Plate 7), Harris presents the atmospheric light of a rainy day on the softened reds and whites of the roughcast façades. The leaves on the trees and on the wet ground are a dull gold. The brushwork too is significantly different. Whereas in *In the Ward* Harris had used areas of vigorously patterned, thick paint,[6] the brushstrokes in *Houses, Chestnut Street*, though at times thick, are calm and almost randomly patterned and contribute their rhythm to the overall elegiac mood of the work, a mood I have not found in Harris's painting before his breakdown.

The composition of *Houses, Chestnut Street* is also similar to some of Harris's contemporary Algoma landscapes, such as *Algoma Woodland* of 1919, in which he presents the wilderness as a wall that he is observing at close range and from a low point of view. But there is nothing elegiac or sombre about Harris's wilderness landscapes at this time, as there is about the urban landscapes. This reflects the higher value Harris was placing on wilderness subjects, associating them with the transcendental level in his two-layered vision of the world. This higher value survived into 1930 and 1931, whereas his last (and by that time, rare) urban landscapes were finished, at the latest, in early 1930.

In *A House in the Slums* of 1920 (Plate 14) Harris again uses the frontal compositional format of his earlier urban landscapes. As in his decorative works, there is a use of thick textures on the main façade, but there are also important differences from these earlier paintings. Like the house in *Outskirts of Toronto,* the shape of the house in *A House in the Slums* is distorted: it is narrower at the eaves than at its base. The roughcast stucco has been damaged and pieces have fallen off. This is a deliberate choice by Harris for it does not occur in the preliminary sketch for this work, *White House* (Fig. 6.2). He also made the windows smaller.

The paint on the façade is in two colours. The areas of roughcast are painted mainly yellow with rough, irregular strokes of brush and palette knife. The rest of the façade is a variable pinkish red, like a diseased animal skin. This biomorphic analogy was probably intentional: on a later

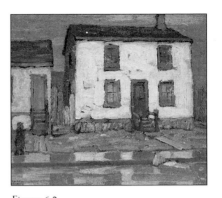

Figure 6.2
White House, c. 1920
Oil on board
26.7 x 33 cm
Art Gallery of Ontario, Toronto
Gift from the Friends of Canadian
Art Fund, 1938

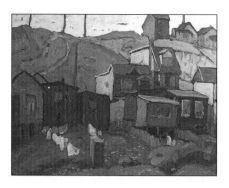

Figure 6.3
Earlscourt, Toronto, 1921
Oil on board
27.3 x 34.6 cm
Private collection

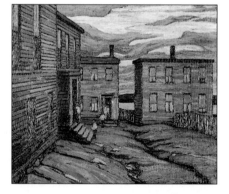

Figure 6.4
Black Court, Halifax, 1921
97.1 x 112 cm
National Gallery of Canada, Ottawa
Gift of the artist, Vancouver, 1960

drawing of the painting he referred to this colour as "mange."[7] This harmonizes with another reference to animal forms in the work: the edges of the façade are curved, like sagging flesh.

The surface of the painting also contributes to the biomorphic impression. At times the paint on the façade has a glistening, lumpy, skinlike surface, which may be accounted for by Harris's technique. Harris's son, the painter Lawren Phillips Harris, remembers his father telling him how carefully he developed textures; sometimes he used the fleshy, soft skin of the inside of his forearm on partly dried paint.[8]

The several biomorphic references in the painting parallel explicitly anthropomorphic similes Harris used when he described a similarly situated house in the first lines of *Contrasts:*

In a part of the city that is ever shrouded in sooty
smoke, and amid huge, hard buildings, hides a
gloomy house of broken grey rough-cast, like a
sickly sin in a callous soul.

These lines reveal Harris's use of the city as a symbol of the dark, evil and materialistic lower levels of existence.[9] This symbolism measures the distance Harris's imagination has travelled from the realist aesthetic within which he began his urban landscapes, one that claimed that ordinary reality, no matter how ugly or plain, was meaningful in itself and worth painting.

Harris was not the only North American artist who painted houses in an anthropomorphic way at that time. Charles Burchfield (1893–1967) started in 1918 to paint views of gloomy houses that appeared "as if they had faces, characters of their own and reflected the grim lives they sheltered."[10] Harris may have seen reproductions of Burchfield's works in *The Dial* in April 1920.[11] Burchfield wanted to suggest the hard lives of the inhabitants of the houses (most of whom he knew personally) without painting them as individuals, but Harris was less directly concerned

with those who lived in the houses he painted and more interested in creating an image of the lower levels of existence. The only other use of anthropomorphism I have detected in a Harris urban landscape is in *Red House in Winter* (Fig. 6.7). Harris often used it in his wilderness landscapes, however, especially in the Lake Superior works, where the dead trees are often stand-ins for human beings. In *Shacks* of 1919, the space is carefully defined in various ways. Beyond the piles of snow in the foreground a fence crosses the painting from left to right; beyond the fence we see other enclosures, presenting layer after layer of space. In these paintings Harris also continued his interest in rich textures, although the intensity of colour seen in *Outskirts of Toronto* was gradually tamed. Among the most interesting aspects of *Shacks* is the brushwork in the nearest façades. For example, the porch of the red house on the right is highly textured with an organization of individual brushstrokes and colours that makes it a miniature abstract painting. The brushstrokes in the two levels of the façade of the same house are organized in a horizontal and vertical way, with a strong texture. This is a link with decorative features of earlier works, such as *Houses, Wellington Street* (Plate 5). This 1910 painting and *House in the Ward* of 1917 presented house façades frontally. In *Earlscourt, Toronto* (Fig. 6.3), however, almost all the buildings are viewed at an angle, stressing their three-dimensional occupation of space. This is the first time Harris had not used the frontal composition for an urban landscape since *Top o' the Hill, Spadina* (Fig. 3.5) in 1909–11.

Earlscourt, Toronto, painted in 1921 on board measuring 27.3 x 34.6 cm, is the sketch for the larger oil on canvas *Spring in the Outskirts* of 1922. In this painting the device of stressing the way the buildings occupy space is intensified by painting the planes of the houses very smoothly and the edges with a knifelike sharpness. Harris has also heightened the brightness of the light and the depth of the shadows. The result is a transformation of the realist city into the battlefield of light and dark, much as he described in his poem

"The World Doubts,"[12] where darkness signifies the lower levels of life, the "millions of mire-bowed heads" and light signifies the transcendental vision that most refuse.

Between the sketch *Earlscourt, Toronto* and the painting *Spring in the Outskirts,* Harris took a sketching trip to Nova Scotia and Newfoundland. In Halifax, where Harris saw more severe poverty than in Toronto, he produced two dramatic urban landscapes that testify to the experience: *Black Court, Halifax* (Fig. 6.4) and *Elevator Court, Halifax* (Plate 15). In both there is an obsession with spatial depth. The repeating lines of the clapboarding of the simple frame houses form orthogonals in both paintings, pulling the viewer into depth even in the foreground areas. In both paintings there is a contrast of light areas in a troubled sky. In *Elevator Court, Halifax* Harris has added radiating forms in the snow and mud of the foreground, and in the pattern of the clouds in the sky. Again, light conveys the opposition of the transcendental level to the darkness and suffering symbolized by the poverty of the houses and their setting. The light source gives three-dimensionality to the enormous red brick smokestack, which Harris has painted smoothly, emphasizing its roundness with the strong highlight.

These urban landscapes of Harris have led to discussion as to whether he was "socially conscious."[13] The aesthetic of the realist tradition insisted that the ordinary subjects of life were worth painting because they were valuable in themselves. Urban realism was very much alive in Berlin while Harris was there, and it was within this tradition that he began his own urban landscapes when he returned to Canada. As we have seen, he transformed that realist tradition into a decorative one with his pre-1918 urban landscapes. After his nervous breakdown, Harris painted the poor parts of the city with a renewed sense of suffering. If those urban landscapes are consistent with the imagery in his contemporary poetry, the poor parts of the city became for Harris a symbol of that part of the world that refused the light. There is little, however, to suggest human sympathy in these paintings, and there is no convincing human presence.

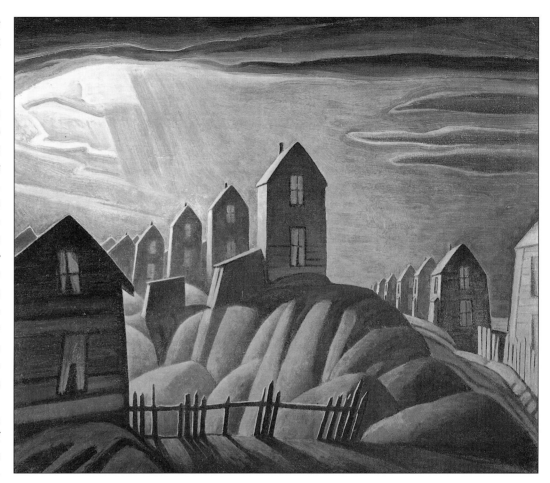

For that reason, it does not seem to me that Harris wanted to call attention to the personalities of poor people or to social evils, or to promote social change. Though he does use the image of poverty, it was probably moral and religious reform that he aimed at, not a wider acceptance in society of the working classes or a redistribution of wealth.

The question of Harris's social consciousness was raised by the reviewer of a later urban landscape, *Miners' Houses, Glace Bay* (Fig. 6.5), finished by 1926. Between 1922 and 1926 Harris did not exhibit any new urban landscapes and apparently stopped painting them. However, he may have been working during these years on *Miners' Houses, Glace*

Figure 6.5
Miners' Houses, Glace Bay, c. 1922–26
107.3 x 127 cm
Art Gallery of Ontario, Toronto
Bequest of Charles S. Band, 1970

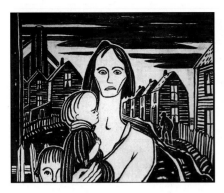

Figure 6.6
Glace Bay, 1925
Ink drawing
14 x 16.8 cm
Private collection

Bay. This work owed its inspiration to Harris's trip to the East Coast in 1921, although it was not exhibited until the fifth Group of Seven exhibition in May of 1926. There is an intensity of emotion in the work that goes beyond that of the Halifax paintings. Depicting the houses of the coal miners in a very poor part of eastern Canada, the painting echoes *Outskirts of Toronto* of 1918 in the type of architecture, and in the distortions of the buildings. In the later painting, the houses in the middle row are systematically distorted, sloping toward the centre of the painting. The buildings on the right and the left slope outwards. These distortions are the main difference between this painting and *Elevator Court, Halifax*. Otherwise, there are similarities such as the contrived lighting and the exaggerated three-dimensional effects. A reviewer for the *Toronto Star* saw it as a painting of social criticism,[14] and to my knowledge, it is the closest that Harris came to that genre. The reviewer's impression may have been prompted by Harris's drawing *Glace Bay* (Fig. 6.6), c. 1925, which had been published in the *Canadian Forum* the previous summer. The figures of the distraught, poverty-stricken woman staring at the viewer and of her children are placed against a backdrop closely resembling the right half of *Miners' Houses, Glace Bay*. Why did Harris wait so long to finish and exhibit the latter work?

I speculate that Harris was deeply upset by the poverty he saw in Glace Bay in 1921. Since his nervous breakdown, Harris had used urban poverty as an image of the lower levels of existence. One of his beliefs about urban poverty was that the millions of "mire-bowed heads" were free to lift themselves toward the light.[15] But in Glace Bay Harris encountered the tragedy of people like the woman and her children in his drawing, who were trapped in economic structures that held them in devastating poverty. Harris was not sure what to do with this insight. The intensity of that tragedy produced the distortions noted above. It is significant that in *Outskirts of Toronto*, done in 1918 when he was at least as upset emotionally, Harris used similar distortions. It is likely that he knew the work of the German Ex-

pressionists, which these distortions, along with the angular geometric forms in the clouds on the right in *Miners' Houses, Glace Bay*, call to mind. Since *Miners' Houses, Glace Bay* is unusual in Harris's oeuvre, one wonders why it was one of the two works he sent to the Société Anonyme exhibition of 1926. Harris's correspondence with Katherine Dreier gives a clue. From Harris's rather anxious letter to her of about 20 September 1926, it is obvious that she had not committed herself to exhibiting whatever he sent. Of the two works Harris had exhibited in the Philadelphia Sesquicentennial Exhibition held from 1 June to 1 December 1926, the one Dreier had admired was the urban landscape *Ontario Hill Town* (Plate 16), not the wilderness landscape *Northern Lake*, which had won a gold medal.[16] In sending *Miners' Houses, Glace Bay* he was probably hoping to appeal to Dreier's taste. Perhaps he also thought its similarity to Expressionist prototypes would more likely be seen as modern in an international exhibition. I think, however, that he must have been disappointed, for in the Société Anonyme's illustrated catalogue, *Miners' Houses, Glace Bay* is easily the most conservative work.

THE FINAL URBAN LANDSCAPES, 1925–30: FROM THE PARTICULAR TO THE UNIVERSAL AND THE LIMITS OF REALISM

Harris seems to have stopped painting urban landscapes in 1922. Four years later he painted *Ontario Hill Town* and completed *Miners' Houses, Glace Bay*. I have found only two works, *Red House in Winter* (Fig. 6.7) and *Summer Houses, Grimsby Park, Ontario* (Plate 17), whose stylistic similarities to the later wilderness landscapes suggest a date as late as 1929 or 1930. The small group of urban landscapes painted after the mid-1920s show Harris trying various ways of using the remnant of the realist tradition.

At this point in his development, Harris's urban landscapes suggest that his imagination had two tendencies,

which he was trying to reconcile in both writing and painting. One was a realist aesthetic with its commitment to the observation of a social milieu and to a naturalism sufficiently detailed to convey these observations. The other was a commitment to expressing the spiritual truths that he believed lay behind appearances. In his writing, Harris expressed this duality in assertions such as "art should stimulate the two great moods of complete at homeness and a great and abiding homesickness"[17] and "Creatively one can only move from and through the particular to the universal." He explained this assertion, using his painting of an urban landscape as an example:

> To achieve universal expression one must give oneself fully to the particular. This is obvious in the process of creating in any art. Thus, if I paint a house, say in a back street in Hamilton, I assume the shape of that particular house, experience its form, its meaning, its relationship to the soil it rises from, the skies that bathe it in reflection of their colours and mood, the neighbouring houses, the mood of the particular house, its age, its inner life; and the more direct my experience of that is, the more I permit that house to dictate to me how I shall paint it and the more certain I am to arrive at pure experience in my art and to create an intense equivalent in terms of my art of my first-hand experience. If my experience is clear and deep enough, the life I get into my picture of that house and the formal relations it dictates for its own expression will become universal.

> The picture of the house, its life expressed by the particular relationships of forms, colours, lines, rhythm, is then bound to bring to life in the spectator, myself firstly, the experience of all life in decrepit houses. But, if I think of achieving a universal expression in my picture, I will get a relative-

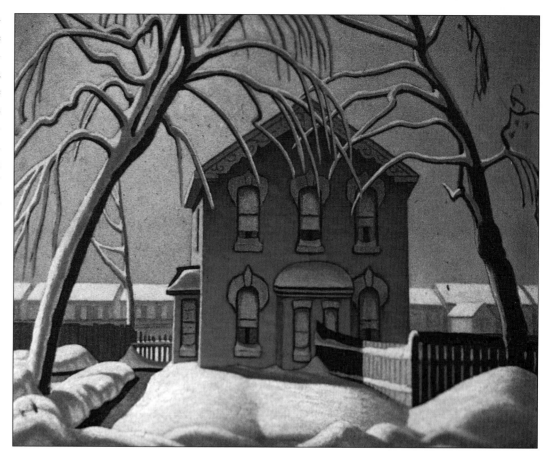

ly shallow expression; for I must feel and think and identify myself with that particular, and then the process once started will move me quite naturally and unconsciously toward a universal expression if my capacity is great enough.[18]

Figure 6.7
Red House in Winter, 1926
85.1 x 104 cm
Hart House Permanent Collection,
University of Toronto

Why did Harris abandon the realist tradition and urban landscapes altogether? In Harris's imagination at this time, the idealist, universalizing thrust was becoming dominant. Houses, however much they are simplified, always belong to specific places and so inhibit the development of a generalizing, universalizing expression. In his last urban landscapes, Harris did not follow his own advice in identifying himself

Figure 6.8
Winter in the City, c. 1925
Pen and black ink with
graphite on wove paper
34.3 x 39.3 cm
National Gallery of Canada, Ottawa

with "the particular"; in both his writings and painting, he attempted to achieve "universal expression." These last urban landscapes were done during a period when Harris was moving toward clarity and simplicity of vision, and away from the complexities observable in the urban environment, and they reflect this transitional period.

Although the commercial or working-class setting is usual in Harris's urban landscapes, there are differences in *Ontario Hill Town* (Plate 16), c. 1925–26. The angle at which the buildings are seen stresses their three-dimensionality. The point of view from down a hill is lower than usual. The painting of the buildings is smooth, allowing a fine gradation of light on the side walls. The complex shape in the sky – edges of clouds lit by an unseen sun – is a disturbing, irregular one, which, combined with the angle of the view of the hill and the buildings, the strong shapes of the sidewalk and the ruts in the streets, creates a sense of instability, as though the forms were in conflict. The foreground of the sloping hill has many lumpish, curving forms, including the curves of the sidewalk and the thickly painted patches of snow on the right. The smooth painting on the two main buildings in the centre forms a counterpoint to these areas of looser brushwork and rounded forms. This contrast is an instance of Harris's interest in presenting the foreground areas as an experienced reality and at the same time the deeper space as the experience of another, broader reality: that is, presenting images of both the particular and the universal. This contrast of the near and the far is also an important aspect of Harris's contemporary wilderness landscapes, such as *Above Lake Superior* (Plate 23) of 1922 or *North Shore, Lake Superior* of 1926 (Plate 24).

Ontario Hill Town was an important work in Harris's career. Because Katherine Dreier, president of the Société Anonyme, liked it when she saw it in the Sesqui-centennial Exhibition in Philadephia in 1926, she included a reproduction of it in the booklet *Modern Art at the Sesqui-centennial Exhibition* published by the Société Anonyme, and asked Harris to join the society, and to exhibit in its upcoming

exhibition of "extreme Modern art"[19] at the Brooklyn Museum.

Red House in Winter (Fig. 6.7) was painted sometime between 1925, the year Harris published a drawing of the same subject, and 1930 when he exhibited the painting for the first time in the seventh Group of Seven exhibition. As in his contemporary wilderness landscapes such as *North Shore, Lake Superior* of 1926, he has created an image of a vast expanse of space. In the *North Shore* painting, the space expands under and beyond the clouds over the surface of the lake. In *Red House in Winter* the sense of space is conveyed by the perspectival orthogonals formed, for example, by the fence on the right and the shovelled path on the left; by the layers of the composition formed by the screen of trees, the red house and the row of lower houses on the horizon; and especially by the infinite expanse of the clear, bright sky. Harris painted this area without a trace of brushwork, and thus it contrasts sharply with the agitated skies in *Miners' Houses, Glace Bay* and *Ontario Hill Town*. *Red House in Winter* is probably the first of Harris's urban landscapes to express his idea that a painting should cause "the wildly active surface of life to be forgotten" so that the viewer could "glimpse the simple and noble serenity of all eternal ways."[20]

As in Harris's *North Shore, Lake Superior* and Rocky Mountain paintings, the brushstroke is generally smooth. The contours of the main feature – here the house – are precise, but one exception to the smoothness of the brushwork is worth noting. As in *North Shore, Lake Superior* the bright sun is shining from the left, stressing the three-dimensionality of the forms. The barely visible left side of the house is gold and displays, in this limited area, a rich but disciplined texture, which emphasizes the three-dimensionality of the building even more than the light alone would do. Harris's drawing of the same subject, *Winter in the City* (Fig. 6.8), is as carefully symmetrical as the painting, but more naturalistic in such details as the bricks of the façade, the chimney with its curl of smoke, the more delicate rendering of the tree

branches and the articulation of the voussoirs in the window surrounds. This comparison makes us aware of the deliberateness of Harris's choices in the painting. One of the differences in the painting is that the scene becomes much less detailed than it would naturally be. A second difference is that in the painting the voussoirs in the window surrounds are made less geometric and suggest anthropomorphic forms with their curving lines.

Harris first exhibited *Summer Houses, Grimsby Park, Ontario* in 1930. The subject was a vacation area on Lake Ontario not far from Toronto. It was probably Harris's last painting in the urban-oriented realist tradition, although only traces of realist subject matter and composition remain. Unlike the shack in *Top o' the Hill, Spadina* of 1909–11 (Fig. 3.5) or the building in *A House in the Slums* of 1920 (Plate 14), the cottages in *Summer Houses, Grimsby Park, Ontario* would have been owned or rented by well-to-do Torontonians.

Of special note here is the colour. Both *Ontario Hill Town* and *Red House in Winter* used large amounts of red. In this painting, even the greens are affected by the overall blue tone of the painting. The warmest colour is a pink on the window sashes, roof and chimney of the house in the middle. At first glance the general composition is typical of Harris's urban landscapes. However, the cottages are arranged like the dead trees in many Lake Superior works such as *Above Lake Superior:* we look between and beyond them into a brighter distance. The tree trunks in *Summer Houses, Grimsby Park, Ontario* are carefully lit from the left, stressing their three-dimensionality. The trunks, foliage and the houses themselves are painted with a simplification and often a smoothness that removes them from a naturalistic mode. In this work and the other late urban landscapes, we have considered the antinaturalism as an expression of Harris's theoretical assertion that the artist's painting from nature required, not the imitation of nature, but "the use of the high powers of selection and arrangement, and ... a simplification of the naturalistic to its fundamental and purest forms."[21] This painting and *Red House in Winter* come closest among the urban landscapes to embodying the "universal expression" Harris had come to value. I believe that in the late 1920s Harris painted only a few urban landscapes because he realized that his wilderness landscapes were more adaptable to such universal and spiritualizing expression.

Wilderness Landscapes
and the Regionalist Tradition I
The Algoma Paintings, 1918–21

Figure 7.1
Emotional
Ink drawing
4.4 x 8.9 cm
Illustration for *Contrasts* (1922), 29

WHY THE WILDERNESS?

Writing to MacDonald in July 1919 about their forthcoming sketching trip into the North Harris asked, "Do you look forward to the fall of this year as longingly as I do?" The year before he had written, "Once we leave the Soo and commence climbing into that paradise you will forget entirely to give your health or state of mind even a passing thought – just give up to drinking in gorgeousness with your eyes, sweet woodsy sounds with your ears and crisp, clean air with your lungs. God bless you!"[1]

The notion of the wilderness as a beautiful paradise that could restore the health of people otherwise confined to cities was part of the wilderness ethos in Canada and the United States. The emergence of this attitude between 1890 and 1930 was due in large part to the growth of cities and to the simultaneous development of railroads, cars and better highways that offered easy escape from the cities. Though the commercial prosperity brought by such growth was highly valued, the city was considered a necessary evil. Canadians who could afford it moved to the suburbs or the country, where they could live like English squires, near "forests unmeasured and unblazed, and streams untraversed." Canada was described as a country where the "nat-

ural beauty of the many regions, which the prosaic hand of civilization has not yet touched affords rest to the tired man or woman of the world."[2] And since most Canadians lived within a few miles of the American border, if they wanted to go into Canadian wilderness, they usually had to go north.

The Ontario North already had hotels and lodges in the 1870s, and development of the large Muskoka Lakes area in the following decade was followed in the 1890s by the summer cottaging movement. Various groups also bought wilderness terrains far away from the cities.

Another indication of the importance of the wilderness was the emergence of "wilderness literature," a category that included the animal stories of Charles G. D. Roberts and Ernest Thompson Seton, and the very popular writings of Grey Owl.

In the emerging group of nationalist painters, Harris was the only one who had been exposed to the wilderness itself during the 1890s and the early years of this century. Thomson did not make his first trip into the North until 1912. A. Y. Jackson, on his first trip to Georgian Bay, found it unpaintable: "nothing but little islands covered with scrub and pine trees."[3] Lismer and Varley did not arrive from England until 1911 and 1912. MacDonald, raised in England, then in Hamilton and Toronto, had no wilderness experience and always found such trips difficult. Harris, on the

other hand, had spent summers in Muskoka as a child and as a youth had gone on canoe trips. In 1903, and probably in other summers as well, Harris's mother summered at the expensive Royal Muskoka Lodge at Lake Rosseau. In 1911, Harris rented a cottage at Go-Home Bay,[4] and a few years later he had his own cottage on Lake Simcoe, where he spent much of the time during and after his breakdown. These sojourns, coupled with his convalescent trip with Dr. MacCallum into the wilderness in the spring of 1918, show that he subscribed to the commonly held belief that the wilderness was a source of healing.

As it turned out, Harris's discovery of the Algoma region on his convalescent trip was indeed an important part of his recovery. It gave him a new and exciting region as a subject for wilderness landscapes, and offered new challenges to his organizational talents. Both these functions contributed to his psychological reintegration and help to explain the personal importance of the elaborate mystic significance he began to see in the North.

Another important fact in his life at this time was his reading of Emerson and Thoreau. Of all the writers he mentions in his correspondence with MacDonald in 1918–19, they are among the ones he admired most and the only ones who had something to say about the wilderness or "Nature." In fact, the wilderness ethos in the United States was indebted to both Thoreau and Emerson. For the transcendentalists nature was a symbol of the spiritual whose reality it manifested. As Thoreau put it, with a phrasing worthy of a Post-Impressionist, "Man cannot afford to be a naturalist to look on Nature directly ... He must look through and beyond her."[5] Nature became the source of religion, the wilderness the environment where spiritual truths were least blunted.

The Illustrations for Contrasts

It is within the context of Harris's interest in the wilderness that his book of poems and his urban landscapes should be placed. The poems – which make no mention of the wilderness or nature – and the urban landscapes picture the world without the consciousness of the spirit and without a consciousness of nature and the wilderness.

It seems at first paradoxical that the poems in *Contrasts*, which are for the most part about urban experiences, should have been heavily illustrated with wilderness scenes. To illustrate the words "Emotional," "Definitions" and "Spiritual," the titles of three of the book's five sections, Harris employed three wilderness landscapes (Figs. 7.1, 7.2 and 7.3). For "Emotional," active curving forms in the water area and in the clouds are echoed in the larger forms making up the island in the centre of the drawing. In "Definitions," the rays of a rising sun silhouette the black forms of steep hills or islands above the calm water. This is almost the only time that Harris actually pictures the sun. Finally, to illustrate "Spiritual," he presents a quiet, smoothly contoured image of hills reflected in still water. Thus Harris gives expression to the transcendentalist belief that nature, or the wilderness, is a symbol of the spiritual reality beyond, but suggested by, the visible.

The Wilderness and the Group of Seven

During these years, Harris's associations with the wilderness had been its healing and spiritual properties. But another theme emerges in the catalogue of the exhibition "Algoma Sketches and Pictures by J. E. H. MacDonald, A.R.C.A.; Lawren Harris, Frank Johnston" held at the Art Museum of Toronto in 1919. Although the introduction to the catalogue is unsigned, the style and vocabulary suggest that Harris had a large part in its composition. In this catalogue the wilderness, or nature, in Canada is linked to the nationalist program of the emerging group: "The whole collection may be taken as an evidence that Canadian artists generally are interested in the discovery of their own country. Too often their work is criticized adversely by an unsympathetic narrowness of mind, as though it had no traceable connection with Nature."[6]

Figure 7.2
Definitions
Ink drawing
4.4 x 8.9 cm
Illustration for *Contrasts* (1922), 77

Figure 7.3
Spiritual
Ink drawing
4.4 x 8.9 cm
Illustration for *Contrasts* (1922), 105

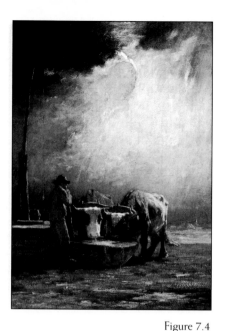

Figure 7.4
Horatio Walker
Oxen Drinking, 1899
127.5 x 92.4 cm
National Gallery of Canada, Ottawa

Figure 7.5
Homer Watson
The Flood Gate, c. 1900
Oil on canvas, mounted on plywood
86.9 x 121.8 cm
National Gallery of Canada, Ottawa

In May of the following year, after the second trip to Algoma, the Group of Seven held its first exhibition. The catalogue, again unsigned, was heavily dependent on Harris. Though the introductory essay stresses nationalism it does not suggest that nationalism is linked to the wilderness. What unites the artists is that they "are all imbued with the idea that an art must grow and flower in the land before the country will be a real home for its people," and see their work as an "art expression that sincerely interprets the spirit of a nation's growth." The artists invoke A. E. (George Russell), the Irish painter, poet, nationalist writer, and theosophist: "No country can ever hope to rise beyond a vulgar mediocrity where there is not unbounded confidence in what its humanity can do," and challenge Canadians with the Irishman's words: "if a people do not believe that they can equal or surpass the stature of any humanity which has been upon this world, then they had better emigrate and become servants to some superior people."[7]

The catalogue of the second Group of Seven exhibition, held in May 1921, contains an introduction of three paragraphs, the third expressing their nationalism by relating their painting to the land and to the "experience" of Canadians. It is much less vehement than the text of the previous year:

> A word as to Canada. These pictures have all been executed in Canada during the past year. They express Canadian experience and appeal to that experience in the onlooker. These are still pioneer days for artists and after the fashion of pioneers we believe wholeheartedly in the land. Some day we think that the land will return the compliment and believe in the artist, not as a nuisance or a luxury but as a real civilizing factor in the national life.[8]

To judge by their exhibited works, the land they had confidence in was the wilderness. All but a few of the eighty-nine works in the exhibition were wilderness landscapes, most from Algoma. The invocation of the pioneer as an image for their activity ties them once again into the wilderness ethos which strove to recreate the closeness to nature that they imagined had been experienced by the original pioneers.

The Canadian Context: The Pastoral Myth and Painting as Aesthetic Experience

The dominant ethos around which painting and other cultural activities were organized in Canada from 1860 to 1890 has been called "the imperialist myth."[9] In many paintings of that period, heroic agents of the Empire are shown in picturesque and dramatic landscapes, which serve both as adversary and backdrop. One of the main painters within this movement was Lucius O'Brien (1832–99), first president of the Royal Canadian Academy, whose painting of 1887, *Through the Rocky Mountains, A Pass on the Canadian Highway* (Fig. 9.1) expresses various aspects of the myth.

Much of the important painting between the end of the influence of this imperialist myth and the successful establishment of the wilderness image of Canada by the Group of Seven in the 1920s subscribed to what can be called "the pastoral myth." For these artists Canada was essentially an agricultural phenomenon. By now, the land had become civilized and tranquil. The two most important artists of this persuasion were Horatio Walker (1858–1938) and Homer Watson (1855–1936).

The subject of Walker's works was Canadian, though the style, which monumentalized the simple life of the French-Canadian habitant, was heavily dependent on Millet. Often, as in his *Oxen Drinking* of 1899 (Fig. 7.4), there are areas of loosely brushed paint which create an atmospheric sense of light. Homer Watson was dubbed "the Canadian Constable" by Oscar Wilde, probably because of the concentration of his painting on the rural life of a small part of southern Ontario. His best-known work is *The Flood Gate* of about 1900 (Fig. 7.5). In the 1920s he was painting in a quite Impressionistic style, still concentrating on rural subjects.

His reputation was eclipsed by the Group of Seven in the 1920s.

Other Canadian artists – all born in the 1860s and all connected with Montreal – had yet a different approach: instead of seeing painting as linked to a nationalist or other ideology, they tended to accept it more as an aesthetic experience.[10] These artists included Maurice Cullen (1866–1934), Marc-Aurèle de Foy Suzor-Coté (1869–1937) and the Canadian artist who was best known internationally, James Wilson Morrice (1865–1924).

When Harris commented on Morrice's contribution to the Canadian Art Club's exhibition in 1913, he had no difficulty praising the works for their "warmth and mystery," "suggestiveness," "full … control and confident balance … and a subtle friendliness that is inviting." By 1926 in his review of the Art Gallery of Toronto opening, he found the sixteen works by Morrice "all pleasing in colour, lyrically designed and sympathetically painted." But he then qualified them as "the work of a minor poet." Why the difference? By 1926, Harris had his own ideology and his own hero, Tom Thomson, whom he considered "a great poet, an artist in the highest sense of the term."[11] Morrice, an expatriate Canadian, had followed a pattern in his life of which Harris and the Group could not approve. Essentially, Morrice openly admired and emulated European models. He spent parts of 1911 and 1912 in Algiers so he could be near Henri Matisse, and toward the end of his life he painted in Trinidad and Cuba. For Harris to praise such an artist in the mid-twenties would have been to weaken the stance taken by the Group of Seven, who presented themselves to the public as the only means by which modern art was arriving in Canada.

Cullen, who had been studying and painting in France since 1888, returned to Canada in 1895, bringing with him the influence of Claude Monet and other Impressionists. He gradually influenced the Montreal milieu with his modernism and was well enough accepted by 1925 to earn $11,000 that year from the sale of his paintings. Jackson remembers that to the younger artists in that city during the early years of this century, Cullen was a hero because he was struggling with some success against a heavy conservatism, and was painting Canadian subjects.[12] Perhaps his best-known painting from his early Canadian years is *Logging in Winter, Beaupré* of 1896. Suzor-Coté also trained in France, where he was strongly influenced by French Impressionism. In 1921 he was still painting works such as *Spring Landscape, Arthabaska* which revealed this Impressionism in the use of broken brushstroke and the sense of its being painted out of doors.

HARRIS'S ALGOMA LANDSCAPES

Harris's encounter with the Algoma region started him on the most creative period of his landscape career. The first trip to Algoma, in the late spring of 1918, had been intended as a trip of convalescence for him. The next two sketching trips to Algoma were made in a boxcar: "The Algoma Central converted an old box-car into suitable living quarters, put in a few windows, four bunks, a stove, water tanks, sink, cupboard, two benches and a table. We carried a one-man handcar inside for use up and down the tracks – two of us could manage to ride on it – and a canoe for use on the lakes and rivers."[13]

The members of the first trip were MacCallum, MacDonald, Johnston and Harris. On the tenth or eleventh of September 1918 they took the regular CPR train to Sault Ste. Marie, 708 km northwest of Toronto. There they picked up the boxcar, which was hauled by the Algoma Central Railway to a siding at Canyon, near the Agawa River, 182 km north of Sault Ste. Marie. After sketching there for a few days, they flagged a southbound freight train and were towed to Hubert, near the falls of the Montreal River. Then, a few days later, they were pulled to Batchawana, their last stop for sketching. After a few more days they were towed back to Sault Ste. Marie, where they caught the train to Toronto.

The second boxcar trip, from mid-September to mid-October 1919, followed the same pattern as the first except

that Jackson went with them instead of MacCallum. Jackson has left a description of life in the boxcar:

> The nights were frosty, but in the box car, with the fire in the stove, we were snug and warm. Discussions and arguments would last until late in the night, ranging from Plato to Picasso, to Madame Blavatsky and Mary Baker Eddy. Harris, a Baptist who later became a theosophist, and MacDonald, a Presbyterian who was interested in Christian Science, inspired many of the arguments. Outside the aurora played antics in the sky, and the murmur of the rapids or a distant waterfall blended with the silence of the night.[14]

In May of 1920, while the first Group of Seven exhibition was at the Art Gallery of Toronto, Harris, Jackson, MacCallum and Lismer spent 10 days in Algoma in a rented cottage. In the fall of that year, Jackson, MacDonald, Johnston and Harris again went to Algoma, where they stayed in log cabins. The sixth and seventh trips to Algoma took place in 1921. In the spring Jackson and Lismer accompanied Harris to the Agawa River and Montreal Lake. In the fall, Harris, Jackson and perhaps Lismer went to the area around Sand Lake. The eighth and last trip to Algoma did not take place until the spring of 1924. It included Jackson, Lismer, MacCallum and Harris.[15] By then, the North Shore of Lake Superior had become Harris's main sketching terrain.

Harris had painted relatively little during the four years preceding his first trip to Algoma. However, in the exhibition "Algoma Sketches and Pictures" held in the spring of 1919 he exhibited forty-eight works, of which forty-two dated from the first boxcar trip in the fall of 1918, and six from the spring trip earlier that year with Dr. MacCallum. The landscape excited him. Not only was there a new vigour obvious in the number of works he produced, there were also types of paintings that he had not done before.

However, the break with his previous painting was not absolute. Harris returned again to the *Waldinneres* type of landscape composition that he had learned in Germany and had already used in some of his snow landscapes. In the early Algoma works, however, there is a more radical presentation of the wilderness as a wall confronting the artist and the viewer, for example in *Wood Interior, Algoma, No. 1* (Plate 18). In these works the sky is not visible at all, little depth is perceived between the trees, and there is only a shallow space between the viewer and the trees and their foliage. In *Algoma Sketch* (Plate 20) Harris presents a night scene, with some spatial emphasis by means of the smooth surface of the water. Although there may be some night sky pictured, the wilderness is still presented as a wall of trees and foliage, and reflections in the water. Variations on this type of landscape, with the wilderness completely filling the picture plane, are *Agawa Waterfall* (Plate 27), *Above a Beaver Dam, Algoma* (Plate 19) and *Algoma* (Fig. 7.6). The latter presents the wall of wilderness in a way similar to *Wood Interior, Algoma, No. 1,* but with an obvious break in the wall through which one sees brightly lit further depths in the wilderness.

Although Harris carried the *Waldinneres* landscape further than his prototypes, his landscape compositions echo the standard German type employed by Walter Leistikow in works such as the two called *Waldinneres* (Fig. 2.6 and 2.7). When he visited the 1906 exhibition of German painting in Berlin, Harris would also have seen this type of landscape; in fact, Christian Morgenstern's *Waterfall in Upper Bavaria* or *Forest Stream in the Harz* from the same exhibition could have furnished prototypes for the close views of small waterfalls such as *Agawa Waterfall.*

There are few colours in *Wood Interior, Algoma, No. 1.* The tree trunks are very dark grey and brown, and the small area of soil is brown. Against this dark background, Harris has placed clumps of brightly coloured autumn foliage. In the top left a delicate orange has been applied with wide strokes of thick paint. Two of the grey trunks appear to be in

front of this area but they do not create a sense of depth. At their bases are small branches with yellow leaves. The tree in the middle has red foliage near the top of the painting and at the base of the trunk. The colours are sophisticated: delicate mixes, by no means the primary colours. This is the first time Harris has set such bright colours against a dark background. His models for this practice were probably two works by Tom Thomson that Harris owned: *Black Spruce and Maple*, which places brightly coloured autumn foliage in the foreground against the darker spruce, and *A Rapid*, 1916, in which Thomson places a bright yellow clump of foliage next to a large black area representing the forest interior. Thomson, who had the least artistic training of all the artists of the nationalist movement, had been instructed by Jackson, Lismer, Harris and others; evidence of their influences, one after the other, has been found in his work. Thomson's influence on Harris, however, is a reversal of this direction and, like Harris's later extravagant praise of Thomson, testifies to the high value Harris placed on his art.[16] It also supports the speculation that before his breakdown Harris was dissatisfied with his own art, especially when he compared it to Thomson's more vigorous and inventive use of colour and brushwork.

In *Algoma Woodland* the brushstrokes are similar to those in *Wood Interior, Algoma, No. 1*, and create a strongly textured flat surface. The tree trunks in this case are a pale green and a light brown. The brightly coloured foliage – mainly across the bottom of the painting – is yellow and orange-red. An important difference in the treatment of the site is that Harris has eliminated any image of the soil out of which the trees are growing, making this work the clearest and simplest statement of the wall-of-wilderness composition.

The oil-on-board sketch *Wood Interior, Algoma, No. 2* presents the wall of wilderness in dark browns and blacks, with brightly coloured red foliage in the foreground. In the larger work based on this sketch, *Algoma* (Fig. 7.6) the drama of the colour contrast is diminished. The red foreground foliage is smaller and the wall of wilderness formed by the more widely spaced and simplified trees has become more clearly a screen through which the viewer perceives the very bright blue sky beyond. This accentuates the experience of distinct layers in the composition: the foreground, the screen formed by the trees, and the bright sky beyond. Such layered compositions appear frequently in Harris's wilderness and urban landscapes from his early works such as *Houses, Wellington Street* (Plate 5) of 1910 and *Winter Morning* (Fig. 3.18) of 1914, and they continue to be an important aspect of his compositional practice until near the end of his landscape period, around 1930.

Both the sketch *Wood Interior, Algoma, No. 2* and the final painting *Algoma* are expressions of the importance Harris was placing on light at this time. In his contemporary poems light was part of a cluster of images that evoked the transcendental levels of existence. There is probably a use of metaphor in these works which harmonizes with the use of metaphor in *A House in the Slums* (Plate 14) of 1920. The opening in the trees revealing the light beyond is a metaphor for the opening available to all, in Harris's vision, to lift their heads and journey toward the light.[17]

Both in his Algoma paintings, and even earlier in the Lake Simcoe works, Harris felt free enough with nature to transfer an interesting motif from one setting to another, or to eliminate aspects of the landscape he did not like.[18] *Algoma Sketch CXIX* (Plate 21) has a yellow-leafed bush in the foreground. Beyond this are the trunks of black evergreens through which can be seen a body of grey water and a distant, olive-green hill. In view of his sketching practices, this was likely how Harris found the motif in nature. But in *Autumn, Algoma* (Plate 22), Harris has copied the yellow-leafed bush branch for branch, leaf for leaf, and placed it in a setting that may be imaginary. The changes are significant, because they show aspects of the decorative style that prevailed in his earlier snow paintings. All the branches have been made more slender and elongated, reduced to mere black lines of varying thicknesses. Almost all the leaves

have delicate black outlines recalling the cloisonism of early Post-Impressionism. In the larger painting the point of view is lower, the bush more clearly establishing a layer in space. Beyond the bush the placid surface of the water reflects the blues and golds of the hill beyond. This hill has a flat, almost tapestrylike surface, with many vertical strokes of similar colours. Harris was quite conscious of the decorative qualities of the work; in the first Group of Seven exhibition, he called it *Decorative Landscape.*[19]

Although Harris began his Algoma period with wall-of-wilderness compositions, he soon developed images of deeper space and adjusted his use of brushstroke and composition accordingly. From a compositional point of view, one could say that the oil-on-board sketch *Montreal River* (Fig. 7.7) is a wilderness version of the layered compositions that Harris used exclusively for his urban landscapes to about 1920. The screen of four trees establishes a plane parallel to the picture plane; through them we see the grey surface of the river and the red and yellow autumn foliage on the distant hill, and farther away, the roughly painted grey sky. In this painting Harris demonstrates a new brush technique, using brushstrokes to summarize the distant forms of whole trees and not, as in the foreground, to suggest individual leaves or branches. Whole areas of trees in more distant parts are summarized in a single stroke. This can also be seen in *Algoma Sketch LXVIII.* In this work there is a robust contrast between the yellow-golds of the sweeping strokes that present the foliage, and the deep blue of the surface of the lake. As in *Montreal River,* the point of view is a high one.

Algoma Country (Fig. 7.8) was first exhibited in the third Group of Seven exhibition in the spring of 1922. It is a large painting (almost 103 x 128 cm) that was probably done in 1921, possibly after Harris had been to the North Shore of Lake Superior for the first time. This might account for the similarities between its screen of apparently dead trees and the one in *Above Lake Superior* (Plate 23). To my knowledge, *Algoma Country* has the only such screen in Harris's

Algoma works. Like the sketches *Montreal River* and *Algoma Sketch LXVIII,* the point of view, unlike those in the earlier, wall-of-wilderness Algoma compositions, is a high one. From the top of a stony hill we look through the screen of smoothly contoured brown tree trunks across a range of lower hills and lakes to the higher hills on the horizon. On the right the more distant, smoothly painted hills are blue-grey. Harris has painted the rest of the hills as though there were only two kinds of trees on them: dark green cedars, and birches in their yellow autumn foliage. The cedars easily lend themselves to Harris's simplification of their shapes to slender, conical forms, but the fluffy textures of the round-crowned birches are less convincing, and appear as three-dimensional, solid forms. Such antinaturalist distortions illustrate Harris's contemporary ideas on the need for an artist to effect "a simplification of the naturalistic to its fundamental and purest forms."[20]

Harris's Algoma period shows a progression from the enthusiastic and colourful roughness of the wall-of-wilderness sketches such as *Wood Interior, Algoma, No. 1* and larger paintings like *Algoma* through intermediate works like the sketch *Montreal River* to the wide and deeper views with their firmly contoured, more simplified forms, as in *Algoma Country* of about 1921. As he came to the end of this period, Harris was seeing religious purposes in art. As he wrote a little later in "Art Is the Distillate of Life," art was meant to give us a view of "the simple and noble serenity of all eternal ways."[21]

During the years he was painting his Algoma landscapes, Harris was also writing poetry. As noted previously, there are no direct references to the wilderness in these poems. However, they do express a similar attitude toward vast spaces. In the paintings there is a progression as though deep space were beckoning Harris, at first through an opening in the forest wall, as in *Algoma,* then to deeper and vaster views. In the poems, Harris pictures a similar progression, which he endows with mystery and spiritual meanings. In one of these poems, "Little Houses," the houses are not the slum

dwellings that Harris painted or his own wealthy houses, but homey, domestic, familiar and simple: "Homes for contented folks / Easy-going, fruit-preserving, cookie-making folks." But at the end Harris reveals the necessity of growing away from the close and familar, with hints that he is writing about a religious vocation:

> The dreamers ever leave you –
> They hear a vague, far cry,
> Perhaps the call of some vacant, high place,
> So often only the wailing of a beckoning pain,
> But the dreamers ever leave you.

In his poem "The Harbour," Harris describes the confined and fretful activities of a harbour and its port city, where "Men are on petty days," but there is a wider world: "And beyond lies the sea." He concludes that "the harbour is no haven for men," who really belong on the wide spaces of the sea. In another poem he is very conscious of the clear image of the horizon, "a sharp drawn line where it [the sea] meets the sky."[22] That clearly drawn sharp line became an important aspect of the Lake Superior paintings that he began in the fall of 1921. In the Algoma paintings the wider, deeper views express his appetite for these deeper spaces. They are to be equated not just with the upper levels of his transcendental two-level world view, but also with his growing desire for continuous spiritual development. In the Algoma landscapes there is no expression of suffering as there is in the contemporary urban landscapes; it was to recur, however, in the Lake Superior landscapes.

Harris's Colleagues in Algoma

Harris was the only participant to go to Algoma eight times. On the first trip, as we have seen, he was alone with Dr. MacCallum. Of the seven subsequent trips he organized, Jackson went on six, Lismer on three or four, and MacDonald and Johnston on three.

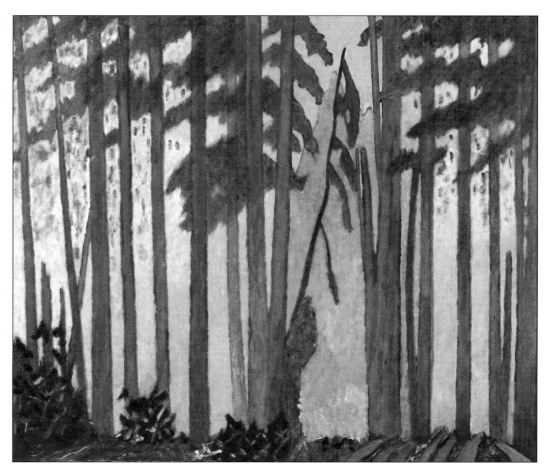

Figure 7.6
Algoma, 1919
106.7 x 139.7 cm
Private collection

The best known of Johnston's Algoma canvasses is *Fire-Swept Algoma* of 1920, which was bought from the first Group of Seven exhibition in the same year by the National Gallery of Canada. This large painting (127.6 x 167.6 cm) is sombre and quiet, in contrast to the high-keyed colour employed by the rest of the group. The slender, fire-scarred grey trees are painted smoothly, silhouetted against distant hills of subdued blues, greens and lavenders applied with a broken though disciplined brushstroke. Instead of the awe and excitement suggested by MacDonald's painting or the vigorous painterly experiments recording Harris's Algoma explorations, Johnston's work is poetic, atmospheric and

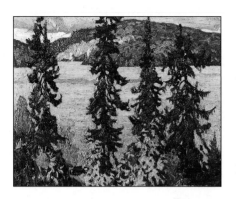

Figure 7.7
Montreal River, c. 1920
Oil on pressed board
26.7 x 34.9 cm
McMichael Canadian Art Collection,
Kleinburg, Ont.
Gift of the Founders,
Robert and Signe McMichael

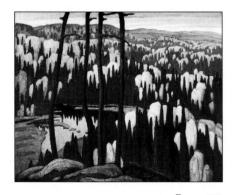

Figure 7.8
Algoma Country, 1920–21
102.9 x 127.5 cm
Art Gallery of Ontario, Toronto
Gift from the Fund of the T. Eaton Co.
Ltd. for Canadian Works of Art, 1948

suggestive. The subject, dead trees silhouetted against a hill, anticipates Harris's *Algoma Country* and most of the Lake Superior works, such as *Above Lake Superior,* that he painted during the winter of 1921–22.

Other aspects of Johnston's sensibility set him somewhat apart from Harris and his other colleagues. He had a fascination with unusual topographical forms and points of view. He painted high cliffs with a smooth naturalism in his poetically named *Where Eagles Soar* of about 1920. Another of his Algoma canvasses, *The Fire Ranger* of about 1920, shows a wide sweep of hill-studded terrain from a point of view high enough to be looking down on a passing fire-ranger's plane. This is one example of an element of civilization within the Algoma wilderness which was not to the taste of the others in the Group. As a matter of fact, Johnston exhibited only once with the Group, in their first exhibition. His final estrangement from them around 1925 has never been thoroughly explained, but artistic differences may have had less to do with it than economics and exhibition policy.[23]

After one of his three or four trips to Algoma, Lismer painted *Isles of Spruce* (Fig. 7.9) in 1922. Although it is an autumn scene, the colours are restricted compared with MacDonald's, Jackson's or Harris's. The dark spruces on the island in the foreground are in shadow, while the background hill of conical evergreens is brightly lit. There is a blue tone to much of the green throughout the painting, which is balanced by the bands of gold foliage of the other trees. This controlled but attractive palette, combined with the calm, reflecting surface of the water, gives the work a sense of stillness. This tranquility, a contrast with many of Lismer's other works, may be due to the influence of paintings by Harris such as *Algoma Country.*

Harris was not the only painter who used the wall-of-wilderness composition for his Algoma works. Although I have not located Jackson's sketch for *Maple Woods, Algoma* (Fig. 7.10) of 1920, the finished painting is a clear example of the wall-of-wilderness type of composition. Jackson has kept a sketchlike vivacity in the brushstroke and in the over-all texture of the simply composed work. In this Jackson departs from Harris's usual practice of smoothing out the brushstroke in the larger paintings, as he did in *Algoma.* The row of curving, dark tree-trunks is also different from the straighter trees Harris depicted in his wall-of-wilderness sketches such as *Wood Interior, Algoma, No. 1* and *Algoma Woodland.*

Harris believed that MacDonald's best work was done in Algoma. Jackson, who agreed, described MacDonald's personality and the impact the Algoma region had on him: "I always think of Algoma as MacDonald's country. He was a quiet, unadventurous person, who could not swim, or paddle, or swing an axe, or find his way in the bush. He was awed and thrilled by the landscape of Algoma and he got the feel of it in his painting."[24] MacDonald did several paintings of Algoma waterfalls, perhaps the most impressive of which is the large (121.9 x 152.4 cm) *Falls, Montreal River* (Fig. 7.11) of 1920. As he did with other similar subjects, the artist seems to have placed himself and the viewer in the middle of the water as it plunges down the steep, wooded hill to the deep blues of the river below. The sense of rush and excitement is emphasized by the roughly textured foreground forms – the white water, the rocks and trees on the right and the darker, shadowed forms farther down the hill on the left – all of which contrast with the softer handling of paint and forms for the river and the distant, sunlit hill. This image of energy in nature contrasts with Harris's no less colourful *Autumn, Algoma.*

All these artists shared a commitment to the wilderness as the main subject for Canadian painting, and, during their Algoma period, a preference for a vigorous, rough application of thick paint as exemplified in Harris's early Algoma sketches and MacDonald's and Jackson's canvasses. They also shared a preference for bright colour used aggressively. It was because these qualities, which were the main elements in their style, were new in Canadian painting that they felt the need of what MacDonald called their "friendly alliance for defense."[25]

Did it make any difference to Harris that he sketched with these colleagues in Algoma, painted with them in the Studio Building and exhibited with them at the Art Gallery of Toronto? I believe it did. Harris, it seems to me, was a person who felt uncomfortable alone. During the Algoma period he was still searching, though with optimism and enthusiasm, for his own spiritual and artistic vision. With the Group around him he was not alone while involved in this arduous quest. For Harris, who was gregarious and a habitual joiner of groups and organizations, this was important. He needed such support, and he frequently organized things –

for example, the Algoma trips and the Studio Building – to make it available.

A. Y. Jackson claimed that the Algoma country was too opulent and heavily wooded for Harris. In retrospect this is correct, for in turning to the North Shore of Lake Superior in the late fall of 1921, Harris showed a preference for a landscape that was more spacious, and more "bare and stark"[26] than Algoma. Nevertheless, between 1918 and 1921, Harris produced an enormous number of Algoma works, which testify to his enthusiasm for the area and to his energy.

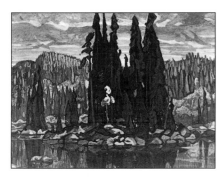

Figure 7.9
Arthur Lismer
Isles of Spruce, 1922
119.4 x 162.6 cm
Hart House Permanent Collection,
University of Toronto

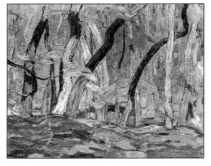

Figure 7.10
A. Y. Jackson
Maple Woods, Algoma, 1920
63.5 x 81.5 cm
Art Gallery of Ontario, Toronto
Purchased 1981 with funds raised in 1977
by the Volunteer Committee (matched
by Wintario) to celebrate the opening of
the Canadian Wing

Figure 7.11
J. E. H. MacDonald
Falls, Montreal River, 1920
121.9 x 153 cm
Art Gallery of Ontario, Toronto

Wilderness Landscapes and the Regionalist Tradition II

The North Shore of Lake Superior

SKETCHING TRIPS TO LAKE SUPERIOR, 1921–28

In the fall of 1921, after the sketching trip to Algoma, Harris and Jackson for the first time went farther west and north, to the North Shore of Lake Superior. They stayed only a few days, but long enough for Harris to make sketches of the new terrain.[1]

In early October 1922, Harris and Jackson camped at Coldwell, about half the journey west along the North Shore from Sault Ste. Marie to Thunder Bay. In 1923 they went back to Coldwell and stayed almost a month. In 1924 Harris, Jackson and Carmichael returned to the North Shore. In 1925, together with A. J. Casson, they again camped at Coldwell and sketched in the surrounding area, then went farther west to Jackfish and the Slate Islands. Harris and Jackson went back to Coldwell in the fall of 1926. Because Jackson went on his first Arctic trip in the summer of 1927, he did not actually go with Harris to the North Shore that year, but Lismer did. The Group's last organized sketching trip took place in 1928, when Harris was accompanied to the North Shore by Jackson, Casson and Carmichael.

Jackson later described the "impressive scenery" of the area: "There is a sublime order to it, the long curves of the beaches, the sweeping ranges of hills, and headlands that push out into the lake." Many of Jackson's anecdotes describe the difficulties of the trips:

> There were few places to stay in this country, so we took with us a tent and camping equipment … In poor painting weather we built a big stone fireplace where we could sit and gossip until it was time to turn in … We had no stove in the tent, so we dug a trench between our sleeping bags, which we filled up with hot embers from the fire. Then we would close up the tent and turn in comfortable even on cold nights.

Other stories record Harris's enthusiastic personality:

> When we camped near a sand beach we went in swimming although the water was very cold. Harris, who liked to have a system for everything, worked out one for bathing in cold water. We would start out far up on the beach, then run at the lake, waving our arms and yelling … This procedure was supposed to distract our attention from the cold water.[2]

It was Harris who, up before daylight, got breakfast and awakened the others, insisting that they get up for sketching,

even if it was raining. Harris was at this time an advocate of a cereal known as Roman Meal. He insisted that it made one "impervious to wet and cold," and he persuaded his colleagues to have a large bowl of it each morning. A. J. Casson remembered Harris as particularly rugged, "eating pan fried onions for dinner and taking a bath by standing bare naked in the snow while pouring a basin of water over his body."[3]

The marked difference between the countryside north of Lake Superior and the Algoma region is important for an understanding of the changes in Harris's painting in 1921. The later Algoma works, such as *Algoma Country* (Fig. 7.8), had already shown Harris's interest in painting distant views and simplified forms. On the North Shore of Lake Superior, Harris experienced deep and expanding space over the waters of the lake. Moreover, the terrain itself had a different shape, which is recognizable in most of Harris's works. The forests in the area had burned about fifteen years before Harris arrived, making the contours of the hills even more visible than before. Harris's first works, for example the sketch *Grey Day, North Shore, Lake Superior* (Fig. 8.1), reflect this feature. The trees Harris chose to paint were partly burned stumps and trunks. These trees are the main elements in the best-known canvasses from this period, particularly *Above Lake Superior* (Plate 23) and *North Shore, Lake Superior* (Plate 24). Harris's concerns with the "high powers of selection and arrangement," and the simplification of nature to "its fundamental and purest form," are well exemplified in these two works.

In the Lake Superior works, the style even of Harris's sketches changed, reflecting his attitude toward the differing terrains. Instead of the animated, broken brushstroke used for his early Algoma sketches, the Lake Superior sketches show a brushstroke less rough and broken, though the paint is still fairly thick. Such oil sketches were better adapted to the smoother forms Harris encountered on Lake Superior. At this time too, he began to use sketch books in which he made hundreds of pencil drawings.

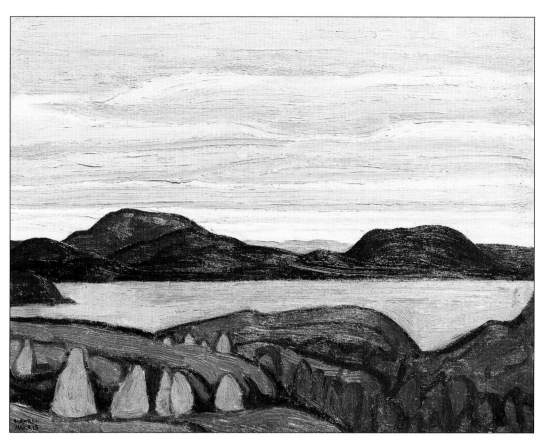

Before his breakdown in 1918, Harris's main wilderness landscapes were his snow paintings of 1914 to 1918. Even the late works of this series, such as *Winter in the Northern Woods* (Plate 10) maintain their highly textured surface, despite some passages of smoother painting. The colours are pastel ranges of blues for the bricklike strokes in the sky, and deeper pinks and greens for the tree-trunks and the branches of spruce and pine. When this painting is compared to *Above Lake Superior* of 1921–22, it is clear that the layered composition typical of Harris's work is common to both. Both paintings achieve this mainly by showing a view through a screen of tree-trunks to a distant hill and the sky beyond. The snow landscape was probably painted in Toronto's High Park, or near one of the city's ravines, though Harris, as was

Figure 8.1
Grey Day, North Shore, Lake Superior (Sketch), 1921
Oil on board
26.3 x 35.3 cm
McMichael Canadian Art Collection, Kleinburg, Ont.
Gift of the Founders, Robert and Signe McMichael

his contemporary practice, probably made the landscape look wilder than it was, and gave it an imaginary title. The North Shore painting, however, shows a true wilderness site. Instead of the textured, flattened surfaces of the earlier painting, *Above Lake Superior* has a decisive presentation of depth in space, and a smooth, almost impersonal brushstroke. Instead of relatively flattened forms, the later painting has emphatically modelled tree-trunks as its dominant feature. Since I have not found any oil-on-board sketches for the snow paintings, but have found one drawing of a snow-laden evergreen similar to trees in the paintings, I suspect that Harris assembled the earlier compositions from drawings of various motifs rather than from sketches. For the Lake Superior works, however, Harris used oil-on-board sketches as well as drawings.

By the time he was painting *Above Lake Superior*, Harris's mystical theory of art was well enough developed to be expressed in this painting. At the time he painted *Winter in the Northern Woods* he had not yet put his thinking about art and life into a coherent form. His breakdown and his recovery occasioned an effort to clarify his thoughts and goals. He had accomplished this by 1922 when he began his most characteristic Lake Superior paintings. The austere clarity and seriousness of *Above Lake Superior* stand in strong contrast to the decorative pleasures of *Winter in the Northern Woods*.

The changes in Harris's work were in harmony with contemporary changes in European art. After World War I, there was a turning away from the various energetic avant-garde enthusiasms of the previous two decades. Picasso, for example, moved from Synthetic Cubism into his neoclassical phase, with its simpler, more naturalistic forms and colours. Le Corbusier and Amédée Ozenfant founded Purism in France, reacting against what they considered the lack of formal discipline in late Cubism. The elitist modernity of Art Deco – by 1925 a popular movement – also relied heavily on line and simple forms. The house Harris had designed and built in 1930–31 in Toronto was strongly Art Deco in style, with only minimal adornment.

Above Lake Superior: Regionalism and Idealism

Since *Above Lake Superior* (Plate 23) was first exhibited in the third Group of Seven exhibition in May, 1922, it must have been painted after Harris's first trip to the North Shore. The composition recalls his earlier layered ones, but differs from them in its more intense presentation of the three-dimensionality of objects – here the tree-trunks – in deep space. The sketch that immediately preceded the painting is *Above Lake Superior, 1921*. Among other works that probably contributed to it is *Rocks and Hill*, which contains all the elements of the work – dead trees, hill and lake, and even the form of one of the dead trees in the final painting. *Lake Superior Sketch XXXVII* is a similar landscape, without trees but with a more smoothly painted sky and the carefully studied contour of a hill cutting the distant horizon in a way similar to the hill in the finished painting.

The differences between the sketch *Above Lake Superior, 1921* and the final painting are worth noting. In the sketch, the trees are painted with thick, vertically worked brushstrokes, and the snow-covered ground and the dead trees on the ground with thick impasto. Harris all but eliminated the roughness from the brushwork in the larger painting – this is most obvious in the tree-trunks themselves. In the sketch, the purple of the hill in the background is interspersed with bands of dark green. In the finished painting, the hill is mainly purple, with touches of green merely suggesting foliage, and the form of the hill is larger and simpler. The two islands that appear on the left of the sketch are transformed into a partial view of the simpler form of a hill. In the sketch, a distant shoreline is visible on the horizon on the right; it has been eliminated in the larger painting. In addition, the horizon line in the larger painting has been lowered until it bisects the canvas. One of the biggest differences is the treatment of the clouds. In the sketch they are of several colours, complex in form and vigorously brushed with mainly horizontal strokes of thick paint, as is the blue of the sky. In the larger painting, the

clouds are simple, three-dimensional and smoothly painted horizontal forms, all of the same colour, arranged in parallel. In *Above Lake Superior,* the clouds decrease in thickness toward the horizon line, and so stress a progression into deep space. At the same time, because all but one of them extend beyond the picture to the right and left, they suggest breadth of space.

One feature of the foreground of the painting is striking. Dark branches on the ground on the lower left resemble the converging straight lines in a perspective diagram. Their function is to ensure that the viewer experiences the foreground of the painting as three-dimensional. The smooth trees, lit strongly from the side, reiterate the three-dimensionality of the foreground, although they still serve as a screen through which one sees farther into the distance. In contrast to earlier screens of trees, this one allows the viewer to experience both the three-dimensionality of the foreground space and the vast expanse of the distance.

The purpose of this transformation of nature through preliminary studies and sketches was to arrive at what Harris called "purity of creative vision" (15).[4] He saw this process as the artist's task, because "vision is clarified in the process of expression" (17). The changes between the sketch and the finished painting illustrate his theory in practice. The suggestions of timelessness and stillness on the one hand, and the immediate reality of the foreground landscape in the vast expanse of space on the other, recall another of his theoretical and religious reflections:

> From every moment of time something different, unique and illuminating can be said about the whole sweep of eternity. From out every environment can speak voices that express the totality of experience. So it is that art at times makes the moment eternal and the locality infinite. This is its function. Any moment, any place can be the starting point for its [art's] flight into the illimitable. (9)

In *Above Lake Superior,* Harris saw himself painting a regionalist, local subject and at the same time presenting, through the carefully presented wide and deep spaces, the universal, spiritual context. He wanted his viewers to experience both the familiarity of the trees, rocks and snow, and also to "adventure into the unknown, where greater and greater amplitude of life awaits us" (5). In his art he strove "to stimulate and fuse the two great moods of complete at homeness and a great and abiding homesickness" (10).

Although Harris responded to the landscape of the North Shore of Lake Superior with new approaches in his painting, these approaches show the influence of Tom Thomson. Thomson's *Burnt Land,* which Harris had owned for years, depicted dead trees silhouetted against a distant, simply painted row of hills and the sky. One of the important differences between *Burnt Land* and *Above Lake Superior,* however, is that Thomson's tree-trunks, although sloping this way and that, are roughly textured and straight. The trees in Harris's painting have smooth surfaces and curving contours. In most instances, the curving contours of Harris's trees echo the works of Leistikow and of some of Leistikow's *Heimatkünstler* colleagues in the Berlin Secession.

On the other hand the vast spaces that Harris began to depict with his Lake Superior works took, I believe, their inspiration from Harris's memory of the works of Caspar David Friedrich. Similarities with Friedrich's works recur from this point in Harris's development until his last landscape works.

The unusual qualities of Harris's *Above Lake Superior* were remarked on by some of his contemporaries. Hector Charlesworth, the major critic of the Group of Seven, wrote: "*Above Lake Superior* has the morbid, sinister qualities one finds in the drawings of William Blake, with its uncanny arrangements of stripped dead trees set against a sullen background."[5] Harris was certainly aware of Blake and owned books about him. His interest was probably prompted by Blake's theosophical speculations and the popularity these

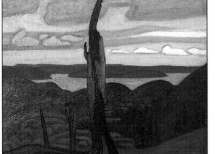

Figure 8.2
The Grand Trunk, c. 1925
Oil on board
28.6 x 36.8 cm
Private collection

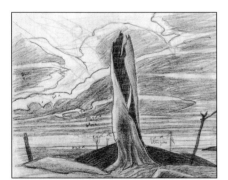

Figure 8.3
North Shore Lake Superior (Drawing), c. 1925
Graphite on wove paper
19.2 x 25.4 cm
National Gallery of Canada, Ottawa
Gift of Lawren P. and Anne Harris,
Sackville, N.B.,
in memory of Lawren S. Harris

had with W. B. Yeats, well known as a theosophical poet.

In commenting on the same showing of the work in 1924, the reviewer for the *Mail and Empire* wrote:

It is one of those paintings in which the work of Mr. Harris makes one think of Rockwell Kent on account of the simplicity of the design and the use of colors … The use of light in this picture, especially on the snow-covered tree trunks, is extraordinarily effective. It is the sort of painting that only a master of the brush like Mr. Harris could achieve. In it you feel the vital north country air. It is one of the finest efforts shown by Lawren Harris in recent years.[6]

The parallel to Kent's work noted by the reviewer holds if one compares the treatment of the sharp contours of the flattened hills in Kent's 1922 *Tierra del Fuego* with the similar sharpness of contour of the flattened hill in *Above Lake Superior*. Harris owned photographs of *Tierra del Fuego* and other works by Kent. The resemblance of their work went beyond formal considerations: Harris and Kent had similar ideas on the spiritual meaning of the northern wilderness. The reviewer, with his comment on "the vital north country air," shows that he himself accepted what had become a pervasive Canadian myth about the North.

In 1926 Housser discussed *Above Lake Superior* at length. He gathered together several comments:

People either love it or hate it. When Leon Bakst the Russian artist saw it he exclaimed "It is not painting, it is sculpture." An Oxford Ph.D. [*sic*] described it as "a horror." A little Irish woman spoke of it as "The Place Where the Gods Live." One man said that Harris should have been locked up for painting it. Another referred to it as a picture of "The Top of the World."[7]

What prompted Bakst to dub the work "sculpture" is probably the way that the solidity of the smooth foreground trees is exaggerated by the light coming from the left. One becomes immediately aware of the illusion of their three-dimensionality, as though they were smoothly carved and polished figures. Housser understood Harris's ideas well, for he too belonged to the Theosophical Society. He interpreted Harris's work as that of a modern mystic who was attempting "to express through painting, moods reached through mystical experience." Like Harris, he believed that art revealed meanings in nature beyond those graspable in the particularities of a specific locale. Through this or that landscape and its summary forms one could enter the landscape of the whole northern region and, further, into the "infinite unfathomable thing, – the wilderness."

North Shore, Lake Superior *and the Symbolism of Light*

Another painting that is both regionalist and idealist is *North Shore, Lake Superior* (Plate 24). A. Y. Jackson was with Harris when he found the stump featured in the painting: according to Jackson, it was nowhere within sight of the lake.[8] Yet one can see the lake in the earliest version of the work that I have located, *The Grand Trunk* (Fig. 8.2). This subject undergoes various compositional simplifications and rearrangements. A pencil drawing, *North Shore, Lake Superior* (Fig. 8.3) is close to the final sketch for the painting. In both of these the numerous hills in *The Grand Trunk* have been reduced to one, centrally placed in the background, and the clouds and the sky are close to the way they appear in the final work. The tree is closely observed in the drawing; there Harris records the curving split in the far wall of the burnt-out stump, as though he saw a potential in this naturalistic detail that he later discarded.

Like the tree trunks in *Above Lake Superior*, the trunk in *North Shore, Lake Superior* is strongly lit from the side, exaggerating the three-dimensionality. Its hollowness is also

clearly felt. The horizon line is lower than in the previous painting, and the bulky clouds are arranged in a triangular mass, leaving the upper left corner of the painting free of them. In the final sketch and the finished painting, slanting rays of light are descending from that corner toward the tree.

This visible presence of the light is one of the important aspects of the painting. In Harris's book of poems, *Contrasts,* light is frequently a major theme. An optimistic poem titled "Darkness and Light" contrasts the weakness of the dark with his ecstatic view of the mystical power of light:

> Now light
> Is just the other way.
> It cannot be fingered,
> It is so fine.
> It must be taken at the flood
> When it smooths through the soul
> In a glittering, loved exaltation,
> Leaving reflections of beauty,
> Leaving warm memories of ecstacy,
> Stirring to love-longing the great freedom –
> And light has no weight,
> Yet one is lifted on its flood,
> Swept high,
> Running up white-golden light shafts,
> As if one were as weightless as light itself –
> All gold and white and light.[9]

Harris was of course writing about the effects of light on people. In another moralizing poem in the same collection, Harris wrote that as long as any "rancour / Flushes the soul" there could be

> No music
> Quickening into gold-singing flame
> All heart homesickness
> 'Till darkness burns out,

> Leaving the soul Transparent,
> Full-receptive
> To all radiance.[10]

The dead trees, stripped of branches and foliage and occasionally hollowed out by fire, further smoothed of bark by frosts and the almost arctic winds, assembled and positioned carefully by Harris in works that stress depth and breadth of space in very simple presentations, symbolize human beings. Harris, as his poetry testifies, believed humanity to be subject to destructive yet purifying forces. Pictorially, the light stresses the three-dimensionality of the tree trunks. On the symbolic level, the light reveals and contributes to the transformation of receptive groups and individuals. The main reference in *North Shore, Lake Superior* is probably to Harris's personal journey through the depths of suffering in his nervous breakdown and his gradual healing. Just as the tree in the painting stands as the carrier of such meanings, so Harris saw himself as the bearer of meaning, the Canadian artist-poet-seer, "Full-receptive / To all radiance" emanating from the transcendent "higher world." His "great struggle" was to give "form in the outer world" to what he had "seen and felt and known" (1).

North Shore, Lake Superior is another mature landscape work that recalls aspects of the German art that Harris had experienced in Berlin. The centrally placed, curving tree trunk in Harris's painting is similar in this regard to the main tree in Otto Modersohn's *Autumn on the Moor* (Fig. 2.9) of 1895. A similar work, likely to have been a stronger presence in Harris's memory, is Friedrich's *The Solitary Tree* (Fig. 2.14) of 1822. In this work, the centrally placed tree is very large and dominates the valley. Friedrich has stressed its importance by silhouetting it against the bands of sunlight and shadow in the valley, the grove and the farm buildings, the distant village with its church spire, the simple forms of the mauve-grey mountains and the bright area of the clouded sky. He has also increased the emphasis on the tree by having a break in the mountains where the tree crosses them.

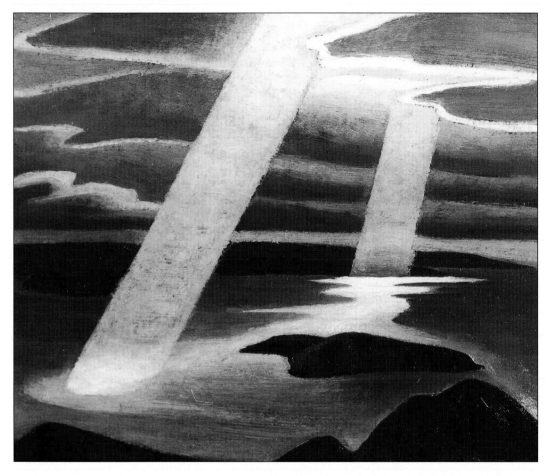

Figure 8.4
Lake Superior Sketch LI, c. 1923
Oil on board
30.5 x 38.1 cm
Art Gallery of Windsor
Gift from the Douglas M. Duncan
Collection, 1970

the foreground, flanked by two smaller stumps and a sheep. The stumps are silhouetted against a calm body of water and a row of dark hills and distant, white-topped mountains. The largest tree stump, like Harris's, is lit from the left. Its placement may well have been a source for *North Shore, Lake Superior*. Other contemporary American artists were interested in modernism combined with the representation of natural though simplified forms. Such painting has been referred to as the American tradition of "Cubist-Realism."[12] Harris's work recalls that of a leading painter of this movement, Georgia O'Keeffe, especially her use of precise lines and simplified surfaces as in her pastel *Single Alligator Pear*. Harris owned photographs of this work and five others by O'Keeffe.

Other Lake Superior Themes

Although most of Harris's Lake Superior works do not show the light in rays as *North Shore, Lake Superior* does, at least two others do make use of this image. In *Lake Superior Sketch LI* (Fig. 8.4), c. 1923, simplified forms depict a vast view of the lake from a high vantage point overlooking Detention Island. Harris has painted a fleeting natural occurrence, clouds separating so that isolated rays of light break through. The breadth of the view gives it a monumental character. Given Harris's ideas on the spiritual meaning of light, the picture is probably heavily symbolic and parallels images from his poetry. In *Lake Superior Sketch XXXIX*, c. 1927, the light source is above the centre of the painting. The rays of light descend in symmetrical wavelike formations, lighting each of the slender dead trees on the side facing the centre, emphasizing their three-dimensionality. The variety of twisting forms in these trees suggests the chaotic sufferings of human beings. The projection from the central, transcendent source brings light, spiritual healing, balance and order.

Harris too has emphasized the centrally placed tree in *North Shore, Lake Superior* by the symmetrical arrangement of the landscape elements that surround it and against which it is silhouetted. The trees of the two paintings are also similar in their curving, anthropomorphic shapes. Friedrich's tree is dying near the top and has lost some of its branches; Harris's is completely dead. On the anthropomorphic level, Friedrich's tree is wounded,[11] Harris's is dead and still being transformed.

Among Harris's thirteen black and white photographs of works by Rockwell Kent was *Summer, Alaska* of 1919. In this landscape, a large, centrally placed tree stump dominates

Another subject that Harris treated over and over during his Lake Superior period was Pic Island. This island is seen

through dead trees silhouetted against a hill in the sketch of about 1922, *North Shore, Lake Superior, Pic Island* (Fig. 8.5). This brown tonal painting was probably done as a result of the first trip to the area. Later works isolated the various themes. Harris frequently painted the island from a very high point of view, as in the large *Pic Island* (Plate 25) of 1924, the best-known of the series. In this work, the hills all have the same rich brown colour and smooth surface, their contours presented as fluid continuities. The island floats on the shimmering surface of the lake, which is cream-coloured and grey. Across the bottom of the painting (the plane closest to the viewer) is a deep blue-green range of forms that could represent low hills. The lines separating these forms suggest sight-lines or orthogonals that would meet in space before the island, a device Harris had used in such earlier paintings as *Wood Interior, Algoma, No. 2* and *Above Lake Superior,* which makes the island appear to be in another layer of space. The sky at the top of the painting is painted smoothly, as are the strongly modelled clouds, and is in dark tones of blues and greys, so that the island and the lake surface are framed by the dark shore and sky. The island is also made prominent by large curving shapes on the surface of the water, which create tension with the curve of the nearer shore of the island. The bands of colours in the sky and the bottom contours of the clouds are similarly curved, and similarly in tension with the hill forms of the island, especially the tallest form that intercepts them. Finally, Harris has treated the light in the painting in an unusual way. From a source beyond the upper left of the painting, the colour of the sky in that area is lightened, while highlights play on the upper level of clouds. But the strongest light emanates from within the island itself, the source shielded from the viewer's eyes by the tallest hill. This light highlights many of the forms on the island and creates an aura or nimbus around the highest peak. By giving the island its own interior light, Harris may have been consciously creating an image that expressed his ideas on nationalism. The island, crouching animal-like on the sur-face of the lake, could symbolize Canada, with the interior light suggesting the creative energy and vision that Harris claimed Canadians should believe that they possessed. As he put it in "Winning a Canadian Background" in 1923, he saw hidden in the Canadian people "unsurpassable glories, capacity for high achievements, aspirations so tremendous that they could force us to scale the heights of all being, shirking no difficulty … nor fearing great beauty."[13]

A work with a different subject that went through many transformations was *Ice House, Coldwell, Lake Superior,* first exhibited in the sixth Group of Seven exhibition in February 1928. It was probably finished close to that date, although it was based on sketches from about 1923. A comparison with the sketches shows that Harris has greatly simplified the landscape elements and has exaggerated the irregularity of the forms of the buildings. The firm contours and the three-dimensionality of the waves, buildings, hills and clouds, intensified by the strong sidelight, relate this work to his other Lake Superior paintings. The clear curving contours of some of the architectural elements and the twisting volume of the ice house recall Georgia O'Keeffe's nearly contemporary Precisionist treatment of the adobe architectural forms in her *Ranchos Church* of 1930. Like O'Keeffe, Harris wanted to reduce the shapes of objects to their essential forms so that a picture would suggest a universal meaning. The painting thus became "dynamic, a bridge" between particular experience and universally valid spiritual meaning, between the "realism of the spirit" and the "realism of the flesh," between the artist and "the spirit of mankind."[14]

A contemporary of Harris, Marcus Adeney, who like Harris and Housser belonged to the Theosophical Society, commented on *Ice House, Coldwell, Lake Superior* in a way that shows his appreciation of Harris's spiritual aims:

Here the shock of contrast between our expectation of sentimental associations and the wisdom of a stark solitude is in no way relieved. At first we seem to encounter death itself. But … It is death as

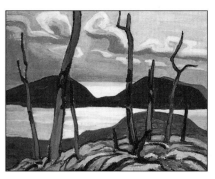

Figure 8.5
North Shore, Lake Superior, Pic Island, c. 1922
Oil on board
27.3 x 35.2 cm
Private collection

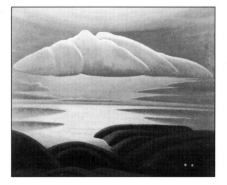

Figure 8.6
Untitled (Clouds, Lake Superior), 1923
102.5 x 127.6 cm
Winnipeg Art Gallery
Gift of Mr. John A. MacAulay, Q.C.

it would appear to eyes that have passed beyond death ... Here is a vision of single, shouting reality in which life and death as we know them have appeared to God during countless ages before the various forms of life had evolved, each with its private and shifting scale of values; the world as it was and as it will be, as it must be even today, regarded in the light of eternity. Here the soul of a man may become one with the Everlasting, beyond sentiment, beyond good and evil, beyond victory and defeat, beyond death itself ... [Harris's] works should be contemplated in silence and immobility: only thus do they become comprehensible.[15]

Lake Superior III

Many of the sketches and some paintings resulting from Harris's trips to Lake Superior are undated. One of them is *Lake Superior III* (Plate 26) which was first shown in the sixth Group of Seven exhibition of 1928. It is typical of Harris's late Lake Superior works in that the dead trees are very slender, and are modelled by the light, which comes not from above but from the lower right. The other foreground elements – highly simplified in both colour and shape – are similarly though less emphatically modelled, recalling the three-dimensional foreground elements in such works as *Above Lake Superior*. The breadth and depth of space are presented through the distant, low horizon line, through the diminishing size of the clouds on the left, and through the careful modulations of colour in the smoothly painted sky.

The trees, with their suggestive, anthropomorphic shapes, represent humans, as they bend or lean toward the light. In this sense they differ from the static trees in *Above Lake Superior* and *North Shore, Lake Superior*. *Lake Superior III* is also asymmetrical, whereas in the earlier Lake Superior works a sense of stasis and clarity is achieved in part by the symmetry of the compositions. This change represents a pictorial expression of an aspect of Harris's thought

that had emerged earlier in his writing. One of his often repeated ideas was the notion that there is no "finality." He wrote in 1925 that there was none in either art or the function of "all the soul's powers." In 1930 he wrote to Emily Carr: "There is no finality, no absolute standard, no infallible judge." A few months later he elaborated his ideas for Carr: "There is no realization, only moments toward realization – the beckoning of all satisfying completion, fulfillment. Something indeed that we cannot attain individually, separately, but only as the complete spiritual solidarity, mankind. But strive we must. All art is but intimation."[16] It is this sense of the need for continual development that I feel is exemplified by the contemplative image of movement in *Lake Superior III*. Not only are the trees in this painting the image of people who are receivers of light, but they are moving, as Harris believed he was himself, toward the source of light.

"There is no finality" was also one of the aphorisms of Paul Thiem, whom Harris had met in Germany. Thiem's phrase was: "Finality in art is a pleasant lie. The deepest art is incomplete, and must be so."[17]

Although few people shared Harris's mystical vision in the way that theosophists Housser and Adeney did, not all the other commentators were hostile. Harris's friend and colleague in the Arts and Letters Club, Augustus Bridle (along with others) found Harris's Lake Superior works strange but nevertheless beautiful. In reviewing the Group of Seven exhibition of 1928, in which Harris first showed *Lake Superior III*, Bridle wrote, "Space and time to Harris are the mother of colour and form. He might explain this religiously. I might call it transcendentalism; others – bunk. But it is all despairingly beautiful and inhuman."[18]

Transformation of Style and Content

The extent of the transformation in Harris's painting can be seen by comparing an oil-on-board sketch done early in his Algoma period, *Agawa Waterfall* of 1919 (Plate 27), with

the finished painting made from it around 1927, *Algoma Waterfall* (Plate 28) of around 1927. The larger painting (87.6 x 102.9 cm) is not only simpler in its forms, eliminating the particularity of the site and the complexity of the surfaces of the water, foliage and rocks, it is more deliberately three-dimensional. The rocks are smooth, carefully lit and modelled. Even the fluffy foliage in the upper right corner of the small painting has become three-dimensional and solid in the larger one. The wilderness wall in the smaller painting, revealing parts of trunks of slender white trees and foliage, is reduced in the larger painting to two dark, cave-like recesses. The colour too has been changed a great deal. In *Agawa Waterfall*, the rough brushwork is in browns, greens, yellows and white. Some of the paint has been applied in dots or small strokes that function in a representational manner, for example, in the leaves floating on the water. The impression conveyed by the colour is one of warmth, variety and liveliness, which suggests the scattered, splashing sound made by the waterfall. The larger painting, however, is mainly blue, with some dark greens for the foliage. The white of the waterfall stands out emphatically against these darker tones. The smaller painting captures a many-faceted and particular moment in Harris's wilderness experience, whereas the agitated moment is stilled and monumentalized in the larger painting. The sense of monumental stillness should be understood in the light of Harris's wish that his work would have "the inner serenity that lifts all worthy work above the accidental, the clever and topical and local and intimate and ephemeral" (10). All these adjectives could be applied to the scene in *Agawa Waterfall*. Through the transformation that led to *Algoma Waterfall*, Harris created a work that embodied what he called in "Art Is the Distillate of Life" "the great and lofty mood of timelessness" (10).

A close view of a forest waterfall lends itself less easily to such monumentalization than dead trees against a flattened hill and a low horizon line, as in the Lake Superior works. In accepting the challenge, Harris could well have been thinking of another statement from his transcendental theory of art: "So it is that art at times makes the moment eternal and the locality infinite" (9).

The Lake Superior Paintings of Harris's Colleagues

Both the Lake Superior terrain and Harris's interpretation of it affected his colleagues' styles. In Jackson's earlier Lake Superior works, such as *Lake Superior Country* of 1924, one can recognize the distinctive contours of the Lake Superior hills in the background. This large painting (117 x 148 cm) is composed of layer after layer of trees silhouetted against richly painted open spaces and the distant hill and roughly brushed sky. Three aspects of the painting make it very different from Harris's contemporary Lake Superior works. First, the brushwork is lively and vigorous. Second, the colours are vibrant and exciting, with combinations of yellows, purples, reds, browns and many greens. Third, it contains many living trees: none of them are dead, as are almost all the trees in Harris's Lake Superior works. Whereas Harris's art changed when he began painting the North Shore of Lake Superior, Jackson, at this stage, remained committed to the vigorous brushwork and high-keyed colour of his earlier works. Jackson's later Lake Superior works did change, however. His *North Shore, Lake Superior* of 1926 (Fig. 8.7) shows a point of land bare of trees overlooking the lake, which is in greys and pale browns. These subdued effects resemble Harris's painting, but the differences remain. The brushwork is still much livelier than Harris's and the colour is brighter. The warm brown hills are painted with the wide, rhythmically curving and interlocking lines that were becoming a Jackson trademark.

Lismer's *October on the North Shore, Lake Superior* of 1927 (Fig. 8.8) contrasts the green-blue water of a small lake or inlet with the roughly painted view of a wide hilly area. As is typical of Lismer's works, the forms in the painting are complicated and entangled. In this, and in the richness of

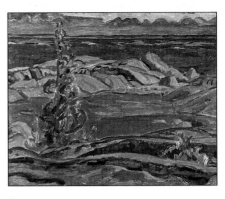

Figure 8.7
A. Y. Jackson
North Shore, Lake Superior, 1926
63.5 x 81.9 cm
Private collection

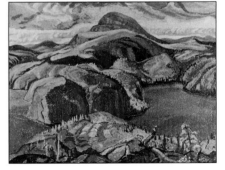

Figure 8.8
Arthur Lismer
October on the North Shore, Lake Superior, 1927
122.4 x 163.3 cm
National Gallery of Canada, Ottawa
Courtesy of Mrs. Marjorie Lismer Bridges

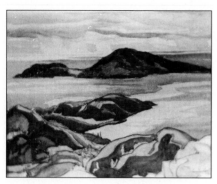

Figure 8.9
Franklin Carmichael
Lake Superior, 1925
Watercolour
24.1 x 30.5 cm
Private collection

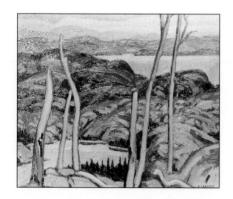

Figure 8.10
A. J. Casson
Lake Superior, 1928
Oil on cardboard
23.8 x 28.4 cm
Art Gallery of Ontario, Toronto
Gift from the Fund of the T. Eaton Co.
Ltd. for Canadian Works of Art, 1952

the palette, Lismer's Lake Superior work differs noticeably from Harris's.

Carmichael's 1925 watercolour *Lake Superior* (Fig. 8.9) shows a treeless view of an island, probably Pic Island. In its simplicity, it resembles some of Harris's works such as *Pic Island*. The subtly painted, clouded sky with its several shafts of light breaking through, the variegated surfaces of the island and the point of land, and the complexity of the foreground details reveal Carmichael as an artist with a stronger commitment to naturalism than Harris.

Although the painting is dated 1928, the foreground of A. J. Casson's oil sketch *Lake Superior* (Fig. 8.10) closely resembles Harris's *Above Lake Superior* of about 1922. The row of dead, barkless trees of varying shapes and sizes and the fallen trees on the ground emphasize the three-dimensional qualities of the foreground layer, and show the strong influence of Harris's work. Nevertheless Casson's work differs from *Above Lake Superior* in three ways. The hills in the middle distance are painted roughly, unlike the smooth treatment of the hill by Harris. Instead of Harris's layered composition, these hills form a gradual bridge to the more distant hills at the horizon line. Despite the strong similarity of the foreground area, the trees in Casson's painting are not lit with dramatic sidelighting, but with the natural, diffused light of a cloudy day.

The camaraderie that had been a feature of the wilderness sketching trips to Algoma continued through the Lake Superior period. The Group still shared the commitment to the Canadian wilderness and even to exploring new regions of it. But there was now a difference. In his reaction to Lake Superior, Harris had discovered a way of painting that distinguished him from his colleagues, a way that helped, for a time, to quench his thirst for images of deeper, spiritual meanings. His spare style of composition, restricted palette and smooth brushwork probably did influence the way some of his colleagues painted. However, these were, especially with Jackson, temporary modifications of their personal styles. In none of the Lake Superior works by Harris's col-

leagues is there a sense of mystical or theoretical meaning. They were responding in more relaxed, naturalistic ways than Harris to the sites, revealing their personal attitudes in their brushstroke, colour and composition. If we follow Harris's development – from the painterly enthusiasms of his early Algoma sketches like *Wood Interior, Algoma, No. 1*, to the quiet contemplation of movement in *Lake Superior III* – we see that more and more, through simplifications of form and composition, and a growing smoothness of brushstroke, he was creating paintings that expressed his belief that art should strive to be impersonal,[19] that traces of the individual artist should disappear in deference to the creative spirit that inspired him and to the universal statement the painting should be making. It is one of the ironies of Harris's career that in his late landscapes he produced an art that is patently stamped with his particular mystical and theoretical personality.

Wilderness Landscapes and the Regionalist Tradition III
The Rockies and the Arctic
A New Personal Crisis

PAINTINGS OF THE ROCKY MOUNTAINS, 1924–29

The transformation of the regionalist tradition that had progressed so decisively through Harris's Lake Superior paintings continued in his paintings of the Rocky Mountains. Nowhere in his work is the transformation from particular, complex perception of the site to rarefied, simple forms more traceable than in some of his mountain landscapes.

Although the Canadian Rockies had been painted earlier it was not until the 1880s, when the Canadian Pacific Railway was completed, that they became widely accessible. The same businessmen and politicians who had built the railway sponsored Canadian painters, sometimes by giving them free passage through the Rockies in return for paintings, at other times through outright commissions. Views of mountains, it was judged, were in the "national interest,"[1] because they would help advertise the beauties of the mountains and attract tourist business for the railway and the Canadian Pacific Railway hotels.

Because of this patronage, the Rockies became enormously popular with painters, and "C.P.R. artists" continued to work through the 1890s and into the early years of this century. The two painters who benefited most from the early

phases of this patronage were Lucius R. O'Brien (1832–99) and John A. Fraser (1838–98). O'Brien's 1887 watercolour, *Through the Rocky Mountains, A Pass on the Canadian Highway* (Fig. 9.1), embodies some of the possessive optimism of Canadian national policy at that time. In the painting, nature has been conquered by the financiers and their engineers, who have spanned the gorge in Kicking Horse Pass with a complex trestle. The two-engine train on the trestle is pulling itself up a steep gradient. The white-plumed engines are framed by the mist-shrouded peaks, the turbulent river and stands of evergreens and foreground stumps that echo a European pictorial tradition going back to Salvator Rosa.

The sponsorship continued at least until 1914, when A. Y. Jackson, C. W. Jeffreys and J. W. Beatty were hired by the Canadian Northern Railway to paint scenes of its new Yellowhead Pass line. By then such paintings were anachronistic, and would not have been painted, as Reid pointed out, unless the railways had been paying for them.[2]

Harris's First Trip to the Rockies, 1924, and Maligne Lake, Jasper Park

Ten years later, and again in the interests of a nationalist art, A. Y. Jackson accompanied Harris on a sketching trip to the Rockies. At first Harris was disappointed:

Figure 9.1
Lucius O'Brien
Through the Rocky Mountains, A Pass on the Canadian Highway, 1887
Watercolour
103.2 x 69.2 cm
Private collection

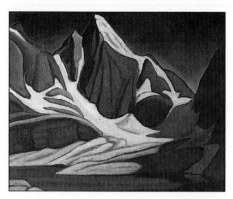

Figure 9.2
Lake Oesa, Rocky Mountains, c. 1925
Oil on board
29.8 x 38.1 cm
Private collection

When I first saw the mountains, travelled through them, I was most discouraged. Nowhere did they measure up to the advertising folders, or to the conception these had formed in my mind's eye. But, after I became better acquainted with the mountains, camped and tramped and lived among them, I found a power and majesty and a wealth of experience at nature's summit which no travel-folder ever expressed.[3]

Harris's response to the mountains was deeply emotional. His friend B. C. Binning, a painter and a long-time teacher at the University of British Columbia in Vancouver, accompanied him on mountain-climbing expeditions. He remembers that, after one long and arduous climb, Harris was deeply moved when he finally reached the peak; in a trancelike state, he experienced glossalalia, and began an ecstatic, unintelligible chanting.[4]

In the late summer and early fall of 1924, Harris took his family on vacation to the Rockies, accompanied by Jackson. They stayed at the lodge in Jasper Park. Not finding the area near the lodge good for sketching, Harris and Jackson went on foot and on horseback, at times with a guide, southeast from Jasper to Maligne Lake, east to the Collins Range, and then north about twenty miles to the west of the Arthabaska River in the Tonquin Valley. On these trips they tented or stayed in cabins. Jackson described one of the nights they spent with the Warden of the Tonquin area:

The Warden's name was Goodair: He was far from friendly, and made it quite clear that he did not like intruders among whom, obviously, he numbered us. After supper there was some desultory conversation in the course of which Harris asked Goodair what he did in the wintertime. Goodair replied that he went to Edmonton where he spent most of his time in the library. When Harris asked him what he read,

he replied that he was most interested in history, biography, and theosophy. Harris was a theosophist and soon they were deep in a discussion of all the books they had read on the subject. After that evening we would have been welcome to stay a month with Goodair.[5]

Harris later described another experience of that first trip. His account reminds us that his sophisticated mystical interests were juxtaposed with the practicality of the seasonal wilderness man that he believed the Canadian artist had to become:

Sometimes we camped in order to sketch in more remote mountain country. In September ... we made a camp high up on the east side of Maligne Lake. We had spent a week there a month earlier and had then blazed a trail to this site. We started early in the morning to tote our bed rolls, small tent, sketching material, and food for ten days up to this spot. The going was tough and so it was not until late that same evening that we were settled. We pitched the tent just above the timber line on sloping ground, there being no level location. I built up a pile of crossed sticks under the foot of my bed roll so that it was level. Jackson did not bother to do the same; he simply crawled in and went to sleep. Next morning at sunrise I awoke and glanced over to where Jackson was when last I saw him. He was not there; neither was his bed roll ... I looked out of the tent flap and there he was twenty feet below, pulled up against a rock, buried in his bed roll, still fast asleep.[6]

Harris visited the Rockies every summer until 1928, though never with another painter from the Group. His commitment to the mountains was a conspicuous one. Articles critical of the Group's exhibitions sometimes made fun of his single-

mindedness and the unusual mountain forms it produced. Lismer's pair of cartoons (Plate 35) reminds us that, for all Harris's high seriousness about art and his own painting, within his circle of friends there was humour and camaraderie. And Harris seems to have welcomed it, since these framed cartoons come from his own collection.

There is a restlessness in Harris's mountain landscapes, shown not by changes in the sites painted but by changes in the ways he chose to paint them. These changes are particularly evident in the large, finished paintings, which display a variety of experiments that stopped only with the intense simplifications of *Isolation Peak* (Plate 29, Fig. 9.4). Many of the smaller oil-on-board sketches, like *Lake Oesa, Rocky Mountains* (Fig. 9.2), *South End of Maligne Lake* and *Lake Edith, Jasper* are naturalistic in their greater complexity of forms and spaces. Harris had abandoned the painterly sketching style he used for the Algoma paintings, and the oil-on-board sketches of the mountains already show efforts at simplification of form and composition. His many sketchbooks contain hundreds of drawings of the mountains. Most of these drawings, especially in their earlier versions, are more detailed and naturalistic than the sketches, for example, *Isolation Peak* (Fig. 9.4).

Although most of Harris's better-known mountain works date from the 1927–30 period, one of the most memorable is *Maligne Lake, Jasper Park* (Fig. 9.3), which dates from his first sketching trip in 1924. The sketch that immediately preceded the painting is *Maligne Lake*. Although most of the elements in the finished painting are present in the sketch, there are interesting differences. Harris has eliminated the central, distant peak shown in the sketch from the final painting. The contours in the sketch are roughly painted, and are less sharp than those in the finished work. The extraordinary sense of stillness exuded by the larger painting was achieved in several ways. One of the most important is the still surface of the water reflecting the other forms, an image echoing one of Harris's illustrations for the "Spiritual" section of *Contrasts*.[7] Only totally still water will

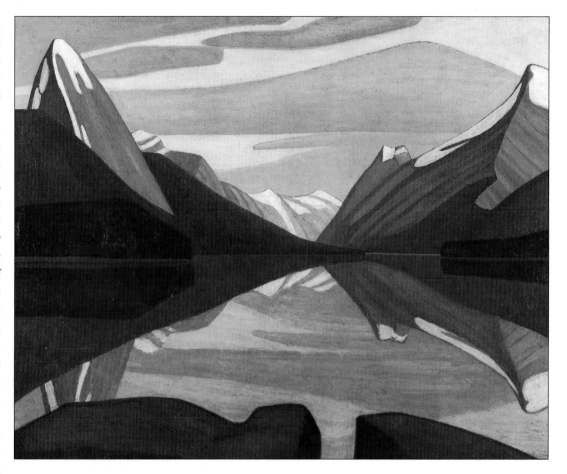

mirror its surroundings so perfectly. The contours and surfaces of the mountains have been simplified and smoothed out, achieving a monumentality of proportion that they lack in the sketch. Colour too is very important for this sense of stillness. The greys and blues in the painting are carefully balanced so that no area in the work draws attention to itself or conflicts with other colours. There are two symmetries in the painting, one vertical and one horizontal. The large mountain forms on the right and left are equal in mass and strength, although their shapes are different. There is also a horizontal line of symmetry: the far shore of the lake, below which the mountains are reflected. The forms in the

Figure 9.3
Maligne Lake, Jasper Park, 1924
122.8 x 152.8 cm
National Gallery of Canada, Ottawa

Figure 9.4
Isolation Peak, Drawing, c. 1930
Pencil
19.4 x 25.4 cm
Dalhousie University Art Gallery
Permanent Collection

foreground of the painting are solidly and blatantly three-dimensional, and arranged so that the viewer experiences depth in the immediate foreground area. Forms with similar functions appear in some Algoma and Lake Superior works like *Above Lake Superior* (Plate 23). In *Maligne Lake, Jasper Park* the forms are different in colour – green – from the rest of the painting, the difference reinforcing the sense of other-worldliness conveyed by the work. Through colour, composition and component forms, Harris has created a work whose stillness is so absolute that it suggests something beyond nature. He seems to have striven to express his ideas that a painting should cause "the wildly active surface of life to be forgotten," and should also "still the little agitations of the soul" so that the viewer could "glimpse the simple and noble serenity of all eternal ways" (10).[8] Thus art could penetrate "the confusing, shifting and ephemeral veils of nature to the great simplicity and grandeur of her eternal forms" (21). In comparison with *Maligne Lake* and especially with *South End of Maligne Lake,* also a sketch-size work, the large *Maligne Lake, Jasper Park* is simplified. However, compared with later works such as *Isolation Peak, Maligne Lake, Jasper Park* keeps fairly close to natural forms.

Unlike Lucius O'Brien's mountain paintings, which celebrated the conquering of nature by man, Harris's *Maligne Lake, Jasper Park* expresses quiet yet intense contemplation. If Harris's approach to painting the Rockies is very different from O'Brien's, it has resemblances to the painting of his American contemporary Rockwell Kent, who shared Harris's belief in the spiritual meaning of the wilderness. Kent (for longer periods) and Harris (for shorter but regular periods) fled from the triumph of technology and from urban life to the tranquilities of undisturbed nature. Their paintings of mountains and hills reflect this orientation with similar formal means. Like Harris in his slightly later works, Kent simplified the mountain forms and surfaces. In his 1919 *Bear Glacier, Alaska,* of which Harris owned a reproduction, the peaks across the back of the painting are presented as smooth, almost pyramidal forms. Their contours are precise

against the sky, as are those of *Maligne Lake, Jasper Park.* However, Harris's mountain forms, though simplified, are more three-dimensional, and the Kent work lacks the sense of stillness and control created by the nearly geometric symmetry and the reflection on the surface of the lake in Harris's painting.

Isolation Peak, *c. 1930*

Harris continued his sketching in the Rockies each summer until 1928, always following the same method. He did many pencil drawings of the mountains, often quite detailed and naturalistic. These were followed by oil-on-board sketches that already reveal the strong sense of simplification and stylization found in the larger oil-on-canvas works. Harris's major canvasses from this period are among his most impressive landscapes. I have been unable to find any statement by Harris from this period on the meaning the mountains had for him, but his friend and fellow theosophist, F. B. Housser, writing in 1927, gives us a clue to their meaning for Harris and the theosophical community:

> Across the northern regions of Canada and down through the Cordilleran area of the North American continent, that area comprising the ridge known as the Rocky Mountains, are sacred and occult centres of the earth. The most ancient traditions of the North American Indian speak of them. They are hinted at in the letters of the Mahatmas and by Madam Blavatsky whom we have reason to believe visited some of them. Some time, if not now, these places will likely become active spiritual centres for the development of the promised new race.[9]

Such ideas would have been in Harris's mind as he painted his most impressive Rocky Mountain landscape, *Isolation Peak* (Plate 29). Exhibited first in 1930, it was preceded by many drawings and smaller oil paintings, until at

last he had the simplified light-flooded version that satisfied him. From the pencil-on-paper version (Fig. 9.4) through simpler intermediate variations and through the early oil with its aura of layers of deepening blues, Harris has resolutely transformed the initial, complex perception of particulars to what he would call a universal expression. The sky, a rich blue-green, is brushed on so as to leave the brushwork visible. Combined with the darkness of the colour, the brushwork gives a velvety texture against which the brightly sunlit pyramid-shaped peak stands out with force.

Isolation Peak is not of an actual site, though to judge by the naturalism of the pencil drawing it began as such. Perhaps it was a peak in the Collins Range, near Maligne Lake, but there is no mountain called "Isolation" in the Canadian Rockies. Instead of reducing the mountain to a triangle, as he had done in *Mountain Forms,* in *Isolation Peak* Harris has made it a pyramid with a flat side isolated in the light. The theme of the mountain as the receiver of light is repeated in *Mount Lefroy.* But here, Harris has pushed the simplification beyond any echo of the particular site to a universal form: not a particular mountain, but all mountains.

There are parallels in the painting to a diagram in C. W. Leadbeater's *Man Visible and Invisible,* a theosophical book that Harris probably knew. The triangular face of Harris's mountain juts above its surroundings into the level where it receives the light. In Leadbeater's diagram (Fig. 9.5), as the columns of matter representing "Human" and "Spiritual" reach the higher levels and cross the line into the mental, Buddhic and nirvanic planes, they become triangles, which Leadbeater refers to as "pyramidal figures."[10]

Many late landscape works of Harris also suggest that memories of Caspar David Friedrich's landscape forms, which he had seen in Germany, were emerging frequently in his imagination. So *Isolation Peak* suggests a parallel with Friedrich's *The Watzmann* (Fig. 9.6). Although Harris may not have seen *The Watzmann,* he had an opportunity to see a reproduction of a similar work in 1906.[11] In *The Watzmann* Friedrich has contrasted the white peak of the mountain with

the darker, curving forms of the foreground. In Harris's painting, the mountain peak and the foreground details have been reduced to the pyramidal shape for the peak and to rolling, swirling forms covering many square miles of mountainous terrain. He simplifies nature so that almost all the elements natural to the scene are sacrificed to the spirtualizing vision, an ideal he expressed around this time by saying that art should "penetrate the confusing, shifting and ephemeral veils of nature to the great simplicity and grandeur of her eternal forms (21)." The mountain form not only escapes particular forms and approaches the universal form of all mountains, it has also become the image of man, albeit an exceptional one, reaching into the higher spiritual planes as they are understood in theosophy and becoming the receiver and the bearer of light. Through its simplifications, studied composition and use of light the work has become an expression of Harris's assertion that art should "convince us that there is eternal clarity" (10).

Other Mountain Works

Brazeau Snowfield, Jasper, also done after Harris's first trip to the Rockies, has livelier forms than *Maligne Lake, Jasper Park,* especially in the foreground, and warmer colours. The smaller peaks and rounded hills are brown. There are two areas of green, probably meant to represent wooded areas but so simplified that they are difficult to construe. The sky is a bright, smoothly painted blue. Although this painting has strong forms on the right and left like *Maligne Lake, Jasper Park,* Harris now forces the viewer to see not further mountains but the expanse of sky itself beyond the high horizon line. The unusually shaped, well-defined clouds to the right and left control and intensify this process. This meditative gaze into the infinite expanse from a high vantage point probably represents some aspects of what Harris termed the "experience at nature's summit."[12]

In some of his works, Harris allowed the mountains to be strongly three-dimensional, while in others he flattened

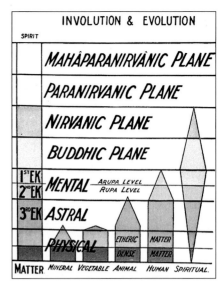

Figure 9.5
C. W. Leadbeater
Involution and Evolution
Plate IV from his *Man Visible and Invisible* (1902)

Figure 9.6
Caspar David Friedrich
The Watzmann, 1824–25
133.4 x 170.2 cm
Nationalgalerie, Berlin

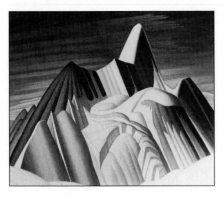

them into mere triangles. Among those that contain flattened images is *Mountains after Rain, Jasper Park* of about 1924, where the mountain peaks are presented as superimposed two-dimensional triangles, similar to the treatment of the peak in *Mountain Forms* about two years later.

Like *Isolation Peak, Mountain Forms,* a very large work (152.4 x 177.8 cm) of 1926, is an image of an imaginary site. Again, stillness plays an important part in the imagery of the work, but here naturalism has been left behind. The still water and the dark low hills are sufficiently three-dimensional to establish a low plane and a horizon line that are overwhelmed by the sudden rise of the mountain form. This exaggeration of height is consonant with Harris's assertion that the Canadian artist was seeking "an intensification of mood," and a "unified, intense expression."[13] The mountain form itself echoes those earlier paintings in which Harris reduced the form to superimposed triangles, though there is a greater three-dimensionality in the triangular shape here. The apex of the mountain bisects the top of the painting. From just above the centre of the frame, two rays of light go to the right and left, as though caused by the mountain piercing the sky. The two sides of the peak are straight lines, making the top of the mountain more two-dimensional. Since this area is light in colour, it tends to advance toward the viewer and so flatten the whole mountain, increasing the sense of height.

When *Mountain Forms* was first exhibited in 1926, the *Mail and Empire* noted that Harris "marches steadily ahead with his process of simplification, so that his pictures are more and more hard sheets of colour." Harris would have been especially pleased with another press comment: "He [Harris] achieves a remarkable structural synthesis and presents landscape purged of its grossness of detail in quintessential symbolism." Someone who was obviously familiar with theosophical literature wrote to the *Canadian Bookman* defending the painting:

Representation is not more indispensable in painting than in music. All truly great art has tended to

depart from it ... the concert-goer is no longer educated to expect the sounds of the barnyard from the Pastoral Symphony ... Surely the high function of both music and painting is to convey an emotion rather than an outward appearance ... A true painting of a mountain is a more or less perfect record of what transpires in the soul ... Consequently, if one elects to feel in Lawren Harris's *Mountain Forms* some profound analogy to these momentary glimpses of that many-coloured land (the Theosophist's seven-layered occult universe) which, in all ages, out of the stillness of meditation, has lifted its celestial peaks against the sombre background of earth-life, it is not because Mr. Harris has set out to preach us this particular sermon, but because ... every natural object has its inevitable spiritual correspondence.[14]

In *Mount Robson* (Fig. 9.7) and *Mount Lefroy* (Fig. 9.8) of about 1930 Harris turned again to decorative devices. These works were probably painted after *Isolation Peak* which, it seems to me, represented a climax of Harris's search for simplification of forms and depth of meaning. But having painted it, he sought other avenues to enrich his mountain painting.

In *Mountain Forms,* which depicts an imaginary site, Harris manipulated the forms to create an exaggeration of height. *Mount Robson,* also a large painting (128.3 x 152.4 cm), shows an actual mountain in Jasper National Park. This mountain was the subject of the six oil sketches that made up Harris's contribution to the Ontario Society of Artists' "Exhibition of Little Pictures" in 1930.

In *Mount Robson,* Harris, in contrast to the flattened shapes of *Mountain Forms,* has stressed the three-dimensional qualities of the peaks, smaller hills, snowfields and glacier forms. The individual shapes have all been changed into geometric forms, as can be seen by comparing the finished painting with one of its preparatory drawings. Harris

has also increased the complexity of some of the forms; for example, the snow formation that arches from the bottom to the centre of the painting is much smaller and simpler in the drawing. Moreover he has added furrows and grooves to the slopes and a row of receding peaks on the left, which, in contrast with the other forms in the painting, have only token modelling.

Returning to the centre of the painting, the viewer sees that the rounded white forms in the foreground are presented as textured surfaces, but do not reveal individual brushstrokes. This is a departure from the Algoma works like *Montreal River* (Fig. 7.7), where individual brushstrokes themselves give the texture of the surface. The snow in the centre of the painting is similarly textured, although it is lit by a warm yellow. Two areas of strong yellow to the right and left of the painting represent lights on parts of the slopes not covered with snow, providing a strong contrast with the dark blue areas of the sky. The final work is emphatically three-dimensional and both more complex and more geometric than the earlier drawing.

In *Mount Robson,* Harris complicated the forms of the mountain by adding the grooves and planes – many of them in parallel sets – that relate the work to the then popular Art Deco style. These additions move the work away from Harris's canon of simplification, creating an ambivalence in the painting: it has both a decorative quality and the seriousnesss that Harris hoped to achieve through his stylizations and simplifications. Why this ambiguity? In the late 1920s, Harris was experiencing uncertainties in his inner, artistic life; he was beginning to feel caught in what he called "solidifying inhibitions." *Mount Robson* probably represented an attempt at a new direction in his painting, a direction with which, since he did not exhibit the work in the 1930s, he himself may not have been comfortable.

Mount Lefroy (Fig. 9.8), which was first exhibited in 1930, shows a mountain near Maligne Lake. The colour contrasts in the painting resemble those used in *Mount Robson.* There is the same range of dark to light blues for the sky and some of the shadows, and a similar bright golden yellow for the highlights on the brown stone, especially on the exposed part of the peak near the top. The richest texture in the painting is reserved for the snow at the apex of the peak. The thickened cream-to-yellow paint extends more than halfway down the right side of the slope, emphasizing the peak itself. This is an image of the reception of light by the peak, which then becomes a light for others to see. It is a Rocky Mountain variation on Harris's theme of the "lover of light."

The repetition of the Art-Deco parallel grooves on the right slope intensifies the verticality of the peak, which, like the one in *Mountain Forms,* almost touches the centre of the top of the painting. The very sharp peak is further stressed by the halolike cloud behind it which has its own aura of receding echoes. Harris has reduced the mountain to a slender, three-dimensional form. An earlier pencil drawing shows that it was broader and had more complex surfaces.

The Group of Seven and the Mountains

Besides Harris and Jackson, Lismer, MacDonald and Varley all tried painting in the mountains, but with the exception of Harris and Jackson on that first trip in 1924, they did not sketch together.

Jackson was not as enthusiastic as Harris about the mountains. To him they were "ancient Chaldean-looking ruins" that had no appeal to him.[15] Lismer went on only one sketching trip to the mountains; like Jackson, he did not enjoy them as a subject, and never returned. MacDonald, on the contrary, liked the mountains and after his first visit in 1924 returned every summer until 1930. MacDonald painted all his mountain works from a low point of view and with very little depth of space; he all but fills the picture area with the mountain. At times he eliminates the sky entirely, as in *Mountain View* (Fig. 9.9).[16] In this he differs from Harris, who painted most of his mountain scenes from high points of view. Harris's vision seems to dominate the mountains in his

Figure 9.9
J. E. H. MacDonald
Mountain View, 1930
53.3 x 66 cm
Private collection

Figure 9.10
Lighthouse, Father Point, c. 1929
Pencil on paper
24.8 x 19.1 cm
Private collection

Figure 9.11
Lighthouse, Father Point, c. 1929
19.2 x 25.3 cm
Private collection

paintings. MacDonald is more accepting of the mountains' complexities, and seems to have looked at them from the point of view of someone who was not a mountain climber as was Harris.

Varley too was interested in the mountains and painted mainly those around Vancouver, where he lived from 1926. His mountain works, like *Mountain Landscape, Garibaldi Park,* present strong, vigorous forms that interlock like animal muscles, quite unlike Harris's images of tranquility. In *The Cloud, Red Mountain, B.C.* of 1927–28, the viewer looks beyond the mountains into a richly coloured sky that recalls Harris's *Brazeau Snowfield, Jasper* of 1924.[17]

LIGHTHOUSE, FATHER POINT

In the fall of 1929, Harris and Jackson went on a sketching trip into Quebec,[18] travelling along the south shore of the St. Lawrence at least as far as Father Point near Rimouski, about 530 km north of Montreal. It was there that Harris made the preliminary studies for his painting *Lighthouse, Father Point* (Plate 31), which was first exhibited in the Group of Seven exhibition in 1930. Harris made his last sketching trips to the North Shore of Lake Superior and the Rockies in 1928, and the trip into Quebec represented a search for new subject matter.

Harris made several preliminary drawings and an oil sketch of the lighthouse. The pencil drawing *Lighthouse, Father Point (Sketch)"* (Fig. 9.14) appears to be a scrupulously accurate rendering of the lighthouse. There is another drawing of the lantern area itself that is equally detailed. This concern for the details of the main structure in the composition reflects Harris's practice of starting from direct observation of nature, which we have seen in his drawings of mountains (Fig. 9.4). The notations on the drawing mainly concern colours and values, although Harris has sketched a partial section of the structure of the building on the upper right. Harris has written just above this diagram, "not round/shaft" (the shaft was hexagonal). On the centre left, he

has written "sharp edge of light," indicating the edge of one of the flying buttresses. Near the top right he has noted "not on centre quite," presumably referring to the lantern section of the lighthouse, which in the drawing is off-centre.

Harris was probably attracted to this motif because of the streamlined modernity of its form. As we have seen, it was important for Harris to be modern. Another reason, however, was probably that the structure was already reduced to its minimal, essential elements: a shaft housing the spiral stair, supported by flying buttresses and surmounted by the lantern. In this already-prepared essential form, the lighthouse resembled the dead trees in the Lake Superior area.

In the finished painting *Lighthouse, Father Point,* Harris has not just simplified the lighthouse, but has made it taller and more slender. With the use of mainly black contour lines on the flying buttresses, he has given the forms an exaggerated clarity and precision. The contour lines also help stress the transparency of the strongly three-dimensional form, which I believe is another aspect of it that attracted Harris. The lighthouse participates in the nearby foreground space, which Harris has presented as strongly three-dimensional, and also in the wider expanse that the viewer perceives in part through the flying buttresses.

The most important step in the development of the painting is from the oil sketch (Fig. 9.14) to the finished painting. In the oil sketch, Harris has silhouetted the lighthouse against a sky with heavily modelled clouds. These clouds are so arranged and lit that a beam from the lighthouse could be illuminating them. In the finished painting, Harris has eliminated the heavy modelling of the clouds: the lighthouse stands not as an emitter of light but as a participant in the light of the sky. This is stressed by the care Harris has taken to bring out the transparency of the top of the lighthouse. No brushstrokes are visible in the sky; its expanse is uninterrupted. This presentation of infinite space was not a feature of the Lake Superior landscapes, nor of the Rocky Mountain landscapes, although Harris had paint-

ed an indefinite expanse earlier, in *Red House in Winter* (Fig. 6.7).

The sky, a soft, subtle, indefinite expanse, suggests, like the movement toward the light in *Lake Superior III* (Plate 26), an expanding, moving spiritual context, not the static, clear presentation of works such as *North Shore, Lake Superior* (Plate 24) or *Isolation Peak* (Plate 29). Harris is moving away from static clarity to an image that suggests there is a mystery about infinity.

The lighthouse is in a soft, cool, indirect light. The combination of the mysterious veil of the sky and the skeletal architecture gives an almost spectral quality to the work. The rather tame highlights in the painting are near the base of the lighthouse itself. The lighthouse is not then an image of man as a light-receiver and bearer as was the mountain in *Isolation Peak*; rather it is an image of man participating in the mysterious half-light of the sky. In comparison to the hard clarity of, for example, *Above Lake Superior* (Plate 23) or *Isolation Peak,* this work suggests the possibility of more light and more development. It may express Harris's desire to transcend the "solidifying inhibitions"[19] that were troubling him. Like *Lake Superior III, Lighthouse, Father Point* expresses in sombre mood that there is "no finality."

With its infinite expanse of sky and similarities in composition, *Lighthouse, Father Point* recalls an important work by Caspar David Friedrich, *Monk by the Sea* (Fig. 2.13), with which Harris would have been familiar. Harris's work makes similar use of a promontory of land, the horizon of the large body of water and the darkly glowing expanse of the sky. The lighthouse in Harris's painting is placed to the left of centre, as is Friedrich's monk. Harris, echoing Friedrich, has painted the softly clouded sky with an uncharacteristic and thoroughgoing naturalism. For Friedrich's monk and for mankind, represented by the lighthouse in Harris's painting, the sky is the expanse of infinity. But beyond the formal similarities, the reduction of the landscape to minimal elements and their similar sites at the edge of a northern sea, the works resemble each other in their ele-

gaic, religious mood. Harris's experiment with naturalism in *Lighthouse, Father Point* is a further indication that he was trying different ways of painting in response to the deep changes in his inner attitudes that were beginning in the late 1920s.

HARRIS'S CHANGING ATTITUDES, 1929–32

The change in Harris's painting emerging in *Lake Superior III* and *Lighthouse, Father Point* is a pictorial expression of an undercurrent of change taking place in his attitudes and his life. Difficulties were emerging – he was finding it hard to paint and to understand himself in what was for him a new, uncertain situation. Crucial to a grasp of this period of Harris's development are his many letters to Emily Carr. They differ from Harris's published articles in that he does not talk down to Carr. At times he seems to be completely open with her, and I believe that he considered her an artistic equal. His main purpose in writing to her was to encourage her artistic career. At times he wrote frankly about his own difficulties to persuade her that she was not alone, that her hardships were those of other creative people: "In so far as I can guess at the attitude of those who are beyond me their experience is like mine save that wisdom informs them, and they are not perturbed at their seeming failures – they are detached from the results of their effort even though these are an indissoluble part of themselves."[20]

Harris was experiencing limitations as a painter and was having difficulty understanding his art and his own feelings. One can speculate on the contradictions in his life: he was committed to modernity, but could not yet accept abstraction; he was continuing his struggle for a national Canadian art based on the North but was trying to paint works that were of universal validity. As early as 1926 he had written to Katherine Dreier that he was moving from "a feeling of National consciousness" toward "a universal consciousness."[21]

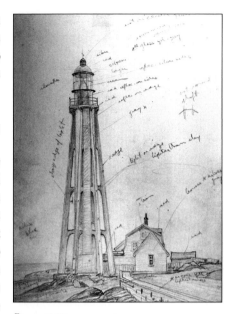

Figure 9.12
Lighthouse, Father Point, c. 1929
Pencil on paper
24.8 x 19.1 cm
Dalhousie University Art Gallery
Permanent Collection

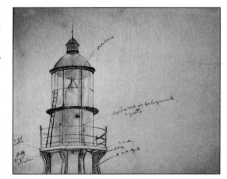

Figure 9.13
Lighthouse, Father Point, Sketch of Lantern, c. 1929
Pencil on paper
19.2 x 25.3 cm
Private collection

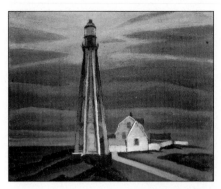

Another strain in Harris's life must have been his developing relationship with Bess Housser. Bess had married Harris's old schoolmate F. B. Housser in 1914, and the three had been friends and colleagues for a long time. Harris had painted Bess's portrait in 1920 (Plate 36); it may have been then that they fell in love. By the late 1920s, they still had not found a solution to their problem. The reason for this delay probably had a lot to do with the Toronto milieu. Canadian culture at that time was dominated by a severe, exacting and pervasive sense of moral rectitude. The wealthy Toronto establishment, of which Harris and especially his wife Trixie were conspicuous members, were expected to set an example as custodians of this morality. For Harris and Bess to divorce their spouses and marry would have caused scandal now hard to imagine (and so it proved a few years later).

Harris's correspondence with Emily Carr reveals his growing consciousness of being in difficulty. In explaining to Carr why he was about to go on a trip to the Arctic with A. Y. Jackson, Harris also reaffirms his mysticism about nature and his belief in the healing effects of the wilderness: "I hope to get loosened up and somewhat freed from my solidifying inhibitions and move into exaltation for a time. I am in great need of losing my littleness and sharing completely in the life of the universe, in water and skies and land and light."[22] The "solidifying inhibitions" may well have included the stylistic modes he had developed for dealing with the North Shore of Lake Superior and the Rocky Mountains. The sense of "littleness" is a mild echo of the devastating experience of his 1918 nervous breakdown. It suggests an untypical lack of the confident clarity his public writing and painting had been proclaiming.

In his description of the trip and his subsequent struggle to paint from the Arctic material, we get a larger picture of the changes going on within his attitudes. In his first letter to Carr after the Arctic trip he wrote: "Jackson and I had an eventful, varied, thrilling (at times), monotonous (at times) trip." Then back in Toronto he complained about the large number of "business things" that were keeping him "infer-nally busy" and away from painting. He claimed that he "got a few useful things in the Arctic and am anxious to work on them."[23]

Only a few weeks later he saw that the Arctic trip had been limited as a painting experience because one could not take one's time and go where one liked. In addition, now that he was turning to the process of creating finished paintings, he was running into difficulties. It was the end of November and he still had not begun to paint: "I've tickled up and worked over my sketches and done a few since getting back and have now a number of possible things but few, too few for canvasses. I need to start, to commence to begin to paint but have not as yet. I find it difficult to pitch right in." Harris saw that his difficulties were both general and personal. Describing himself, he wrote, "Sometimes I feel as if my shell were creeping around me shutting me off from zest and light and pure fun." Of his difficulties with painting, he continued: "I don't know a thing and yet I feel as if I'd been through enough. Now, if that isn't damn foolishness – I need to get to work and disregard all the silly vagaries of personal feelings. Always somehow, if one keeps working something comes through."[24]

Carr must have been upset by this letter of Harris's for on November 30 he wrote again, obviously to reassure her. He did, nevertheless, revert to his troubles and what he saw as his needs: "But I have nowhere anything to complain about – any pickle I get into is my own silly fault, and that I know better than I know anything. I would decidedly like to alter many things in myself. I need much much more goodwill, buoyancy, light in the heart." The difficulties continued until they virtually stopped him from painting. Sixteen months later, Harris says he is still trying to paint but admits he has only been "biding" his time: "No – for more than a year I have felt that I have had my say – and that my usefulness may take another direction – I may be quite wrong of course – but I keep myself aware for intimations of what that direction may be – and am ready for anything."[25]

THE ARCTIC PAINTINGS, 1930–32

On 1 August 1930, Harris and Jackson (who had already been to the Arctic in 1927) left from Sydney, Nova Scotia, on board the *Beothic,* the government supply ship that served the Canadian Arctic outposts. The trip took almost two months. In 1948, Harris remembered the adventure with enthusiasm:

A few years after Jackson's and Banting's trip to the Arctic, Jackson and I joined the Government Arctic expedition. We were most fortunate on this occasion as this particular expedition made the most extensive trip ever taken in the Arctic region in one season. The ship went directly north to Godhaven on the Greenland coast, and then up the coast to Etah where Commander Peary used to winter, and then into Kane Basin. From this point we went south along the coast of Ellesmere Island into Lancaster Sound where we were held up by ice for days. For four hours on our way out the ship was in danger of being crushed by the immense weight of the huge moving ice-floes. We then went around the top of Baffin's Island, down the east coast to Hudson's Straits, through the straits and across the northern waters of Hudson Bay to Chesterfield Inlet. Later we returned through the straits and proceeded southward along the Labrador coast to Nova Scotia.[26]

Harris made a black and white film during the trip. To judge from the film, the trip was an exciting and highly varied experience, in contrast to the stillness and uninhabited views in Harris's paintings. Perhaps the most energetic sequence shows the ship careening in a heavy storm. While waves wash over the deck, the crew struggles to secure the barrels of supplies, which have become loose. Other sequences feature the crowd that came on board at many of the stops, including many Inuit wearing decorated parkas, RCMP officers and black-cassocked missionaries. One sequence shows a comic chase around the deck after the ship's pet pig. Inuit also appear frequently in their kayaks or on shore with their dog-teams, and there are views of polar bears, seals, icebergs and mountainous shores. All this activity, in conjunction with Harris's painting, underscores the habitual reflex of his painter's imagination which sought to create images of stillness and to transcend the accidental and ephemeral surfaces of nature.[27]

Harris also described the conditions in which he and Jackson had to paint:

While we were on this trip Jackson and I painted a large number of sketches, although painting was difficult as we usually saw the most exciting subjects while steaming through channels or while being bumped by pack ice. On many occasions we had time only to take rapid notes. These notes we worked up into sketches, crowded into our small cabin, seated on the edge of our respective bunks with only a port-hole to let in the light.[28]

This trip and Harris's subsequent painting from the drawings and sketches he made on it took place during a period of change and uncertainty in his personal life. He went to the Arctic for personal, artistic and mystical reasons, but in the public domain, the trip was also the logical continuation of his nationalist ideology based on the North. Within that ideology the Arctic, though remote, was part of the Canadian environment, and Harris's trip was within the framework of the regionalist tradition of loyalty to one's landscape.

Echoing the regionalist tradition, Harris took care to note the proper names of all the sites he drew, sketched and later painted. Thus the titles of his works can be used to follow the progress of the trip. Proceeding northward through Baffin Bay (between the Canadian islands and Greenland)

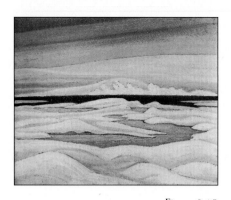

Figure 9.15
Fog and Ice, Kane Basin, 1930
Oil on board
30.3 x 37.9 cm
Art Gallery of Ontario, Toronto
Bequest of Sir Frederick G. Banting, 1941

and Smith Sound, Harris made the drawing *Icebergs, Smith Sound* (Plate 34), followed by an oil-on-board sketch. *Fog and Ice, Kane Basin* (Fig. 9.15) records the most northerly site in his work. However, the better-known Arctic landscapes come from the southern and western return trip to Sydney, Nova Scotia. These include *Bylot Island* (Plate 32), *Bylot Island I* (Plate 33), *Eclipse Sound and Bylot Island* (Fig. 9.16) and *North Shore Baffin Island I.*

In *North Shore Baffin Island I* Harris employs the largest range of blues in any of his paintings — from very dark navy to pale blue, almost white — to create a blue tonal painting. The intensity he has achieved by juxtaposing so many blues recalls his belief that the Canadian artist should seek to create a "unified intense expression." The purpose of such intensity was to help produce "a pure work of art and the expression of new spiritual values." Harris had painted completely blue works before, such as the beautiful and contemplative Rocky Mountain work *Consolation Lake* (Plate 30) of about 1927, although none achieved the intensity present in *North Shore Baffin Island I.* In this and his other blue works, Harris has probably relied on the theosophical doctrine of colours, which considered blue, depending on its value and hue, to be, variously, the colour of high spirituality, devotion mixed with affection, devotion to a noble ideal, pure religious feeling or religious feeling mixed with fear.[29]

The new element in Harris's Arctic works, however, is the emergence of a pattern of forms that forecasts some aspects of his later abstract development. The best example of this is *Bylot Island,* which presents the viewer with a pattern, a stable coordination of lines and forms across the painting in a band of relatively shallow space. Thus, a two-dimensional aspect emerges within a three-dimensional context. This phenomenon can also be seen in *Bylot Island I, North Shore Baffin Island I* and others.

Harris did several paintings of icebergs. One can speculate on why he was interested in them. Besides providing him with an Arctic object *par excellence,* an iceberg is, like

the tree in *North Shore, Lake Superior* (Plate 24), a natural object that has been shaped by the forces of nature into a unique, mysterious form that reminds the viewer of these forces. The most dramatic of the iceberg paintings is *Icebergs, Davis Strait* (Fig. 9.17). The sketch for this work is *Iceberg, Baffin Bay North.* In the finished painting, Harris has elongated and smoothed the forms, adding lines that articulate the planes. With its smoothness and use of parallel lines, *Icebergs, Davis Strait* recalls his similar use of such Art-Deco devices in *Mount Lefroy* and *Mount Robson.* Although the grey sky broken by darker clouds in the Arctic painting is not the infinite expanse Harris presented in *Lighthouse, Father Point,* the paintings are similar in that the strongest highlights are at the bases of their main forms. These – the lighthouse and the iceberg – are not presented as receivers and bearers of light as was *Isolation Peak.* Reaching high above the horizon, the iceberg has a pale blue and white spectral quality silhouetted against the dark sky. Harris has added at the bottom of the painting the low, mounded forms with the orthogonal-like, space-controlling lines that appear frequently in works such as *Pic Island* (Plate 25) from the Lake Superior period on.[30] He thus elaborates again the layered compositional type that he favoured from the beginning of his landscape career.

One of the last areas Harris drew or sketched on the Arctic trip was Labrador. *North Labrador* (Fig. 9.18) recalls again Harris's commitment to the regionalist aesthetic, not only because of its presentation of the region, but also because its composition exploits the high horizon line of early works such as *Near St-Jovite* (Fig. 2.20) of 1908, which is close to this work in colour scheme. In this late landscape, however, Harris builds the transition into deeper space more carefully; the modelling is more subtle and varied. It is uncharacteristic of his landscapes since the beginning of the Lake Superior works in 1921, in that he has given greater prominence to the dark land mass than to the expanse of water or sky. The sketch probably records his feeling on seeing land after eight weeks of snow and ice.

Like Harris, A. Y. Jackson brought his current stylistic devices to the Arctic. His *Iceberg* shows the gently curving lines of his Algoma and Lake Superior landscapes, here used for the long clouds and for the shore and hill lines. The iceberg itself stands out less clearly against the sky than does Harris's and contains many curving, flowing lines. Varley too travelled to the Arctic (in 1938), but, like works by artists outside the Group who went, his paintings convey complexity of form and a range of warm colours rather than the simplifications and the cold colouring of Harris's work.

Though Harris complained to Emily Carr of his difficulty in painting after his Arctic trip, by December 1930 he had enough sketches to exhibit with Jackson at the National Gallery of Canada, in "Arctic Sketches by A. Y. Jackson, R.C.A. and Lawren Harris." The following May, in "Arctic Sketches by Lawren Harris and A. Y. Jackson, R.C.A." at the Art Gallery of Toronto, Harris exhibited thirty-two oil-on-board sketches and six larger canvasses. It was he, more than any other Canadian painter, who was responsible for integrating the Arctic into the Canadian landscape tradition. This was probably because the exaggerated simplicity of his style expressed the mental picture that southern Canadians had of the Arctic.

HARRIS'S UNDERSTANDING OF HIS OWN DEVELOPMENT AS A LANDSCAPE ARTIST

One of the most interesting passages in Harris's writing is his description in 1928, in his article "Creative Art and Canada," of his own development as an artist. Although ostensibly about "the Canadian artist," Harris's description does not fit the art of any of his colleagues. Harris had a view of his development as a continuum; his categories overlap and at times flow into each other. Harris presented this description as an illustration and verification of his mystical theory of landscape painting. He begins with a paragraph in which nature and the North are all but interchangeable ideas. He moves from an acquaintance with nature's

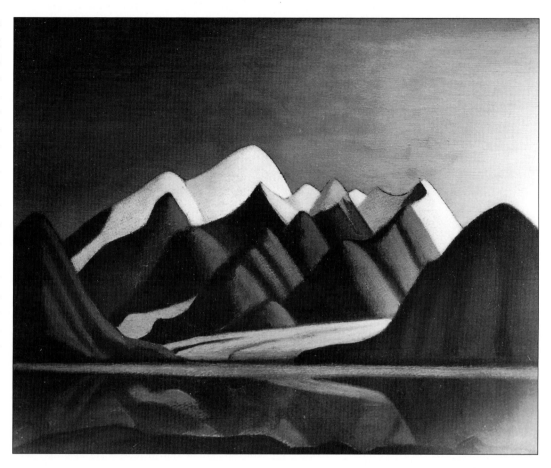

presence "to feel the spirit that informs" the diverse outward aspects of nature:

> So the Canadian artist in Ontario was drawn north, and there at first devoted himself to Nature's outward aspect until a thorough acquaintance with her forms, her growth and idiosyncrasies, and the almost endless diversity of individual presences in lakes, rivers, valleys, forests, rocklands and habitations, led him to feel the spirit that informs all these."[31]

Figure 9.16
Eclipse Sound and Bylot Island, c. 1930
Oil on board
30.2 x 38 cm
McMichael Canadian Art Collection, Kleinburg, Ont.
Gift of Col. R. S. McLaughlin

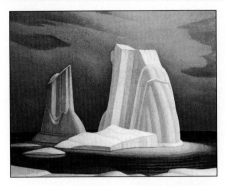

Figure 9.17
Icebergs, Davis Strait, 1930
121.9 x 152.4 cm
McMichael Canadian Art Collection,
Kleinburg, Ont.
Gift of Mr. and Mrs. H. Spencer Clark

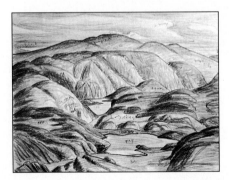

Figure 9.18
North Labrador, 1930
Pencil on paper
Private collection

He then describes the artistic processes related to this early phase:

> Thus living in and wandering over the north, and at first more or less literally copying a great variety of her motives, he inevitably developed a sense of design, of selection, rhythm and relationship in individual conformity to her aspect, moods and spirit.

A sense of selection and design is certainly present in Harris's work. Almost from the beginning he opted for a layered composition, which, as we have seen, corresponds to the layered vision found in his transcendentalist and theosophical world view. Thus we find it in his late urban landscapes, such as *Red House in Winter* (Fig. 6.7) of about 1926, and in his *North Shore, Lake Superior* (Plate 24) of the same year. Harris seems to have chosen the layered composition at first by instinct; it reflected a natural and personal mental structure. As his thinking developed, the compositional pattern became part of the conscious expression of his vision.

Harris's emphasis on "moods and spirit" recalls his roots in the attitude of the German *Heimatkunst* painters toward the moods they found in nature. In this passage, "spirit" seems little more than a synonym for "mood." We should, however, read into it Harris's theosophical notions of the realm of the spirit. By using it in this context, he gave the "universal spirit" a regional or local expression:

> Then followed a period of decorative treatment of her great wealth of material into design and colour patterns conveying the moods of seasons, weather, and places. Then followed an intensification of mood that simplified form into deeper meaning and was more vigorously selective and sought to have no element in the work which did not contribute to a unified intense expression. The next step was a utilization of elements of the North in depth, in three dimensions, giving a fuller meaning, a more real sense of the presence of the informing spirit.

The "decorative treatment" was probably exemplified in Harris's view by his snow paintings of about 1914 to 1918, the urban landscapes he did before 1918 and even by some Algoma works like *Autumn, Algoma* (Plate 22). Harris did not, however, often use weather as a motif. The "intensification of mood that simplified form" into "a unified intense expression" may have been represented in Harris's mind by large Algoma works like *Algoma Country* (Fig. 7.8) where the screen of trees articulating the nearby layer of space in the composition is smooth and firmly contoured. The composition stresses the experience of both the near and the far, and in comparison to that of *Autumn, Algoma,* the mood is intense. It is probably in works such as *Above Lake Superior* (Plate 23) that Harris felt he had achieved some of his most intense expressions, through the emphatic use of three-dimensional forms in the foreground set in a deep and wide space. This depth and three-dimensionality he associated with "a fuller meaning, a more real sense of ... the informing spirit." Such works showed Harris the progress he was making in his struggle to express that presence.

At this point, Harris interrupts the flow of his text to mention briefly the fourth dimension, apparently prompted by his mention of "three dimensions" just before: "Let me here suggest that a work in two dimensions may contain an intimation of the third dimension and that a work in three dimensions may contain an intimation of the fourth dimension." This analogy is the standard theosophical way of dealing with the concept of the fourth dimension. Harris's source was probably Ouspensky, whose book *Tertium Organum* he had reviewed in 1924. Though not well integrated into his text, this idea parallels the point he wants to make to his readers, that the purpose of landscape art is to lead them into an awareness of spiritual realities.

Harris then continues his overview:

Today [in 1928] the artist moves toward purer creative expression, wherein he changes the outward aspect of Nature, alters colours, and by changing and re-shaping forms, intensifies the austerity and beauty of formal relationships, and so creates a somewhat new world from the aspect of the world we commonly see; and thus he comes appreciably nearer a pure work of art and the expression of new spiritual values. The evolution from the love of the outward aspect of Nature and a more or less realistic rendering of her to the sense of the indwelling spirit and a more austere spiritual expression has been a steady, slow and natural growth through much work, much inner eliciting experience.

Harris's aim of a "purer creative expression" and a "pure work of art" echoes the aims of Kandinsky, Mondrian and Malevich. Although Harris's goal was similar – to create an art that put the viewer in touch with the world of the spirit – at this point in his career he did not think it necessary to use abstraction to achieve this aim. As we have seen, Harris, at least since his Lake Simcoe period, had felt free to move around and change the elements of nature found in one or more landscape sites. In this essay of 1928, his regular practice has acquired a rationale.

Harris had used the word "austerity" in commenting favourably on Homer Watson's contribution to the Canadian Art Club's exhibition of 1913, calling it appropriate for depicting Ontario pioneer life and "often the brother to strength."[32] This puritan meaning is a survival of the southern Ontario religious culture Harris was struggling to transcend. In 1928 the word fitted easily into his spiritualizing interpretation of reality and art. It was also consistent with the theosophical notion that the spiritually developed person is elevated to the levels and planes above the physical world that theosophists described as dense, coarse matter, the lowest and least valuable levels of reality.

In valuing an art that "creates a somewhat new world"

Harris is discarding the orientation toward reality implicit in both his realist urban landscapes and his regionalist wilderness ones. In short, he is describing an idealist conception of art, art seen as an alternative to life.

Harris's image of the transcendent as an energetic irrepressible force[33] and not a calm, serene and tranquil deity corresponds with his focus on intensity. He saw that the artist must strive to achieve the "intensification of mood," the "unified intense expression" that "intensifies" the experience of austerity. By recalling that his development was due to "much work, much inner eliciting experience," he reveals that he did not see himself as a contemplative passively receiving his vision. Rather, he saw himself as a spiritual activist energetically seeking the right expression. He had articulated this attitude earlier in the essay, "Art Is the Distillate of Life," when he asserted that the artist must "love into being appropriate forms for his vision." As we have seen, in Harris's view it was in the labour of creating the "appropriate forms" that vision clarified itself. Believing that art was "the record of the joyous adventure of the creative spirit in us toward a higher world," he could see himself as lending his own energies to the task of the universal creative spirit.

Harris concludes his reflections by expressing his faith that the artist, having passed through all this work, and not having been distracted by "the stultifying desire for reward, whether it be cash or fame or position" can become "one with the hidden, forming aspirations of his race and people toward divine clarity and the spirit of life itself." Moreover, when this happens to a number of artists, they can create "an art and a home for the soul of a people."

No artists in Canada's history came closer to achieving this goal than Harris and the Group of Seven. Yet Harris had a thirst for continual spiritual and artistic development that urged him beyond his familiar horizons, in both his art and his life.

PART III

AN EXPATRIATE PAINTER OF ABSTRACTIONS, 1934–40

COLOUR PLATES IN PART III

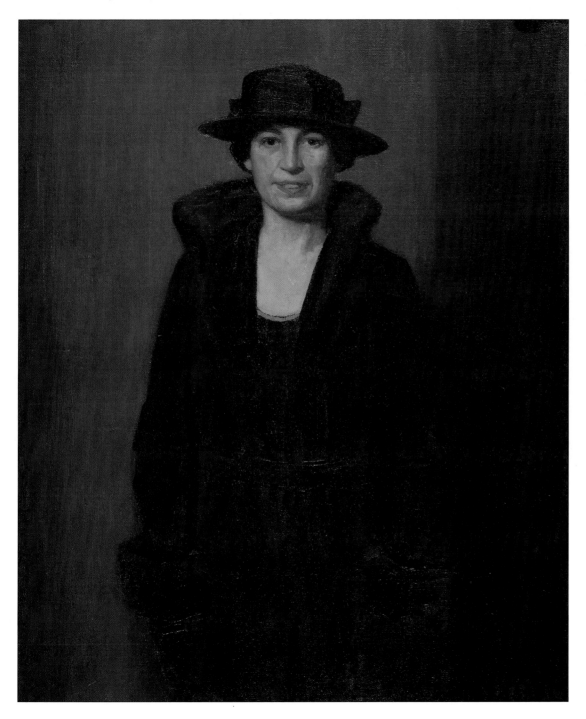

Plate 36
Portrait of Bess, 1920
112.5 x 92.2 cm
Art Gallery of Ontario, Toronto
Gift of L.S.H. Holdings Ltd., Vancouver, 1989

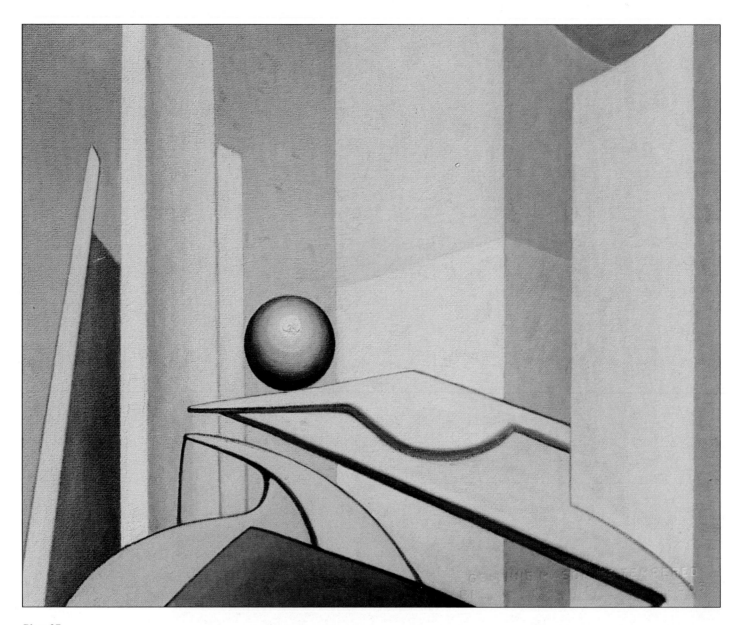

Plate 37
Poise, 1934–36
Oil on masonite
45.7 x 55.9 cm
Private collection

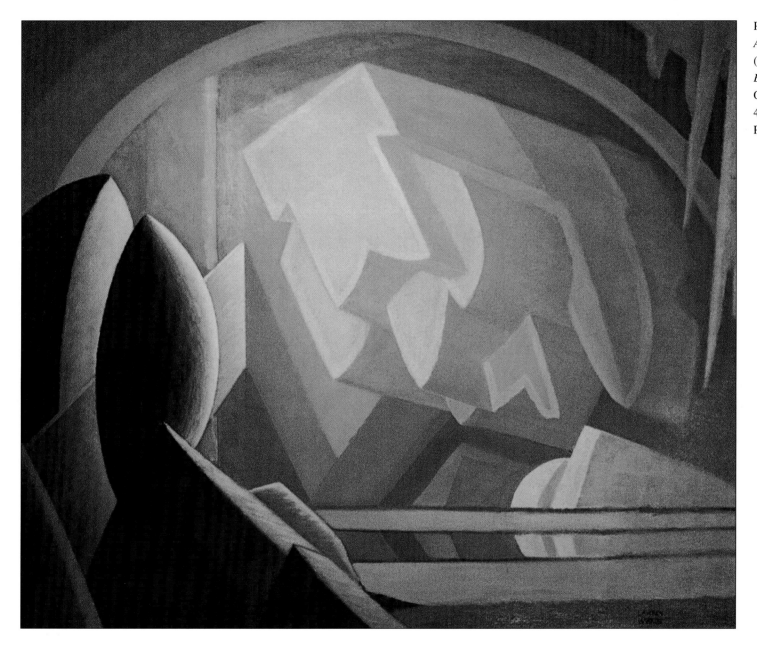

Plate 38
Abstraction 1936 I
(also known as *Riven Earth II*), 1936
Oil on masonite
49.5 x 59.7 cm
Private collection

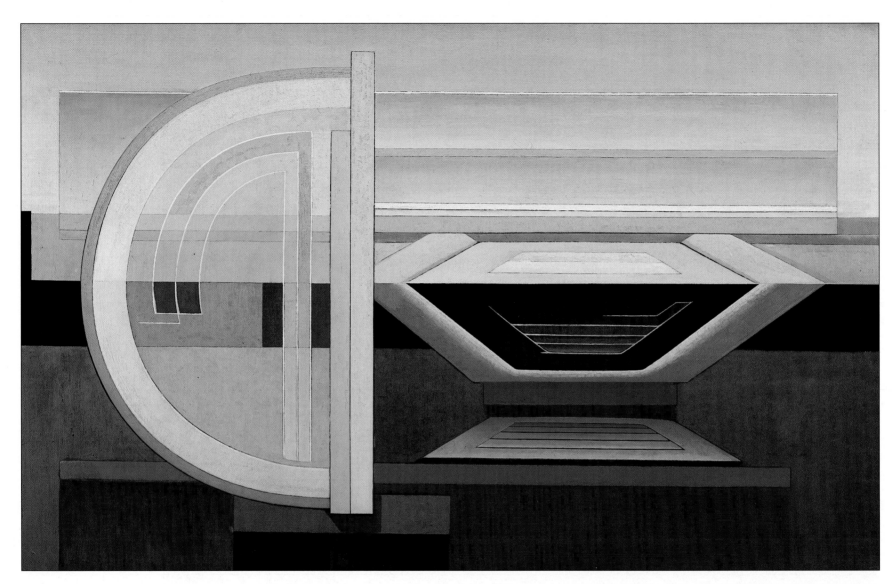

Plate 39
Equations in Space, c. 1936
76.3 x 122.2 cm
National Gallery of Canada, Ottawa

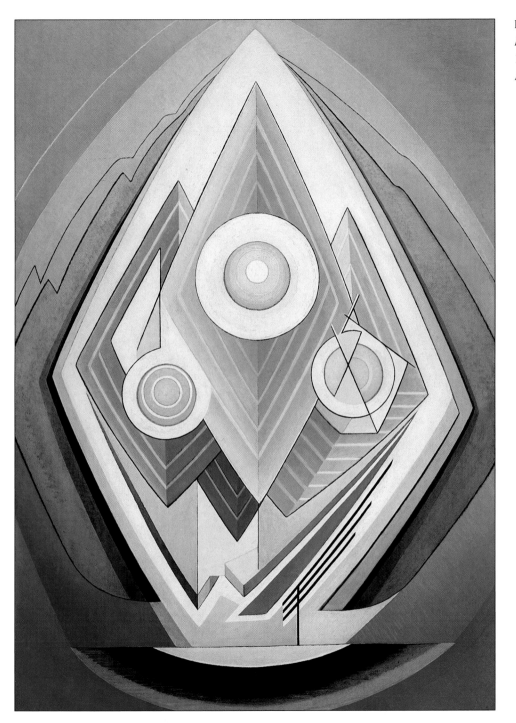

Plate 40
Painting No. 4 (Abstraction 94), c. 1938
129.5 x 93 cm
Art Gallery of Ontario, Toronto

Plate 41
Composition 10, 1937
101.6 x 81.3 cm
L.S.H. Holdings
Courtesy of Mira Godard Gallery, Toronto

Plate 42
Composition (Abstraction No. 99), c. 1938
91.5 x 76.6 cm
Art Gallery of Ontario, Toronto

Plate 43
Abstraction (Involvement 2), c. 1938–39
140.6 x 87.6 cm
National Gallery of Canada, Ottawa
Gift of the estate of Bess Harris,
and of the three children of Lawren S. Harris, 1973

Out of the Toronto Chrysalis – 1933–34

This means a transvaluation of values and the new values emerge in the process of the destruction of the old chrysalis and the birth into a new life, a new seeing. In this process, false and true, good and evil are purely relative.

Lawren Harris, 1939[1]

THE OLD CHRYSALIS

Nineteen thirty-four was a watershed year for Harris: he made two decisions of great and long-range importance for his personal life and his art. He left Trixie, his wife of twenty-four years, their three children and their elegant new Art-Deco mansion in Toronto, and married Bess Housser, the former wife of one of his best friends. Harris also turned his back on his nationalist program of landscape painting, turned away from many of his friends, colleagues and supporters in Toronto, and, all but unthinkable three or four years earlier, left Canada. Shortly after arriving in the United States late in 1934, he began to paint abstractions; by early 1935, he had firmly decided to paint no more representational art.[2]

How were such drastic changes possible? The answer lies almost completely in Harris's interior life. We have already seen that during the late 1920s and early 1930s Harris's public stance as an optimistic, aggressive nationalist was being undermined by shifting inner attitudes, doubts and questions that eventually produced an absolute block to painting. By 1934, he had been living with that block for two years. In 1932, he wrote to Carr: "No – for more than a year I have felt that I have had my say – and that my usefulness may take another direction – I may be quite wrong, of course – but I keep myself aware for intimations of what that direction may be – and am ready for anything."[3]

It is not possible to reconstruct exactly the crisis of June and July 1934 and the sequence of events that led up to Harris's departure from Canada. We do know that on 13 June 1934, at 10:00 PM, Harris left his wife Trixie and the elegant modern home they shared with their three children on Ava Crescent in Toronto. On 6 July he left Canada. On 29 August he and Bess Housser were married somewhere in the United States, probably in Nevada.

In part from interviews with surviving friends and acquaintances, this is what I think happened: in 1920 Harris had painted a portrait of Bess Housser, the wife of his friend and theosophical colleague, Fred Housser. The story persists that it was then that they fell in love. Lawren liked Bess's buoyant spirits and happiness, and the portrait conveys the image of a smiling young woman with just a touch of jaunty

unconventionality about her (Plate 36). Heavily swathed as she is, though, in dark hat, coat and dress (even her hands well hidden in the coat pockets) there is hardly a hint of sensuality. Perhaps Lawren found her intellectually provocative. He nicknamed the painting *The Christian Scientist* because Bess was then a member of that church and seemed to embody its traditions of optimism and energy, traditions Harris knew quite well since his mother was also a Christian Scientist with a reputation for cheerfulness.

The relationship between Lawren and Bess developed over the following fourteen years. Lawren, after his nervous breakdown in 1918, developed a deep commitment to a spiritual view of the universe, became an active theosophist and gradually articulated his mystical theories of Canadian nationalism. One of the people who supported him and his friends, and who came to understand him better than most, was Bess Housser.

For years there was probably nothing in the friendship that threatened their existing marriages. But I speculate that as Lawren and Bess became more and more involved with each other in an increasingly exclusive relationship, Fred Housser came to resent the time they spent together. Eventually a romance developed between Fred Housser and the artist Yvonne McKague. Matters came to a head during the late winter and spring of 1934. It appears that Bess (without, I speculate, expecting to marry Lawren) got a Reno divorce from Fred because of his relationship with Yvonne.[4] The plan was that Bess would move into Harris's studio in the Studio Building, and he would take over Thoreau MacDonald's for his painting (though I think he intended to continue living at home). This would probably have been, at the latest, in early June of 1934. Bess's moving into the studio building provoked the final crisis in Harris's marriage. The result was that Harris left his family on 13 June.[5] That started an outcry in Toronto now difficult to understand.

In response, Bess called on many of her friends and acquaintances to explain that her relationship with Lawren was not sexual, but intellectual and platonic. Though they were deeply in love theirs was a relationship meant to foster their continuing spiritual development. Apparently they were not at first planning to marry, since they did not intend to live together as man and wife.

One person to whom Bess spoke and whom I have interviewed remembered that she did not believe Bess's account of the relationship and angrily insisted that Bess leave her home. This reaction may not have been atypical, for many others did not believe the story either. But the sculptor Frances Loring did believe Bess's account. Writing to Eric Brown, the director of the National Gallery, she described the "upheaval" in Toronto and added that Harris and Bess "are not getting married. Theirs is to be a purely spiritual union – and knowing Bess I can well believe it."[6] This celibate relationship expressed the deep commitment both Lawren and Bess had to their spiritual beliefs. They did not intend to marry because their relationship was not sexual and because what they were doing had the highest spiritual motive. In their eyes their conduct was above laws, moral codes, ethical systems and the conventions of Toronto morality. They wished to allow their contact with beauty, that is, with the realm of the universal spirit, to dictate to them how they should behave, rather than follow what seemed to be merely local traditions.

But they did get married. It was Harris's mother, Anna Stewart Raynolds, who persuaded them to change their minds. By appearing to be so close, Anna argued, they were causing a lot of gossip, bad feelings and anger and they would find it unnecessarily difficult to move about and be accepted socially. They accepted her reasoning, and thus Lawren's special relationship with Bess became a special marriage. It was to be – and, as far as anyone knows, remained – a celibate marriage.

Harris himself claimed that the marriage was not going to be a sexual union. Haworth remembers Harris's words. Harris's refusal to use the word "sex" was typical of his habitual puritanism (and perhaps of his times); as he put it:

"There's to be none of that there," and he assured Haworth that he and Bess would always have separate bedrooms. In Hanover, Bess mentioned the separate bedrooms at one of their addresses. In Santa Fe, Bess used the only bedroom in their house and Harris slept in his studio, where he had his own bathroom.[7]

But having decided to get married, Lawren and Bess probably still did not plan to leave Toronto. This changed because of the continuing anger not only of Trixie's family but of many friends and acquaintances. Bess, writing from Hanover on 14 November 1934, used a theosophical and Christian-Science vocabulary to describe their experience of this hostility:

> It is still so near. – The upheaval. – The venomous hate it aroused in the world when one endeavours to move from the spirit's dictates is quite a different thing to pass through than consider objectively. Animal magnetism is known with all its brutal and destructive force directed into one's own very life and vision. It seems to create a great vortex and it will with fiendish delight do away with you there if it can.

Only weeks later, she wrote again to the same friend: "Alex [A. Y. Jackson] bothered me at one time because I felt he should instinctively know that the things he was saying of me were untrue – I forgot that he was not so interested in their truth as in the social usage that he could make of them, and that he got a kick out of that!" Bess then describes Yvonne and Fred as being "my greatest difficulty – my personal self tells me that they have used me with a ruthless cunning and cruelty. To their own ends."[8] One of their acquaintances suggested to me that this was because Yvonne and Fred were saying, or were allowing to be said, that their own relationship was at least partly due to the hardships Fred had been enduring from Bess and Lawren's more and more exclusive one. I have not been able to verify this. After Fred Housser's death in December 1936, Bess began a long and affectionate correspondence with Yvonne.[9]

Another factor was the risk that if Bess and Lawren married and stayed in or near Toronto, Trixie or her angry family would have Harris charged with bigamy, since the Reno divorces that Bess and Lawren obtained were not valid in Canada. The couple, by then planning marriage, left Toronto, probably separately, for the United States.

"THEOSOPHY AND ART": HARRIS'S RATIONALE FOR PERSONAL AND ARTISTIC FREEDOM, 1933

In 1918, mysticism had offered Harris a ladder out of the despondency of his nervous breakdown. By 1933–34, he had reached the point where he consciously staked his life and reputation on his unusual mystical beliefs and readily accepted the consequences.

A clear window into Harris's inner life at the time of his divorce and remarriage is provided by two articles, both called "Theosophy and Art," which he published in the summer of 1933 in the *Canadian Theosophist*.[10] These articles not only convey his ideas on the relationship of art and religion in his theosophical view of the universe, they also describe the intellectual justification he was piecing together for his rupture with his family life, his participation in the upper levels of very proper Toronto society, his leadership of the nationalist movement in Canadian painting and his long-standing commitment to representational painting.

It is helpful to approach these articles with Harris's earlier writing in mind, especially his unpublished paper of about 1925, "Art Is the Distillate of Life." In that paper the key idea was ecstasy. With this notion Harris linked together the artist's experiences of inspiration and impersonality in the act of creation with the viewer's experience of ecstasy in front of the work produced. In the 1933 articles, Harris analysed this experience of ecstasy and related it to his idea of "beauty" and what he called "the aesthetic attitude."

In "Theosophy and Art [1]" Harris's chief subject is the mystical notion of beauty. He describes beauty as "essential to the inner balance of man" and "a phase of truth that should permeate all action, all thought, all feeling and aspiration" (129). Beauty "is an indissoluble part of all that we consider high, worthy and divine. And it comes to focus on earth for man, in the arts." Not surprisingly, Harris relates art and beauty to his theosophical interpretation of the growth of the human soul: "until such time as we become perfected in beauty, the arts will be for us the highest, practical importance in that they mirror for us ... the essential order, the dynamic harmony, the ultimate beauty, that we are all in search of, whether consciously or not."

For Harris the theosophical view of the oneness of all religions is identical to the oneness of all art:

> And precisely as we [theosophists] find, that the essence of religions throughout time are the same, and their real message, which lies hidden within the outer trappings is identical, and the source one and not many. So we will find that art throughout the ages, is in essence the same, and the message within the various idioms, its different expressions and concepts, is identical, and its source one and not many. (133)

Harris states that as we uncover "the element of beauty more fully within ourselves, we will value the great discovery, that the source of art and the source of religion are identical, and that neither can have their true, their full being without the other" (130). The experience of beauty is "the true talisman, whereby we may know that we are participating in a life greater and more enduring than the evanescent, constantly changing lives of our personal selves"; beauty is a "pervasive power in art and life" (130). Harris also relates beauty to the Buddhic plane:

Beauty as a pervasive power in art and in life is the very spirit of the plane of being we theosophists call buddhi, that is that eternal plane of being wherein abides the immortal part of man and the universe, and which is beyond sensuality and the intellect and desire, and is the source of all high inspiration and devotion. (130)

In fact, Harris identifies beauty with the theosophical notion of God as "the underlying, informing spirit of the universe" and calls it "a power at work in the universe ... and in man through the laws of his spiritual evolution" (131).

In this context Harris gives his spiritual rationale for the avant-garde tension in his life as an artist: this "newness of vision ... often creates strife between the artists and the public", but the artist must "maintain the integrity of his vision" in the face of such opposition: "Only so can he be of value, of use to his fellow men" (131).

Beauty in art, Harris claimed, is first, an "elevating, transforming and unifying power" and second, "a searching light that ultimately penetrates all the secret places of the soul." After elaborating further on the power of beauty, he relates these ideas about the creative artist and beauty to his interest in occultism:

> Theosophists know that occultism, which is truth put into practice, is an immense, almost devastating power ... and the creative individual in the arts also knows, that beauty at work in the soul, is likewise an immense power ... that will ultimately stir the entire man into life and disclose tendencies and temptations he was unaware of. (131)

Harris ends the first of the two articles by asserting the unity of theosophy and art: "The theosophist and the creative artist stand here on somewhat common ground, sharing a similar high vision, involved in the same struggle, and using the same faculties." (132)

The second article begins in an apodictic and incantatory style and with what appears at first to be an abrupt shift in point of view:

We have for the conduct of mankind on earth four main divisions or categories of ideas.

We have, firstly, laws, fashioned by man to meet the exigencies of time and place and people, and administered by courts, judges and police …

Secondly, we have a moral code. This varies in different ages and in different places and with different people. It is dictated by general self interest or expediency; is personal and possessive, dogmatic and inelastic, and is most frequently derived from some so-called authoritative religion … It is of the desire nature, of and for the lower man.

Thirdly, we have ethics, which is of the mind, is logical and results in a scheme or theory.

And fourthly, we have aesthetics, which is of the intuition or spiritual intelligence. It is of the life of the soul as distinct from that of the person. It is an attitude, not a code or creed, nor a scheme or theory. It is an attitude which discloses the memory of the divine in us … It is the source of all the creative arts. It is indefinable and can only be known when it is lived in terms of direct experience, in some degree. (161)

Aesthetics, says Harris, "cannot be a set of rules; it cannot be put into a creed or code nor a scheme or theory, because it is a way of seeing, a way of life, governed and inspired by the indefinable laws of beauty" (161). Thus the expression "aesthetic attitude" gave Harris a verbal equivalent of his theosophical view of the universe and the privileged position that art is given there. Harris makes strong claims for the aesthetic attitude. It implies "a divine being within us, not an exterior God"; it is "creative and fertile" and "implies adventure at the very forefront of one's being"

(163). The aesthetic attitude is proof that "we have known and know a superior realm of being. Possessing the aesthetic attitude is a condition for living creatively and functioning with the inner standard of the innate ideas of perfection."

The expression of this aesthetic attitude Harris sees as "fluid, never fixed." It grows "with every increase of vision, every new and vital experience" and is free from "the established, the accepted" (163). Harris compared the aesthetic attitude with the theosophical use of the notion of karma: as karma is to the universe, "the aesthetic attitude in man is the same, an undeviating, constant tendency to restore and maintain equilibrium."

Laws, moral codes and ethical systems can be understood by studying them in books. Aesthetics or the laws of the spirit, on the other hand, have to be lived, because "the spirit of all great art and all true religion" cannot be translated into words. And Harris sees this as a reason to say: "Thus in one sense the aesthetic attitude is the essence of all religions. It is the living expression of their spirit." Because it "is innate in the soul … it is its own discipline, exacting a different order of conduct than morality connotes … It dictates conduct in terms of the universality of the higher self … It is inspired by and aims at divine identity" (164).

The great spiritual teachers – Harris offers Jesus and the author of the *Bhagavad Gita* as examples – did not lay down hard-and-fast rules, i.e., a moral code or creed, but wanted "to convey an attitude toward life" (165). For Harris, theosophy and art are "one in spirit" because they subscribe to no "creed or set of dogmas" and are "essentially creative, a way of life." For these reasons, the arts can show the "divine aesthetic" better than any other human activity. Echoing the theosophical doctrine of Jinarajadasa, Harris asserts that this is the real function of the arts. He believed that the "genuine inspirations of art come from a higher plane of our being than the ethical or intellectual. We can only understand what they [the arts] imply and embody by first hand, direct experience" (165–66).

Harris's perception of a spiritual reality and unity in works of art reveals again the transcendentalist structure of

his thought. As we have seen, he found similarly described spiritual realms behind what he called the veil and appearances of nature.

In these two articles Harris constructed a philosophical justification for the use of abstract imagery that soon transformed and came to dominate his work.

But just as Harris needed the justification of the spiritual theory he had been developing for years to enable him to break with his earlier painting styles, so too in his personal life he needed a philosophical justification for his break with his family, with many of his friends and with all that was conventionally important in Toronto.

In the first article, Harris discusses the power of beauty to change a person. At times his vocabulary suggests his puritan background. Beauty is "severe and exacting, and once invoked, will never leave him alone, until he brings his work and life into some semblance of harmony with its spirit" (131). He and Bess believed that the relationship they were trying to create was an expression of their experience of beauty, their contact with the world of the eternal spirit. An artist becomes aware that "beauty at work in the soul … is an immense power that will ultimately stir the entire man into life and disclose tendencies and temptations he was unaware of, and that this needs a great care, a readjustment of his whole make up if he is to achieve a new and wider balance of vision" (131–32).

The personal implications for Harris of the aesthetic attitude are clearly crucial. He is more explicit about the need for people of advanced spiritual development to be free of ordinary laws, moral codes and ethical systems. Once the aesthetic attitude is awakened in people, they can be free of "the stifling realities of moral codes"; they can begin "to live creatively." The individual must be willing to change everything, and in accomplishing this transformation, must become "inwardly free from attachment to any fixed code, and creed, any cut and dried philosophy" (164). Given such thinking, it is not hard to understand why the following year Harris was able to break with the Christianity of his Baptist and Presbyterian background; leave his wife and their grown family; deepen his special relationship with Bess; and renounce both his dominant role in the nationalist movement and representational painting.

Separating himself further from the conventional Toronto milieu, Harris claims that the aesthetic attitude "is its own discipline, exacting a different order of conduct than morality connotes, that it dictates conduct in terms of the higher self, because that alone is appropriate to the soul." The aesthetic attitude asks whether an activity, a thing, an idea is "beautiful, is it in terms of the highest one knows?" This idealistic stance, Harris believes, must be maintained "despite the hells that may rage in the lower nature." To have written this before he attempted his break with Toronto suggests that Harris had already experienced some of the tension in his life in this way: an intellectually soaring, elitist idealism coupled with his perhaps rebellious suffering on the more ordinary, sentient and emotional levels of his life, what he would call, in theosophical fashion, the "lower nature."

Harris continues his argument. What is beautiful in man "must put aside a great many of the decrees of morality as an insult to the soul because inappropriate to it." He chooses an example that might hint at the difficulties in his own marriage: "Morality condemns the poor girl who has conceived a child out of wedlock, and condones endless cruelties that go on within the married state" (164).

In 1939, Harris drafted a letter to his friend Doris Huestis, whose own marriage was breaking up. In a serene tone that contrasts with his writing in 1933, Harris recapitulated the theosophically understood meaning of such changes in the life of a creative person. His soothing words are for his friend in distress, but his ideas are also for himself and Bess and the unconventional choices they had made:

Once in a lifetime every man jack of us and every lady jill of us is brought face to face with his or her incarnational problem. The problem arises from the chrysalis of thought, belief and ideas formed by

ourselves in the past and the solution is the dispersion of that chrysalis so that we are born into a new life, a little greater creative freedom – and so on and on until eventually we achieve real spiritual oneness with all life. Every idea is a chrysalis, every concept, every fixed or solidified attitude toward life. It has been said that we must be willing to give up at any moment our old moorings though these seem perfectly satisfactory and our inclination is to cling to them because the open sea of experience is in every individual case uncharted. This means a transvaluation of values and the new values emerge in the process of the destruction of the old chrysalis and the birth into a new life, a new seeing. In this process, false and true, good and evil are purely relative. For when we are through with a given process what once seemed good will no longer appear so – we have grown and have changed our values and view point and we now see more and further than we did ... and so on and on until eventually we achieve real spiritual oneness with all life.[11]

Spreading His Wings, 1934–38
Early Abstract Paintings in Hanover

By 1934 Toronto had become a chrysalis from which Harris had to escape. The metamorphosis is easy to follow. He spread his wings in Hanover, into a new life with Bess and, after years of stifling his ambitions in Canada, into the early phases of his abstract painting.

The most important fact of Harris's early period at Hanover is that almost from the day he arrived, probably 13 November 1934, he started to draw and paint again. The two-year block was over. The miles and months separating him from the turmoil in Toronto had their healing effects. To a friend, Bess described their travelling not as geographical but as a psychological and spiritual journey. She gathered under the term "animal magnetism" all the interior hardships they had endured while confronting the hostilities generated by their unconventional choices: "Both of us have experienced it – we know it and have met it. – and it now has no power to confuse or weaken us. While that was seething it was impossible to do any creative work … perhaps to say that we are both starting to work now will tell you more than anything else."[1]

Hanover is still a lovely, northern New England college town hidden in a hilly area of great beauty in New Hampshire. From vantage points, distant snow-topped mountains can be seen. In and near the town, the white geometries of colonial style houses resist absorption into the wilderness. There is an impression of aloof separateness about the whole town that probably appealed to Harris, an impression enhanced by the distinguished architecture of Dartmouth College.

When Bess and Lawren first arrived, they planned to stay only a few months,[2] but the months stretched out to almost four happy years, until the spring of 1938. Their original connection with Hanover was through Harris's young uncle and friend, William Kilborne Stewart, with whom Harris had spent the 1904–1905 academic year in Berlin.

Lawren and Bess made new friends easily in this sophisticated and relaxed social environment. They were soon part of a lively, loosely knit group of intellectually stimulating, elegant people who regularly dressed for dinner on Saturday nights. All the time Harris was at Hanover, the art historian Churchill P. Lathrop was there, first as a teacher and then as chairman of the art department. He claimed that "the whole Art Department found him [Harris] most congenial and we had many social evenings at his house and he had such at our house." Bess and Lawren were considered "really fascinating people" who had "a great elegance about them." Bess always wore white or pale grey.[3] They gave the impression they were always happy together. Both of them did yoga exercises and meditated every morning. They were very fit

physically, well coordinated and walked beautifully and with great ease together. Though generally seen as light-hearted people, they were also perceived to be very serious about their work as modern artists.

When Harris arrived at Dartmouth College, it had just acquired a new art building, and the faculty, although most of them were academic art historians, were particularly enthusiastic about modern art and wished the department to develop competence in this area. These desires dovetailed perfectly with Harris's passion for modernism. Just when he arrived on the scene, the art department had studio space available in the new building but no funds to hire an artist in residence. Harris needed studio space but did not need a paying job. So both needs were met at once.

Harris enjoyed his contact with the students and the students liked him. He had, however, no specific duties. As Lathrop put it, the milieu was favourable to Harris and Harris stimulated it. For Harris brought to the art department the presence of an artist committed to modernism. The faculty were keen on Picasso, Matisse, Kandinsky, Klee and other famous modern artists. Lathrop pointed out that these artists were not widely known in America at that time and that the department was excitedly acquiring an avant-garde reputation.

Harris would have been particularly interested in the series of visitors who came to the department while he was there. The department, which was blessed with a large lecture budget, brought in modern architects, artists, designers, painters and other thinkers of the period, becoming the locus of an exciting ferment of modernist ideas from a wide horizon. The visitors while Harris was there included Walter Gropius from the Bauhaus; Alvar Aalto the Finnish architect, planner and designer; and architect Mies van der Rohe. R. Buckminster Fuller came frequently. Among the painters who came while Harris was there was the modernist theoretician of colour Josef Albers, famous for his Homage to the Square series of abstractions. Although Georgia O'Keeffe did not visit the campus during Harris's years

there, several of her works were exhibited and Lathrop remembers Harris's admiration for and discussion of her work.

At this time Harris read "everything he could get his hands on" about Picasso, Matisse, Kandinsky and the other great moderns. It was a good time for reading about modernism at Dartmouth College. Lathrop, who was the Art Library Officer, bought every book he could find on "Expressionism, Fauvism, Cubism, Futurism, abstraction, Dada and Surrealism." And, Lathrop added, "Lawren relished them all, especially the portfolios of original prints such as Kandinsky's "Kleine Welten" or Max Ernst's "Natural History" (frottages)."[4]

Dartmouth College and Hanover provided a cultural environment where Harris could commit himself to modernism and not have to defend his interests in abstraction or any aspect of modern art. He was praised and welcomed for those very interests which had led to arguments, struggles and inhibitions for him in Toronto.

An important advantage of Hanover for Harris was its proximity to New York City. He made a determined effort to keep up with all the gallery and museum exhibitions of modern art in New York. In fact, he probably saw every major exhibition of modern art there from the Museum of Modern Art's fifth anniversary exhibition, which opened in December 1934, to the show of Joan Miró's recent works at the Pierre Matisse Gallery in April and May 1938. The full list of exhibitions that he would have seen would be a long one indeed. It would include the controversial "Fantastic Art, Dada and Surrealism" at the Museum of Modern Art in December and January 1936–37, and the same museum's "Cubism and Abstract Art" in March and April 1936. The latter's famous catalogue by Alfred H. Barr, Jr. is among Harris's books.

The Whitney Museum showed "Abstract Painting in America" in February and March of 1935. This important event had important results: the artists involved organized themselves in 1936 into an exhibiting group, American

Abstract Artists. Harris would have seen their first two exhibitions in 1937 and 1938. Some of their members went on to significant careers. In 1937, thirty-nine artists exhibited works, including Josef Albers, Ilya Bolotowsky, Burgoyne Diller and the sculptor Ibram Lassaw. By the time of their second exhibition in March of 1938 they had added at least five members, including Fritz Glarner and the sculptor David Smith.[5] Artists with one-man shows in New York during the years of Harris's regular visits included Joan Miró, Férnand Leger, Kandinsky, Paul Klee, Lyonel Feininger and André Masson.

A. E. Gallatin, then a member of American Abstract Artists, had an important collection of modern art that he called the "Museum of Living Art." From 1927 it was on permanent view at New York University's Washington Square College. Harris's copies of the museum's well-illustrated 1933 catalogue and its *Bulletin* for February 1935 are still among his books. This collection included works by Cézanne, Gauguin, Matisse, Picasso, Braque, Gris, Klee, Miró and others. Gallatin had also acquired works by many European and American painters and sculptors of abstractions, among them Jean Arp, and Constantin Brancusi and Alexander Calder.[6]

In the spring of 1938 Harris had what was apparently his first view of an important New York collection when the Solomon R. Guggenheim Collection of Non-Objective Paintings was shown at the Gibbes Memorial Art Gallery in Charleston, South Carolina. The large illustrated catalogue is also still in Harris's library.[7]

There was another gallery that exhibited modern, often abstract art during the years that Harris was regularly visiting New York. From 1929 until his death in 1946, Alfred Stieglitz, photographer and pioneer exhibitor of avant-garde art in the United States, directed the gallery he called "An American Place." One of its most interesting exhibitions was called "Beginnings and Landmarks: '291,' 1905–17," celebrating some of the early modernist works Stieglitz had championed in his first gallery, "291." It was on view

between 27 October and 17 December 1937 and included works by Arthur Dove, Georgia O'Keeffe, Francis Picabia, Constantin Brancusi and the American Synchronist painter, Stanton Macdonald-Wright.

Much of the modern art that Harris saw in those years was geometric abstraction. But though most of his paintings during this period are also geometric abstractions, they cannot be reduced to these influences. Harris valued all manifestations of modern culture but, as we have seen, he thought the artist's personal impulse and integrity were absolutely necessary. As he meditated in front of his easel he found his own ways, at times naive and clumsy, of creating abstractions.

HARRIS'S EARLIEST ABSTRACTIONS, 1934–38

Before beginning a study of Harris's earliest abstract works, there are two introductory remarks to make. The first concerns Harris's vocabulary of geometric forms. Almost all the paintings Harris did in Hanover to 1938, in Santa Fe to 1940 and in Vancouver up to about 1945 are geometric abstractions. These paintings include a vocabulary of geometric shapes and devices that for Harris were richly multivalent, not merely attractive but empty aesthetic forms. This chapter examines Harris's first experiments in this genre.

Harris insisted that abstract painting embodied spiritual meaning and contained "the possibility of expressing everything." His triangles and pyramids, circles and spheres embodied natural, cosmic, philosophical, spiritual and modernist references for Harris and so expressed the major commitments of his life. Referring to Plato's notions of innate ideas, Harris affirmed that although we have not experienced perfect circles or squares, "yet we judge all circles, spheres, squares and cubes because we have within us an idea of perfect ones." This level of meaning Harris described not as mere geometry but as "a higher world; a world in which all ideas, thoughts and forms are pure and beautiful and completely clear, the world Plato held to be perfect and eternal."[8]

In some of Harris's drawings and paintings of this early period, triangles and pyramids were references to the natural forms of mountains. It is likely that his religious feeling for the mountains as a symbol of human aspiration is present in all his triangles. In addition triangular shapes had theosophical and mystical meanings. The triangular form in the illustration "Upward Rush of Devotion" from the theosophical work *Thought Forms* (Fig. 13.13) is one example Harris would have known well. Another is the theosophical assertion that an "upward pointing triangle" signifies "the threefold aspect of the Spirit."[9]

Circles and spheres also carried theosophical and spiritual significance. Patterned and figured circles from *Thought Forms* illustrate "the results of a systematic attempt to send helpful thoughts." Another circular illustration depicts "The Logos manifested in Man" (Fig. 11.1). Yet another spherical illustration (Fig. 11.2) shows "a thought of a very high type – an endeavour to think of the LOGOS as pervading all nature."[10]

Triangles and circles were also important to modernist artists whom Harris admired: they are significant in Kandinsky's aesthetics and are often found in his paintings during the twenties and thirties. The influence of Kandinsky's geometric abstractions was widespread in the abstract painting Harris saw in New York. In a passage Harris probably knew, Kandinsky suggested something of the cosmic and spiritual meanings that these forms held for him: "The contrast of an acute angle of a triangle with a circle has no less effect than the contact of the finger of God with the finger of Adam in Michelangelo."[11]

The second introductory remark is really a brief overview of formal aspects of this period of Harris's work. His abstract painting from 1934 to 1940 developed simultaneously within two modes. In the first group of works, the abstract forms are presented as solid and three-dimensional and suggest a relationship to the perception of landscape elements (for example, Plates 37 and 38). The second mode comprises paintings dating from at least as early as 1937. In these usually vertical works there is a more delicate, two-dimensional, floating, aerial imagery making use of transparent planes and other devices (for example, Plate 41). The two modes are synthesized in works begun around 1940 in Vancouver, for example, *Composition No. 1,* (Plate 44), of 1941. However it is by no means easy, even with the help of information assigned to paintings and drawings by Bess Harris, to date works with confidence to the Hanover, Santa Fe or Vancouver periods.

After he arrived in Hanover in mid-November 1934, Harris began making landscape drawings and subsequent landscape paintings (I have found no intervening oil sketches). But after only a few weeks, probably by mid-December at the latest, he began his first abstract paintings, based on a vocabulary of geometric forms including spheres, circles, triangles and pyramids. Either simultaneously or very soon thereafter he began a series of drawings that strove to link nature and abstraction in various ways. However, the abstract mode was dominant.

The earliest Hanover drawings and paintings were of the New Hampshire mountains. One of them, *Mountains, Winter,* shows a snow-covered mountain peak, but bears little resemblance to the late Canadian mountain works such as *Isolation Peak* (Plate 29). In the later painting the carefully observed complexity and delicacy of painted surface and subtly modulated brushstroke betray Harris's naturalist intentions, whereas in *Isolation Peak* he had simplified both the form of the mountain to a pyramid and the surface brushwork to an impersonal, unnatural smoothness. Harris's brief return to naturalism in 1934 was not surprising considering that he was starting to paint again for the first time in more than two years. It was probably an exploration of the basic processes of painting and in this was similar to the naturalism of his Lake Simcoe paintings around the time of his nervous breakdown in 1918.

Less than a month after his arrival, however, Harris made his decisive move into abstraction. It was a jump, not a gradual development from his contemporary or earlier

Figure 11.1
Logos manifested in Man
Fig. 41 from A. Besant and
C. W. Leadbeater, *Thought Forms* (1905)

Figure 11.2
The Logos pervading all
Fig. 42 from A. Besant and
C. W. Leadbeater, *Thought Forms* (1905)

Figure 11.3
Abstraction No. 3, 1936
74 x 92.1 cm
Yale University Art Gallery
Gift of KSD to the
Collection Société Anonyme

landscape painting. Harris would probably have said that these earliest of his abstract paintings were "created from an inner seeing" rather than "from naturalistic sources," the two types of abstractions that he had distinguished in 1927 when reviewing the Société Anonyme exhibition in Toronto. Many of these early abstractions, I believe, were concerned with ideas of balance and equilibrium, qualities which Harris was striving to achieve in the changed circumstances of his life and in his art. I think that these paintings are meant to reflect Harris's concern with karma, which he had described as "an undeviating tendency in the universe to restore equilibrium." And for Harris, the aesthetic attitude in an individual was "the same, an undeviating constant tendency to restore and maintain equilibrium."[12] Harris's continuing preoccupation with establishing such balance in his personal life after such great changes appears in both his writing of 1933 and his draft letter to Doris Huestis Mills in 1939, quoted in chapter 10.

Poise (Plate 37) is an interesting example of Harris's early abstractions; it was done in 1935, or perhaps as late as 1936. In *Poise,* as in many of his early abstract works, the dominant feature is an emphatically three-dimensional sphere almost in the middle of the painting. It is surrounded by balancing factors: with the strong form of the sphere off centre, care had to be taken to balance the composition. This particular painting contains some two-dimensional, unmodelled forms, as well as the three-dimensional ones. The two-dimensional forms seemingly support the sphere. This simple, naive way of doing abstractions is probably related to Harris's thinking about abstraction, seeing the "perfect forms" that he believed existed behind the particular, imperfect forms of nature.

In another, perhaps slightly later work, *Abstraction No. 3* (Fig. 11.3), the sphere is on the central axis of the painting and there are strong two- and three-dimensional forms, including some apparently distant three-dimensional devices. The tension between the two- and three-dimensional aspects is more evident than in the previous work.

Many of Harris's early abstractions manipulate the perception of two and three dimensions, so that the painting can be seen as a balance of these two modes of perception and the viewer's eye must shift back and forth between them. This practice is probably related to Harris's interest in the fourth dimension, about which he had written in 1928: "Let me here suggest that a work in two dimensions may contain an intimation of the third dimension and that a work in three dimensions may contain an intimation of the fourth dimension."[13] The fourth dimension, for Harris as for many artists and others who found the quasi-mathematical notion attractive, was a symbol of the realm of the spirit, eternity, the reality behind the three-dimensional illusions of the physical world. The serene colour in these early works – beige, pale blues and greys – is probably an expression of the relaxed environment he now found himself in.

That Harris used spheres so early in his abstract painting suggests that he had models. He would certainly have known Katherine Dreier's *Unknown Forces,* which had been part of the Société Anonyme's exhibition in Toronto. This work includes a disk and other geometrical forms, some of them clearly three-dimensional. Her *Abstract Portrait of Marcel Duchamp,* like some of Harris's early abstracts, presents solid forms, whether triangles, circles or other shapes, that are abstract but nevertheless three-dimensional and so occupy the illusion of real space. In his early abstracts, Harris seems to have been prompted by such suggestions in Dreier's works.

HARRIS'S THINKING ABOUT ABSTRACTION IN THE 1930s

During his American years (1934–40), Harris published nothing on nonrepresentational or abstract painting. However, two letters are interesting in this regard. In January 1937 Harris wrote to Carl Schaeffer that he thought nonrepresentational painting was "basically, in spirit … the same as representational painting." The former, however, was "a different idiom, requiring a different approach." He

felt that nonrepresentational art "opens up a new field both of subject matter or plastic ideas." Harris insisted to Schaeffer that an artist required a "long background of representational painting before tackling" nonrepresentation. Harris also conveyed his enthusiasm for abstraction to the younger painter: he found that the "possibilities" in nonrepresentational art "are very very great and most enticing. There is no predicting where one is going or what one will be into next and that is exciting."[14]

Writing three months later to Emily Carr, Harris claimed that the further he kept away from the representational "and into abstract idiom the more expressive the things become." But he again links abstraction and nature: "Yet one has in mind and heart the informing spirit of great nature. This seems fundamental." Harris's enthusiasm for the new horizons comes through clearly:

> I must say that I become more and more convinced that non-representational painting contains the possibility of expressing everything. It takes the expression away from the specific, the incidental and can lift it into another place, where the experience is enhanced, clarified – and its great fun – there is so much of adventure in it and an intensity of concentration that I like."[15]

It seems that in developing his abstract painting, Harris had to set aside his earlier preference, stated in 1927, for an abstract art that sprang directly from the mind and cope with at least "the informing spirit of great nature." His own early abstractions frequently allude to nature, at times in obvious ways, at times cryptically. An obvious reference to nature is the landscapelike colour scheme in early abstractions like *Abstraction 1936 I* (Plate 38) and *Abstraction 1936 II*.[16] Each of these has dark earthlike brown tones near the bottom and the blues and whites of a sky near the top. In this they resemble one of Harris's simplified Lake Superior landscapes of the mid-1920s. The same colour scheme is present, though less obviously, in other early works such as *Poise*.

Another way Harris combined nature and abstraction was to insert abstract forms into a simplified or stylized landscape. In the pencil drawing *Study of Space, Autumn, New Hampshire* (Fig. 11.5) of about 1936, many landscape elements – horizon line, trees (one growing from the end of a cylinder), clouds and a receding row of mountain forms – are combined with abstractions: triangles, a broken cylindrical solid and a geometric framing device across the bottom of the drawing. *Design for a Panel, Autumn* of about 1936 is a similar compaction of forms. In the drawing *Mountain, New Hampshire* (Fig. 11.6) of 1934–35, Harris has reduced the main form in the painting to a series of softly modelled triangles, and added, to the right of centre, some quite incongruous, precisely drawn, sharply three-dimensional floating abstract forms. By creating a sense of perspective, these forms indicate in the drawing another way of perceiving space. Harris once called abstract painting "a dance of the spirit"[17]: in works like this, geometric and organic ways of perceiving space and form do a *pas de deux*.

Similarly modelled mountain-triangle forms occur in the large blue mountain in the centre of *Winter Comes from the Arctic to the Temperate Zone* of 1935–37; the framing devices in the upper half of the painting suggest Harris's awareness of the work of John Marin. The painting's mountain-triangle forms are combined with unusual dull white and yellow shapes in the foreground. Although difficult to recognize, they are not abstract forms but a representation of Hanover shrubs and trees typically misshapen under a heavy load of wet, New Hampshire snow.[18] In the painting, Harris has not only contrasted the cold-blue arctic and the temperate zone, he has also recorded nature herself making "abstract forms" out of snow and trees, a paradox he no doubt found amusing.

Harris also made cryptic references to nature in his abstractions through the system of proportion known as "dynamic symmetry." Harris probably knew Jay Hambidge's

Figure 11.5
Study of Space, Autumn, New Hampshire, Drawing No. 85, c. 1936
Pencil on paper
27.7 x 21.4 cm
Private collection

Figure 11.6
Mountain, N.H., Drawing No. 79, 1934–35
Pencil on paper
Private collection

Figure 11.7
Abstraction (Panel No. 63), c. 1937
64.1 x 50.8 cm
Private collection

well-known theories of proportion long before coming to Hanover. If not from some other source, he would have learned about them when the artist C. W. Jefferys lectured on them in Toronto in the mid-1920s. The system was based on analyses of both Greek art of the classical period and certain rhythms of nature. *Practical Applications of Dynamic Symmetry,* one of Hambidge's many books on the subject, was required reading for art students at Dartmouth College; Lathrop remembers that Harris read the book and discussed it with him.[19]

During his Hanover years, Harris used this system – at times very loosely – to help organize the compositions of some of his abstract paintings. One aspect of the system that he found attractive, I believe, was that by using dynamic symmetry he would be incorporating into his work not only the supposedly ideal proportions of Greek art but also the rhythms and proportions of nature. From these, according to Hambidge, the Greeks had derived, through the long since lost but now rediscovered system of dynamic symmetry, the proportions of their eminently successful arts. In its search for order, stability and universally valid canons of proportion, the interest in dynamic symmetry reflects the neoclassical mentality of the period following World War I. Contemporary artists who used dynamic symmetry did so to help them make of modern art something that would be as strong as the art of the Greeks at their best.

Nor is it surprising that Harris was attracted by this system, given his search for his own modes of abstract painting and his general tendency to seek the security of supporting theoretical structures. Dynamic symmetry's supposed link through Greek art with the rhythms of nature paralleled Harris's contemporary concern with the relationship between nature and abstraction. Given his Platonic bias, Harris could easily have seen the rectangles and diagonals, "the whirling squares" of the system, as abstract signs of the hidden forces of nature. Thus he could maintain his link with nature without painting representational works.[20]

An early Hanover painting in which Harris made use of

dynamic symmetry is *Abstraction 1936 I* (Plate 38). Harris has divided the rectangle of this painting according to the directions of Hambidge.[21] This system involves producing diagonals on geometric principles from the corners of the original rectangle, and creating from them a series of ever-smaller rectangles within the original one, all with identical proportions. If a drawing of these spiralling rectangles and their diagonals is superimposed onto the painting *Abstraction 1936 I,* correspondences become clear (see Fig. 11.4). The top edge of the planklike slicing device on the left corresponds to one diagonal; the bottom edge of the same device is drawn on another diagonal. The top edges of the two wedge-shaped forms that rise to the spherical form from the bottom centre of the painting are on a line parallel to a diagonal of the original rectangle. The almost-white vertical line that rises from the slicing device to the arching blue form above corresponds to one side of the fourth rectangle.

Harris probably drew all the diagonals and rectangles on the underpainting of *Abstraction 1936 I.* However, as though he wanted to give a deliberate clue to his use of the system, he drew one of the vertical lines, in pencil I believe, on the surface of the painting after finishing it. The line makes the process of understanding the painting something like solving a puzzle. However, uncovering Harris's use of dynamic symmetry by no means "solves" the painting. The centre and left of the painting are filled with blue and white forms which do not fit into the dynamic symmetry proportional system. Some of the forms, for example those at the bottom right, are like icebergs reflected in calm water and recall his Arctic and other stylized landscape works. The irregular battering-ram form, in pale blue sky colours, is probably a naive representation of the imperious spirit intruding itself on nature, represented by the earthier colours of the forms on the lower left. These darker forms are "natural" not only because of their colour but also because they are derived from nature through dynamic symmetry.

Thus *Abstraction 1936 I* becomes an image of the destruction of a world that has to take place if one is to

advance in the spiritual realm. Harris has placed the same earth-coloured forms in another painting of the same period, *Abstraction 1936 II,* although there the spherical form is at the bottom of the painting. Nevertheless the sphere and the other forms follow the dynamic symmetry system. Harris has transplanted the forms from the rectangle of *Abstraction 1936 I* to the quite different rectangle of *Abstraction 1936 II*: they cannot be derived from the rectangle of *Abstraction 1936 II.* Again, earth-coloured forms confront a mainly sky-blue area across the top of the painting, and the picture contains both two- and three-dimensional forms. The fact that Harris has shifted the forms derived by the rules of dynamic symmetry from *Abstraction 1936 I* to *Abstraction 1936 II,* that is, to a rectangle that could not have generated them, is significant because it shows that Harris was by no means a slavish follower of the system.

In both works Harris, I believe, has attempted to embody a universal image of the principle of human growth, of matter – the physical man, as Harris might have put it – being confronted by the spirit. But they also embody the destruction of his earlier, more restricted world in Toronto and the larger horizons now unfolding before him.

Harris was not concerned solely with the relationship between nature and abstraction during his early abstract period. He was also interested in the motifs he was adapting from nature and other sources – the triangles, sometimes derived from mountain forms, sometimes from theosophical imagery, the circles, spheres, and so on. Harris used them as it pleased him; they were like chords to a composer. Triangles were very important to Harris at this stage of his career: they occur again and again, sometimes transparent, as in *Abstraction (Panel No. 63)* (Fig. 11.7), c. 1937, at times solid and pyramid- or mountainlike as in the background of *Abstraction 60.* Sometimes the triangles are combined with other geometric forms as in *Abstraction 13* (Fig. 11.8) or *Abstraction 196* (Fig. 11.9).

The juxtaposition of two-dimensional and three-dimensional forms and spaces in the same painting was

another important theme in Harris's early years as an abstract painter. Nowhere is the balance of these dimensional systems in one painting more deliberate or thoroughgoing than in *Equations in Space* (Plate 39), probably painted as early as 1936. The right and larger portion of the painting is given over to three-dimensional forms drawn with orthogonals that stress perspective as some of them wrap around a solid rectangular form in the middle of the painting. The background of this portion of the painting has a horizontally fluted screen. Thus the right side of the painting is treated like one of the Lake Superior landscapes, such as *Above*

Figure 11.4
Abstraction 1936 I analysed with Dynamic Symmetry Lines
(see Plate 38)

Figure 11.8
Abstraction 13, c. 1937
Oil on masonite
45.7 x 55.9 cm
L.S.H. Holdings,
Courtesy of Mira Godard Gallery,
Toronto

Figure 11.9
Abstraction 196, 1941
L.S.H. Holdings, Vancouver

Lake Superior (Plate 23). The viewer's eye is guided through the orthogonals of a clearly three-dimensional foreground to confront the deepest space, a typical Harris device.

In the left portion of the painting, however, space is handled differently. The viewer confronts the half-circles of the main form, which is two-dimensional and transparent. Because of these transparencies we are aware of a flat surface object through which we perceive other flat planes. Thus Harris has created a space out of transparent and opaque overlapping planes. More than a two-dimensional space, it is not a representational, three-dimensional space, but a pictorial space, part of the alternative world of the idealist. In creating this pictorial space using transparent planes, Harris developed a mode of abstraction that served him during the next few years of painting. His interest in transparent planes went all the way back to 1927, when he had noted some in works in the Société Anonyme's exhibition in Toronto. He found that some of the works "by rendering transparent some of the planes, sought to give the experience of the unreality of appearances."[22] The sense of "layers" was one of the deepest reflexes in Harris's imagination, and, as we have noted above, constituted the standard way he composed his wilderness and urban landscapes.

Harris's abstract works in Hanover developed from the earthy, lumpish and naive abstractions like *Abstraction 1936 I* toward works that express an airy spaciousness. In *Painting No. 4* (*Abstraction 94*) (Plate 40) there is the residue of a horizon line with a circle of light and shadow underneath it. The main forms in the painting are a compaction of lozenge and triangle forms, spheres and circles. Although they are aerial forms floating above the horizon line they have the air of something solid, not unlike the solid-looking clouds Harris painted in his Lake Superior period. The colouring of the painting has come a long way from that of *Abstraction 1936 I*. The strong structural forms that occupy the main part of the painting, the lozenge and triangular forms, are actually prefigured in a painting that is roughly contemporary with *Poise*. In *Abstraction 98* (Fig. 11.10) the sphere is placed on

the central axis of the painting, surrounded by the solid lozenge form; like *Poise*, the work uses the earth-and-water colour scheme. *Abstraction 98* seems to be the prototype of many of Harris's paintings of this period, which are compactions of signlike shapes on the central axis of the picture. *Painting No. 4* is a complex compaction of forms. It contains two spherical forms, one on the central axis. On the right is a sphere that has been interrupted by straight lines so that parts of it become a circle: another example of Harris shifting between two and three dimensions as part of the perceptual exercises he wants us to undergo.

Time and again Harris has done this. I believe that this manipulation is related to his idea of the fourth dimension, which he saw as a kind of progression of awareness of dimensions. As Harris himself said, it is possible in a two-dimensional painting to give an intimation of three dimensions, and in a three-dimensional painting to give an intimation of the fourth dimension. He would have considered this perception of shifting dimensions a very spiritual experience, especially since it was an image of the shift of the person into the fourth dimension. This is what he wanted his paintings to do, promote the shift into the spiritual sphere.

Landscape elements are also obvious in *Abstract Painting 95* (Fig. 11.11). In this work the horizon line is even lower in the painting, with rows of horizontally worked clouds rising from it. However, dominating these clouds and in front of them is the large abstract form. It is much less solid-looking than the forms in *Painting No. 4*. The landscape reference is emphasized because the abstract forms are reflected on the surface of the water in the painting. This work was probably painted around 1938, possibly in Santa Fe.

Abstract Painting 95 recalls, as does *Painting No. 4* to a lesser degree, Harris's use of a series of illustrations in *Thought Forms*. These illustrations were one of the main sources of the details in his abstract paintings. In this instance, *Thought Forms* provides not details, but a source for the whole composition. For instance, the colour illustrations "M" (for Mendelssohn), "G" (for Gounod, Fig. 11.12)

and "W" (for Wagner, Fig. 11.13) illustrate for Besant and Leadbeater what a clairvoyant saw while listening to specific works of these composers. They resemble the last two paintings by Harris in that they are forms suspended over a landscape, meant to express pictorial equivalents of musical realities. They are important to the abstract artist as ways of depicting coherent and related elements of form that are not connected to normal representational purposes.

These illustrations from *Thought Forms* are supposedly pictures of music, which was generally understood as the most abstract of the arts; the other arts were seen as aspiring to the nonrepresentational, nonmaterial condition of music.[23] Many of Harris's interests come together in such considerations. There was his life-long obsession with music. He played records so loudly in his Dartmouth College studio that he became legendary for it on campus, and he did much the same at home when he had friends in. That the *Thought Forms* illustrations are images of music suggests that Harris's paintings are as well. Rather than having a loose, continuing structure like a melody, his aerial abstractions of the 1930s are more like firm, definite chords. The visual elements of the chords are drawn from many sources – his landscape experience, his varied experience of abstraction and his use of signs and imagery (the circles, spheres, triangles, pyramids and other geometric devices) from theosophical literature. What is characteristic of Harris's works of the thirties is that they are often centralized, vertical compositions, like complex, tension-filled and emblematic road signs, and they are usually definite and clear in form and outline. They are like assertive chords of music made up of many elements, combined in harmonies and colour schemes that vary, although Harris maintained a mainly cool palette throughout this period.

There may have been influences other than theosophy and music at work in another aerial abstraction of this period, Harris's *Composition 10 (Abstraction No. 79)* (Plate 41). Harris thought enough of this painting to exhibit it in December 1937 with the Canadian Group of Painters

in Toronto. There its title was *Composition*, and it was either No. 2, 4, or 10. In 1939 Harris exhibited it in the "American Art Today" show at the New York World's Fair, where it was called *Composition No. 10*.[24] The aerial image here is interesting; it represents an attempt to make light and space-filled forms rather than the bulky forms and partly dark, earthy colours of many of his earlier abstractions. *Composition No. 10* probably represents works in which Harris used the image of space to represent the spirit. The image of the spiralling around the central axis may well be a reference to the spiralling squares and rectangles

Figure 11.10
Abstraction 98, c. 1936
74.3 x 91.4 cm
L.S.H. Holdings,
Courtesy of Mira Godard Gallery,
Toronto

Figure 11.11
Abstract Painting 95, c. 1937
142.2 x 116.8 cm
Collection of Georgia Riley de Havenon

Figure 11.12
Gounod
Plate G from A. Besant and C. W. Leadbeater,
Thought Forms (1905)

Figure 11.13
Wagner
Plate W from A. Besant and C. W. Leadbeater,
Thought Forms (1905)

of dynamic symmetry and so to the proportions of Greek art and the proportions and forces of nature. This work has less connection with natural imagery than *Abstract Painting 95*. It suggests that Harris experimented, by using an earth-free imagery, to see how this approach could help him move more thoroughly into abstraction. That is probably why he valued it and showed it in both New York and Toronto.

It is significant that Harris's paintings of the Hanover period do not very much resemble the works that he was seeing in New York. The probable explanation is that Harris did not conceive of space in a way that allowed such influences to enter his art. It is not until much later in his life that his pictorial space is actually freed from representational space. It is as though Harris in the 1930s had not yet assimilated Cubist space. Space in most of Harris's early abstractions is not an independent, flattened field of vision. No matter what forms are presented, it is rather like a window opening onto natural space. The unity of the surface of his painting is often not clear because even his compactions of forms suspended in the middle of a composition occupy not a pictorial but rather a representational, aerial space. In other words, Harris's paintings do not have the pictorial independence that is associated with the Cubist concept of space. It is as though he had a vocabulary for geometric abstractions but was unfamiliar with the spatial syntax.

I speculate that Harris was unfamiliar with Cubism because he had been isolated from both New York and Europe by his nationalist ideology during the two decades after the Armory Show of 1913. During that period, his modernist American contemporaries had developed an intense awareness of Cubism. They had assimilated Cubist notions of space and were able, in their geometric abstractions, to organize the space as though it approached two-dimensionality and to distribute their pictorial elements with a sense of its integrity and importance.

For Harris, however, the transparent planes were meant to convey meanings he valued, rather than function as a formal, surface-saving device. His was an aesthetic of the exploration of spiritual content, not an exploration of the possibilities of form. He was, I believe, painting images of what he thought were spiritual realities and truths. He set up these images of truths in a way very similar to portraits or landscapes. However suspended they looked, it was nevertheless air they seemed to be suspended in.

The deployment of aerial, almost floating forms in Harris's Hanover paintings also looks forward to several paintings he did in Santa Fe between 1938 and 1940, his next and very happy period.

Soaring, 1938–40
With the Transcendental Painting Group in Santa Fe

AN IDYLLIC LIFE

The Harrises' move to Santa Fe took his friends and acquaintances in Hanover by surprise. Lawren and Bess had taken a spring trip to the American South and Southwest, the trip on which they visited the Museum of Non-Objective Painting at the Gibbes Memorial Art Gallery. As Harris later put it in a list of personal data for the astrologer Dane Rudhyar, he arrived in Santa Fe for the "first time" on the eighteenth of March 1938 and "settled" there on the nineteenth. He added that he "arrived in Santa Fe for residence" on 1 October of the same year.

One aspect of Santa Fe that attracted Harris was the surrounding Sangre de Cristo mountains, actually a section of the Rockies. The city itself was 7,000 feet above sea level. Here were dramatic mountains that could be contemplated and climbed; Harris had mentioned missing such excitement in Hanover.[1] The city and the mountains were set in a red-brown desert peopled by Indians living on mesas and in pueblos in a mystical relationship to their land, a combination of factors Harris must have found irresistible. Like Hanover, Santa Fe protected Harris from the difficulties – still alive back in Canada – of his divorce and second marriage, and gave him a peaceful environment in which he could pursue his interests in abstraction and mysticism, shel-

tered from the threatening social turmoil of the Great Depression. The small city of charming adobe houses and ancient churches again provided a milieu that valued Harris's talents and fostered his commitment to modernism and to abstract or nonobjective painting, although here it would be called, with Harris's approval, "transcendental" painting.

What Santa Fe had that Hanover did not have was artists who shared Harris's spiritual and mystical interests and who admired his painting. Hanover with its sympathetic academics, particularly in the art department at Dartmouth College, had accepted and supported Harris in a broad-minded, liberal and secular way, but had offered Harris no job more challenging than that of unofficial artist-in-residence. In Santa Fe Harris found kindred spirits passionately involved in his own kind of artistic and religious speculation, and a chance to work on a shared task he deeply believed in. This was important for Harris because he almost always felt more at home working with a group.

Writing to his friend Harry Adaskin less than a month after his first arrival in Santa Fe, Harris made no efforts to contain his enthusiasm:

> And what do you think has happened to us? We feel
> we have found our place here in Santa Fe. Life

opens up for us here as it did nowhere in the East – both creatively and in terms of usefulness. We both felt the place the day we motored in. It has an unseen atmosphere that is at ease in Zion – creatively free and stimulating – the district is spiritually magnetized – unanalizable [*sic*] but potent. Right from the start things commenced to happen as if prearranged, we became useful and our being spread naturally into the creative life of the place ... and there are a goodly number of rather swell folks ... We have made some good [friends] and they are the real creative folk just now moving into the new creative shape or vortex I spoke of – spiritual abstractions. Yes, there is something on the make here that I doubt can occur in the same way anywhere else on the continent.[2]

We have artist Raymond Jonson's description of how he and his wife first met the Harrises:

One day, it must have been in early 1938, we [Raymond Jonson and his wife, Vera] saw a stunning looking couple walking past our home and studio in Santa Fe. I went out and introduced myself to them and they to us ... I was delighted with our meeting for I knew of Lawren Harris as I had seen an exhibition of his work at the Roerich Museum ... in New York in late 1931 or early 1932. It was a beautiful and wonderful exhibition and impressed me tremendously ... A close friendship resulted and we saw each other as much as possible.[3]

Thus a new chapter in Harris's life began suddenly, pleasantly and with the promise of a friendly community of creative artists.

The Transcendental Painting Group was formed in late 1938 by Jonson (1891–1982) and Bill Lumpkins (1909–) both then living in Santa Fe; Emil Bisstram (1895–1976) and

three of his students, Robert Gribbroek (1907–70), Florence Miller (1918–) and H. Towner Pierce (1916–58) then living in Taos; Stuart Walker (1904–40) in Albuquerque; Agnes Pelton (1881–1965), in Cathedral City, California; and Harris. Jonson insisted that Harris "was not a late comer as a member of the Transcendental Painting Group. At the time of our meeting [i.e., the Jonsons and the Harrises] we were just in the phase of organization and he immediately joined with us and was a vital personality in the meetings and discussions we could arrange."[4]

Bill Lumpkins was twenty-four years younger than Harris, and admired him enormously. He and Jonson may have initiated the conversations that led to the idea of forming a group; the conversations began at Jonson's painting supply store and it was Jonson who talked to Bisstram about it. All of the painters were working in abstraction. What began to hold them together was the need to "protect themselves from the realist swarms"[5] that dominated the exhibitions. It was extremely difficult to get abstract works exhibited. Their group was to help correct this situation. It was Harris who put up the money for the incorporation costs of the American Foundation for Transcendental Painting, Inc., the group's promotional arm.[6]

Harris's closest friend in the Transcendental Painting Group was probably the organizationally talented and warmhearted Jonson. When Harris was away from Santa Fe they wrote frequently; their letters reveal Jonson as an affectionate, admiring friend whose loyalty extended to the very onerous task of packing and shipping Harris's musical records and paintings after Harris moved back to Canada. The admiration was mutual. Shortly after their first meeting Harris placed a reserve on and eventually bought Jonson's *Cosmic Rhythm No. 4*. He wrote Jonson that it was "a canvas we both [he and Bess] admire immensely, unboundedly." A couple of months later Harris wrote Jonson again and his closing paragraph conveys his personal feelings for the other painter: "Our most affectionate greetings to you both and just general all around and up down pleasure and gratitude

for the channels we were moved along in Santa Fe, our new but seemingly long known friends and the new art movement – so far we have come upon no better designation than transcendental painters."[7]

Jonson was the main writer of the brochure that the group published in 1938. One interesting paragraph suggests how close the goals of the group were to Harris's own. They shared a desire to present the realities they so strongly believed existed behind normal appearances: "The word Transcendental has been chosen as a name for the group because it best expresses its aim, which is to carry painting beyond the appearance of the physical world, through new concepts of space, color, light and design, to imaginative realms that are idealistic and spiritual." The brochure also included statements by Dane Rudhyar and Alfred Morang. Rudhyar, a theosophist, writer and astrologer whose book *Art as Release of Power* Harris owned, saw the Transcendental Painting Group as one of the "minorities of creative personalities" whose task it was to face the "economic materialism" and other related evils of the age. He concluded with a ringing sentence whose absolutism resembles Harris's earlier statements about art: "Great art always emerges out of such a historical necessity – and in no other way."[8]

For years Harris had been preoccupied with thinking, writing and painting about such spiritual concepts. While in Hanover, he had been discreet about his interest in theosophy, perhaps because of the scepticism he would expect to find even in such a liberal academic milieu. But in Santa Fe, theosophy was an interest that his friends respected and to some extent could share. Many of the titles of the paintings in the group reveal their interest in the spiritual and cosmic imagery and ideas that permeate theosophy. There were even meetings at which theosophy was discussed.[9]

In fact Emil Bisstram and his wife Maryan had been active theosophists when they lived in New York, and weekly meetings were held in their apartment in Taos, under the leadership of Dane Rudhyar. By the time Lawren and Bess got to know them, the Bisstrams had "drifted over to Tibetan yoga."[10] Mrs. Bisstram remembers that although her husband and Harris were different in some ways – Bisstram was a "rough diamond and a roughneck" while Harris "had polish" – the two men "hit it off" immediately and had many long discussions in which they seemed to be in complete agreement about art and its morality, spirituality and high purposes. Harris acquired several drawings of "esoteric symbolism" by Bisstram.

Mrs. Bisstram's descriptions of Harris underline how well-accepted Harris must have felt in this environment. She remembers that he was tall and slim and had rosy, fair skin and a shock of white hair. He held his shoulders back, walked with great dignity and "carried his head as if he wore a crown." He was most courteous and considerate of Bess, and they both had an air of serenity. The Bisstrams quickly felt that they had known them for a long time. Yet they felt that there was a certain reserve and dignity about Lawren and Bess, a line around them one would be foolish to try to cross.

Bill Lumpkins remembers that, in response to some inquiries, Lawren and Bess explained to their close friends about their previous marriages and said that they had waited for Lawren's children to grow up before getting divorces and marrying.[11] Harris's circle of friends accepted this, although none of them, save the Bisstrams, seem to have had an inkling of the special nature of the marriage. Mrs. Bisstram insists that they never asked the Harrises direct questions about their personal life, but that Lawren and Bess did discuss the nature of marriage with the Bisstrams. Mrs. Bisstram remembers that they all agreed: "Marriage isn't always a necessity, nor are the activities of marriage necessary"; that two people of the opposite sex could share their lives and live a very beautiful and very creative and constructive life. This is a point of view, said Mrs. Bisstram, that the general public found very difficult to accept, but she thought that Lawren and Bess gave a very practical demonstration of such a relationship. "And of course," she commented, "in the esoteric philosophies of the East, the final step is celibacy."[12]

Lumpkins has vivid memories of the Harrises' life in Santa Fe. He described them as "very striking people" who were always immaculately dressed, usually in "shades of white" which, along with their white hair, created a special effect. In Santa Fe, the Harrises seem to have been more formal than their colleagues, but that was accepted as a Canadian trait. This formality probably contributed to another perception: Lumpkins, echoing Maryon Bisstram, remembers Harris as "a very impressive looking person … sort of a regal man … princely," although he found Harris's personality "warm" and attractive. He also described the interior of their house as having the white walls that were usual in such adobe-style houses, but also white furniture and carpets, which were unusual. Harris apparently had some of his Arctic paintings on the walls and Lumpkins referred to these as "white on white" paintings and remembers that Harris said he was "obsessed with white."[13]

Harris's rented house was part of a linked complex of four or five brown two-storey adobe-style homes that has changed little since Harris's day. The complex, Plaza Chamizal, is entered by a driveway from a busy street on the edge of town. From the dusty street one comes into a haven of greenery and the peace and charm of the randomly placed adobe buildings with their softened corners and edges. It has the sense of a privileged interior garden, a careful assemblage of peaceful forms. The Harrises' house had a small walled garden and a handsome private patio with an outdoor fireplace, partly shaded by verandas and trees. Harris was able to add a second-floor studio built to his designs. As he put it, "house and studio are in a kind of park along with several of the landlady's houses – a quiet, private and grand spot to work." Bess described the house to a friend in Hanover:

> We have a house that suits us to perfection. – a beauteous studio at the end of the living room with a ten foot hall between – with two pairs of double doors. – one pair in glass, the other wood. – all

household sounds are shut off completely. The music box sits in one corner of the studio and the music has at least forty or fifty feet to go before it reaches the listeners in the living room. – The conditions for our two most important activities – music and painting are therefore perfect … the whole living room is white – ivory calsomine. On either side of the fireplace … is a curved arch and doorway – one to the kitchen and dining room and the other to my room. Lawren sleeps in the studio and has a bathroom and dressing room off its ten foot hall. The other long wall of the living room has a large window and a pair of french doors. – these open into the garden … The whole property is surrounded by a high wall, – It really is delightful.[14]

Lawren and Bess often held musical parties, at which Harris would introduce the musical selections by showing some of his recent paintings. There would follow an hour or so of listening to records on Harris's excellent sound system. The speakers were in Harris's studio: played at high volume and echoing down the long corridor to the living room, they gave the nearest thing to stereophonic sound that one could get at the time. Harris often played what Lumpkins described as "northern music," Grieg and Sibelius.

But do we know anything about Lawren and Bess's relationship? Lumpkins was particularly struck by the affectionate, courteous bond of mutual self-awareness they seemed to have, as if there were unspoken communication between them. Bess is remembered as a superb hostess, but her role was probably much more than that. She too was a painter and her perceptions were, she felt, of help to Harris. Writing to her friend Doris Huestis Mills, she explained why she "must move into the abstract" rather than continue representational painting for which she would want to be outdoors, mentioning both "inner and outer reasons." The reasoning reveals her perceptions of her relationship to Lawren, her modest estimation of her own abilities as a

painter and the apparently total subordination of her talents to his:

> I need to be in the house and available. – even to be in the studio. – It is needful. It is also a joy that I can be really useful to Lawren in his own creative work … I am blessed with more painting perception than I am blessed with ability to do, – so it is good to use it. – Whenever Lawren finds himself in a questioning place he comes for me and we go and talk it over – perhaps just the looking and talking together, – starts the creative flow once more. – Anyway there it is. – I don't feel free to go outdoors painting even should I want to … Anyhow my true creativeness is in my relationships.[15]

Harris might well have stayed in Santa Fe for the rest of his life, but in September 1939, Canada declared war on Germany, setting off a series of national wartime decisions that included restrictions on the outward flow of funds. This created problems for Harris and Bess, who needed their Canadian money. The funds were crucial not just for their own expenses but for Harris's mother, who was by then more or less an invalid and living in California, and whose care they were supervising. When Harris left Santa Fe on his regular summer trip in 1940, friends there knew that he might not come back. At the time he left, Harris did not know precisely what he was going to do or where he would go. One has the impression that he had to find out the ramifications of the new Canadian regulations and then make up his mind. There was also the problem of Trixie's family and the possible bigamy charge. What probably happened was that the Phillips family agreed that Harris could come back to Canada as long as he did not live in Ontario. The first documentation we have of Harris's travels in 1940 is a letter to Jonson in late November, written from the Windsor Arms Hotel in Toronto, where he and Bess were staying. They had been very busy, caught in a whirlwind of being entertained

and renewing old friendships and "sitting in on other folks problems – family and friends … After the general all around ease of Santa Fe and the lovely air and climate this seems another and dizzy world."[16] By this time Harris had already been to Victoria, where his mother was going to live, and to Vancouver, where he and Bess were going to rent a house at 4749 Belmont Avenue for the winter and spring.

In late December, Harris wrote to Jonson that he and Bess could not return to the United States until after the war. Sometime during those first six months in Vancouver they decided to stay there permanently. At first neither of them had been enthusiastic about going to Vancouver, but by March 1941, Bess could write, " – now we are grateful that Life took us in hand and landed us in these beauteous parts."[17]

HARRIS'S TRANSCENDENTAL PAINTING

In his painting in Santa Fe, Harris continued developing some themes from his Hanover period. *Composition (Abstraction No. 99)* (Plate 42) is a later use of a sphere motif in a painting; it was done, I think around 1938, perhaps in Santa Fe. I interpret it like a piece of music in two movements. In the painting there is a progression from the dark colours near the bottom left along an ascending diagonal toward the realms of light in the upper right. The colours of the lower sections are earthbound: black, wood-grain brown, a dark and then a lighter green. The green and white spheres nearest the centre are each related to the shapes under them as head to shoulders, so are suggestions of human forms. I believe the painting is Harris's contemplation of a human being's movement toward higher realms of clarity and light. There is such a difference at the white sphere that a sense of a transcendent layer or plane is created. In 1933, Harris had written about this plane:

> Beauty … is the very spirit of the plane of being we theosophists call buddhi, that is, that eternal plane

of being wherein abides the immortal part of man and the universe, and which is beyond sensuality and the intellect and desires, and is the source of all high inspiration and devotion.

The progression of the individual to this level or plane is what I think of as the first movement in this painting. The second movement is the experience of light itself that makes up almost all the right half of the painting. No colour reproduction has fully captured the rich combination of painstakingly applied pale blue and yellow paint that creates this radiance. The image of order and light in this transcendant shadowless realm functions like the gold-leafed areas in Byzantine icons, which also represent the transcendent realm of divine light/energy as the context of human living and growth. As we will see in chapter 14, Harris's interest in these dimensions of light became more intense toward the end of his life.[18]

Throughout his later Hanover and Santa Fe periods, Harris continued to produce abstract paintings of basically two kinds. One kind stressed solid-looking, three-dimensional forms that at times resembled rocks or mountains or suggested other forms from nature – for example, *Abstraction 53 (Mountains and Pyramids)* of about 1938. At times Harris painted heavy-looking forms such as *Pyramid* of about 1939 (Fig. 12.1) that seem, incongruously, to float in space.

In the second kind of abstraction, Harris created airy-looking images. *Abstraction (Portrait of Bess)* (Fig. 12.3) of about 1938 is particularly interesting. This painting is a constellation of mainly flat forms – circles, triangles and Art Deco–derived parallel lines clustered around, in the absolute centre of the painting, a still, white disk. The disk itself, although it has some textured paint, is flat, as is the blue field that covers most of the canvas. This distinguishes it from similar compositions such as *Abstract Painting 95* (Fig. 11.11), which clearly presents a vast landscape space around abstract elements. With the special flatness of *Abstraction (Portrait of Bess)* Harris has rendered the image

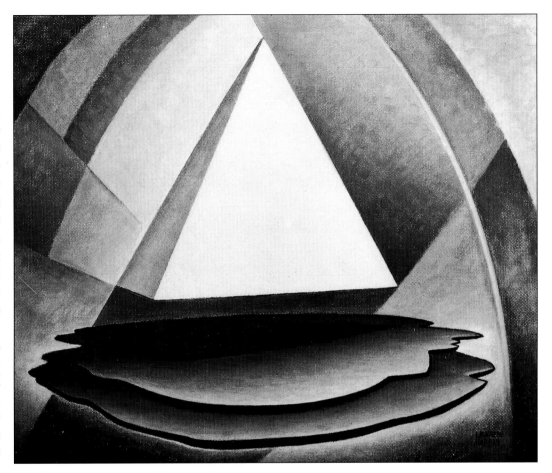

more spiritually refined and delicate than in any of his contemporary paintings. The idea for this white centre may well have come to Harris from the theosophical idea of "white light, which always indicates unusual spiritual power."[19] Thus the painting, whose two preparatory drawings were labelled by Bess Harris herself (see Fig. 12.2), is a portrait of the woman whose spiritual strengths helped change Harris's life. To compare it with the 1920 *Portrait of Bess* (Plate 36) is to grasp something of the extent of their artistic and spiritual journey.

Another work of this period, *Abstraction (Involvement 2)* (Plate 43) of 1938 or 1939, illustrates, I believe, an adaptation

Figure 12.1
Pyramid, c. 1939
Oil on masonite
45.6 x 55.9 cm
Art Gallery of Windsor
Gift of Yvonne McKague Housser,
Toronto, 1964

Figure 12.4
Involvement 2 Santa Fe (Drawing 96)
Pencil on paper
27.7 x 21.5 cm
Private collection

Figure 12.2
Abstraction (Portrait of Bess), Drawing
Pencil on paper
25.4 x 15.9 cm
Dalhousie University Art Gallery Permanent Collection

Figure 12.5
Involvement 2 Santa Fe (Drawing 97)
Pencil on paper
27.7 x 21.5 cm
Private collection

Figure 12.6
Jay Hambidge
Figs. 14a and 14b from his *Dynamic Symmetry:*
The Greek Vase (1922), 15

Fig. 1. Nolan Amphora 13.188 in the Boston Museum.

Figure 12.7
Jay Hambidge
Nolan Amphora in the Boston Museum (A Theme in Root-Three)
Fig. 1 from his *Dynamic Symmetry: The Greek Vase* (1922), 60

of dynamic symmetry. In Santa Fe, Harris had renewed his contact with this system of proportion through his friendship with Emil Bisstram in the Transcendental Painting Group. Bisstram regularly organized his painting classes around dynamic symmetry, and Bess Harris was one of his students.[20]

The preparatory drawings for *Abstraction, Involvement 2* are helpful. The form in the centre of *Involvement 2, Santa Fe (Drawing 98)* is not unlike a pipe from an organ, and had already appeared in *Abstract Painting 95* (Fig. 11.11). The next two preparatory studies, *Involvement 2, Santa Fe, (Drawing 96)* and *(Drawing 97)* (Figs. 12.4 and 12.5) recall Jay Hambidge's dynamic symmetry analyses of rectangles where the larger rectangle is divided systematically into smaller ones with the same proportions (Fig 12.6). In *Drawing 96* Harris, in dynamic symmetry fashion, has drawn lines perpendicular to the diagonals of the smaller rectangles and has generated on this grid the four pairs of straight lines that meet in points at the edge of the drawing, two on each side.

In *Drawing 97* Harris has added shading that, respecting these lines, reveals more clearly the forms in the upper half of the painting. Thus the dynamic symmetry system has helped Harris create the main spiralling forms in the upper half of the painting. His less-than-purist attitude toward the system, however, has allowed him to shorten the large but not the small rectangles in the drawings and to use a different rectangle for the final painting. My nickname for *Abstraction (Involvement 2)* is "The Greek Vase," because of the wide convex and concave curved lines that descend from the top right and left of the painting almost to the bottom, where they meet and form a sharper curve. They are similar to the outlines Hambidge has drawn in the many illustrations of Greek vases (Fig. 12.7) whose proportions he has analyzed within grids of rectangles in his well-known study, *Dynamic Symmetry: The Greek Vase.*

Harris's two-year Santa Fe period ended almost as abruptly as it began. The Jonsons and the rest of the group of spiritually minded artists never forgot the Harrises, their hospitality, musical evenings and creative energies. Lawren and Bess left behind a compatible community and a stimulating and trouble-free milieu where they had been very happy. However, after a brief period of uncertainty, life smiled on them again.

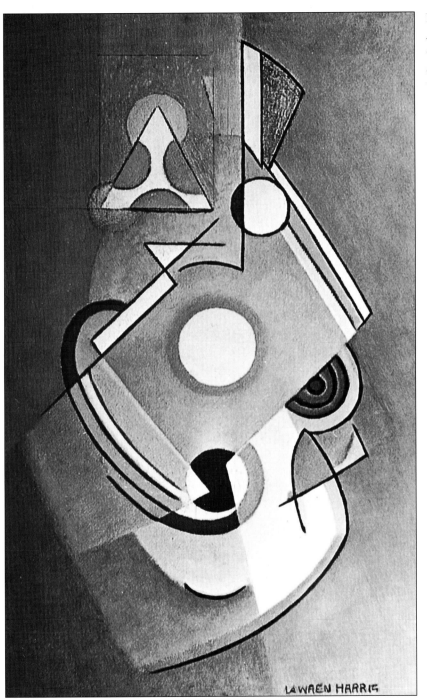

Figure 12.3
Abstraction (Portrait of Bess), c. 1938
Oil on masonite
61 x 38.1 cm
Unlocated

PART IV

FROM ARTISTIC POLITICS TO MYSTERY, 1940–70

COLOUR PLATES IN PART IV

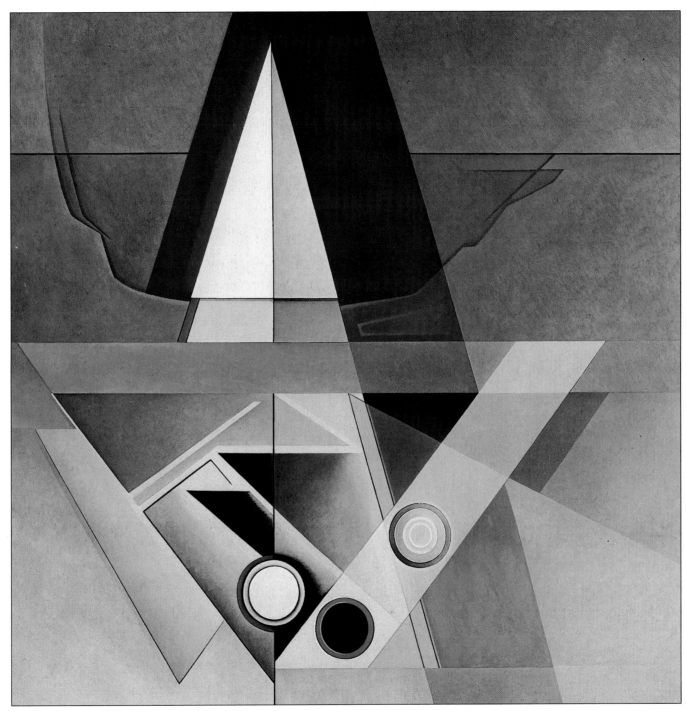

Plate 44
Composition No. 1, 1941
157.5 x 160.7 cm
Vancouver Art Gallery
Gift of Mr. and Mrs. Sidney Zack,
Vancouver, 1965

Plate 45
Abstraction 119, c. 1945
146.1 x 120.7 cm
Unlocated

Plate 46
Abstract Sketch, c. 1936
30.7 x 38 cm
McMichael Canadian Art Collection,
Kleinburg, Ont.

Plate 47
Flame Forms (Abstraction 70), 1950–55
127 x 101.6 cm
Private collection

Plate 49
Lyric Theme II (Abstraction No. 125), c. 1956
68.6 x 92.1 cm
L.S.H. Holdings, Vancouver

Plate 48
Formative III (Forming toward Beneficence), 1950
104.1 x 129.5 cm
L.S.H. Holdings
Courtesy of Mira Godard Gallery, Toronto

Plate 50
Abstraction 140 (Subjective Painting), c. 1957
79.4 x 125.7 cm
L.S.H. Holdings
Courtesy of Mira Godard Gallery, Toronto

Plate 52
The Spirit Settling into the Heaven World State, c. 1960
107.3 x 127 cm
L.S.H. Holdings
Courtesy of Mira Godard Gallery, Toronto

Plate 51
Calligraph Forming, c. 1958
95.3 x 123.2 cm
L.S.H. Holdings, Vancouver

Plate 53
The Three Planes of Being, 1962–63
135.3 x 127 cm
Gordon Capital Corporation, Toronto

Plate 54
Intimations, c. 1955
76.2 x 125.7 cm
Private collection

Plate 55
Frolic (Abstraction 30), c. 1955
63.5 x 76.2 cm
L.S.H. Holdings, Vancouver

Plate 56
Frolic (Abstraction 102), c. 1955
121.9 x 121.9 cm
L.S.H. Holdings, Vancouver

Plate 57
Spirit of Remote Hills, 1957–62
111.8 x 127.6 cm
L.S.H. Holdings, Vancouver

Plate 58
Abstraction 106, 1958
Oil on masonite
91.8 x 50.8 cm
L.S.H. Holdings, Vancouver

Plate 59
Abstraction "J," c. 1964
162.6 x 106.7 cm
Private collection

Plate 60
Abstraction "K," c. 1964
161.3 x 125.7 cm
Private collection

Plate 61
Abstraction "V," c. 1965
116.8 x 165.1 cm
Private collection

Plate 62
Abstraction "B," c. 1966
124.5 x 167.6 cm
Private collection

Plate 64
Detail of *Abstraction "R"*

Plate 63
Abstraction "R," c. 1967
171.5 x 111.1 cm
Private collection

Plate 65
Abstraction "T," c. 1967
111.8 x 167.6 cm
Private collection

Plate 66
Abstraction "E," c. 1967
116.8 x 165.1 cm
Private collection

Plate 67
Abstraction "A," c. 1968
116.8 x 165.1 cm
Private collection

Plate 68
Abstraction "P," c. 1968
106.7 x 165.1 cm
Private collection

Plate 69
Abstraction 103, c. 1964
114.3 x 139.7 cm
L.S.H. Holdings, Vancouver

Plate 70
Abstraction "S," c. 1968
104.1 x 121.9 cm
Private collection

Plate 71
Abstraction "D," c. 1968
116.8 x 165.1 cm
Private collection

Celebrity Landing in Vancouver, 1940–47
The Federation of Canadian Artists and a New Nationalism

LIFE AND PAINTING

Probably one of the main attractions of Vancouver for Harris was that he saw he could be useful there, that there was an important task to be carried out: the modernizing of the local culture. Once his sense of responsibility was aroused, Harris took tasks very seriously. In Vancouver he could face his old familiar enemies – a British-oriented colonial mentality together with ignorance of or hostility to modern art – which he had successfully wrestled with in Toronto years earlier. By 1940, Harris had six years of modernist freedom behind him as an artist committed to abstraction. He could now struggle toward the goals he believed in in a clearer and more integrated fashion. His modernist and mystical ambitions, his continuing interest in nationalism, his painting practice and his style of life had been fused together.

Even before Harris arrived in Vancouver, the red carpet was spread. The word was out that "this noted Canadian artist" was coming, an event that "would be welcomed by all those interested in the growth of cultural life in the West." His eminence on the local scene was quickly established. By 6 March 1941, he had been referred to as the "world-famed Canadian painter" who had graciously "accepted an invitation" to hold a one-man exhibition (his first anywhere) at the Vancouver Art Gallery.[1]

Vancouver was like a smaller Toronto, but isolated by the Rockies from the central Canadian art establishment. The city hadn't had a municipal art gallery until 1931. For the few Vancouverites interested in art who didn't go to England, the cultural traffic was more likely to be southward than eastward. But Vancouver, like Toronto, was proud to be part of the British Empire. In fact, the first collection at the Vancouver Art Gallery was British art of the previous century or so.

However, Harris was not the first modernist there. In 1926 the Vancouver School of Decorative and Applied Arts had hired Fred Varley and a Scottish modernist, Jock (J. W. G.) Macdonald. Thanks to Varley there was growing acceptance for a new way of seeing the spectacular landscape, and Jock Macdonald introduced abstraction with the first exhibition of his "modalities" in 1938.[2] Both Macdonald and Varley, not unlike Harris, were enthusiastic about Eastern cultures and religions and were seeking a new spiritual vision to express in their art. This too made important inroads into the established British colonial ethos of Vancouver and to some extent prepared the way for Harris's arrival.

After a dispute in 1933 with Charles Scott, the director of the Vancouver School of Decorative and Applied Arts, Varley and Macdonald had founded the short-lived British Columbia College of Arts. Among the people they attracted to this venture was the colourful Austrian Harry Tauber,

whose calling card bore the message, "Exponent of Modern Art." He was an enthusiastic supporter of Expressionism, metaphysics, Constructivism and spiritualism. Through their classes in both schools passed a generation of British Columbia artists who still remember the excitement generated by Varley's and Macdonald's modern attitudes toward aesthetics and art.[3]

By the time Harris arrived in Vancouver in 1940, Varley had been gone for four years, but Harris and Jock Macdonald quickly became allies in the cause of modernism. Their main arena of cooperation was the Vancouver Art Gallery. Macdonald had been a member of the Gallery's Council since 1932, and during some of that time a member of the hanging and exhibition committee as well. Harris was an Elected Representative on the Council regularly from 1941 to 1957. In May 1942 he was made chairman of the exhibition committee, a post he held probably until the end of 1956.

Harris's formal connections with the Vancouver Art Gallery barely hint at his influence. Essentially he was an always-enthusiastic catalyst who strove to broaden the horizons of the gallery and the city. Thanks to his wealth, he was the first modern artist acceptable to the conservative businessmen who controlled the gallery's board and its finances. Nan Cheney, a painter who was on the board in 1940, remembers that when Harris's coming was discussed around the gallery before his arrival, the elderly businessmen on the board didn't know who he was. When they found out he was rich, they were ready to ask him questions and listen to his answers; they liked this well-dressed man with his impeccable manners.[4] Puzzled by him they probably were, but they accepted him as one of their own.

But it was Harris's reputation as a pioneer modernist with wide experience that made him acceptable to younger artists. He was soon championing their cause and showing their work at the gallery. He praised talent and excellence generously wherever he found it, and that within a wide variety of artistic styles. Writing to critic Robert Ayre (who had

just assumed, thanks partly to Harris's vigorous political work, the editorship of *Canadian Art*), he praised Lemoine Fitzgerald's recent watercolours: "These water colours are very beautiful, have a marvelous ease and grace – there is nothing like them in this country or this continent, for that matter." His friend B. C. Binning's drawings were "excellent, have humour and style – delightful." Though differences in personality and attitudes between Harris and Jack Shadbolt were already in evidence by 1945, they did not prevent Harris from praising the younger artist's exhibition of water colours: "An excellent show – he has improved immeasurably – first class, top-ranking stuff. He is now into his stride."[5] Harris also suggested to Ayre that Shadbolt's paintings would make a good article for *Canadian Art*.

Harris's support for artists did not stop at verbal praise. As a trustee of the Emily Carr Trust from 1941 to 1962, he was able to direct money to scholarships for promising young artists. To his credit, he awarded these scholarships to artists with different kinds of talent, and encouraged the recipients to study outside Canada – in the United States and Europe – despite his own continuing nationalism. He was proud of the achievements of those awarded Emily Carr Trust scholarships. To fellow trustee Ira Dilworth in 1956, he wrote, "the new director of the National Gallery [Alan Jarvis] was here in the fall, visited the artists' studios and stated that the most outstanding painting being done in Canada today was in B.C., in Vancouver, and with two exceptions the painters were all Emily Carr Scholarship awardees (if that's a word)."[6]

Harris was the obvious artistic leader in Vancouver, and most of the art community accepted his leadership without question and in most cases with sincere admiration and gratitude. The architect Arthur Erickson, for example, who was first interested in painting, sought Harris's advice about whether he should follow an artistic career. Harris told him that he had to make up his own mind and Erickson values that advice to this day. Erickson was only seventeen in the early 1940s when he was invited to the Saturday musical

soirées at the Harrises'. He thinks the influence of Bess and Lawren "is still felt by all those who came in contact with them," and he remembers the spirituality and "serenity" of Lawren and Bess:

> you are aware of their spiritual view of things. I think probably that this was one of the great influences on me. [It] gave me a confidence that this was a way one could view the world. This was a way one could work, and that it had a purpose because they [Lawren and Bess] dedicated everything – the way they lived, their house, their work, their association with others – to try through art to bring people closer to that spiritual serenity.[7]

Well-known painter B. C. Binning, a professor of fine art at the University of British Columbia, was a close friend of Harris until the latter's death. He stresses that Harris had "enormous prestige" in Vancouver, and doubts that Harris himself knew how easily he could make or break somebody's career. He found Harris generous to a fault, so eager to encourage talent that he was "far too uncritical" in, for instance, writing letters of recommendation for artists. Binning, who was one of the few people in Vancouver with whom Harris discussed theosophy, correctly attributed this "weakness" to Harris's mysticism: "Harris just couldn't say no to anybody. All men were his friends … It wasn't really sentimental. It was a kind of almost spiritual thing: We must all be brothers."[8]

But there were dissenting voices. Even Joe Plaskett, one of Harris's grateful admirers and a protégé whose paintings Harris frequently bought, felt that Harris could be "a dictator in his way." He also saw that Harris's wealth enabled him to live in a somewhat artificial world, a "Shangri-La" unlimited by the difficulties that made other artists' lives so hard. Maud Varley, Fred Varley's widow, was not part of the Harris circle and felt that Harris's artistic gatherings were only for the sophisticated and rich. Jack Shadbolt agreed.

Quick to stress that he had the highest admiration and respect for Harris, and that he saw that Harris had a "place in Canadian art [that was] supreme," Shadbolt nevertheless had criticisms. He had originally been a "habitué" of the Harrises' musical evenings (which he called "music seances" in an "exclusive minor temple"). Shadbolt believed that he fell out of favour because he asked questions when Harris made his "absolute statements" about artistic and other matters. He thought that he was the only one who had dared to disagree with Harris.[9]

Harris's prominence in artistic circles in Vancouver was enhanced by his lecturing and writing. A good example is the talk he gave in 1942 to the British Columbia Region of the Federation of Canadian Artists, which was later published in the *Art Gallery Bulletin* of the Vancouver Art Gallery as a series of five short articles on "The Function of an Art Gallery." These articles must have shown Harris as knowledgeable about a wide range of matters relevant to art, and consolidated his position as an artistic eminence in Vancouver. After carefully distinguishing in the first article between art galleries (which should be "dynamic" and concerned with "the creative manifestations going on about them") and art museums (which should house permanent collections of past art) he surveyed, in the second article, the great art galleries and museums in London, Paris and Berlin. The third article he devoted to the art galleries in New York City, and the fourth to the galleries and museums in the rest of the United States and their dependence on New York as the source for purchases and exhibitions. In the fifth and last article he discussed Canadian galleries, particularly the role of the National Gallery of Canada.[10]

In Vancouver Harris and Bess delighted in a broad range of business, intellectual and artistic friends, including faculty members of the University of British Columbia, musicians and writers. The Harrises' frequent musical soirées and dinners were important social and cultural occasions that brought together artists and intellectuals of various kinds.

The Harris dinner parties also reflected Harris's lively social vision of the interrelatedness of the arts. He had probably first encountered this *Gesamtkunstwerk* idea while a student in Germany almost forty years earlier, and had certainly had it in mind in 1913 when he had conceived the Studio Building as part of a larger complex where other arts such as music and drama could be brought into fertile contact with the visual arts.

The dinner parties are remembered fondly by many, including Dr. Geoffrey Andrews, an academic at the University of British Columbia, who wrote:

Actually I've never in my life enjoyed dinner parties more than the Harrises' dinner parties. The food was absolutely superb … The table was really a work of art: the mahogany, the silver, the flower arrangements, the food. The guests were chosen with care too, and the conversation was very wide ranging. [It was] not particularly philosophical, but in terms of the arts and politics, conversation was always stimulating and Lawren was a very active part of it … But the thing that impressed me more than anything else at that time was that a good deal of their [Lawren's and Bess's] joint creative energy went into the enjoyment of society. By Society they certainly didn't mean only the rich and powerful. They meant interesting, intellectual people.[11]

Another factor in Harris's role as catalyst was his connections with directors and curators of galleries in central Canada, through whom he was able to bring exhibitions to Vancouver.

Harris's life in Vancouver during these years was extremely busy. He spoke so often at gallery openings and elsewhere that he was obviously the city's most sought-after speaker on artistic matters. He used his prestige and power as often as he could for the benefit of his vision of modern art. But, especially in conservative circles, he gradually acquired the reputation of being autocratic. At the Vancouver Art Gallery itself, he was always at odds with curators and directors, such as G. H. Tyler, who was much involved with the gallery for many years, becoming interim curator in 1947 and eventually the director. Tyler (like Shadbolt) claimed that he was "probably the only person in Vancouver that disputed with Lawren Harris … He was Lord Almighty, you know, a domineering person." In a 1983 article, Tyler recalled Harris's high-handedness: "We had a show from Calgary and there was a flower painting by somebody. Harris hated flower paintings. I hung the show and went out for lunch. When I came back the painting was gone. Harris had ordered it down and had it put in the basement." Tyler had the painting returned and its frame attached to the wall by a six-inch spike in case Harris tried to remove it again.[12]

A similar story illustrates Harris's continuing puritanism. Both he and Bess disapproved of nudes in art. One evening, Harris arrived early at the gallery for the opening of a small retrospective of the work of British artist Matthew Smith. Harris objected to two nudes by Smith and without hesitation removed them from the gallery walls before the other guests arrived.[13]

It wasn't long before Harris's autocratic ways and commitment to modernism provoked criticism, such as the accusation in the local press that "the Gallery is run by 'moderns' and therefore older styles of painting [are] discriminated against." Later, in the *Vancouver Sun,* Harris was accused of "dictatorship of the worst kind." On at least two occasions, Harris wrote to the paper defending himself and the gallery's policies.[14]

Harris's writing during this period was often more concerned with the relationship between art and society than with art itself. The list of topics he wrote or lectured about is impressive, and shows him attempting to apply his spiritual interpretation of art to a wide range of issues, some raised by the war. His manuscript titles include "Canadian Art and Internationalism," "Art and Propaganda," "Art as an

Expression of the Values of its Day" and "Democracy and the Arts."[15]

In "Democracy and the Arts," written in 1943, Harris is very critical of the Nazis and, like many Canadians of that time, praises the Russians. After explaining why art, in his view, is essential to a democracy and must become "an organic part of our life" in Canada, Harris tries to answer questions about elitism in the arts in a democracy:

> The totality of production in the arts should form an unbroken creative chain from the poorest and most fleeting efforts to the most inspiring and enduring expressions. So that no link is missing and thus no one is left out ... this means that we need the highest possible standard at the top of the creative chain in the arts – if the flow of life for all of us is to be most fruitful.

Harris however repudiates the idea that art should appeal to the lowest common denominator:

> But should any of us fancy that because in a democracy the arts should serve all the people therefore each and every artist should work for the widest possible approval, we would be wrong. No man should write or compose or paint down to a preconceived idea of popular appeal. Any let down, any lowering of creative integrity is a betrayal of purpose – and is therefore an insult to the public.

> Though you and I may not understand what it is all about at the top of the creative chain – though we may not understand the best work in any of the arts – our only chance of coming to understand it is to see that it exists. Let me say just here that it is a great mistake to think that what we do not understand is undemocratic. If we are to participate in the life in the arts on whatever level of understanding we may

be, it is essential for us that our best creators in the arts are free and at work ... If we curb art we curb life ... From the top to the bottom of the creative chain in the arts – from the greatest writers, poets, composers of music and painters down to the feeblest amateur there is a flow of inspiration. That flow of inspiration is the *vitality* of art, both as an incentive on every level of endeavor and as a transforming social force. This starts at the summit with the most advanced – the ablest and most inspired workers in the arts.

For Harris, the elite position of the creative artist remains secure, even in a democracy. He insists that inspiration does not come from "the people" to the artist: "The best art in any country never originates in terms of 'What the public wants,'" because the "creative individual in the arts ... or in any pursuit is always ahead of the public in his own work." Harris describes this as "a mystery which is at the very heart of human interdependence."[16]

Thus Harris's absolute faith in the spiritual mission of the artist, first articulated in the 1920s and developed as "the aesthetic attitude" in his writing on theosophy and art in 1933, survived into the 1940s and beyond and remains the aesthetic framework within which his own abstract painting must be studied.

HARRIS AND THE FEDERATION OF CANADIAN ARTISTS

An address Harris delivered to the graduating class of the Vancouver School of Arts in May 1943 provides an important illustration of his vision of art at the time. He reasserted his ideas about the importance and essentially spiritual value of art, but with a difference. In 1943 Harris placed his theory within the context of the lengthening World War and his concern about national growth in the postwar period. Echoing the antimaterialistic vocabulary of

theosophy, Harris saw the basic conflict of the war as the "struggle between the relentless drive for material power and the guiding principles of the spirit."[17]

He insisted that the arts were of great importance because "unlike philosophy or religion" they do not "teach" or "preach" about the spirit but rather "embody the life of the spirit as living, harmonious experience." Thus the arts cultivated the values of the spirit in the public perceiving them, the values that were "the only guide we have in making anything on earth harmonious and fine," and life "sane and balanced." He repeated many of the ideas and images from his nationalist rhetoric of the 1920s, though with important changes in emphasis. First, the similarities: "In the main," he wrote, "we have been too busy pioneering our new and vast land to give ourselves to the full life of the mind and spirit. That is our greatest lack. It is the cause of our lingering sense of inferiority. It is the reason we still look beyond our borders for our creative and cultural standards." Paradoxically, in support of this claim, Harris used the same quotation from the Irish poet and theosophist A. E. (George Russell) that he had used in 1920 in the first Group of Seven exhibition catalogue. "No country can ever hope to rise beyond a mere vulgar mediocrity where there is not unbounded confidence in what its humanity can do." And, again echoing his 1920s vocabulary, he insisted that such unbounded confidence is the characteristic of "a creatively virile people."

However, in the 1940s Harris's vision is no longer a mystical geographic determinism focusing on "the North" as the basis for Canadian identity. And with the geographic and mystic notion of "the North" no longer the determining factor, the word "race" has disappeared from Harris's nationalist vocabulary. Like most of his generation, he was probably pushed in this direction by the contemporary horrors of racism in Nazi Germany. He no longer referred to one "new race" being formed in North America, but mentioned "differences of race" as one of the facts of Canadian life that his theory of national unity could sucessfully cope with. By

1943, he was more concerned with the diversity of regions and other factors in Canadian culture. He insisted that art was a spiritual experience and that "only through creative life in the arts can we achieve a unity of purpose in Canada." He believed that through the arts Canadians could find "the firm centre of our own conviction. We will make the principles of the spirit an active guide of our manifold activities, over and above our differences of race, beliefs and sectional prejudices." He no longer took an anti-European stance or blamed "the English attitude in Canada" as part of the problem. Rather, he now wanted all Canadians to make greater efforts to find, through creative art, their own independent spiritual consciousness. On this would be based their emerging, self-confident national identity. This is the mystical and nationalist vision behind Harris's major writing during this period and his participation in the political activities of the Federation of Canadian Artists, which became one of his major commitments at least until 1947.

The Federation was the broadest-based and most powerful group with which Harris ever worked. His years of participation (often as a leader) in groups such as the Arts and Letters Club, the Group of Seven and the Canadian Group of Painters in Toronto, and the Transcendental Painting Group in Santa Fe, had trained him well, giving him leadership experience and confidence in his developing vision. In the mid-1940s he strove to make his own mystical view of art and of the national well-being part of the Canadian cultural establishment, principally through the Federation of Canadian Artists.

Harris was a charter member of the Federation and put prodigious amounts of energy into establishing it and into its various projects. The Federation was the main result of the well-publicized national conference of the arts (usually called the Kingston Conference) convened in Kingston in late June 1941 by the painter André Biéler. In a letter to Biéler about the conference, Harris suggested that "all of the art societies in Canada and the staffs of all the art colleges in Canada could unite in one federation and work together

toward their own creative and social enlightenment." He had to miss the Kingston Conference because his mother was seriously ill, but he sent a paper to be read there by Jack Shadbolt.[18] Harris did attend the first annual meeting of the Federation, held in Toronto on 1–2 May 1942, where he chaired the "Painting Working Section," presented the report for British Columbia, became chairman of the British Columbia Region and was appointed to the executive council.

In March 1944 Harris succeeded André Biéler as president of the Federation, an office he held until 1947. In his first presidential letter Harris described his vision of the Federation in words similar to the ones he had used in his nationalist and mystical writing in the 1920s. Here again Harris appears as both a visionary and a hard-headed, practical organizer:

> The chief aim [of the Federation], as I see it, is to make the creative and replenishing life in art an inseparable part of the life of Canadians from coast to coast. All other aims stem from this one and are secondary. In other words, as a Federation, we will serve the arts and the needs of the artist best, if our aim is first to serve our own people. So that will be the informing idea behind what I write.[19]

In the same letter, Harris revealed how robustly the nationalist aspects of his earlier vision had survived both his exile in the United States and his decisive turn to abstraction. Although he no longer advocated the representation of Canadian landscape subjects as essential for Canadian art, Harris still clearly believed creative art in Canada to be a force that could unify the country. Whereas in the 1920s Harris had usually taken the point of view of an Ontarian looking at the rest of Canada, the letter shows that by the mid 1940s he was acutely aware of Canada as a diversity of regions:

> This country cannot be pulled together by politics, by economics, by any one religion, but it can be greatly guided toward a unity of spirit by and through creative activity in the arts. This is so because the living spirit of the arts transcends our differences of economic ideas, our political bias, our religious affiliations, our racial differences and our sectional prejudices. Otherwise that spirit would have little if any meaning.[20]

In 1942–43, Harris had proposed a new role for the National Gallery of Canada in the last of his five articles on the function of an art gallery. He had praised the gallery for fostering Canadian art in recent decades (meaning, of course, the Group of Seven and related painters): "The Canadian artists created the Canadian tradition in painting, the National Gallery sponsored and publicized it." But he felt that the gallery should now change its policy, and "distribute itself across the country … into as many small and active centres as possible" – more necessary, in his opinion, than the new building the gallery was campaigning for at the time.[21]

These and related ideas became the policy of the Federation during Harris's presidency and the topics of Harris's published articles during the mid-1940s. In "The Federation, the National Gallery, and a New Society" of early 1943, Harris argued that only if people in Canada got together with each other in spite of regional and other differences would they have anything to contribute to the new international society that had to emerge after the World War had been won. Harris saw the Federation of Canadian Artists as the paradigm of the kind of service to the community at large needed to bring about such a new society in Canada. The National Gallery, Harris believed, was the natural ally of the Federation in this service, and should the gallery decentralize and become "more a people's gallery all across Canada" it too could serve the country from coast to coast, in both big and small centres.[22]

By 1944 Harris and the Federation described in some detail what they called the "National Art Centre Plan." Twenty-five "major cultural community centres" were to be

built in larger Canadian cities from coast to coast, plus fifty minor centres in smaller towns and regions. Harris's description of the major centres is interesting because it recalls his original hopes for the Studio Building in Toronto: "All the creative arts, not just painting, are important and should be able to interact with one another, and they should be available to all the people." He felt there should be "one supervising architect for all seventy-five buildings," although this person would collaborate with local architects.

> Each building of a major cultural community centre would include an auditorium with a seating capacity of 800 or more … this auditorium to be designed and equipped for drama, ballet, orchestra and concerts of all kinds, films, lectures and meetings. In addition the centre would contain an art gallery for all kinds of exhibitions, including crafts, workshops for crafts, lithography, silk screen printing, mural painting, etc. rooms for art classes and children's work and space for storage, packing, assembly, and administrative purposes. There would also be a library. 23

Harris promoted these community art centres as the centrepiece of a national cultural policy and felt that even the National Gallery, once decentralized, should function through these cultural centres along with regional facilities of the National Film Board and the Canadian Broadcasting Corporation. Six months later, after he and his colleagues had presented the brief to the House of Commons, he wrote: "the one great possibility of integrating all of the arts with the life of our people, of evoking the creative spirit in our people into a rewarding life, is through the establishment of community art centres for the arts all across Canada."24

HARRIS'S PAINTING, 1940–47

The first work Harris completed after arriving in Vancouver in 1940 was *Composition No. 1* (Plate 44). It brings together the two traditions of Harris's early abstract painting – images of solid forms such as *Abstraction 53* (*Mountains and Pyramids*) and images of aerial, often transparent, floating forms. Unlike the aerial paintings from Santa Fe, this work (and others done about the same time in Vancouver) is horizontal. As in *Pyramid* (Fig. 12.1), c. 1939, a strong geometrical form dominates the painting. Through subtle differences in colour in *Composition No. 1* this form looks like a pyramid, although it could also be a bisected triangle whose sides don't quite match. In *Pyramid* the main form floats heavily over two green layers or levels. In *Composition No. 1,* however, all the edges of the pyramid have lines extended through different contexts. Those in the centre and on the right reach to the bottom of the painting. The latter form the edge of a wide band that also extends off the top of the painting. Rather than the floating forms of *Abstraction (Involvement 2)* (Plate 43), there is a sense of stability and rootedness. Harris valued transparent forms because they suggested the realities he believed lay beyond appearances, but here the glowing white pyramid form among the transparent forms looks solid and dominant, as though there were something permanent in its symbolism. The three circles are most likely derived from theosophical illustrations of the results of the mental effort of projecting "helpful thoughts,"25 but also recall similar circles and discs which were pervasive in geometric abstract painting of the 1930s and in Art Deco.

The painting is bisected horizontally by a wide blue band. Above this band the dominant colour is blue; below the band there are greys and tans and a harsh lemon yellow that most reproductions tone down. The viewer experiences the yellow as moving aggressively forward, which, in combination with the recessive blues in the top half of the painting, recreates in an abstract idiom the layered composition Harris preferred for almost all his landscape works.

If we took a hint from theosophical ideas about the meanings of blue and yellow, we could interpret the painting as contrasting and relating intellectual energy (the yellow) with religious or spiritual experience (the blues of the upper half). Harris is presenting his transcendentalist and theosophical vision again, but now, with the white peak against the blue and its wide-based, architecturelike stability, the work has a landscape reference that is absent from such Santa Fe paintings as *Abstraction (Involvement 2)*.

The visual stimulus for this reference was probably the mountainous landscape surrounding Vancouver, which intoxicated Harris. From a psychological point of view, however, I suspect this change in his painting may well be due to his rediscovered sense of rootedness in Canada. Thus *Composition No. 1* expresses Harris's transcendentalist vision, but without isolating that vision totally from the brown forms of the earth as do works like *Abstraction (Involvement 2)*.

Harris's paintings during the early years in Vancouver were not, with several exceptions, very impressive, perhaps because he was so busy with other activites. Many paintings contain triangles or pyramids, and most are horizontal like *Composition No. 1*. Several of theses works are surprisingly dark, cool and opaque in colour; perhaps Harris's palette had been affected by the war. A similarly dark palette is used in paintings of floating rocklike forms. One of these, *Abstraction 195* (Fig. 13.1) is mainly brown and grey and has a sense of naturalistic rock texture. This is not the first appearance of a heavy floating object in Harris's abstract painting. Such imagery, which began in the 1930s with

Figure 13.1
Abstraction 195, c. 1940
Oil on masonite,
71.1 x 38.1 cm
L.S.H. Holdings, Vancouver

Figure 13.2
Abstraction 92 (Painting No. 2), c. 1939
130.5 x 91.9 cm
McMichael Canadian Art Collection,
Kleinburg, Ont.

Figure 13.3
Abstract Painting No. 20, 1945
152.4 x 152.4 cm
National Gallery of Canada, Ottawa
Gift of the artist, Vancouver, 1950

Figure 13.4
Door (New Hampshire)
Drawing 81, c. 1934
Pencil on paper
27.6 x 21.5 cm
Private collection

Figure 13.5
Abstraction (Door) New Hampshire, c. 1934
Pencil on paper
21.2 x 27.6 cm
Private collection

Figure 13.6
Study (Wood Grain and Geometric Forms), undated
Pencil on paper
21.1 x 27.3 cm
Private collection

Figure 13.7
Abstract Painting 12, c. 1940–45
Oil on masonite
45.7 x 73.7 cm
L.S.H. Holdings, Vancouver

Figure 13.8
Abstract Painting 28, c. 1940–45
Oil on masonite
30.2 x 37.5 cm
L.S.H. Holdings, Vancouver

Figure 13.9
Abstract Painting 21, c. 1940–45
Oil on masonite
50.8 x 61 cm
L.S.H. Holdings, Vancouver

works such as *Abstraction 92 (Painting No. 2)* (Fig. 13.7) and continued with *Pyramid* (Fig. 12.1) of about 1939, is probably in debt to Harris's encounter with surrealism on visits to New York. In *Abstraction 195* and the drawing that preceded it[26] Harris returned to naturalist observation to paint the stone, but placed it unnaturally by having it float; he also accompanied it with white triangles through one of which the viewer examines part of the stone. This partial return to naturalism may be a sign, as it had been in 1918 and 1934, that Harris was once again searching for a new approach in his art.

Abstract Painting No. 20 (Fig. 13.3), which Harris finished in 1945, had its beginnings in Hanover in 1934 or 1935. Its preparatory drawings and the paintings that lead up to it form an interesting branch on the tree of Harris's development during this, his first abstract period. Harris's preoccupation with nature and abstraction is nowhere seen better than in this series of works, that begins with a straightforward drawing of a door about 1934 in New

Hampshire (Fig. 13.4) and culminates in the large oil of 1945.

In the drawing of the unpainted door, Harris is careful to note the grain in the wood. He followed the detailed naturalism of this drawing with another, *Abstraction (Door) New Hampshire* (Fig. 13.5). In this drawing, he has focussed on the irregular curving lines of the wood grain, abstracting them from the door. These unique shapes from nature probably fascinated Harris for the same reasons that the unusual shapes of icebergs did, or the Lake Superior tree trunks shaped by fire, frosts and winds. We can see in the wood grain an overlapping organization of forms within forms. The wood-grain lines become the starting point for a series of drawings and paintings culminating in *Abstract Painting No. 20,* but the natural forms of the wood grain cannot be discovered in the large oil without knowing something of the long development of the project.

In the drawing *Study (Wood Grain and Geometric Forms)* (Fig. 13.6) the patterns abstracted from the wood

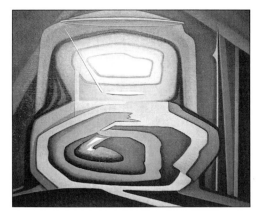

Figure 13.10
Abstract Painting 90, 1940–45
81.3 x 99.1 cm
L.H.S. Holdings, Vancouver

Figure 13.11
Study (Drawing), 1940–45
Pencil on paper
21.2 x 27.6 cm
Private collection

Figure 13.12
Study for a Canvas, c. 1945
Pencil on paper
45.7 x 38.1 cm
Private collection

grain are lined up on a vertical axis. They are still random-looking, curvilinear shapes which contrast with the geometric forms on the right. There is also the start of a depth-creating device at the bottom of the drawing, which will survive into the final painting. In *Abstract Painting 12* (Fig. 13.7), the wood-grain lines have been simplified and the form clarified. The topmost element in the drawing has been reduced to a floating disc. The forms on the right, though still geometric, are less complex and emphatic. A blue mantle, like an aura, around the top part of the wood-grain forms on the left will reappear in the last painting in the series.

Two other paintings in the series are the very similar *Abstract Painting 28* (Fig. 13.8) and *Abstract Painting 21*

(Fig. 13.9).[27] Although they clearly belong in the series, their exact position in it is difficult to establish. My guess is that they were done between the drawing *Study (Wood Grain and Geometric Forms)* and the painting *Abstract Painting 12*. In *Abstract Painting 28*, Harris has simplified and stiffened the wood-grain forms while making the forms on the right less geometric, leaning them toward the centre. The addition of the twisted rope form creates a strong, though banal, image of tension. The rope and the strong sculptural elements in the bottom of the painting survive into what is probably the next version of the work, *Abstract Painting 21*. Here the forms are still lumpy and curving at the bottom; they survive into the final painting as simplified, geometric forms. One of the

Figure 13.13
Upward Rush of Devotion
Fig. 14 from A. Besant and
C. W. Leadbeater, *Thought Forms* (1905)

elements that links these two paintings to all but the very last work of the series is the disc at the top. *Abstract Painting 90* (Fig. 13.10) is very similar to *Abstract Painting 12* (Fig. 13.7). In contrast to the two paintings just discussed, they have a serene mood achieved mainly by the simplification of the main forms at the bottom of the paintings – forms similar to the ones in *Study (Wood Grain and Geometric Forms)*.

One would like to ask Harris why he made changes from *Abstract Painting 12,* such as the small disc that is now not attached to the bottom half of the painting. Why did he add the slender, floating wand form on the upper left, and the transparent vertical form linking the upper and lower portions of the painting? The transparency of that vertical form is the first hint of the large transparent form that dominates most of the surface of the final work in the series, *Abstract Painting No. 20.*

In the drawing *Study* (Fig. 13.11), which presents only the top of the forms in the paintings described above, the transparent vertical form is wider and closer in position to where it appears in *Abstract Painting No. 20.* In another drawing, *Study for a Canvas* (Fig. 13.12), Harris introduces a strong, stiffening sense of geometry. The disc, still in the top of the work, and the spear-shaped geometric form on the right make their appearance for the last time. An important aspect of this drawing is that in the lower section the main forms have been geometricized until they scarcely recall their origin in the random curves and patterns of wood-grain lines. This firm contour, which echoes the firm geometry of Harris's work in the early 1940s, survives into the final painting, as does the depth-creating pathlike form on the bottom right.

In the final work, *Abstract Painting No. 20,* the orthogonal spatial devices at the bottom – almost a Harris trademark in his mature landscape works of two decades earlier – are now like three planks cantilevered over a pool of light. They contrive for the viewer a familiar illusion of depth within naturalistic space. They stop abruptly, and the viewer is con-

fronted with a gap and the transparent planes and ambiguous spaces of the abstraction itself. It is as if one had to make a leap before getting involved with something enormous and complicated that towers above.

There are many allusions to light in the work. The planklike shapes are cantilevered over a light source. Near the top of the painting, from behind the dark blue background screen at the two points where the lighter blue mantle or aura meets it, rays of yellowish light emanate vertically. It is as though Harris wished to express that the experience embodied in this abstraction took place in an environment of light. The large transparent form, like a curving sail of light with its vertical section down the centre of the painting, appears as both a barrier and a bridge into the centre. This form is in reality part of a larger transparent form that covers most of the main part of the work. Through the bottom part of the form, the viewer sees a pair of intersecting triangles. These triangles link the work to the many abstractions up to this time in which Harris has used triangles, often solid, often transparent, and often as the main element in a composition. The bottom triangle here probably represents the "Upward Rush of Devotion" (Fig. 13.13), an image familiar to theosophists. For the theosophists the triangle is an image of an unselfish human being aspiring toward true spiritual reality. The downward intersecting triangle probably represents "The Response to Devotion" (Fig. 13.14) in which the "LOGOS pours forth His light, His power, His life" on the aspiring individual.[28] It is an image of the intersection of the infinite spirit and a human being. Such an important theme is presented in small format but, given the rhetoric of forms in the painting, certainly in a privileged position.

Writing about abstract art in 1927, Harris had noted that some of the artists "by rendering transparent some of their planes sought to give the experience of the unreality of appearances."[29] Harris often used transparent planes for his early abstractions, but only in *Abstract Painting No. 20* is the transparency deliberately presented as a liftable device, although given Harris's belief in a transcendentally struc-

tured world, it makes perfect sense. As one person pointed out when I presented a paper on this series of paintings and drawings, the painting still represents a door, albeit a door into realms of meaning available when the natural is left behind. The painting probably represents Harris's act of faith in such meaning.

Abstract Painting No. 20 is now in the collection of the National Gallery of Canada. Harris himself had a high opinion of the work. In 1949, he wrote to Harry McCurry, the director of the gallery, "This canvas is being sent to you to submit to the National Gallery Board. Most people, painters and others whose opinion I respect consider it the best of the abstract paintings as I do myself." Harry McCurry sent Harris a clipping of an Austrian critic's remarks about the work; Harris's reply reveals his sense of humour and his confidence in his vision:

> I was set back on my pagan heels by a comment in a clipping you sent me. The writer referred to the "eye of God" in the large abstract painting the Gallery owns. There ain't no eye of God in it nor an eye of any kind. I don't believe in a God with an eye – no anthro-pormorphic [*sic*] God for me. I believe in everlasting divine spirit."[30]

Another painting of 1945, *Abstraction 119* (Plate 45) gathers together Harris's interest in abstract triangles and other geometric forms, selected natural forms, and tiny, well-contained landscape views similar to his Lake Superior works. The work also recalls earlier abstractions like *Abstract Painting 95* (Fig. 11.11), in that the composition apparently hangs in the air like the "Forms Built by Music" in Besant and Leadbeater's *Thought Forms*, especially the high, wide and expansive *Wagner* (Fig. 11.13). The main naturalistic forms in the painting are the flowing clouds that link the various geometric forms and the landscape. The whole is framed by a deep blue expanse. Harris probably thought of the work as a fusion of natural and abstract forms

that embodied the contribution each can make to spiritual expression, although in this work abstraction is dominant.

The paintings we have just discussed look back to Harris's earlier abstractions. But in the mid-1940s, although he had passed his sixtieth birthday, Harris was by no means ready to settle down to one or another style of painting. His intense spiritual search continued, and he was in the preliminary stages of the significant final developments in his painting.

Figure 13.14
The Response to Devotion
Fig. 17 from A. Besant and C. W. Leadbeater,
Thought Forms (1905)

Out of Certitudes into Light, 1947–70

HARRIS'S LAST TWENTY-FIVE YEARS

After Harris finished his term as president of the Federation of Canadian Artists in 1947, he was able to settle down as an artist. No longer could he complain, "For months I have been too busy to paint." He was no longer criss-crossing Canada trying to persuade towns and cities to accept his and the Federation's idea of community art centres. However, from March 1950 to April 1961, Harris did make at least two trips a year to Ottawa for the two- or three-day meetings of the Board of Trustees of the National Gallery of Canada. He was the first artist member of the board and when he resigned for health reasons in October 1963, he was praised in a special resolution for the "vigorous championship of contemporary Canadian art" which he had exercised with "wit and … wise decisions." After the intensity of the Federation's work, this regular travelling was not a burden. As Bess put it: "I think that he thoroughly enjoys the connection [with the NGC] and loves the three day train journey looking at the northern landscape which has such enormous variety."[1]

Harris did other travelling in the late 1940s and in the 1950s to benefit his inner life and his painting. Sometimes the trips were vacations, particularly for Bess's sake. There were regular summer trips to the Rockies, three late-winter car trips to Tucson, Arizona, frequent trips across the continent to New York to see the galleries, and a trip to Italy.

The Rocky Mountains were such a permanent source of spiritual enrichment for Harris that he spent two to six weeks there every year. His idea of such a trip was to climb as much as possible, in as remote a spot as possible and eventually to be stimulated by a subject for a mainly abstract work or, after climbing to a peak himself, to achieve a prized experience of ecstasy.

Harris made at least four autumn trips to New York – in 1948, 1950, 1952 and 1954 – and he may have been there in the spring of 1947 as well. The late-winter car trips to Arizona were vacations, in February 1953 and in March of both 1954 and 1955. To judge from Bess's descriptions, they spent much of their time enjoying the plants, birds, wildlife and landscape of the desert. In March and April of 1956, Bess and Lawren took a leisurely cruise from New York to Italy, travelling as far north as Florence, where they spent two weeks. Bess described the tour as "an art pilgrimage … we spent our days looking at masterpieces." She felt that the trip had a beneficial effect on Harris's work: "It seems to me that there is a fresh creative wave up his beach."[2]

We get a picture of Harris's way of life in the early 1950s in a letter from Bess to a friend:

When we leave Vancouver, Lawren's one idea is to get back as fast as possible! But I should be very pleased about it because the cause is such a pleasant one: – He loves everything about his home – is completely relaxed and happy – and finds it perfect for work. – What more could one ask for a creative environment – and also the fact that he does work so steadily at his age – (which is the astounding one now of 66.) – every day. – Monday through Sunday … he is at his easel from 10.30 to 1.30 – has lunch – does garden chores or walks – then has another hour in the afternoon – and after dinner in the evening we have a discussion over what has taken place – the – pros and cons of colour and composition – during the day.[3]

Though Bess was a talented woman, it is obvious that she persisted quite happily in subordinating her own artistic ambitions to Harris's painting. She saw this as her creative participation in his more important work. Explaining why she herself was painting so little, she wrote:

It is not always the actual work in the house that breaks in on me – but the planning and organizing – arranging and keeping everyone concerned happy – The house is run for Lawren and his work – primarily – I could not be comfortable – with my philosophy – doing anything else – also the female in me likes to please – and I have … We do quite a lot of entertaining – mostly at dinner – it is a great pleasure to Lawren – I think he enjoys it more than anything – having people here – he is not nearly so pleased about going out.[4]

An abrupt change occurred in Harris's life on 10 April 1958, when, at the age of seventy-two, he underwent a five-hour operation for an aneurysm of the aorta. He came through the critical healing period rapidly, and in August of that year, Bess painted a glowing picture of his convalescence: "He is enjoying life, indeed we are having a lovely time together! The weather has been ideal for months, the garden is very lovely and convalescence is not hard to take under such favorable circumstances." But in fact, Harris never fully recovered his strength after the surgery. While his physical energy was gradually failing, though, his painting energy seemed to increase, to judge by the larger works he was producing. As his friend B. C. Binning put it, "The weaker he got the bigger he wanted to paint."[5]

By 1962, the Harrises were living what Bess called "quiet, retired lives … I do not mean that we are entirely isolated from friends – but mostly they come to us – which is very satisfactory from our point of view." Harris's mountain-climbing days may have been over, but he kept himself as active as possible. Bess Harris again gives us an insight into his life: "Lawren is stronger than he was – he paints a part of every day and takes long walks – sometimes not so long – … in the evening we read – Now he likes to be read to instead of being the reader."[6]

But what was it he and Bess read? A partial selection of the books that entered Harris's library from the mid-forties to the late sixties includes Ouspensky's *The Psychology of Man's Possible Evolution*, T. S. Eliot's *Four Quartets*, W. H. Auden's *For the Time Being*, Earle Birney's *Now Is Time*, Robert Frost's *New Hampshire*, Paul Klee's *On Modern Art*, Herbert Read's *Henry Moore*, art journals such as *Art International*, Susanne K. Langer's *Feeling and Form*, Bertrand Russell's *New Hopes for a Changing World*, Freud's *An Outline of Psychoanalysis*, Erich Fromm's *Psychoanalysis and Religion*, and Jung's *Memories, Dreams and Reflections* and *Man and His Symbols*. Very frequently Harris made marginal notes or underlined phrases that were important to him.

Harris seemed happy to live in tranquil retreat. By 1965 he wanted few or no visitors. His health alternated between deterioration and partial recovery. The following year he was again in hospital and was too weak even to sign his name.[7]

Figure 14.1
Abstract Painting, 1940–45
81.3 x 101.6 cm
Private collection

HARRIS'S PAINTING AFTER 1945

There is no five-year period in Harris's entire career more difficult to piece together than the years from about 1945 to 1950. There are some works that are known to have been done around 1950. The catalogue of the 1948 retrospective exhibition of Harris's works claims that *Abstract Painting* (1940–45, Fig. 14.1) is one of Harris's most recent works, although it is done in a geometric style more typical of the early forties.[8] Still, it is possible that Harris did sometimes work with this geometric imagery right up until 1948. What makes our ignorance of these five years so frustrating is that between the mid-1940s and 1950 Harris's style changed. In the early 1940s he was painting works like *Composition No. 1* (Plate 44), with its reliance on triangles, clear, exact angles and lines, a smooth, impersonal brushwork and a sense of stability. All this contrasts strongly with a work of 1950, *Northern Image* (Fig. 14.2), which has an exuberant plume of variously curving lines and forms that appears to burst out of an ocean like a contained, asymmetric explosion with a roughly painted aura around its top. In form – shapes floating above a horizon line – the painting is like *Abstract Painting 95* of about 1937. Both paintings, I believe, are dependent on illustrations of "Forms Built by Music" from Besant and Leadbeater's *Thought Forms*. But where did the calligraphic lines and colour arrangements in this painting (and in many others of this period) come from? Harris didn't leave any written evidence, but there are some clues.

I believe that the change in Harris's art in the mid-1940s was due in part to his renewed acquaintance with Surrealism and automatic painting. In the mid-1940s, thanks to his friend Jock Macdonald and to the British Surrealist painter and psychiatrist Grace Pailthorpe, Harris found himself among practising enthusiasts of Surrealism and automatic painting. Pailthorpe's work had been shown in the Museum of Modern Art's major exhibition "Fantastic Art, Dada and Surrealism" in New York during the winter of 1936–37, which Harris almost certainly saw. Pailthorpe first visited

Vancouver in 1943 or 1944, and there was an exhibition of her paintings at the Vancouver Art Gallery in April 1944, during which she gave a lecture on Surrealism. Harris, as chairman of the Exhibition Committee, would have been intimately involved with this project. He would also have noted how Macdonald's art had benefited from the experiments in automatic painting. This was probably additional encouragement for Harris to try it for himself, and I believe he did.

In 1954 Harris discussed Surrealism and automatic painting in his book *A Disquisition on Abstract Painting*:

> Surrealism is automatic painting, wherein the whole process comes from and is controlled by the unconscious. Whereas the process of abstract painting is a creative interplay between the conscious and the unconscious with the conscious mind making all the final decisions and in control throughout. This leads to quite different results in that it draws upon the full powers of the practitioner and therefore contains a much fuller range of communication and significance.[9]

Harris's son Lawren Phillips Harris and Harris's friend B. C. Binning both remember Harris using the technique of automatic drawing. Harris kept blank paper beside his easel on a lectern and he would let his pencil wander over this paper in response to feelings supposedly from his unconscious. Binning thought that Harris "got a lot of inspiration from … subconsciously motivated letting [his] arm move around or letting it be moved by some superior power." But this is as far as Harris seemed to be willing to go in applying subconscious methods to his painting. He would then examine lines produced by this automatic technique and select those he wished to include in a painting. He insisted that "the conscious mind" must make "all the final decisions" and must be "in control throughout."[10]

With a few exceptions,[11] lines were the important expressive elements in Harris's painting of whatever period.

Clear lines were essential for Harris's geometric abstractions. It is not surprising that when Harris experimented with automatic painting, he chose to begin with lines rather than fields or patches of colour. As Harris put it when writing on abstraction in 1949: "Indeed, in themselves, all lines, straight or curved, and their various modifications and accentuations evoke different responses in the onlooker."[12]

In about 1944 in Victoria, Harris gave a "little talk" that he called, "The ABC of Abstract Painting," illustrated with twenty-four large drawings (Figs. 14.3–14.16).[13] These drawings reveal how Harris was thinking about painting during the mid-1940s. In his talk he claimed that "All elements of expression … must have emotional value," and it is tempting to speculate about what emotional value he would have found in the simple arrangement of four lines in *Drawing One* (Fig. 14.3). He has given us a clue, in the form of several words written at the bottom left of the drawing, the first one of which is "static." As Harris bends the lines symmetrically, they suggest a simple, calm, stable composition like his *North Shore, Lake Superior* (Plate 24). The repeating angles in *Drawing Two* (Fig. 14.4) and the repeating curves or waves in *Drawing Three* (Fig. 14.5) were probably intended to give an example of lines conveying differing emotions, but similarly affected by rhythm and intensity. The straight lines in Drawings *Four, Five, Six* and *Seven* are spare, more subtle and intriguing, and suggest that they were intended to illustrate the emotional effects of different kinds of two-dimensional compositions. *Drawing Eight* (Fig. 14.6) is a completed abstract drawing in which Harris has used straight lines and sharp angles in an explosionlike composition to express, probably, emotions related to discomfort and pain. *Drawing Nine* (Fig. 14.7), in contrast, uses only curved lines in a quite different rhythm, creating gently interlocking forms for a peaceful effect. With *The Indignant One (Drawing Ten)*, and *The Proud One (Drawing Eleven)* (Figs. 14.8 and 14.9), Harris continues using lines to express emotions but manages, like a good pedagogue, to insert humour into his presentation.

Figure 14.2
Northern Image, c. 1950
116.8 x 124.5 cm
University of British Columbia

Figure 14.3
Drawing One, c. 1944
Illustrations from Harris's lecture,
"The ABC of Abstract Painting"
Unless otherwise described, *Drawings One–Twenty-four* are
pencil and charcoal on paper and measure 62.2 x 85.4 cm

Figure 14.4
Drawing Two, c. 1944

Figure 14.5
Drawing Three, c. 1944

Figure 14.6
Drawing Eight, c. 1944

Figure 14.7
Drawing Nine, c. 1944

Figure 14.8
The Indignant One (Drawing Ten), c. 1944
Pencil and charcoal heightened with white
on paper
85.4 x 62.2 cm

Figure 14.9
The Proud One (Drawing Eleven), c. 1944
85.4 x 62.2 cm
Pencil and charcoal heightened
with white on paper

Figure 14.10
Drawing Twelve, c. 1944

Figure 14.11
Drawing Fourteen, c. 1944

Figure 14.12
Drawing Fifteen, c. 1944

Figure 14.13
Drawing Seventeen, c. 1944

Figure 14.14
Drawing Nineteen, c. 1944

Figure 14.15
Drawing Twenty-one, c. 1944

Figure 14.16
Drawing Twenty-three, c. 1944

Figure 14.17
Abstraction, c. 1946
97.8 x 123.2 cm
L.S.H. Holdings, Vancouver

Then, in drawings *Twelve* through *Twenty-four* (Figs. 14.10 to 14.16), Harris demonstrates how an abstract work can be created with lines. As we will see, the creation of the painting is almost totally an interaction of various kinds of lines. What is more, Harris's painting *Abstract Sketch*, c. 1936 (Plate 46), which was either done from the drawings or possibly provided a starting point for them, is itself all but monochrome.[14]

Harris's experiments with automatism in the mid-1940s constitute the middle ground between geometric abstraction and his later Abstract Expressionist work. Unfortunately there are very few pieces we can date confidently to this period. One likely candidate, however, is *Abstraction* (Fig. 14.17), because it is very similar to *Drawing Nine* (Fig. 14.7). The paint is applied smoothly, which also suggests that the work is not far from the time of the geometric abstractions. Two other related elements suggest that *Abstraction* is a transitional piece and belongs in the mid-1940s. As in many of the geometric abstractions, there are transparent bands on the right side of the painting. Second, these transparent bands, espe-

cially the lower of the two which is "emitted" from a concave shape, resemble rays of light. This image is very similar to, and almost certainly derived from, one of the coloured illustrations of "Helpful Thoughts" in *Thought Forms* (Fig. 14.18).[15] As Harris moved away from geometric abstractions into automatism and Abstract Expressionism, he also moved away at least temporarily from such references to explicit theosophical pictorial sources. Harris himself later saw automatic painting as a step toward Abstract Expressionism, a movement for which he made large claims.

It is not surprising to find that Harris's abstract works participate in the movements of abstract painting current in other countries, for he made an effort, through frequent visits after 1945, to keep himself up to date with what was going on in New York. His enthusiasm for Abstract Expressionism in his 1954 book *A Disquisition on Abstract Painting* was based on extensive experience. The Vancouver artist Alistair Bell, a friend of Harris, remembers that when Harris came back to Vancouver (probably in 1947 or 1948) from the trip on which he first saw the painting of the American Abstract

Expressionists, "he was still wildly excited, particularly [by] Rothko's work."[16] The influence of Rothko later showed particularly in the large, luminous paintings of Harris's old-age style.

Harris also had a detailed familiarity with the painting and aesthetic ideas of the German-American artist and teacher Hans Hoffmann, who was a major influence on the American Abstract Expressionists. Harris clearly saw his own painting as part of the tradition of Abstract Expressionism, which, by 1954, he considered the major development in abstract painting. He had already painted many works – for example, *Nature Rhythm* of about 1950 (Fig. 14.19) – which he himself called Abstract Expressionist. He claimed Abstract Expressionism "increased the range of possible subjects in art beyond anything known before," opening the way to "inexhaustible experiences of the new visual realm." He felt that it was really more than a style as style is usually understood:

But the recent expansion of abstract painting into the realm of Abstract Expressionism has inevitably led the artists to employ many different styles and invent new ones to accommodate the great increase in expressive and vital visual ideas. In other words, Abstract Expressionism is not a style like impressionism, cubism, magic realism or geometrical abstract painting. It is a new realm in which the imagination is released into an illimitable range of new subjects and new visions of old subjects and has already created a number of new styles and will create many more.[17]

This assertion is significant for an understanding of the development of Harris's own work. An important change had already taken place by the time he wrote this in 1954. His art had changed from a search for spiritual objectivity to one where subjectivity had a place, however well controlled. Even before he began painting his geometric abstractions in the 1930s, Harris had made many of the doctrines of the theosophists and of other mystical writers his own. His geometric abstractions expressed his clear certitudes about mysteries he considered to be beyond the personal plane, in the realm of the impersonal, objectively real spirit. The works he termed Abstract Expressionist, on the other hand, represent selected aspects of his personal, interior reactions to such mystical certainties. For example, on the back of one painting of this period Harris has written the title, *Subjective Painting: Mountain Experience* – now known as *Abstraction 140 (Subjective Painting)* (Plate 50) .

Harris's works of the early 1950s were on view in 1955 when the Vancouver Art Gallery held an exhibition of twenty-two of his recent paintings, supposedly all done within the previous five years. Each of the twenty-two had a title. This went against Harris's usual practice: he preferred generic names like "Composition" or "Abstraction," on the grounds that a title "is likely to interfere with the onlooker's direct response."[18]

The works from the 1955 exhibition contain suggestions of automatic drawing which link them to Harris's mid-1940s experience of Surrealism. The many lines in *Ritual Dance of Spring* (Fig. 14.20) probably originated in one or more of the automatic drawings Harris did beside his easel. By augmenting the lines through colour and thickening, and by frequently using echoing lines, Harris then developed his painting. There are many variations on these lines in his works from around 1950 or perhaps before to (I believe) about 1967 (for example, Plates 48 and 50, and Fig. 14.22). Sometimes, as in *Northern Image* (Fig. 14.2), Harris brackets such lines within landscape or other forms. But gradually the lines become the main formal elements in many paintings. Their interactions – often contrived – generate the compositions. Such lines enable Harris to approximate at times the "all-over" compositions he was seeing in the work of American Abstract Expressionists such as Jackson Pollock and others; that is, the painting does not contain a dominant shape but bears equal stress over most of the canvas, creating a surface

Figure 14.18
Helpful Thoughts
Fig. 48 from A. Besant and
C. W. Leadbeater, *Thought Forms* (1908)

Figure 14.21
Eclipse of the Spirit, c. 1955
109.9 x 93.3 cm
L.S.H. Holdings
Courtesy of Mira Godard Gallery,
Toronto

Figure 14.20
Ritual Dance of Spring, c. 1953
101 x 81.3 cm
L.S.H. Holdings, Vancouver

Figure 14.19
Nature Rhythm, c. 1950
101.7 x 129 cm
National Gallery of Canada, Ottawa
Gift of the estate of Bess Harris,
and of the three children of
Lawren S. Harris, 1973

that approaches the two-dimensional. *Eclipse of the Spirit* (Fig. 14.21) and *Abstraction 101* (Fig. 14.23) of about 1955 are paintings in this mode.

Until the early 1960s, Harris painted many variations on the linear themes derived from his automatic drawing. By adjusting the rhythm, colour and sharpness of lines and varying the colours of the flat areas they often surrounded, he was able to make quite different-looking paintings. The strongly coloured *Abstraction* of about 1950 pits thick curved and jagged lines against each other around a bright, roughly brushed yellow area. The result suggests an aggressive, even violent experience. By contrast, *Lyric Theme II* (Plate 49) of about 1956 has the softly painted, gentle, warm colours and quiet expansive forms suggested by its title. Occasionally, as in *Abstraction 140 (Subjective Painting),* the lines have almost disappeared, leaving only the flat, coloured areas between them. In other paintings, the lines become dominant, as in *Abstraction 101* (Fig. 14.23). This painting is similar to *Calligraph Forming* (Plate 51) whose title, I believe, is indicative of this whole long series of variations on the linear themes that Harris chose from his automatic drawings. The paintings are probably meant as new calligraphic signs of Harris's spiritual and mystical intuitions. In *The Spirit Settling into the Heaven World State* (Plate 52) of about 1960, the gently coloured blue, tan and yellow lines are encased in a grey, shell-like form, which is surrounded by a roughly painted radiance and framed by linear devices in three of the corners. The result is a dominant form that leaves behind the all-over design that had been a feature of these works. The explicit title suggests a reference to a mystical text, which I have not been able to locate.

Three sets of variations on lines, one above the other, are found in another work of the early 1960s with a mystical title. *The Three Planes of Being* (Plate 53), painted in 1962–63, combines Harris's controlled use of subjectivity with an objective attitude toward theosophical doctrines about the levels or planes of reality.[19] Each of the three sets

of lines is different. The lower range, only slightly curved, are jagged at the top and dark green, suggesting Harris's emotional reactions to some of the lower planes of reality. Separated from this dark range is a middle one that is mainly blue – the theosophist's colour for the expression of religious feelings – though this blue is interspersed with some forms of soft, creamy light. The lines in the middle are more curved than the lower ones, but less so than the ones at the top, which are cream and soft yellow in colour. The top range is linked with the middle range by shared forms on the right and left. The three ranges or levels, and the spaces between them, are all suffused by a flow of light which begins at the bottom level and expands to include all of the top level. On each level Harris has depicted distilled versions of his subjective reactions to different planes of what he perceived as objective spiritual reality.

An interesting work from the 1955 exhibition is *Intimations* (Plate 54). Not only does it contain some carefully placed lines derived from the automatic drawing and stiffened into a mainly two-dimensional composition, but it also has at its centre a sharp-edged white irregular quadrangle that looks as if it has an indentation. Harris often used this precise shape as an indentation or a cutout in earlier geometric paintings, such as *Abstract Sketch* of 1936 (Fig. 14.24) which contains the same shape – here transparent – in a vertical composition of three-dimensional forms. In the two-dimensional field of *Intimations,* the indentation causes the viewer to gently experience the third dimension. This shift from two to three dimensions, and the work's title, recall Harris's statement, "A work in two dimensions may contain an intimation of the third dimension and ... a work in three dimensions may contain an intimation of the fourth dimension."[20]

The 1955 exhibition also contained some abstractions that are related to landscape views. Two of these are *Nature Rhythm* (Fig. 14.19) and *Mountain Rhythm – The Cascades* (Fig. 14.25). In both of these, landscape forms, elements and colours are separated from their normal placing and reassem-

Figure 14.22
Abstraction 181, c. 1950
120 x 94.6 cm
Private collection

Figure 14.23
Abstraction 101, c. 1962
101.6 x 136.8 cm
L.S.H. Holdings, Vancouver

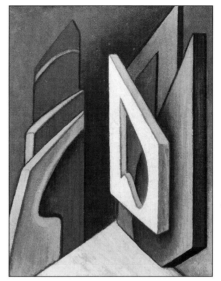

Figure 14.24
Abstract Sketch, 1936
Oil on board
37.9 x 30.2 cm
National Gallery of Canada, Ottawa

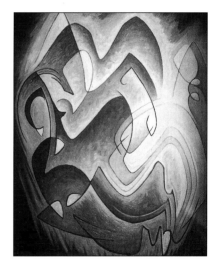

Figure 14.25
Mountain Rhythm – The Cascades, c. 1955
93.3 x 81.9 cm
L.S.H. Holdings
Courtesy of Mira Godard Gallery,
Toronto

bled. Another abstract work from this period with important landscape imagery is *Mountain Spirit* (Fig. 14.26) of about 1950. Here the lines derived from Harris's automatic drawing cling to, and seem to hover in the air over, a small cluster of mountain peaks. The work could be called a naive abstraction, but it echoes the enormous importance the mountains had in Harris's spiritual and artistic life. A second, much larger version of this painting has the same title, but Harris has removed the mountains at the bottom. The two pictures give us another clue to the use Harris was making of these lines to express emotional and spiritual feelings for the mountains or for spiritual truths experienced in some other setting. Harris has painted the lines separately, that is, without reference to a source experience or object, as they are in *Abstraction* and most of the paintings we have been examining in this section. Sometimes Harris has attached the lines to natural objects, as in *Mountain Spirit,* relating them to the mountains Harris found so important.[21]

Harris had still other variations on the lines derived from his automatic drawing. In *Frolic I* the lines, of various sizes, shapes, colours and textures and probably derived from his automatic drawings, are clustered across the bottom third of the work. Some lines reach into and across a flatly painted area in the middle and help create a three-dimensional floating shape. What is different in this painting is the exuberant combination of linear rhythms, buoyant shapes and light, cheerful colours. The painting probably expresses something of the new range of "emotional structures" that Harris saw as possible within the framework of Abstract Expressionism. Harris completed this painting perhaps only a few weeks before his major surgery in early April of 1958, placing it in what Bess Harris described as a

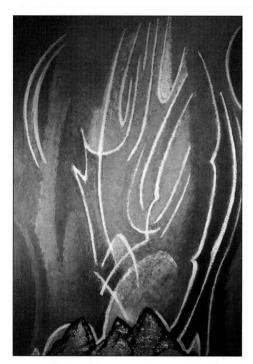

Figure 14.26
Mountain Spirit, c. 1950
Oil on masonite
73.7 x 55.9 cm
Alma Mater Society of the
University of British Columbia

"new and creative period" for Harris.[21] Harris painted two larger versions of this work, *Frolic (Abstraction 102)* (Plate 56) in perhaps 1955 and *Spring Frolic (Abstraction 154)* of 1961–62. These larger works have generally the same colour scheme but less spontaneity and heavier lines and forms; they lack the illusion of emitting or radiating light that marks *Frolic I* and looks forward to Harris's last paintings.

Around 1960, Harris painted some works that again made use of lines, but now toward the edges of the paintings, which have wide, three-dimensional images in the centre. *Spirit of Remote Hills* (Plate 57) combines two-dimensional lines with a view of white hills that seem to float beyond the foreground lines under a fairly spacious sky that is in turn bracketed by two-dimensional lines. There is a similar polarity in *Day and Night* (Fig. 14.27), in which a definite landscape and sky, complete with moon or sun, possibly in eclipse, are all but framed by Harris's two-dimensional linear devices. There are two kinds of perception in these works: the two-dimensional patterning of the lines, and the presentation of deeper space in a gentle, undramatic way. It is as though Harris found the landscape references as useful in presenting his meaning as the more abstract elements in the painting.

Harris's use of wide areas of gently brushed colour in both these paintings resembles the work of another Abstract Expressionist painter, Mark Rothko, whom he especially admired. There are also at least three abstract works by Harris that suggest that he admired the rough textures and dark, flat surfaces of the work of Clyfford Still. The most obvious of these is *Abstraction 108* (Fig. 14.28). Another painting, *Abstraction 106* (Plate 58), repeats the flat, textured surface of Still's painting but is much more of a Harris work. Harris used only a thinly painted, shimmering white surface against a blue ground. This produced a very quiet, veil-like, contemplative work, which Harris had hanging in his bedroom during his last illness.

HARRIS'S OLD-AGE STYLE: PAINTINGS
c. 1964–69

The idea that there is such a thing as an "old-age" style has recently interested art historians.[22] Kenneth Clark believes that most great artists who lived into old age did create successful new styles, but that many of their late works were seen as an embarrassment – a sign of artistic decline or a deterioration of technique.[23] It was only later generations who came to see the late works of these artists as important breakthroughs, as even the culmination of their careers. Harris's late works, which have been seen by very few people, did not escape this kind of judgment. They were, at the time of his death, considered of such dubious value that they were not included in the Lawren S. Harris Holding Company list of works.

From a stylistic point of view, Clark finds in the old-age styles of the artists he examines, "a retreat from realism, an impatience with established technique and a craving for complete unity of treatment, as if the picture were an organism in which every member shared in the life of the whole."[24] These remarks, with one exception, could be applied to almost all Harris's late works – the exception is "a retreat from realism," since Harris had long been a painter of abstractions. There is a parallel, however, in Harris's retreat from the detailed and careful painting of a set mystical iconography and from the controlled, curvilinear representations of his mystical feelings, derived in part from from his experiments with automatic painting.

On the other hand, Clark's discovery of "transcendental pessimism" in the old-age style does not apply to Harris, whose last paintings suggest that he was not deserted by his religious, mystical and abstract artistic vision as he approached death. One of Harris's strongest beliefs was in the doctrine of reincarnation. Specifically, he believed that he was the reincarnation of the well-known theosophist William Q. Judge. The paintings, however, suggest that Harris's vision as he was approaching death was not of

immediate reincarnation but of moving into greater light.

The least that can be said about the works Harris painted between about 1964 and 1969 while he was a sick and often bedridden man advancing into his eighties, is that they are surprising. In September 1969, Bess described what had probably been Harris's condition for some time: "Lawren is not interested, nor strong enough to do anything but paint 'creatively' when the spirit moves him."[25] The results of Harris's painting "creatively" are startling because of their large size (many are 117 x 165 cm), their often bold and simple design and loose, highly textured, contour-diminishing brushstroke.

Establishing the chronology of these works is all but impossible since none of them were dated; nor were they exhibited in Harris's lifetime.[26] They constitute a departure from his previous work – an authentic instance of an old-age style. These paintings can be divided into four groups: paintings in which Harris has created new abstract forms; large repaintings of earlier abstractions; paintings with deliberate anthropomorphic references; and paintings with sunlike images of light.

In the first group, the paintings in which Harris created new abstract forms, some are geometric and firm of line and so perhaps were done earlier when his hand and arm retained more of their steadiness; others are painted more roughly. This group includes some of the largest and simplest works Harris ever created, such as *Abstraction "J"* (Plate 59) and *Abstraction "K"* (Plate 60). The clearly defined edges of the former recall Harris's geometric abstract paintings of the 1930s, but there are only three colours in this large (162.6 x 106.7 cm) two-dimensional work, white for the large irregular shape, brown for its clear edges and blue stripes on white for the field. In *Abstraction "K"* the large, well-defined, fanlike cadmium orange and white form dominates a blue field painted with bricklike strokes that may have been suggested by tranquil sky or water. These decisive paintings are very different from the more diffuse Abstract Expressionist works Harris had painted only slightly earlier. They seem to

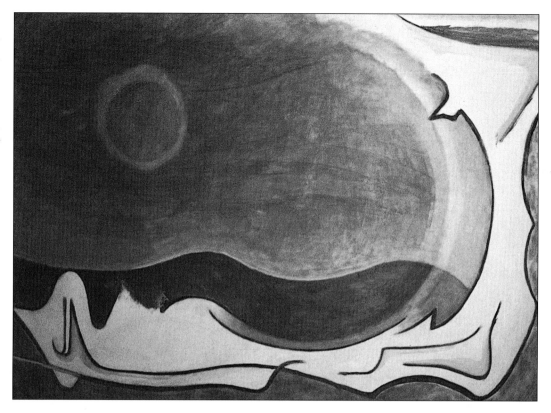

have no connection with the gestural lines derived from his experience of automatic painting, and so do not imply, as did his Abstract Expressionist works, a strong subjective component. These works do show that Harris was keeping up with late developments in "hard edge" and "post-painterly abstraction" even though he was unable to do much travelling. In 1962 he probably did see the exhibition "Art since 1950: American and International" at the Seattle World's Fair; the catalogue is still among his books. This exhibition included Ellsworth Kelly's hard-edged abstraction *Blue-White,* which was also illustrated in the catalogue. Like *Abstraction "J,"* the Kelly work is basically two colours – and very large. Harris probably did not see the "Post-Painterly Abstraction" exhibition when it was at the Art Gallery of Toronto in the winter of 1964–65, though he may

Figure 14.27
Day and Night, c. 1960
92.1 x 132.1 cm
L.S.H. Holdings, Vancouver

Figure 14.28
Abstraction 108, c. 1958
101.6 x 139.7 cm
L.S.H. Holdings, Vancouver

have seen the catalogue. Among the paintings illustrated is a large one by the American Kenneth Noland called *Cadmium Radiance,* which could have had something to do with the fanlike shape in Harris's *Abstraction "K"* as well as the use – unusual for Harris – of cadmium orange.[27]

Blue, orange, yellow and white combine in another large (116.8 x 165.1 cm) painting, *Abstraction "V"* (Plate 61), possibly done in 1965. The simple wave shape is repeated several times and the whole is loosely brushed. The brightness of the painting depends on simple colour contrasts and the large white area that echoes the simplicity of the design. In *Abstraction "B"* (Plate 62) Harris employs similar curves to make a simple yellow beanlike shape. This yellow shape and its green outline are loosely overpainted with white, a colour combination that makes the work look as though it were not just bright but emitting a soft light. Harris's enthusiasm for Rothko's painting is evident in this shimmering, light-filled passage.

The second group of Harris's old-age works are larger repaintings of earlier abstractions. This group is well exemplified by *Abstraction "R"* (Plate 63) of about 1967. It is a large (171.5 x 111.1 cm), loosely painted version of *Abstraction* (Fig. 14.29) a small (55.6 x 33.3 cm), precisely-drawn, tightly composed, signlike geometric abstraction done thirty years earlier in 1938. The earlier work is an example of the aerial type of abstraction Harris painted in New Hampshire and Santa Fe; it shows a compaction of triangles, circles and transparent and opaque planes floating in the air like an image of a chord of music. The composition is ultimately derived from *Thought Forms.* Though the later work illustrates Harris's continuing interest in theosophical and religious themes, he has simplified the composition, heightened the colours and softened the geometric discipline of the lines and edges.

The most important difference in *Abstraction "R"* is the rough texture of the paint and the way Harris has worked it to give the painting a glowing luminescence. Nevertheless, there is a decisiveness and a great deal of control of other kinds in

the painting which suggest that in these late works he has not lost any of his painting skill or judgment. For instance, the shimmering effects of light around the two triangles near the top of the painting are carefully planned and executed. In the blue field around these triangles (see the detail, Plate 64), Harris has clustered in random fashion some white and some dull-gold dots and small rough strokes of paint. Then, to many of the small individual white dots and strokes he has added minuscule touches of red. This careful combination helps to create the shimmering effects. In the 1938 painting, Harris created an image that was firm and certain in its clarity, expressing his firmly-held beliefs about transcendental religious experience. In *Abstraction "R"* Harris is drawn again to the religious imagery of the 1938 painting, but in the later work he evokes a sense of mystery about those same religious beliefs. Here in these late versions, the objective truths are pictured, but with a sense of wonder and mystery that is personal and flows, for the most part, from the random-looking touches of his brushstroke, the freely drawn geometric forms and the vague but powerful luminescence.

Harris transformed some of the abstractions of the 1950s in similar ways. In three later versions (Figs. 14.31 and 14.32 and Plate 65) of *Atma Buddhi Manas* of 1962 (Fig. 14.30), he has simplified and expanded the forms in the painting. The lines become gradually softer and the shapes less angular until in the final tranquil and luminous result (Plate 65) they only faintly echo the tensions, the angularity and the strong colouring of the earlier version.

The third group of works in Harris's old-age style comprises those with anthropomorphic references, recalling the anthropomorphic trees in Harris's earlier landscape painting and anthropomorphic shapes in some of his earlier abstractions. They too represent an innovation in his three decades of abstract painting. Landscape forms – the curve of a hill against distant mountain forms and a blue sky – appear in the lower two-thirds of a large, late painting, *Abstraction "C"* (Fig. 14.33). However, the painting is dominated by a large, loosely brushed shape that seems to be a pair of widely spaced

eyes, each with its own highlight. This anthropomorphic reference is unexpected in Harris's abstract style, and equally a departure from his religious outlook, since he had rejected all anthropomorphisms in referring to God.[28] He was probably referring in this painting to an ultimate spiritual reality but in an anthropomorphic way, alluding to intelligence or perception in the infinite.

These speculations are even more appropriate when we look at two other late and very large (116.8 x 165.1 cm) paintings. In *Abstraction "E"* (Plate 66), a pair of eyes similar to those in *Abstraction "C"* forms part of a schematically presented masklike face which is painted over a loosely brushed yellow and white field of light. Wavelike lines echoing the shape of the head reach to the frame on the right and left. In a very similar painting, *Abstraction "A"* (Plate 67), the face is presented even more as though it were a source of light in a field of light.

But how should we interpret these works painted at the end of Harris's long development? By their simplicity, all these paintings suggest a different religious awareness. As Harris approached death, he seemed to be shedding the dogmatic precisions and psychological complexities of his vision. It is also likely that at this time in his life, images rose from his memory and his subconscious with an energy his previously strict conscious control either could no longer subdue or chose not to.

What is surprising in *Abstraction "E"* and *Abstraction "A"* is the human faces in these otherwise abstract paintings. It is as though Harris, facing the light he had been painting for decades, was wondering if – or discovering that – after all his abstract theosophical speculations, there was a person within the light of the spirit. In this hypothesis, three things come together in these paintings. Harris's childhood and early youth had been saturated by a strict, long-since-abandoned Baptist and Presbyterian upbringing, which held (among other beliefs) that God was a person. This notion was re-emerging in his imagination to mingle with both his theosophical beliefs about the divinity being an impersonal,

"everlasting divine spirit"[29] and the artistic vision that had been fascinated by light as an image of the spirit. Harris wrote about this aspect of light as though it were not just a belief but a tangible aspect of reality.

Paintings in the fourth group of Harris's old-age style concentrate on images of light as a sunlike source. Light is a theme that had interested Harris particularly since the 1920s when he wrote about it in his poetry and painted it as rays of light in his landscapes, though in none of these paintings was the sun itself ever pictured directly.[30] But if Harris was fascinated by light in the 1920s, in the paintings of his old-age style he seems obsessed with it. *Abstraction "P"* (Plate 68) of about 1968 combines yellow, orange, white and blue in a flat, flaglike composition. It is almost certainly the sun that is pictured. In spite of the hot colours Harris achieves a certain emotional distance through the crisp curves of the large orange shape, the dark outline around the sun form and the geometry of the radiating white lines.

Another of these paintings of light that still has a firmness in the brushwork and some of the contours is *Abstraction 103* (Plate 69). In this painting there is an urgency and energy that carry the work beyond the cool influences of then-contemporary hard-edge abstraction. A suitable title might be "The Eros of Light," with "Light" understood in Harris's sense as the image of the "everlasting divine spirit." But for Harris light was even more than a symbol of the everlasting divine spirit; it was somehow the spirit itself. In this startling painting what we probably have is an abstract image of the mystical union of a human being with God, a union Harris had been seeking consciously, and at times passionately, since his nervous breakdown in 1918. The ascending and penetrating disk and its cometlike tail are blue, the theosophical colour of "high spirituality" and "pure religious feeling." The shape of the disk and its tail recall another theosophical image with a similar content, the blue cone of the "Upward Rush of Devotion" (Fig. 13.13). In Harris's painting, the blue disk is received and clasped by the spiralling radiance of yellow and gold light, that is, by

Figure 14.29
Abstraction, 1938
Oil on masonite
55.6 x 33.3 cm
Private collection

Figure 14.30
Atma Buddbi Manas, 1962
101.8 x 138.4 cm
Courtesy of Garth Drabinsky Collection
Photo courtesy of Art Gallery
of Ontario, Toronto

God, the "everlasting divine spirit." This image recalls another theosophical illustration, "The Response to Devotion" (Fig. 13.14), in which, in answer to devotion, "our LOGOS pours forth His light, His Power, His life."[31] Harris's image carries the idea further. His blue cone is more aggressive and is in actual contact with the light/God, not passively awaiting the downpouring like the cone in the image from *Thought Forms*.

This abstract image of Harris's also has an erotic quality. His attitude toward sexuality had been, from at least the 1920s, more than puritanically severe. The most telling expression of his belief that sexual activity was incompatible with spirituality was his celibate marriage to Bess. Against this background, *Abstraction 103* marks a significant change in Harris's attitude. An integration seems to have taken place. He is now able to create a painting in which sexual

imagery – albeit abstracted – forms an important aspect of a painting which, as usual for Harris, also has spiritual and religious meanings.

Abstraction "S" (Plate 70) has some of the same colours, but here Harris seems to have been liberated from a deliberate-looking, programmatic type of painting. The painting shows a circle of light within a larger circle of light, a yellow-white circle within a more golden circle in a field of blue, all of it roughly and loosely painted. It seems free from a tight dependence on cerebral thought; at least the cerebral is absorbed within the vibrant quality of the painting. At the same time the work is less intense – a kind of looseness in feeling about the painting goes with the brushwork. It is less definite in its content and outlines and this undefined character perhaps expresses Harris's awareness of the mystery and ambiguity, as well as the excite-

Figure 14.31
Abstraction 148, c. 1965
L.S.H. Holdings, Vancouver

Figure 14.32
Abstraction "F," c. 1966
113 x 167.6 cm
Private collection

Figure 14.33
Abstraction "C," c. 1967
116.8 x 165.1 cm
L.S.H. Holdings, Vancouver

ment, of his mystical experience. Harris probably saw his approaching death as a journey into the light and these paintings, in their various ways, record his mystical intuitions. In *Abstraction "D"* (Plate 71) the traveller has already entered the realm of light but is progressing further toward the source through a cave or glowing womb. Although this may not actually have been his last painting, it is an appropriate work with which to end this study of an artist who had as one of his favourite expressions, "For the creative artist there is no finality."[32]

29 September 1969 and 29 January 1970

The last four months of Harris's life began with the sudden death of his wife Bess on 29 September 1969. The cause was an aneurysm of the aorta – the same heart ailment that Harris had suffered from. Bess was five years younger than Lawren and had been in generally good health. The expectation was that she – who had been supervising the care of her often-ailing husband for years and had just finished preparing her book on his art for publication[33] – would survive him. Her death was a surprise for everyone. For Lawren, it must have been a powerful shock.

From this point on the task of caring for Harris was taken over mainly by his daughter, Margaret H. Knox, and her husband James. Mrs. Knox has vivid memories of those last four months. She remembers that her father "was lost without Bess." His love of music helped; nearly every day during this period, until he himself lost consciousness, he listened to Rossini's *Stabat Mater.*[34]

Harris insisted on painting, although he didn't have the strength for it. Mrs. Knox later wrote:

> He would sit looking north to the mountains and then at the half finished painting on the easel – and call for help. I would help him over to the painting and stand behind him with my arms around his waist, feet braced, while he leaned over the palette table trying to mix and paint, forgetting he was being held upright, until I was ready to drop with fatigue. Finally he'd put the brush down and let me take him back to his chair, often to find that what he had just done, he did not like at all.[35]

After a series of heart attacks and strokes, Harris himself died on 29 January 1970.

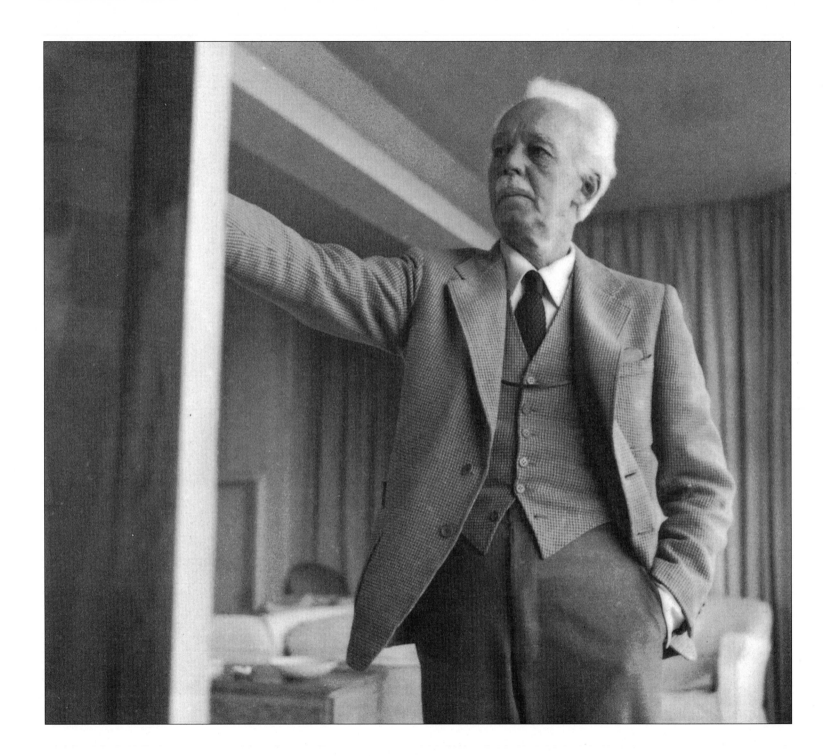

AN AFTERWORD

As a graduate student in the history of modern art I had to choose a thesis topic. I desired two things: that it be modern and that it be Canadian. For suggestions, I went to the well-known head of a large art-history faculty in English Canada. He assured me, without hesitation, that there was no Canadian artist worth the energy of a Ph.D. thesis. It is ironic that Columbia, a non-Canadian university, thought differently. My research, as it progressed, was disproving the first judgment and finding an unexpected appropriateness in the second: Harris was an international modernist more than he was a Canadian nationalist.

Harris was a citizen of the world. Trained in modernist Berlin, he adopted the paradigms of international modernism as a way of working in and healing Western culture. Even in the 1920s, in his nationalist landscape period, Harris kept in touch with a wide range of international art and, when he could, fostered it in Canada. When he moved to the United States in the 1930s, he began his life-long admiration for New York's Museum of Modern Art with its collections of Harris's heroes, Cézanne, van Gogh and Gauguin, and many other eminent as well as more recent international artists. During the 1940s and 1950s, the centre of the art world was shifting from Europe to New York. Harris made frequent visits to the city and was enthusiastic about Rothko in particular and Abstract Expressionism in general. These forces liberated him to transform his later art.

But Harris's world was wider than Western culture: through theosophical readings of Eastern texts and teachings,

Harris was in contact with the religious thought and meditation practices of Hinduism, Buddhism and other Eastern philosophies; they influenced him profoundly, offering the stability of an alternative world view in which to work. In his mind spiritual concepts such as reincarnation, karma, the planes of being and the possibility of infinite development were melded with modernism. They gave him a way of articulating the antimaterialist energies of his own art and the art of his time.

Harris did not create, invent or originate forms. He acquired almost all his landscape forms from German traditions. In his early Canadian works, he forced these prototypes into new realms of meaning. The unfocused social awareness of Liebermann's city landscapes became, in Harris's urban works, bearers not of social but of transcendental religious content. Through simplifications, Harris's German-derived wilderness landscape forms came to express a smooth, hard, cerebral intensity that made them his own. Such transformations were needed to carry his more focused religious meanings: the vague romantic mystery of Friedrich had been transformed into Harris's religious clarity.

Beginning with his early abstractions of the 1930s, Harris borrowed details of his paintings and often the form of the whole painting from illustrated theosophical books. Again, although the forms were borrowed, they contained Harris's own compactions of meanings. Then, after contact in the 1940s with Surrealism's automatism, Harris created, in a new calligraphic painting style, signs of his subjective reactions to the realm of the spirit. The abstractions of his

old-age style, though deeply influenced by Rothko and other recent art, embody profound religious awarenesses that are Harris's own.

Harris's Post-Impressionist heroes, Cézanne, van Gogh and Gauguin, each in their own distinct way, were in the avant-garde of the effort to affirm new values against the materialism and dominance of science in Western culture. The paradigm offered by their lives of struggle was the only one in which Harris could imagine himself.

I believe that Canadians should not be disconcerted by the nourishing links connecting Harris with other artists and with the wider world. Describing the influences creative people have on one another, Harris coined a phrase: it is "a mystery … at the heart of human interdependence."

NOTES

Chapter 1
SILVER SPOON IN SOUTHERN ONTARIO

1 From Lawren Harris's answers to the 32-page questionnaire he filled out for the Art Gallery of Toronto, in preparation for their retrospective exhibition, "Lawren Harris, Paintings 1910–1948" (14 October–16 November 1948). (Hereafter Harris, AGT Questionnaire, 1948.) The questionnaire contains important information, much of which was not used in the exhibition catalogue, and some of which is not otherwise known.

2 Merrill Denison, *Encyclopedia Canadiana,* s.v. "Harris, Alanson"; *Harvest Triumphant: The Story of Massey-Harris* (Toronto: Collins, 1949), 50.

3 John Clare, "The Massey-Harris Company: Hundred Year Harvest," *Maclean's Magazine,* 15 March 1947.

4 For this interpretation of nineteenth-century Ontario culture, see William E. De Villiers-Westfall, "The Dominion of the Lord: An Introduction to the Cultural History of Protestant Ontario in the Victorian Period," *Queen's Quarterly* 83, no. 1 (Spring 1976): 47–70. See also his more recent and more comprehensive *Two Worlds: The Protestant Culture of Nineteenth Century Ontario* (Montreal and Kingston: McGill-Queen's University Press, 1989).

5 *The Canadian Album, Men of Canada: or Success by Example,* vol. 1 (Brantford: n.d.), 254.

6 Mrs. Bess Harris to Russell Harper, curator of Canadian art, the National Gallery of Canada, Ottawa, 14 July 1962. (Hereafter Bess Harris, 1962.) Many of Bess Harris's letters about her husband and his work are helpful, but this long letter – eight typed pages – is a particularly valuable source of information about Harris's life, work and attitudes. In writing it Mrs. Harris constantly consulted her husband, who was ill at the time. Although she did not know Harris as a child, her letter is an excellent expression of what I call the "family tradition" of memories and legends about the painter, and is supported by other accounts. Herself a painter, art critic and religious person who shared much of her husband's vision, Bess Harris seems careful to present events, influences, friendships and feelings critically. She often distinguishes her own interpretations and observations from the statements or observations of her husband and others. The best account of the life of William Boyd Stewart is contained in an article about his son, William Kilborne Stewart. See Herbert F. West, "He Makes Students Think: Biographical Portrait of William Kilborne Stewart, Dynamic Influence throughout Forty Years of Dartmouth Teaching," *Dartmouth Alumni Magazine* (December 1939): 12. Bess Harris implies that this was Lawren's only trip to Europe before he went as a student in 1904. Ian McNairn, a friend of Harris, claimed that there were several early trips to Europe "with relatives": Introduction to *Lawren Harris: Retrospective Exhibition, 1963* (Ottawa: National Gallery of Canada, 1963), 10.

7 Bess Harris, 1962; interview with Churchill P. Lathrop, Dartmouth College, Hanover, N.H., 9 October 1973. The expression "unofficial artist-in-residence" is Lathrop's.

8 Harris, AGT Questionnaire, 1948; interview with Margaret H. Knox, the painter's daughter, Vancouver, B.C., 7 November 1973. According to Mrs. Knox, this was her grandmother's own statement.

9 *Thomas M. Harris,* described in the Prefatory Note as a "brief Memorial of Thomas Morgan Harris … issued from the press" (Canadian Baptist Press: Brantford, n.d.), 14.

10 Margaret H. Knox, "Personal Reminiscences," a chapter contributed to the limited edition of Joan Murray and Robert Fulford, *The Beginning of Vision: The Drawings of Lawren S. Harris* (Toronto: Mira Godard Gallery, 1982), 222.

11 Bess Harris, 1962; interview with Lawren Phillips Harris, the painter's son.

12 Bess Harris, 1962; interview with Margaret H. Knox.

13 Bess Harris, 1962.

14 Lawren Harris, "Jack Brown," *St. Andrew's College Review,* no. 1 (December 1902): 20–22.

15 F. B. Housser, *A Canadian Art Movement: The Story of the Group of Seven* (Toronto: MacMillan, 1926). The continuing friendship is attested to in Harris's letter from Hanover, New Hampshire, to Martin Baldwin at the Art Gallery of Toronto, 7 June 1936. In this letter, Harris mentions that he could count on Housser to look after some affairs for him.

16 Housser, *Canadian Art,* 34–35. Harris himself claimed that he was at the university for only half a year: see the questionnaire he filled out in 1944 for *Who's Who in American Art.*

17 Bess Harris, 1962. At the time Bess Harris was writing, her husband was not sure whether he had gone to Germany in the autumn of 1903 or of 1904. However, William Kilborne Stewart's records at Dartmouth College confirm that they went for the 1904–1905 academic year.

Chapter 2
MODERNIST BERLIN AND THE MIDDLE EAST, 1904–1908

1 The main sources are Harris, AGT Questionnaire, 1948, and Bess Harris, 1962.

2 For a description of this aspect of the period in Berlin, see Rudolf Pfefferkorn, *Die Berliner Secession: Eine Epoche Deutscher Kunstgeschichte* (Berlin: Haude und Spenersche Verlagsbuchhandlung, 1972), especially chapter 3, "Kunstpolitik in der Wilhelminischen Ära," 22–30. See also Werner Doede, *Berlin Kunst und Künstler seit 1870: Anfänge und Entwicklungen* (Recklinghausen: A. Bongers, 1961), 53–110.

3 Bess Harris, 1962.

4 Interview with Margaret H. Knox. However, the violinist Harry Adaskin, who was a close friend of Harris from the 1920s until Harris's death in 1970, had never heard that Harris studied violin in Berlin (interview with Harry Adaskin, Vancouver, B.C., December 1973). When Harris returned to Toronto, he continued to play the violin, taking part in at least one musical soirée at the Arts and Letters Club of Toronto as a member of the orchestra. He was also among the first in Toronto to have a record player.

5 Interview with Lawren Phillips Harris, the painter's son, Sackville, N.B., 29 March 1974; West, "He Makes Students Think," 12; Bess Harris, 1962.

6 Lawren Harris, "The Group of Seven in Canadian History," in *The Canadian Historical Association: Report of the Annual Meeting Held at Victoria and Vancouver June 16–19, 1948* (Toronto: CHA, 1948), 32.

7 Bess Harris, 1962; letter from Lawren Harris to Sydney Key of the Art Gallery of Toronto, 9 May 1948. Harris was responding to a request from Key for more detailed information on Harris's years in Germany.

8 Norman Rosenthal, "Germany, Norway and Switzerland: Idealism and Naturalism in Painting," in John House and Mary Anne Stevens, eds., *Post-Impressionism: Cross Currents in European Painting* (London: Royal Academy of Arts, 1979), 150–53.

9 Lawren Harris to Sydney Key.

10 Bess Harris, 1962. This is the only indication that we have that Harris worked in oils while he was in Germany. The only certain student works that survive are drawings and watercolours. However, some of the small oil sketches and pictures in family collections may well have been done in Germany.

11 Harris, AGT Questionnaire, 1948, 1; Bess Harris, 1962.

12 I have found very little archival material about von Wille in East or West Berlin, where he is now relatively unknown, or in Düsseldorf, his usual artistic base, and I have been unable to document that von Wille was in Berlin while Harris was there, or that Harris travelled to Düsseldorf or the Eifel region for instruction from von Wille. However, the similarities between Harris's subject matter and early styles and those of von Wille, and the similarities in their tastes and their philosophies of regionalism, are persuasive. Von Wille was a favourite of the Kaiser, who bought von Wille works for his private collection. In 1910, von Wille was given the honorary title of "Professor."

13 W. Vogel, "XII Jahresausstellung der Freien Vereinigung Düsseldorfer Künstler," *Die Kunst für Alle* 18 (1903): 335. All quotations from German publications are my translations.

14 Bess Harris, 1962. I depend on this source for the following details as well.

15 Georg Voss, "Ein Berliner Realist," *Die Kunst für Alle* 3, no. 11 (1888): 168–70; the second quotation comes from: "hn" [*sic*], "Franz Skarbina," *Zeitschrift für Bildende Kunst,* Neue Folge 3 (1892): 4.

16 K. S. [*sic*], "Chronik," *Kunst und Künstler* 8, no. 9 (1910): 478.

17 J. J. [*sic*], "Studio Talk, Berlin," *Studio* 32, no. 128 (1907): 321.

18 Lovis Corinth, *Das Leben Walter Leistikows: Ein Stück Berliner Kulturgeschichte* (Berlin: Paul Cassirer, 1910). In 1889, when Impressionist-influenced German artists were refused official permission to send their works to the Paris World Exhibition, Liebermann and Leistikow persuaded the Berlin artists to send their works to Paris privately (Ulrich Fincke, *German Painting from Romanticism to Expresssionism,* London: Thames & Hudson, 1974, 161). Three years later, Leistikow helped found the Vereinigung der XI, and soon after, became "the soul of the opposing circle out of which developed … the Vereinigung der Berliner Secession." Paul F. Schmidt, in U. Thieme and F. Becker, *Allgemeines Lexikon der Bildenden Künstler* (Leipzig: Seeman, 1907–50), vol. 22, 599. Figs 2.7 and 2.8 are reprinted from Corinth (Plates 45 and 39 respectively).

19 W. Fred, "A German Decorative Landscape Painter: Walter Leistikow," *Studio* 22, no. 98 (1904): 287.

20 Werner Haftmann, *Painting in the Twentieth Century,* 2d ed. (London: Lund Humphries, 1965), vol. 1, 50–51 – see also Fincke, *German Painting,* 190–91, who called it "Nature Lyricism;" Fred, "Walter Leistikow," 293.

21 Haftmann, *Painting in the Twentieth Century,* vol. 1, 50–51.

22 "Munch – Ausstellungen" in Henning Bock's and Gunter Busch's *Edvard Munch: Probleme – Forschungen – Thesen* (Munich, Prestel-Verlag, 1974), 239–48; Doede, *Berlin Kunst,* 97.

23 Werner Doede, *Die Berliner Secession: Berlin als Zentrum der Deutschen Kunst von der Jahrhundertwende bis zum ersten Weltkrieg,* "Beilage B., Auslandische Künstlers (Auswahl)," (Propylaen: Frankfurt a.M., n.d.), 28; Hayward Gallery, *Ferdinand Hodler, 1853–1918* (London : Arts Council of Great Britain and the Pro Helvetia Foundation of Switzerland, 1971), 21. A passage from Hodler's theory of parallelism is presented by Linda Nochlin, *Realism and Tradition in Art 1848–1900: Sources and Documents,* Sources and Documents in the History of Art Series, ed. H. W. Janson (Englewood Cliffs, N.J.: Prentice-Hall, 1966), 180–81.

24 Doede, *Berlin Kunst,* 92, 94.

25 John House, *Post-Impressionism,* 83. *The Birth of Christ* is reproduced in colour in Georges Wildenstein and Raymond Cogniat, *Gauguin* (New York: Doubleday, 1972), 64.

26 "Exposition du Centenaire de l'Académie Royale des Arts de Berlin," *Gazette des Beaux Arts* 34 (1886): 343.

27 Andreas Aubert, "Caspar Friedrich," *Kunst and Künstler* 3 (1904–1905): 198.

28 Linda Siegel, "Synaesthesia and the Paintings of Caspar David Friedrich," *The Art Journal* 33, no. 3 (1974): 203, and note 27, 204.

29 Fincke, *German Painting,* 226.

30 Those works that do survive all come from Harris's own collection and most have been in the possession of his children until recently. One likely student work, the small oil painting *German Village,* was recently acquired by the Art Gallery of Ontario. I suspect that Harris destroyed all but a few of his student works. In notes prepared for our interview, Thoreau MacDonald, J. E. H. MacDonald's son, described an incident in 1934: "Before Lawren left, he threw all his outdoor sketches and drawings in a heap on the basement floor and gave orders to get rid of them" (interview with Thoreau MacDonald, 27 September 1976).

31 See L. R. Pfaff, "Portraits by Lawren Harris: Salem Bland and Others," *RACAR* 5, no. 1 (1978): 21–27. Pfaff has found only eleven portraits.

32 Norman Duncan, "Riding Down to Egypt," *Harper's Monthly Magazine* 107, no. 698 (July 1908): 165–74; "In Camp at Bir el-Abd," ibid., no. 701 (October 1908): 651–61; "The Camel-Trader from Ain el Kaum," ibid., no. 702 (November 1908): 915–28; "One Day's Adventures," ibid., vol. 108, no. 703 (December 1908): 133–44; "The Diwan of Ahmed Ased-Ullah," ibid., no. 704 (January 1909): 198–209; "A Sheikh of et-Tih," ibid., no. 705 (February 1909): 449–58; "Breaking Camp at Kantara," ibid., no. 706 (March 1909): 516–29; "Beyond Beersheba," ibid., no. 707 (April 1909): 782–94. The book was Norman Duncan, *Going Down from Jerusalem* (New York: Harper Brothers, 1909).

33 It is thanks to Harris's list of his early sketching trips in Canada that we know that he was back in Canada by the autumn of 1908 (Harris, AGT Questionnaire, 1948, 4). Housser wrote that Harris "returned home in 1909 [*sic*], but almost at once left on a trip to Arabia" (*A Canadian Art Movement,* 35). If Harris did leave for the Middle East immediately after arriving home from Germany, it would have had to be during November 1907. Although this early a date contradicts Bess Harris's assertion that Harris spent four winters in Berlin (Bess Harris, 1962), it agrees with Harris's own statements on two separate occasions that he spent three years there.

34 Duncan, "Riding Down to Egypt," 165. Details of the trip are taken from Duncan's magazine articles.

35 Quoted by Sydney Key in the exhibition catalogue of the Art Gallery of Toronto, *Lawren Harris: Paintings 1910–1948* (Toronto, 1948), 29.

36 Duncan, "One Day's Adventures," 142.

37 Duncan, "The Diwan of Ahmed Ased-Ullah," 209.

38 Duncan, "In Camp at Bir el-Abd," 651, 661.

39 Duncan, "One Day's Adventures," 142.

40 Duncan, "Breaking Camp at Kantara," 524–25.

Chapter 3
THE FIRST CANADIAN DECADE OF A WOULD-BE MODERNIST, 1908–18
Nationalist Rhetoric, Decorative Painting and a Nervous Breakdown

1 I am indebted to Margaret H. Knox for the information about Harris's residences.

2 Augustus Bridle, *The Story of the Club* (Toronto: Arts and Letters Club, 1945), 10.

3 Ibid., 20.

4 Harris, AGT Questionnaire, 1948, 8.

5 Augustus Bridle, "Points about Pictures: What Is Canadian Art Doing for Canada?" *Canadian Courier,* 22 April 1911, 12.

6 Ibid.

7 Augustus Bridle, "The Homes of Workingmen," *The Canadian Magazine* 23, no. 1 (November 1903): 33–40.

8 "The Group of Seven," talk delivered in the Vancouver Art Gallery in April 1954 and broadcast by radio station CBU, Vancouver, 15 September 1954. From the typescript of the radio talk, 4. Harris was genuinely excited by MacDonald's painting, but his statement must not be taken at face value; he was pervasively influenced by his experience in Germany as a student.

9 This work is traditionally dated 1912 by the artist's family, but see Jeremy Adamson, *Lawren S. Harris: Urban Scenes and Wilderness Landscapes, 1906–1930* (Toronto: Art Gallery of Ontario, 1978), 68, who dates it as "c. 1916."

10 Harris, AGT Questionnaire, 1948, 4.

11 Norman Duncan, "Higgins – A Man's Christian," *Harper's Monthly Magazine* 119, no. 710 (July 1909): 165–78. The book was *Higgins: A Man's Christian* (Harper & Brothers: New York and London 1909).

12 *A Lonely House,* referred to by W. Vogel, "XII Jahresausstellung der Freien Vereinigung Düsseldorfer Künstler," *Die Kunst für Alle* 18 (1903): 335.

13 "Notes on Pictures at the Ontario Society of Artists Exhibition," a pamphlet now bound with the 1911 OSA catalogue (Toronto: OSA, 1911). All exhibiting artists were invited to comment on their work.

14 L. H. [Lawren Harris], "Hemming's Black and White," *The Lamps* 1, no. 1 (October 1911): 11.

15 Lawren Harris, "The R.C.A. Reviewed," *The Lamps* 1, no. 2 (December 1911): 9.

16 Lawren Harris, "The Canadian Art Club," in *The Year Book of Canadian Art 1913* (London and Toronto: J.M. Dent and Sons, 1913), 213–16.

17 Nancy E. Robertson, *J. E. H. MacDonald, R.C.A., 1873–1932* (Toronto: Art Gallery of Toronto, 1965), 13. I am indebted to this source for the following information on MacDonald.

18 Joan Murray, *The Art of Tom Thomson* (Toronto: Art Gallery of Ontario, 1971).

19 Dennis Reid, *Le Groupe des Sept/The Group of Seven* (Ottawa: National Gallery of Canada, 1970), 21–22. I am frequently indebted to Reid's research for information on the members of the Group of Seven and their sketching trips.

20 Colin S. MacDonald, *A Dictionary of Canadian Artists* (Ottawa: Canadian Paperbacks, 1971), vol. 3, 566–69.

21 A. Y. Jackson, *A Painter's Country: The Autobiography of A. Y. Jackson* (Toronto: Clarke Irwin, 1964), 26.

22 Lawren Harris, "The Group of Seven in Canadian History," 31.

23 A.Y. Jackson, *A Painter's Country,* 29.

24 Ibid., 33. I know about the original idea from an interview with J. C. Fraser, Harris's financial advisor and friend. Harris's interest in cultural centres continued; later in his life he advocated a national programme of such institutions. See his article, "Community Art Centres," *Canadian Art* 2, no. 2 (December 1944–January 1945).

25 From notes prepared by Thoreau MacDonald for our interview. Jackson, however, says in *A Painter's Country* that he and Thomson occupied the same studio. Thoreau MacDonald collected the rents, paid the janitor, got exhibitions ready and worked with his father in his studio.

26 A. Y. Jackson, ibid., 139.

27 H. F. Gadsby, "The Hot Mush School, or Peter and I," *Toronto Star,* 12 December 1913; J. E. H. MacDonald, "The Hot Mush School, in Rebuttal of H. F. G.," *Toronto Star,* 18 December 1913. Thirty-five years later, Harris wrote: "The painters and their works were attacked from all sides … such a display of anger, outrage, and cheap wit had never occurred in Canada before" ("The Group of Seven in Canadian History," 37).

28 Lawren Harris, "The Federal Art Commission," Toronto *Globe,* 4 June 1914.

29 In a letter to Lawren Harris on 26 March 1913, quoted in Housser, *A Canadian Art Movement: The Story of the Group of Seven* (Toronto: Macmillan, 1926), 79. Jackson refers to "the modest millionaire" whom Harris claimed was helping himself and MacDonald with the new movement. It is Housser who identified the millionaire as Walker.

30 Fergus Kyle, "The Ontario Society of Artists," in *The Year Book of Canadian Art,* 187.

31 Housser, *A Canadian Art Movement,* 185, 184.

32 On the back of *House in the Ward,* Bess Harris has written: "Painted in 1917 on leave."

33 A. Y. Jackson, "Lawren Harris: A Biographical Sketch," in Art Gallery of Toronto, *Lawren Harris: Paintings 1910–1948,* 8–9.

34 Christian Brinton, *Exhibition of Contemporary Scandinavian Art* (New York, American Scandinavian Society, 1912); J. E. H. MacDonald, "Scandinavian Art," talk given at the Art Gallery of Toronto, 17 April 1931.

35 Harris, "The Group of Seven in Canadian History," 31; see also Housser, *A Canadian Art Movement,* 63–65.

36 Dennis Reid, *Tom Thomson: The Jack Pine/Le Pin* (Ottawa: National Gallery of Canada, 1975), 8–9.

37 Harris to J. E. H. MacDonald, July and late August 1918.

38 Harris to J. E. H. MacDonald, 7 July 1919 and August 1918. Harris referred to the breakdown twice in later life: "The Group of Seven in Canadian History," 33–34, and "The Group of Seven," a talk delivered at the Vancouver Art Gallery in April 1954, 6.

39 Housser, *A Canadian Art Movement,* 136–37.

40 Interview with Margaret H. Knox, Vancouver, B.C., 7 November 1973.

41 Letter from A. Y. Jackson to J. E. H. MacDonald, 4 August 1917, quoted in Ottelyn Addison, *Tom Thomson: The Algonquin Years* (Toronto: Ryerson Press, 1969), 75; A. Y. Jackson, Foreword to Blodwen Davies, *Tom Thomson: The Story of a Man who Looked for Beauty and for Truth in the Wilderness* (Vancouver: Mitchell Press, 1967), 5.

42 Bess Harris, 1962.

Chapter 4
BREAKDOWN CURED
Mysticism, Theosophy and Canadian Nationalism

1 Lawren Harris, "The Group of Seven in Canadian History," 34.

2 F. B. Housser, *A Canadian Art Movement,* 137–38.

3 Harris to MacDonald, August 1918.

4 Lawren Harris, *Contrasts: A Book of Verse* (Toronto: McClelland & Stewart, 1922). See chapter 5.

5 In 1926, Harris won a gold medal at the Sesqui-centennial International Exhibition in Philadelphia for his urban landscape *Ontario Hill Town* (Plate 16). In January 1931, he was awarded the Baltimore Museum of Art Award for *North Shore, Lake Superior* (Plate 24), which was shown in the First Baltimore Pan-American Exhibition of Contemporary Paintings. The Société Anonyme exhibition was held 1–24 April: see chapter 5.

6 Bertram Brooker, ed., *Yearbook of the Arts in Canada* (Toronto: Macmillan, 1929), 178.

7 The best-known of these controversies occurred when Hector Charlesworth singled out MacDonald's *The Tangled Garden* for severe criticism in his review of the 1916 OSA exhibition. Charlesworth accused MacDonald of belonging to the "Hit 'em in the eye" school of artists, and called two other MacDonald works "Hungarian Goulash" and "Drunkard's Stomach": "Pictures That Can Be Heard," *Saturday Night,* 18 March 1916, 5. MacDonald replied with verve in "Bouquets from a Tangled Garden," Toronto *Globe,* 27 March 1916.

8 Art Museum of Toronto, *Algoma Sketches and Pictures: J. E. H. MacDonald, A.R.C.A., Lawren Harris, Frank Johnston* (Toronto, 1919), 8. Quoted in Reid, *The Group of Seven,* 91, n. 33.

9 Hector Charlesworth, "Reflections," *Saturday Night,* 13 December 1919, 2.

10 Art Museum of Toronto, *Group of 7: Catalogue, Exhibition of Paintings, May 7th–May 27th, 1920* (Toronto, 1920). The catalogue is reproduced in Peter Mellen, *The Group of Seven* (Toronto: McClelland & Stewart, 1970), 216. William Colgate, *Canadian Art, Its Origin and Development* (Toronto: Ryerson Press, 1967), 82.

11 Harris to MacDonald, August 1918. Harris and MacDonald had gone on a sketching trip to Minden – in the Haliburton Highlands, north of Lake Simcoe and south of Algonquin Park – in the fall of 1915. This is the only indication we have that MacDonald found that trip difficult. Harris's care to organize the Algoma trip so that it would not be too rugged for MacDonald was valuable: most observers agree that MacDonald's Algoma canvasses are among his best.

12 Harris to Eric Brown, 1 May 1924.

13 Harris did not exhibit with the Société Anonyme when he brought them to Toronto. For a more detailed discussion of his work on behalf of this exhibition, see chapter 5.

14 Dennis Reid's account of the years of the Group's success is the most useful and interesting: see "The National School," in *The Group of Seven,* 195–203.

15 Hector Charlesworth, "The National Gallery a National Reproach," *Saturday Night,* 6 December 1922, 3.

16 Hector Charlesworth, "Canada's Art at Empire Fair," *Saturday Night,* 15 September 1923, 1; "Canadian Pictures at Wembley," *Saturday Night,* 17 May 1924, 1; "Freak Pictures at Wembley," *Saturday Night,* 13 September 1924, 1; "Canada and Her Paint Slingers," *Saturday Night,* 8 November 1924, 1.

17 Hector Charlesworth, "The Group System in Art," *Saturday Night,* 24 January 1925, 3.

18 Merrill Denison, "No More Pyrotechnics at Painting Exhibition," *Toronto Star,* 22 December 1928.

19 "Minute Book of the Toronto Theosophical Society Beginning from February 20, 1921." "Affiliated to" probably indicated that Harris was already a member of the Theosophical Society, and was attaching himself to a local branch. Exactly when he did join for the first time remains a mystery.

20 Bess Harris to Dennis Reid, 25 October 1968.

21 Lawren Harris, "Strength," *Canadian Theosophist,* 7, no. 5 (15 August 1927): 104; "Science and the Soul," ibid., 12, no. 10 (December 1931): 298–300; "Theosophy and Art," ibid., 14, no. 5 (July 1933): 129–32, and no. 6 (August 1933): 161–66.

22 Bess Harris to Dennis Reid, 25 October 1968; interview with Margaret H. Knox, Vancouver B.C., 7 November 1973. During his last years Harris told his friend, the violinist Harry Adaskin, "You know I've always felt that I was a reincarnation of Judge": see transcript of interview with Harry Adaskin by Nancy Ryly of the CBC, 1982; interview with Harris's son-in-law James Knox, Vancouver, B.C., 7 November 1973.

23 "Science and the Soul," 299–300.

24 H. P. Blavatsky, *The Key to Theosophy* (Pasadena: Theosophical University Press, 1889), 63.

25 Ibid., 39.

26 Annie Besant, *Theosophy* (London: T. C. and E. C. Jack, 1912), 12.

27 Annie Besant and C. W. Leadbeater, *Thought Forms* (London: The Theosophical Publishing Society, 1905), 11.

28 Wassily Kandinsky, *Concerning the Spiritual in Art, and Painting in Particular* (New York: Wittenborn, 1947), 33.

29 C. Jinarajadasa, *First Principles of Theosophy,* 11th ed. (Adyar, Madras: Theosophical Publishing House, 1960; first published in 1921), 317, 318. See also his *Art as Will and Idea,* 2d ed. (Adyar, Madras: Theosophical Publishing House, 1954; first published in 1927).

30 C. W. Leadbeater, *Man Visible and Invisible* (Adyar, Madras: Theosophical Publishing House, 1959), 143. (First published in 1902.)

31 For those readers interested in studies that explore the relationship between modern art and the spiritual, I recommend Linda Dalrymple Henderson, *The Fourth Dimension and Non-Euclidean Geometry in Modern Art* (Princeton: Princeton University Press, 1983) and a more comprehensive work, Maurice Tuchman et al., *The Spiritual in Art: Abstract Painting 1890–1985* (Los Angeles: Los Angeles County Museum of Art, 1986). The latter is the catalogue for an exhibition of the same name; although Harris's work was not included in the exhibition, it is favourably mentioned, and his *Abstract Painting 95* (Fig. 11.11) is illustrated in colour.

32 "Science and the Soul," 298–99. The unidentified author is probably William Q. Judge, whose *Notes on the Bhagavad Gita* Harris owned.

33 A. G. Lehmann, *The Symbolist Aesthetic in France 1885–1895,* 2d ed. (Oxford: Basil Blackwell, 1968), 107.

34 For the influence of theosophy on Kandinsky, see Sixten Ringbom, *The Sounding Cosmos: A Study in the Spiritualism of Kandinsky and the Genesis of Abstract Painting* (Äbo, Finland: Äbo Academi, 1970), 40, n. 1; for Malevich's abstract art and its relation to theosophy, see Robert C. Williams, "Theosophy and the Fourth Dimension: Malevich's Suprematism," in his *Artists in Revolution: Portraits of the Russian Avant-Garde, 1905–1925* (Bloomington, Ind.: Indiana University Press, 1977), 101–27; for similar influences in Mondrian's art, see Robert P. Welsh, "Mondrian and Theosophy" in *Piet Mondrian, 1872–1944: Centennial Exhibition* (New York: Solomon R. Guggenheim Museum, 1971), 35–51.

35 Lawren Harris, "The Greatest Book by a Canadian and Another," *Canadian Bookman* 6, no. 2 (February 1924): 38; Bess to Dennis Reid, 25 October 1968. I believe that Bess's assertion is something of an overstatement, especially for the early abstracts of the 1930s which are discussed in chapter 11.

36 Lawren Harris, "Modern Art and Aesthetic Reactions: An Appreciation," *Canadian Forum* 7, no. 80 (May 1927), 241; Harris to Emily Carr, [June] 1930.

Chapter 5
HARRIS'S MAJOR WRITINGS ON ART, MYSTICISM AND NATIONALISM, 1918–30

1 Quoted in Bess Harris and R. G. P. Colgrove, eds., *Lawren Harris* (Toronto: MacMillan of Canada, 1969), 10. (Hereafter "Colgrove.") The text in Colgrove's book consisted of extracts from Harris's published works and from his papers.

2 Lawren Harris, *Contrasts: A Book of Verse* (Toronto: McClelland & Stewart, 1922). Quotations from this work are cited in the text, in parentheses. B.F. [Barker Fairley], "Contrasts," *Canadian Forum* 3 (January 1923): 120, 122.

3 Ralph Waldo Emerson, *Essays by Ralph Waldo Emerson: First and Second Series Complete in One Volume* (New York: Thomas Y. Crowell, 1926), 93.

4 Ibid., 40, 41.

5 See, for example, Emerson's essay "Spiritual Laws": "If we look wider, all things are alike; laws and letters and creeds and modes of living seem a travesty of the truth" (ibid., 97).

6 Roger Fry, *Vision and Design* (Harmondsworth, Middlesex: Penguin Books, 1961), 237; Lawren Harris, "Art Is the Distillate of Life," Lawren S. Harris Papers, Public Archives of Canada. Quotations from this paper are cited in the text, in parentheses. I have assigned the page numbers; where Harris has written on the back of a page, that page has a "B" number, e.g., [the back of p. 14] 14B.

7 Lawren Harris, "Theosophy and Art [1]," *Canadian Theosophist* 14, no. 5 (15 July 1933): 130.

8 Lawren Harris, "Theosophy and Art [2]," *Canadian Theosophist* 14, no. 6 (15 August 1933): 162.

9 Lawren Harris, "Different Idioms in Creative Art," *Canadian Comment on Current Events* 2, no. 12 (December 1933): 32.

10 George Russell [A. E.], *The Candle of Vision* (London: Macmillan, 1918), 11, 33–34, 49; H. P. Blavatsky, *The Key to Theosophy* (Pasadena: Theosophical University Press, 1946; first published in 1889), 328, 10.

11 Clive Bell, *Art* (New York: G.P. Putnam's Sons, Capricorn Books, 1958; first published in 1913 – Harris's copy was the 1916 edition), 29, 63, 68, 40; Harris quoted in Colgrove, 32.

12 Harris, "The Greatest Book by a Canadian and Another," *Canadian Bookman* 6, no. 2 (February 1924): 38. We have already seen Jinarajadasa's similarly structured theosophical view in chapter 4.

13 Lawren Harris, "Pen and Ink Drawings by Bertram Brooker," in Art Gallery of Toronto, *Catalogue of the Fifty-seventh Annual Exhibition of the Ontario Society of Artists* (Toronto, 1929), 38.

14 Lawren Harris, "Strength," *Canadian Theosophist* 8, no. 5 (15 July 1927): 104.

15 Canada Has Given Birth to a New and National Art," Toronto *Star Weekly,* 26 January 1924.

16 Lawren Harris, "Winning a Canadian Background," *Canadian Bookman* 5, no. 2 (February 1923): 37; Merrill Dennison, *The Unheroic North: Four Canadian Plays* (Toronto: McClelland & Stewart, 1923).

17 Lawren Harris, "Artist and Audience," *Canadian Bookman* 7, no. 12 (December 1925): 197.

18 Ibid.

19 Lawren Harris, "Sir Edmund Walker," *Canadian Bookman* 6, no. 5 (May 1924): 109.

20 Henry Thode, *Paul Thiem und seine Kunst* (Berlin: G. Grote'sche Verlagsbuchhandlung, 1921), 111. For a discussion of these ideas see George L. Mosse, *Toward the Final Solution: A History of European Racism* (New York: Howard Fertig, 1978), especially chapter 7, "The Mystery of Race," 94–112. My discussion depends on Mosse's research.

21 For Thiem's position, see Thode, *Paul Thiem,* 58–59.

22 Philip L. Nicoloff, E*merson on Race and History: An Examination of English Traits* (New York: Columbia University Press, 1961), 111, 69; Howard Mumford Jones, Introduction to his edition of Ralph Waldo Emerson's *English Traits* (Cambridge, Mass.: Harvard University Press, Belknap Press, 1966), xx; Emerson, *English Traits,* 203.

23 Blavatsky, *The Secret Doctrine*, vol. 2, 444–45.

24 Lawren Harris, "Theosophy and the Modern World: War and Europe," *Canadian Theosophist* 19, no. 9 (15 November 1933): 285; "The Greatest Book," 38.

25 Harris to MacDonald, 7 July 1919.

26 Lawren Harris, "Revelation of Art in Canada," *Canadian Theosophist* 7, no. 5 (15 July 1926): 86. Lawren Harris, "Creative Art and Canada," *The McGill News (Supplement)* 10, no. 1 (December 1928): 8.

27 Lawren Harris, "The Group of Seven," talk delivered in the Vancouver Art Gallery in April 1954 and broadcast by radio station CBU, Vancouver, 15 September 1954. From the typescript of the radio talk, 4.

28 H. Mortimer-Lamb, "The Art of Curtis Williamson, R.C.A.," *Canadian Magazine,* November 1908, 71. For further discussion of the Canadian concept of the North, see Carl Berger, *The Sense of Power: Studies in the Ideas of Canadian Imperialism 1867–1914* (Toronto: University of Toronto Press, 1970) and Carl Berger, "The True North Strong and Free," in Peter Russell, ed., *Nationalism in Canada* (Toronto: McGraw-Hill Ryerson, 1966), 3–26.

29 Harris, "Revelation of Art," 86.

30 Harris, "Hemming's Black and White" (see chapter 3); "Creative Art and Canada," 9; "Revelation of Art," 86; Colgrove, 48.

31 Harris, "Revelation of Art," 86, 85–86. In "Creative Art and Canada," 8, Harris had suggested that the movement of educated Canadians across the American border looking for employment could be "one of the means of infiltration of a certain polarity and unpretentious devotion, certain intangible elements in the quiet side of the Canadian character that is born of the spirit of the North and reflects it."

32 Harris, "The Group of Seven in Canadian History," 37. He is quoting from "Creative Art and Canada," 10; The two exhibitions were "American Art Today" at the 1939 New York World's Fair, and "Contemporary Art" at the Golden Gate International Exposition, San Francisco. In the catalogue of the former, Harris is referred to as coming from New Mexico; in the San Francisco exhibition, Harris is referred to as coming from Santa Fe, New Mexico. However, at the New York World's Fair Harris also exhibited two works in the "Exhibition of Canadian Art," with the "Canadian Group of Painters," and at San Francisco he exhibited two other paintings in the Canadian section of the same "Contemporary Art" exhibition. He was also responsible for the selection of the other Canadian works for this exhibition.

33 Lawren Harris, "The Federal Art Commission," Toronto *Globe,* 4 June 1914; "Creative Art and Canada," 8; Harris, quoted in Colgrove, 11; Harris, "Revelation of Art," 87.

34 Harris to Carr, [June] 1930, 8–9.

35 Harris, "Winning a Canadian Background," 37; "Sir Edmund Walker," 109; "Revelation of Art in Canada," 86.

36 Harris, "Artist and Audience," 197.

37 See, for example, his discussion of the particularity of a house he was painting in "The Final Urban Landscapes," chapter 6; Harris, "Creative Art and Canada," 6–7; "Sir Edmund Walker," 109.

38 Harris, "Creative Art and Canada," 11; "Theosophy and the Modern World: War and Europe," *Canadian Theosophist* 14, no. 9 (15 November 1933): 286, 288. For a discussion of the opposition of theosophy to science see chapter 4.

39 Art Gallery of Toronto, *Catalogue of the Inaugural Exhibition,* 29 January–28 February 1926 (Toronto, 1926); Lawren Harris, "Review of the Toronto Art Gallery Opening," *Canadian Bookman* 8, no. 2 (February 1926): 46–47. The oil-on-board sketch for *A Man with a Hoe* was borrowed from the former H. S. Osler Collection, Montreal; it is now considered a fake. See Robert L. Herbert, *Jean-François Millet* (Paris: Editions des Musées Nationaux, 1975), 201.

40 Harris, "Review of the Toronto Art Gallery Opening," 46–47.

41 Lawren Harris, "Modern Art and Aesthetic Reactions: An Appreciation," *Canadian Forum* 7, no. 80 (May 1927): 240; Art Gallery of Toronto, *Catalogue of the Exhibition of an International Exhibition of Modern Art (Assembled by the Société Anonyme) …* (Toronto, 1927), 1–24 April 1927. For a recent study of Drier and her work, see Ruth L. Bohan, *The Société Anonyme's Brooklyn Exhibition: Katherine Dreier and Modernism in America* (Ann Arbor, Mich.: UMI Research Press, 1982).

42 Harris, "Modern Art and Aesthetic Reactions," 240.

43 Ibid. *Proun 99* is llustrated in Associates of Fine Arts at Yale University, *Collection of the Société Anonyme: Museum of Modern Art 1920* (New Haven: Yale University Art Gallery, 1950), 159.

44 Harris to Carr, 12 March 1930.

45 Harris to Carr [June] 930.

46 Harris, "Art Is the Distillate of Life," 1.

Chapter 6
REALISM AND THE CITY WITHOUT THE SPIRIT
Harris's Urban Landscapes

1 Harris, *Contrasts,* 36. In the poem "A Question" (ibid., 57–58), there are references to streets; in "Occupied People" (55–56), the bustling city is implied.

2 *Essays by Ralph Waldo Emerson: First and Second Series Complete in One Volume* (New York: Thomas Y. Crowell, 1926), 247.

3 For a discussion of Munch's importance in Berlin during Harris's years there, see chapter 2; *Evening on Karl Johan Street* is illustrated in Robert Rosenblum et al., *Edvard Munch: Symbols and Images* (Washington, D.C.: National Gallery of Art, 1978), 37.

4 He articulated this stance in 1928: "The next step was a utilization of elements of the North in depth, in three dimensions, giving a fuller meaning." "Creative Art and Canada," 10.

5 Harris, *Contrasts,* 107.

6 For a more detailed discussion of this aspect of *In the Ward,* see chapter 3.

7 This was a rough drawing in pencil on torn paper, done to describe the painting to a third party. The drawing is in a private collection.

8 Interview with Lawren Phillips Harris, Sackville, N.B., September 1970.

9 Harris, *Contrasts,* 11.

10 John I. H. Baur, *Charles Burchfield at Kennedy Galleries: The Early Years* (New York: Kennedy Galleries, 1977), unpaged. Two Burchfield works, his hallucinatory water-colour *Tall Whte Sun* of 1917 and *Night Wind* of 1918 are illustrated in Matthew Baigell, *Charles Burchfield* (New York: Watson-Guptill Publications, 1976), 68, 40; his *Cottages in the Winter Rain,* c. 1920, is illustrated in Paterson Sim, *Charles Burchfield: A Concentration of Works from the Permanent Collection of the Whitney Museum of American Art* (New York: the Whitney Museum, 1980), 16.

11 *The Dial* 67 (April 1920): after 478.

12 Harris, *Contrasts,* 116–17.

13 For a recent discussion, see Jeremy Adamson, *Lawren S. Harris: Urban Scenes and Wilderness Landscapes 1906–1930* (Toronto: Art Gallery of Ontario, 1978), 114.

14 "Disdainful of Prettiness New Art Aims at Sublimity," *Toronto Star,* 6 May 1926.

15 Harris, *Contrasts,* 117.

16 The second work Harris sent to the Société Anonyme exhibition was *Mountain Forms,* a large (203.2 x 157.5 cm) canvas, which I have not been able to locate. Nor do I know of any other work of this size. See Harris to Katherine S. Dreier, 1 September 1926; see also Philadelphia, *Paintings, Sculpture and Prints in the Department of Fine Arts, Sesqui-centennial International Exposition,* 4th ed. (Philadelphia, 1926), 87.

17 Harris, "Art Is the Distillate of Life," 10.

18 Colgrove, 24 and 26. Although I have not been able to examine the texts, they should be dated around 1928. See also Harris's "Creative Art and Canada," *McGill News (Supplement)* 10, no. 1 (December 1928): 7.

19 Christian Brinton, *Modern Art at the Sesqui-centennial Exhibition* (New York: Société Anonyme, Museum of Modern Art, 1926); Katherine S. Dreier to Lawren Harris, 26 August 1926.

20 Harris, "Art Is the Distillate of Life," 10.

21 Ibid., 15.

Chapter 7
WILDERNESS LANDSCAPES AND THE REGIONALIST TRADITION I
The Algoma Paintings

1 Harris to MacDonald, 7 July 1919 and late August 1918.

2 Walter S. Johnson, "By Canoe," Canadian Magazine 23 (June 1904): 125. Quoted in Douglas Cole, "Artists, Patrons and Public: An Enquiry into the Success of the Group of Seven," *Journal of Canadian Studies/Revue d'études canadiennes* 13, no. 2 (Summer 1978): 70. I depend on this article for much of the following information concerning the wilderness ethos in Canada.

3 Quoted in Reid, *The Group of Seven,* 34.

4 Jackson, *A Painter's Country,* 56. Mrs. Harris wrote to the Lawrenceville School, Lawrenceville, N.J., from the Royal Muskoka Lodge to enroll her son Howard in 1903. For Harris's rental of a cottage at Go-Home Bay see Cole, "Artists, Patrons and Public," 74.

5 Roderick Nash, *Wilderness and the American Mind* (New Haven: Yale University Press, 1967), 84-85; Henry David Thoreau, *The Journal of Henry David Thoreau,* ed. Bradford Torry and Francis H. Allen (Boston: 1906), V:45; quoted in Nash, 85.

6 Art Museum of Toronto, *Algoma Sketches and Pictures,* 8.

7 Art Museum of Toronto, *Group of 7: Catalogue, Exhibition of Paintings, May 7–May 27, 1920* (Toronto, 1920), unpaged. The quotations from A.E., slightly adapted (e.g., "a people" instead of "Irish people") are from "Ideals of the New Rural Society," in his *Imaginations and Reveries* (Dublin and London: Maunsel, 1915), 95, 96.

8 Art Museum of Toronto, *Exhibition of Paintings by the Group of Seven, 7–29 May 1921* (Toronto, 1921), unpaged.

9 Dennis Reid, *"Our Own Country Canada": Being an Account of the National Aspirations of the Principal Landscape Artists in Montreal and Toronto 1860–1890* (Ottawa: National Gallery of Canada, 1979). For a discussion of O'Brien's painting, see chapter 9.

10 See J. Russell Harper, *Painting in Canada, A History* (Toronto: University of Toronto Press, 1966), chap. 21, "Painting as an Aesthetic Experience," 245–61.

11 Lawren Harris, "The Canadian Art Club," 213. For more about Harris's review, see chapter 3. Harris, "Review of the Toronto Art Gallery Opening," 47.

12 Harper, *Painting in Canada,* 256; Jackson, *A Painter's Country,* 19.

13 Harris, "The Group of Seven in Canadian History," 34. For Algoma and Harris's role in organizing the trips, see chapter 4.

14 Reid, *The Group of Seven,* 128, 136-38; Jackson, *A Painter's Country*, 56–57.

15 Reid, *The Group of Seven,* 159–60, 180.

16 For Thomson's career, see chapter 3.

17 See, for example, his poem "The World Doubts," quoted in part in chapter 5.

18 Harris to MacDonald, late August 1918. About his Lake Simcoe sketches, Harris wrote: "One has here to note skies, then go a sketching – say one quite attractive tree, put behind it a sky seen days ago, cut out the pastures and substitute a lake, bushes put on a distant shore and the result is sometimes surprisingly pleasing — when one bears in mind the meagerness of material at hand."

19 Reid, *The Group of Seven,* 144.

20 Harris, "Art Is the Distillate of Life," 15.

21 Ibid., 10.

22 Harris, *Contrasts,* 19–20, 18, 23.

23 *Where Eagles Soar* is illustrated in Reid, *The Group of Seven,* 128; *The Fire Ranger* is illustrated in colour in Mellen, *The Group of Seven,* 139. Johnston's break with the Group is discussed by Mellen, ibid., 138.

24 Harris, "The Group of Seven in Canadian History," 34; Jackson, *A Painter's Country,* 56.

25 J. E. H. MacDonald quoted in Nancy E. Robertson, *J. E. H. MacDonald, R.C.A.* (Toronto: Art Gallery of Toronto, 1965), 14.

26 A. Y. Jackson, "Lawren Harris: A Biographical Sketch," in Art Gallery of Toronto, *Lawren Harris: Paintings 1910–1948,* 7; Jackson, *A Painter's Country,* 57.

Chapter 8
WILDERNESS LANDSCAPES AND THE REGIONALIST TRADITION II
The North Shore of Lake Superior

1 Details of the sketching trips are taken from Reid, *The Group of Seven,* 180 and 217–19.

2 Jackson, *A Painter's Country,* 57, 57–58, 58.

3 Ibid., 58; William G. Harris, *The Group of Seven and Lake Superior* (Port Arthur, Ont.: Lakehead University, 1964), unpaged.

4 All quotations followed by a page number in parentheses are from Harris's unpublished paper on the nature of art, "Art Is the Distillate of Life."

5 Hector Charlesworth, "O.S.A. Annual Exhibition," *Saturday Night,* 29 March 1924. In1973 Charles Hill of the National Gallery of Canada listed books owned by Harris that were then in the possession of Mrs. Margaret H. Knox, Harris's daughter, including "books on Blake."

6 "Ontario Painters Doing Vital Work," Toronto *Mail and Empire,* 17 March, 1924. Harris's photographs of works by Kent and Georgia O'Keeffe were part of the collection referred to in chapter 5, and are now with the Lawren S. Harris Papers in the National Archives of Canada.

7 F. B. Housser, *A Canadian Art Movement,* 189, 191, 190.

8 Jackson, *A Painter's Country,* 59.

9 Harris, *Contrasts,* 90–91. Dennis Reid examines the meanings of light in Harris's painting in his article "Lawren Harris," *artscanada* 25, no. 5 (December 1968): 9–16.

10 Harris, *Contrasts,* 118–19.

11 Helmut Borsch-Supan, *Caspar David Friedrich* (New York: George Braziller, 1974), 130. *The Solitary Tree* is reproduced in colour, plate 32.

12 Milton Brown, *American Painting from the Armory Show to the Depression* (Princeton: Princeton University Press, 1955), 113.

13 Harris, "Winning a Canadian Background," 37.

14 Harris quoted in Colgrove, 3–4. Colgrove described these paragraphs as "Introductions by Lawren Harris for a book he was planning during 1934–1938." Two of the sketches for *Ice House, Coldwell, Lake Superior* are illustrated in Adamson, *Lawren S. Harris: Urban Scenes and Wilderness Landscapes,* 130. *Ranchos Church* is illustrated in Georgia O'Keeffe, *Georgia O'Keeffe* (New York: Viking Press, Studio Books, 1976), plate 63.

15 Marcus Adeney, "Lawren Harris: An Interpretation," *Canadian Bookman* 10, no. 2 (February 1928): 43.

16 Harris, "Artist and Audience," 198; Harris to Carr, 7 February 1930 and October 1930.

17 Paul Thiem, quoted in Thode, *Paul Thiem,* 55.

18 Augustus Bridle, "The Group of Seven Display Their Annual Symbolisms," *Toronto Star,* 8 February 1928.

19 For Harris's notion of the impersonality of art, see chapter 5.

Chapter 9
WILDERNESS LANDSCAPES AND THE REGIONALIST TRADITION III
The Rockies and the Arctic — A New Personal Crisis

1 Dennis Reid, *"Our Own Country Canada,"* 381. Before this both Paul Kane (1810–71) and William G. R. Hind (1833–39) had painted the mountains. However, Kane was mainly interested in recording the customs, costumes and artifacts of the Indians of North America; for the most part, his views of the mountains were incidental to this interest. Hind came to Canada from England in 1852. He travelled to the Rockies with the "Overlanders of '62," who were heading for the gold fields of British Columbia, but the mountains were not his major interest either — he focused Indians and prospectors.

2 Reid, *"Our Own Country Canada,"* 437.

3 Harris quoted in Colgrove, 62.

4 Interview with B. C. Binning, December 1973.

5 Reid, *The Group of Seven,* 191; Jackson, *A Painter's Country,* 107.

6 Lawren Harris, "The Group of Seven in Canadian History," 35.

7 For Harris's illustrations for *Contrasts,* see chapter 7 and Fig. 7.3.

8 Quotations followed by a page number in parentheses are from "Art Is the Distillate of Life."

9 F. B. Housser, "Some Thoughts on National Consciousness," Canadian Theosophist 8, no. 5 (15 July 1927): 82.

10 C. W. Leadbeater, *Man Visible and Invisible,* 29.

11 Friedrich's *Rocky Craig in the Harz Mountains* was illustrated in Andreas Aubert, "Caspar Friedrich," *Kunst und Künstler* 3 (1904–5): 199. *The Watzmann* is illustrated in colour in Helmut Borsch-Supan, *Caspar David Friedrich,* 145.

12 Harris quoted in Colgrove, 62. *Glacier, Mount Robson Area,* is illustrated in Adamson, *Lawren S. Harris: Urban Scenes and Wilderness Landscapes,* 174.

13 Harris, "Creative Art and Canada," 10.

14 "New Member Is Added to Group of Seven," Toronto *Mail and Empire,* 8 May 1926; "Disdainful of Prettiness New Art Aims at Sublimity," *Toronto Star,* 6 May 1926; W. G. M., "A Subscriber Writes of the Group Show," *Canadian Bookman* 8, 180. "W. G. M." was probably Wilfred Gordon Mills, an amateur poet and an admirer of Harris. At the time Mills was married to Doris Huestis Mills (later Mrs. Doris Huestis Speirs), a painter who knew both Harris and Bess Housser well. Doris Speirs assures me that the reference to theosophy in parentheses in the quotation would not have been from Mr. Mills. I speculate that it was inserted by the editor, Bess Housser, Harris's friend and future wife (interview with Doris Huestis Speirs, Pickering, Ont., September 1976).

15 A. Y. Jackson, quoted in Reid, *The Group of Seven,* 193.

16 See also *Mountain Snowfall, Lake Oesa,* illustrated in colour in Mellen, *The Group of Seven,* 163.

17 *Mountain Landscape, Garibaldi Park* is illustrated in Reid, *The Group of Seven,* 225; *The Cloud, Red Mountain, B.C.* is illustrated in colour in Mellen, *The Group of Seven,* 171.

18 For the date of this trip, see Reid, *The Group of Seven,* 205 and n. 6.

19 Harris to Emily Carr, [June] 1930. For a discussion of Harris's belief that there was "no finality," see chapter 8. Square brackets indicate that the exact date did not appear on the letter, but was arrived at through internal and external evidence. The letters are in the Emily Carr Papers, National Archives of Canada.

20 Harris to Carr, [October] 1930.

21 Harris to Katherine Dreier, [mid-December] 1926.

22 Harris to Carr, [June] 1930.

23 Harris to Carr, [October] 1930.

24 Harris to Carr, [November] 1930.

25 Harris to Carr, 30 November 1930 and 20 March 1932.

26 Harris, "The Group of Seven in Canadian History," 36.

27 See Harris, "Art Is the Distillate of Life," 10. Harris's film of the trip is at the National Film Archives, Ottawa, under the title "Lawren Harris in the Arctic."

28 Harris, "The Group of Seven in Canadian History," 36.

29 Harris, "Creative Art and Canada," 11; Besant and Leadbeater, *Thought Forms,* frontispiece, "Key to the Meaning of Colours," and 23–24.

30 See, for example, *Pic Island* (Plate 25) and *Maligne Lake, Jasper Park* (Fig. 9.3).

31 This and the following quotations are from "Creative Art and Canada," 10–11.

32 Harris, "The Canadian Art Club," 214.

33 See his poem "The Irrepressible," quoted in part in chapter 5.

Chapter 10
OUT OF THE TORONTO CHRYSALIS, 1933–34

1 Draft of a letter from Lawren Harris to Doris Huestis Mills, October 1939; the letter was never sent.

2 Interview with Mr. and Mrs. Peter Haworth, Toronto, June 1983.

3 Harris to Carr, 20 March 1932.

4 This agrees with the way Harris's daughter remembers the events: "Yvonne and Fred were in love. Fred spoke to Bess who got the divorce from Reno, starting it off" (interview with Margaret H. Knox, 25 November 1983).

5 Frances Loring to Eric Brown, [15] July 1934. The 13 June departure and similar personal information come from notes Harris made in Santa Fe for Dane Rudhyar, probably in 1938. Rudhyar, a well-known astrologer, was preparing Harris's horoscope.

6 Loring to Brown [15] July 1934.

7 Interview with Mr. and Mrs. Peter Haworth; Bess Harris, Santa Fe, N.M., to Betty Dankert, Hanover, N.H.

8 Bess Harris to Doris Huestis Mills, 14 November 1934 and 6 January 1935.

9 Bess wrote Yvonne McKague Housser ten letters in all, dating from 30 December 1936 (two days after Fred Housser's death) to 11 September 1956. Often the letters are on theosophical topics, and Bess seems to be offering Yvonne counsel.

10 "Theosophy and Art [1]," *Canadian Theosophist,* 14, no. 5 (15 July 1933): 129–32, and "Theosophy and Art [2]," ibid., no. 6 (15 August 1933): 162–166. References to these articles in this chapter are by page numbers in parentheses.

11 Draft of the letter from Harris to Doris Huestis Mills, October 1939, referred to in note 1.

Chapter 11
SPREADING HIS WINGS, 1934–38
Early Abstract Paintings in Hanover

1 Bess Harris to Doris Huestis Mills, 14 November 1934.

2 Ibid.

3 Interview with Mr. and Mrs. Churchill P. Lathrop, 9 October 1973.

4 Interview with Churchill P. Lathrop, 9 October 1973; Churchill P. Lathrop to the author, 25 July 1983.

5 The best article about the group I have found is in the catalogue of a travelling exhibition circulated to eight American galleries in 1980–81. See Barbara Rose, "The American Abstract Artists: The Early Years" in *American Abstract Artists* (New York: American Abstract Artists Publications, 1980), 5–13. See also Esphyr Slobodkina, *American Abstract Artists: Its Publications, Catalogs and Membership* (Great Neck, N.Y.: Urquhart-Slobodkina, 1979).

6 Others included Robert Delaunay, Naum Gabo, Alberto Giacometti, Fritz Glarner, Julio González, Hans Hartung, Kandinsky, Fernand Léger, Jacques Lipchitz, El Lissitzky, Piet Mondrian, Antoine Pevsner, Man Ray, Kurt Schwitters, Joaquín Torres-García, Theo Van Doesburg and Georges Vantongerloo.

7 *Solomon R. Guggenheim Collection of Non-Objective Paintings: Third Enlarged Catalogue,* a Loan Exhibition from the Solomon R. Guggenheim Foundation (New York, 1938). There were two earlier catalogues that Harris probably saw: the first was published in 1936, also for an exhibition in Charleston, S.C., the second in 1937 for an exhibition in Philadelphia.

8 Harris to Carl Schaeffer, 15 April 1937; Harris, "Theosophy and Art [2]," 163; Harris, "Art Is the Distillate of Life," 1.

9 Besant and Leadbeater, *Thought Forms,* 36 and Fig. 15; 60. In the Foreword, Annie Besant states that "The drawing and painting of the thought-forms … has been done by three friends — Mr. John Varley, Mr. Prince and Miss Macfarlane."

10 Ibid., 65–66 and Fig. 54; 60 and Fig. 41; 61 and Fig. 42.

11 Wassily Kandinsky, "Reflexions sur l'art abstrait," *Cahiers d'art* 6 (1931): 352. Quoted in Sixten Ringbom, *The Sounding Cosmos,* 203.

12 Harris, "Modern Art and Aesthetic Reactions," 240; "Theosophy and Art [2]," 164.

13 Harris, "Creative Art and Canada," 10. See also Henderson, *The Fourth Dimension.*

14 Harris to Carl Schaeffer, 21 January 1937.

15 Harris to Carr, 15 April 1937.

16 The names of these two paintings are a problem. *Abstraction 1936 II* was no. 31 in the Canadian Group of Painters exhibition of November 1937, where it was called *Composition 8* (Art Gallery of Toronto, *Canadian Group of Painters,* Toronto, 1937, 13 and illustration on 5). The painting was exhibited in Harris's 1948 retrospective as no. 68, but called — like seventeen other works — simply *Abstract Painting.* In Harris's 1963 retrospective it was exhibited as *Abstraction.* I have not been able to determine exactly when the two paintings got the titles *Riven Earth I and II,* which appear in the List of Paintings in Colgrove, 145 and 146. In the same book, *Abstraction 1936 II* is illustrated on 108 where it is called *Abstraction 1936. Abstraction 1936 I* is illustrated on 124, also titled *Abstraction 1936.* I prefer the names *Abstraction 1936 I* and *Abstraction 1936 II* partly because the so-called *Riven Earth II* was painted before the so-called *Riven Earth I* and partly because Harris himself, especially in the 1930s but also for both his retrospectives, preferred the more general or abstract titles.

17 Harris quoted in Colgrove, 114.

18 I am indebted to Mr. and Mrs. Lathrop for this observation.

19 Robert Stacey, *Charles William Jefferys, 1869–1951* (Kingston: Agnes Etherington Art Centre, Queen's University, 1976), 20; Jay Hambidge, *The Elements of Dynamic Symmetry* (New York: Brentano's Publishers, 1926) – see especially the first chapter, "The Dynamic Symmetry of the Plant," 1–17; Jay Hambidge, *Practical Applications of Dynamic Symmetry,* ed. and arranged by Mary C. Hambidge (New Haven: Yale University Press, 1932); interview with Churchill P. Lathrop.

20 For a fuller treatment of dynamic symmetry and similar quasi-mystical systems, see Milton W. Brown, *American Painting from the Armory Show to the Depression,* 161–64.

21 See Hambidge, *Dynamic Symmetry: The Greek Vase* (New Haven: Yale University Press, 1922), 13 and Figs. 7, 8.

 In the rectangle ABCD Harris would have begun by drawing the diagonal BD. Then he would have drawn a line from the corner A perpendicular to the diagonal BD and produced it to the side BC at E. A line drawn from E to the opposite side AD at F makes a rectangle whose proportions are identical to the first rectangle. The line AE, which is perpendicular to the diagonal BD of the original rectangle, becomes the diagonal of the second rectangle, ABEF. From F a line perpendicular to the diagonal AE is drawn and produced to the side AB at G. The line GH drawn to the side FE of the second rectangle makes a third rectangle AGHF with the same proportions as the first and second rectangles. A fourth rectangle, IJHF, is drawn in the same way, and a fifth, sixth and so on, are possible.

22 Harris, "Modern Art and Aesthetic Reactions: An Appreciation," 240.

23 The classic modern expression of this view is in Kandinsky, *Concerning the Spiritual in Art,* especially 40.

24 Harris had a painting which, in 1938, artist Raymond Jonson, a friend of Harris from Santa Fe, referred to as *Celestial Weathervane.* When I showed Jonson a reproduction of *Composition No. 10,* he could not remember whether or not it was *Celestial Weathervane.* However, I suspect they are one and the same work because of the weathervane-like blades and their relation to a central vertical axis.

Chapter 12
SOARING
With the Transcendental Painting Group in Santa Fe, 1938–40

1 Interview with Churchill P. Lathrop, 9 October 1973.

2 Harris to Harry Adaskin, 15 May 1938.

3 Jonson to the author, 14 November 1973.

4 Ibid. However, Alfred Morang, in "The Transcendental Painting Group, Its Origin, Foundation, Ideals and Works," *The New Mexico Daily Examiner,* 21 August 1938, made no mention of Harris.

5 Interview with Bill Lumpkins, 1 June 1982.

6 See Jonson to Harris, 26 October 1942.

7 Harris to Jonson, 28 April 1938; Harris (from Colorado Springs) to Jonson, [early June 1938].

8 *Transcendental Painting Group* (Santa Fe, 1938), unpaged. Harris's copy of Rudhyar's book had been carefully read and had many marginal notes and marks. Dane Rudhyar, *Art as Release of Power: A Series of Seven Essays on the Philosophy of Art* (Carmel, Calfornia: Hamsa Publications, 1930).

9 Interview with Churchill P. Lathrop. Lathrop speculated that one reason for Harris's sudden move to Santa Fe was the presence there of people with similar religious tastes and convictions. Jonson to the author, 14 November 1973.

10 Interview with Maryan Bisstram in Taos, 2 June 1982. At the time, I was working as a consultant with CBC-TV for a documentary they were preparing on Harris. My own notes and interview transcripts, kindly made available by the CBC, form the basis of this account of Bisstram's relationship to Harris.

11 Interview with Bill Lumpkins, 1 June 1982.

12 Interview with Maryan Bisstram, June 1982.

13 Interview with Bill Lumpkins, 1 June 1982.

14 Harris, from Belton, Montana to Harry Adaskin, 3 July 1938; Bess Harris to Betty Dankert, 7 March 1939.

15 Bess Harris to Doris Huestis Mills, 28 December 1938.

16 Harris to Jonson, 28 November 1940.

17 Harris to Jonson, 29 December 1940; Bess Harris to Doris Huestis Speirs, 16 March 1941.

18 "Theosophy and Art [1]," 130.

19 Besant and Leadbeater, *Thought Forms,* 64.

20 Harris's respect for Bisstram was deep and long-lasting. In 1945, he recommended to Joe Plaskett, the first winner of an Emily Carr Trust Scholarship, that he study under Bisstram (interview with Joe Plaskett, 31 October 1983).

Chapter 13
CELEBRITY LANDING IN VANCOUVER, 1940–47
The Federation of Canadian Artists and a New Nationalism

1 "Artist's Return, *Vancouver Daily Province,* 5 December 1940; "Lawren Harris, Noted Artist, Will Give One-man Show Here," *Vancouver Daily Province,* 6 March 1941.

2 Lorna Farrell-Ward, "Tradition/Transition: The Keys to Change," in *Vancouver: Art and Artists, 1931–1983* (Vancouver: Vancouver Art Gallery, 1983), 15. The best study of Macdonald's work is Joyce Zeman's *Jock Macdonald: The Inner Landscape/Le Paysage Intérieur, A Retrospective Exhibition* (Toronto: Art Gallery of Ontario, 1981); see especially chapter 7, "The Modalities," 81–96.

3 See, for example, Jack Shadbolt, "A Personal Recollection," in *Vancouver: Art and Artists, 1931–1983,* 34–36.

4 Interview with Nan Cheney, Vancouver, 11 November 1983 (by telephone).

5 Lawren Harris to Robert Ayre, 12 September 1944, 30 October 1945 and January [1945]. For Shadbolt's description of their differences see "A Personal Recollection," 40.

6 Lawren Harris to Ira Dilworth, 15 January [1956]. The trust was set up by Emily Carr in 1941–42. It had a collection of her works that could be exhibited or sold at the trustees' discretion to realize income for certain projects, including scholarships for promising artists at the discretion of the trustees. According to John E. A. Parnall, who succeeded Harris as one of the trustees in 1962, the original idea for the trust was Carr's, not Harris's as has been claimed. I believe Harris probably had a major influence on its development.

7 Arthur Erickson, transcript of a CBC-TV interview, 1982 (for the film *Lawren Harris: Journey Towards the Light,* for which I was art-historical consultant).

8 Interview with B. C. Binning, December 1973. For Blavatsky's statement on the theosophical belief in "a Universal Brotherhood of Humanity," see chapter 4, "Theosophy."

9 Interviews with Joe Plaskett, 24 October 1983; Mrs. Maud Varley, 23 November 1973; Jack Shadbolt, December 1973.

10 Lawren Harris, "The Function of an Art Gallery," *Art Gallery Bulletin* 10, no. 2 (October 1942); "The Function of an Art Gallery: Second Article," ibid., no. 3 (November 1942); "The Function of an Art Gallery: Third Article, Art Galleries in New York City," ibid., no. 4 (December 1942); "The Function of an Art Gallery: Fourth Article, Art Galleries in the United States," ibid., no. 5 (January 1943); "The Function of an Art Gallery: Fifth Article, Canada's Art Galleries – The National Gallery", ibid., no. 6 (February 1943).

11 Transcript of my interview with Dr. Geoffrey Andrews, December 1973.

12 Interview with John Korner, 30 November 1983; G. H. Tyler, quoted in Tony Robertson, "The First Fifty Years: The Vancouver Art Gallery, 1931–1983" *Vanguard* 12, no. 8 (October 1983): 16.

13 Interview with Harris's friends, the artist Alistair Bell and his wife Betty, 24 November 1973. In 1927, Harris had agreed with those who objected to the inclusion of two European paintings of nudes at the CNE art exhibition in Toronto.

14 Exhibition Committee, "Thirteenth Annual B.C. Artists Exhibition," *Art Gallery Bulletin* 12, no. 4 (December 1944): 2. Lawren Harris, "Sun Critic Doesn't Understand Idea of New Art Exhibition," *Vancouver Sun,* 8 December 1950, and "No 'Clique' Controls Art Gallery Which Shows Few Abstracts," *Vancouver Sun,* 27 December 1951.

15 All of these unpublished mss. are in the Lawren Harris Papers, National Archives, Ottawa.

16 Lawren Harris, "Democracy and the Arts," 1943, 18, 19, 20, 23 and 26.

17 The address was published as "The Function of Art" in the *Art Gallery Bulletin* 11, no. 2 (October 1943): 2–3.

18 Lawren Harris to Andre Biéler, 14 June 1941. After the conference, Harris was concerned about reports that Shadbolt hadn't read all of his material; he suspected bias against his positions. On 7 July 1941 he sent Biéler two pages of detailed, urgent questions that he wanted answered "to guide me here in my work with the artists as well as for my own protection." He wanted to know what Shadbolt's position and behaviour at the conference had really been. Biéler's answers (in a letter, as yet unlocated, of 15 July 1941) seem to have been satisfactory and calming; on 1 August 1941, Harris wrote to Biéler to thank him for his letter, commenting, "That clears the air and I am much relieved. I hate like h_____ being suspicious of anybody."

19 Lawren Harris, "Letter no. 1" (1944), FCA Papers, Queen's University Archives, Kingston, Ont. Harris also wrote a "Presidential Letter" in 1945 and in 1947.

20 Ibid.

21 Harris, "The Function of an Art Gallery: Fifth Article," 2–3.

22 Lawren Harris, "The Federation, The National Gallery, and a New Society," *Maritime Art* 3, no. 4 (April–May 1943): 126–127.

23 Lawren Harris, "Reconstruction through the Arts," *Canadian Art* 1, no. 5 (June–July 1944): 186.

24 Lawren Harris, "Community Art Centres: A Growing Movement, Commentary from Lawren Harris," *Canadian Art* 2, no. 2 (December 1944–Jauary. 1945): 63.

25 Besant and Leadbeater, *Thought Forms,* 65–66 and Fig. 54.

26 The drawing, entitled *Study (Vancouver)* by Bess Harris, is Drawing No. 100 in the estate of Howard K. Harris.

27 The numbers of the paintings in the L. S. H. Holdings company, which appear in the titles, were assigned by the cataloguers as the pictures came to hand in the storage vault – they have nothing to do with the chronology.

28 Besant and Leadbeater, *Thought Forms,* 36–37 and Figs. 15 and 17.

29 Harris, "Modern Art and Aesthetic Reactions, an Appreciation," 240.

30 Harris to Harry McCurry, 13 March 1949 and 3 May 1950.

Chapter 14
OUT OF CERTITUDES INTO LIGHT, 1947–70

1 Lawren Harris to Charles F. Minton ("Carlos"), Santa Fe, 26 November 1944; National Gallery of Canada, "Minutes of the One Hundredth Meeting of the Board of Trustees of the National Gallery of Canada Held at the National Gallery of Canada, Ottawa, 16 and 17 October 1963," in the *Minute Book, Board of Trustees* (Gallery Archives); Bess Harris to Vera Jonson, Santa Fe, 26 April 1955.

2 The approximate dates of the trips to New York come mainly from Bess Harris's correspondence with Doris Huestis Speirs, and also from a letter of Harris to Joe Plaskett, 3 December 1950. Bess's letter about the Italian trip is also to Doris Huestis Speirs, [December 1956].

3 Bess Harris to Doris Huestis Speirs, 12 January 1952.

4 Bess Harris to Doris Huestis Speirs, 8 January 1950.

5 Bess Harris to Vera Jonson, 10 August 1958; interview with B. C. Binning, December 1973.

6 Bess Harris to Doris Huestis Speirs, 2 January 1962.

7 Bess Harris to M. Pierrard at the National Gallery of Canada, 17 November 1966.

8 Art Gallery of Toronto, *Lawren Harris: Paintings 1910–1948* (Toronto, 1948), Plate 15.

9 Lawren Harris, *A Disquisition on Abstract Painting* (Toronto: Rous and Mann, 1954), 8.

10 Interview with Lawren Phillips Harris, 29 March 1974, and taped interview with B. C. Binning, December 1973; Harris, *Disquisition on Abstract Painting,* 8.

11 The exceptions are the early Algoma sketches of about 1918 (e.g., *Wood Interior, Algoma, No. 1,* Plate 18), and his last paintings (e.g., *Abstraction "R,"* Plate 64, and *Abstraction "S,"* Plate 70.)

12 Lawren Harris, "An Essay on Abstract Painting," *Journal of the Royal Architectural Institute of Canada* 26, no. 1 (January 1949): 7. This article was reprinted in *Canadian Art* 6, no. 3, (Spring 1949): 103–7, and again, with additions, especially about Abstract Expressionism, in Harris's *A Disquisition on Abstract Painting.*

13 The ms. of the introduction and the twenty-four drawings are part of the Lawren S. Harris Papers, National Archives of Canada. (Unfortunately, Harris did not write down his comments on the drawings.) I photographed the drawings before they were given to the National Archives, and they are reproduced here from my own slides.

14 *Abstract Sketch*, and the painting *Resolution*, preceded rather than followed the drawings, although perhaps similar drawings were involved in the genesis of the sketch and paintings.

15 See Besant and Leadbeater, *Thought Forms,* 65–66 and Fig. 48.

16 Transcript of a CBC-TV interview with Alistair Bell, 1982 (see chap. 13, n. 7); my interview with Alistair and Betty Bell, 24 November 1973.

17 Harris, *Disquisition on Abstract Painting,* 10, 11.

18 Lawren Harris, quoted in Sydney Key's essay, "The Paintings," in the catalogue of the 1948 retrospective exhibition at the Art Gallery of Toronto, *Lawren Harris: Paintings 1910 – 1948,* 32. The Vancouver exhibition was held 10 May–15 June 1955. B. C. Binning wrote the introduction to the catalogue, Vancouver Art Gallery, *Lawren Harris: Recent Paintings* (Vancouver, 1955). The list of works includes *Equations in Space* (Plate 39), which was probably done in the 1930s in Hanover.

19 See for example "Harris's Mystical Interests and Theosophy," chapter 4, and Figs. 4.1, 9.5, 14.1 and Plate 61.

20 Harris, "Creative Art and Canada," 10. For Harris's remarks on the fourth dimension, see chapter 9.

21 Harris, *Disquisition on Abstract Painting,* 11; Bess Harris to Vera Jonson, 10 August 1958.

22 For example, Hugo Munsterberg, *The Crown of Life: Artistic Creativity in Old Age* (New York: Harcourt Brace Jovanovich, 1983) and Kenneth Clark, "The Artist Grows Old," in *Moments of Vision and Other Essays* (New York: Harper and Row, 1981), 160–80. This essay was Clark's Rede Lecture, delivered at Cambridge University in 1972.

23 Clark, "The Artist Grows Old," 175.

24 Ibid., 174–75.

25 Bess Harris to Dennis Reid, 14 September 1969.

26 Most of these late paintings are identified by an estate letter, e.g., "Estate 'A,' " rather than a number from the Lawren S. Harris Holding Company. When the cataloguers were sorting through Harris's paintings after his death, they felt that these late paintings were not up to standard and did not belong with the more recognizable and firmly controlled styles of the work already listed in the holding company, so they were kept separate. In this book I refer to them by the estate letters as *Abstraction "A,"* etc.

27 Seattle World's Fair, *Art since 1950: American and International* (Seattle, 1962), 33. "Post-Painterly Abstraction" was organized by the Los Angeles County Museum of Art; Noland's *Cadmium Radiance* is No 69 in the unpaged catalogue.

28 See the end of chapter 13 (Harris to Harry McCurry, 3 May 1950).

29 Ibid.

30 Harris apparently did paint an Arctic landscape called *Arctic Sunset (Arctic Painting No. 8)* of about 1931. A drawing of this painting – done by Hans Jensen, probably in 1935 – is in a loose-leaf collection of drawings Harris had made to serve as a catalogue of his work up to that time. A huge sun is the central image. On the drawing Harris has marked "unfinished" and "destroyed."

31 Besant and Leadbeater, *Thought Forms,* 36 and Fig. 17.

32 Lawren Harris, "The Paintings and Drawings of Emily Carr," in *Emily Carr: Her Paintings and Sketches* (Toronto: Oxford University Press, 1945), 28.

33 *Lawren Harris,* edited with the help of R. G. P. Colgrove (the book referred to in these notes as Colgrove).

34 Margaret H. Knox, "Personal Reminiscences," a chapter contributed to the limited edition of *The Beginning of Vision,* 230; interview with Mr. James Knox, Vancouver, November 1973.

35 Margaret H. Knox, "Personal Reminiscences," 230.

PHOTO CREDITS

In order to reproduce as many little-known works by Harris and others as possible, and to keep the book affordable, many of the illustrations have been reproduced from the author's own slides, and the author takes responsibility for any imperfections in them. He and the publisher wish to thank the many private collectors and institutions who allowed works to be reproduced this way. They gratefully acknowledge photographs from all other sources below; numbers in boldface are the illustration numbers.

All works by Lawren S. Harris are reproduced with the permission of his estate. While the author and the publisher have made every effort to trace the present owners of Harris pictures, we apologize for any case where this has not been possible.

COLOUR PLATES

Acme Photography (André Beneteau), **19, 30, 47, 48, 60, 61, 62, 67, 71**; Art Gallery of Ontario, **7, 36, 40, 42** (Carlo Catenazzi), **15, 23**; Art Gallery of Windsor, **2**; Hart House, University of Toronto, **29** (Thomas Moore Photography Inc.); Mira Godard Gallery, **10**; McMichael Canadian Art Collection, **11, 25**; National Gallery of Canada, **39** (© NGC/MBAC), **26** (M. Neill), **24, 31, 32, 43**; Sotheby's Canada Inc., **18**; University College, University of Toronto, **16** (Thomas Moore Photography Inc.); Vancouver Art Gallery, **44** (Jim Gorman).

BLACK AND WHITE PHOTOGRAPHS

Art Gallery of Ontario, **3.9, 6.2, 6.5, 7.8, 7.10, 7.11, 8.10, 9.15, 14.30**; Art Gallery of Windsor, **8.4** (Saltmarche), **12.1**; Dalhousie University Art Gallery Permanent Collection, **9.4, 12.2**; Hart House, University of Toronto, **6.7, 7.9**; McMichael Canadian Art Collection, **3.6, 3.12, 3.14, 3.17, 7.7, 8.1, 9.7, 9.8, 9.16, 9.17, 13.2**; Mira Godard Gallery, **7.6**; National Gallery of Canada, **8.8** (© NGC/MBAC), **3.11, 3.16, 3.18, 3.19, 3.20, 6.4, 7.4, 7.5, 8.3, 9.3, 9.14, 13.3, 14.19, 14.24**; University of British Columbia, **14.2, 14.26**; Winnipeg Art Gallery, **8.6**; Yale University Art Gallery, **11.3**.

Photographs of Lawren S. Harris by Jack Long: National Archives of Canada, 73174 (page 37), 73178 (page 180).

INDEX

Paintings, drawings and written works by Lawren Harris are indexed by title. Other artists' works are indexed under the name of the artist. Boldface numbers indicate illustrations: colour plates are listed by *plate number,* black and white figures by *page number.*